DIGITAL
PHOTOGRAPHY
MASTERCLASS

TOMANG

DIGITAL
PHOTOGRAPHY
MASTERCLASS

London, New York,
Munich, Melbourne, Delhi

Senior editor Nicky Munro
Designer Sarah-Anne Arnold
Editorial team Hannah Bowen, Diana Vowles,
Bob Bridle
Design team Joanne Clark, Angela Won-Yin Mak,
Sharon Spencer
Creative retoucher Adam Brackenbury
Producer, pre-production Lucy Sims
Producer Linda Dare
Jacket designer Mark Cavanagh
Jacket editor Manisha Majithia
Jacket design development manager
Sophia Tampakopoulos
Managing editor Stephanie Farrow
Senior managing art editor Lee Griffiths
Publisher Andrew Macintyre
Art director Phil Ormerod
Associate publishing director Liz Wheeler
Publishing director Jonathan Metcalf

First published in Great Britain in 2008 by
Dorling Kindersley Limited

Second edition published in Great Britain in 2013 by
Dorling Kindersley Limited
80 Strand, WC2R 0RL

Penguin Group (UK)

2 4 6 8 10 9 7 5 3 1
001 192366 July/2013

Copyright © 2013 Dorling Kindersley Limited
Text copyright © 2013 Tom Ang

A CIP catalogue record for this book
is available from the British Library.

ISBN 978-1-4093-3390-6

Printed and bound by
South China Printing Company, China
Discover more at
www.dk.com

contents

mastering your camera

tutorial 1 | key camera controls

tutorial 2 | exposure control

the digital darkroom

tutorial 10 | perfecting the image

tutorial 11 | manipulating the image

tutorial 12 | advanced manipulation

advancing your photography

tutorial 13 | travel photography

tutorial 14 | portrait photography

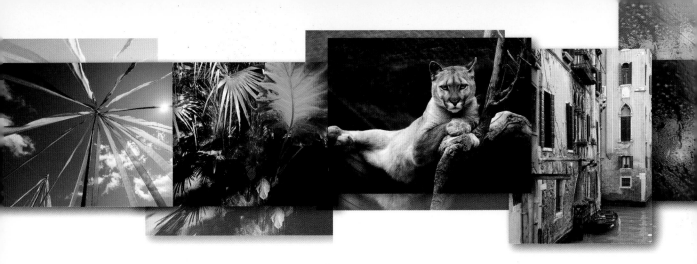

introduction

For a few years, photography resembled a building site. We walked between piles of rubble from the ruins of once-great manufacturers who had not adapted to the new digital climate. We gazed upon the abandoned edifices of established practices, wondering what was to become of them, their glory days over. Between the destruction and emptied spaces, however, new structures were springing up – unpredictable shapes and unfamiliar forms. In fact, the new order was growing so quickly that we could see it burgeon as we watched.

Now the transformation of photography is complete. While the digital phenomenon was once seen as the enemy of traditional photography, then became accepted as its greatest boon, the disorder of change became the springboard for the most exuberant growth and vigorous expansion ever seen in the history of photography.

If you are one who has been newly entranced by photography, you are part of this truly tremor-inducing cultural, social, and visual revolution. And this book is written for you. It is for those of you who enjoy the creative rewards photography can deliver; those who simply delight in making photographs, and those who choose to succumb to it as an obsession. It is also for the many of you who will, by now, have tried your hand at manipulating your images too. You are all joined by a yearning to take your photography further.

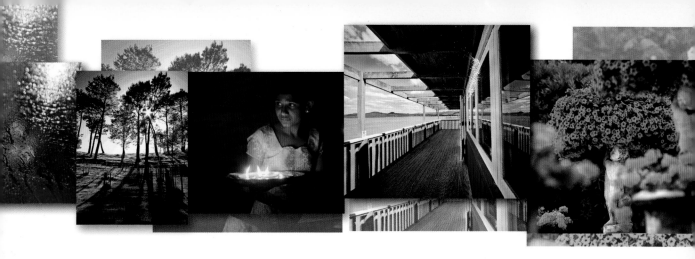

While the book covers the techniques of digital photography, it does so in a number of special ways. Subjects are presented as tutorial masterclasses, each of which culminates in an invitation to you to carry out a self-paced assignment. You are then shown how these same assignments have been interpreted and completed by a selection of photographers from around the world. Their images have been chosen and critiqued to show you what others, like yourself, find achievable and what they find difficult.

The crowning glory of the book comprises interviews with outstanding photographers selected from around the world. Once ambitious amateurs like you, these photographers have pushed their art, creativity, and talent to go further. Their thoughts, motivations, and experience offer more invaluable advice and insight than can be obtained after years of individual study. Look, read, and re-read this section as inspiration for years to come.

And that is the core of my aim: if reading this book and seeing the images within it inspires you to pick up your camera and hit the road, then off you go. It's been a good class.

Modern cameras are absurdly easy to use. You need only press two buttons – they identify themselves pretty obviously – and all is done for you. This series of tutorials may go over ground that is familiar to you, but, like musicians who practise scales all their lives, the more you rehearse, the less you need to think about. Then the more confident your photography will become.

key camera controls

You can measure your progress in photography by your attitude to camera controls. At first they seem like a burden – an obstacle rather than an advantage – but as your command over them improves, they turn into invaluable tools, a power helping your creative processes. And of all the camera controls, the shutter setting is the most distinctively photographic.

fact file

The use of the term "shutter speed" can cause confusion. A camera's shutter travels at the same speed whatever it's set at. With a long exposure ("slow shutter speed") of one second or a short exposure ("fast speed") of 1/1000 sec, the shutter blades always travel at the same speed.

shutter settings

The shutter setting determines much more than the exposure time. From past practice, the priority was to use short shutter times in order to ensure that the images were sharp. Once that was satisfied, the appropriate aperture to achieve correct exposure was set. Now, the arrival of cameras and lenses with image stabilization means the guidelines are being rewritten.

exposure times | sharpness and blur

The shutter's primary function is to set the exposure time. While it's open, the photographic exposure is created by a summing up of all the light that falls on the sensor. The resulting record is not just of the light falling, but also its spatial relationship with the sensor. This means that the sensor records all changes in position of the subject or of the camera itself, however minute they may be: in short, the sensor records both light intensity and movement.

> 〝 unshackle yourself from the tyranny of the brief exposure time and its adherence to sharpness 〞

With a short exposure time, there's less chance for movement to travel a significant distance on the sensor. This means the blur from any movement cannot be easily seen; the image looks sharp. If we hold the shutter open for longer, movement both in the subject and in the camera can draw a blur that's large enough to be seen. Given a blur only about a tenth of a millimetre long, from a distance of about 20cm (8in), the eye assesses the image as unsharp.

short exposures | longer exposures

While using the shortest exposure time seems the obvious solution in order to obtain the sharpest picture, it can, in fact, have a negative effect on your image. A brief exposure may require a large aperture, or you may need to use a high ISO setting – sometimes both.

These compensations may undermine your attempts to capture a sharp image: the large aperture reduces depth of field, calling for more precise focusing, and may also reduce image quality. A high ISO setting may increase noise. This reduces the sharpness of detail, not to mention lowering the quality of colours.

Consequently, you may find that if you unshackle yourself from the tyranny of the brief exposure time and its adherence to sharpness, your pictures improve. Allow yourself a longer exposure to work with blur or allow slight movement into your image. The cameras featuring image stabilization give us a marvellous new way to approach movement. It helps us hold the camera steadily during long exposures, yet we can still capture movement blur.

FLASH + 1/125 SEC

FLASH + 1/60 SEC

1/5 SEC

0.6 SEC

5 SEC

2.5 SEC

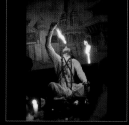
1/10 SEC

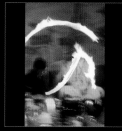
3 SEC

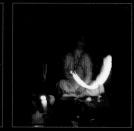
1/2.5 SEC

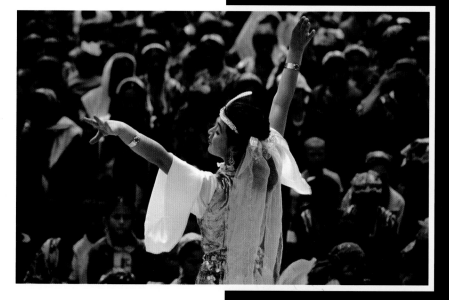

lightbox

exposure effects

In **1–3**, flash was combined with different lengths of exposure times to capture a dancer's show. Images **4–6** show combinations of movement with differing exposure times – the longer exposures give longer blurs, but the exact effect depends on other movements. In **7–9**, different motion is captured in the fire-eater's show: with unpredictable subjects it is best to experiment with exposure times.

dance action

Short exposures are classically used to capture action such as dance. But a relatively long exposure can be used if action is caught at its peak, when a gesture or pose may be held for a fraction of a second.

close-up depth of field
The minimal depth of field at close-up distances is often decried as a difficult and technical problem. But if you accept the inevitable – a consequence of physical law – you can work with it and exploit the narrow depth of field to bring the viewer's attention to precisely the part of the image you wish them to examine.

depth of field

It's hard to get excited about depth of field, taken in its usual definition. But it's more than cold optics – the span of image space within which an object appears acceptably sharp. It is, in effect, the depth of sharpness, which is about the plasticity of the image: its handling of space and solids.

sharpness | and space

In normal vision, barely five per cent of what we see is sharp – only the part of the visual field that we can see in detail. However, a scene appears sharp overall because our eyes continuously refocus as they flit from detail to detail, scanning the scene to build a fully focused picture.

In a typical photograph before the digital era, hardly any of the image was sharp. The premise of the influential f/64 school of photography (created in 1932) was the worship of extensive depth of field – most easily achieved when photographing distant subjects, which made landscapes the group's favoured subject matter.

This changed in the digital era. With the use of small sensor chips calling for lenses with short focal lengths, depth of field suddenly became very extensive. Everything looked sharp, and at first this was welcomed, but negative reactions swiftly followed: all pictures looked the same, and it was difficult to find a way to make the main subject stand out.

observer's | eye

The main controls we have over depth of field are aperture, focal length, and magnification. Depth of field increases with smaller apertures, shorter focal length, and smaller magnification (where the camera is further away from the subject). To decrease depth of field it is necessary to increase lens aperture, use a longer focal length lens, or move closer to the subject.

However, these controls are insignificant compared to the observer's opinion about sharpness and how critically the image is being

viewed. The perception of depth of field will also be influenced by the size of the print at which the image is viewed. The smaller it is, the greater the apparent depth of field.

quality | of blur

Given that so much of a typical image is unsharp, what may matter more is the quality of the unsharpness, or blur. It was only in the late twentieth century, and the use of inexpensive lenses with odd-shaped aperture diaphragms in point-and-shoot cameras, that photographers learnt about unattractive unsharpness – where the blur was uneven, lacked smooth transitions, and was sometimes fringed. The quality of unsharpness is called "bokeh", and good bokeh is now an image quality prized in almost equal measure as sharpness.

The net result is that the plasticicity of your image – how it feels and the way it conveys the picture space to the viewer – depends heavily on your control of depth of field. That in turn depends on you using larger sensors if you want to create reduced depth of field, and high-quality lenses for smooth blur.

SMALL APERTURE

LARGE APERTURE

depth of feeling

Whether you choose to show more or less depth of sharpness in the image depends on what you wish to say. A small aperture (above left) gives greater depth of field – more extensive sharpness – and appears clean and crisp. With a larger aperture (above right), much of the image is blurred: sharpness is limited to the orange stamens, giving us a softer, less clinical, more sensual image.

telephoto focus

Combining a large aperture of f/2.8 with long focal length of 200mm and a large sensor gives narrow focus with pliant blurs.

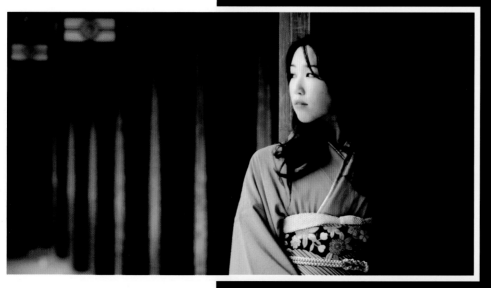

OFF-CENTRE FOCUS

OUT-OF-FOCUS BLURS

image **analysis**

Discovering a perfect miniature landscape that hundreds of tourists have passed by without noticing is one of the joys of photographic mastery. Remember to leave a "zero footprint" – no matter how much you want the picture – so the next person can enjoy the scene as you have.

shutter | times

The shutter setting was central to the success of this image. Not only did using the correct shutter time ensure that the water was captured with just the right amount of flow, but other settings, such as depth of field, were directly affected by it. At 1/8 sec, the exposure was long enough to require a tripod, especially as a medium-long focal length of 130mm was needed for the tight view. Much of the scene is shadow or dark green, so an exposure override of -1 stop was dialled in, which helped ensure that the bright waters were not over-exposed. In addition, an extensive depth of field was necessary to sharply capture each level of water and greenery. This called for a small aperture of f/22 but, for this to be possible given the low light levels, the camera's sensitivity was increased to ISO 400. (Fortunately, even a high noise level is disguised by the rich textures in this image.) Finally, the shot needed a little luck with the timing because the varying flow of water produced different cascades. It can take many attempts to catch the ideal shot.

in detail

The main difficulty with taking close views of waterfalls is usually confined to the physical conditions rather than the photography itself. You need to avoid getting wet or slipping on the rocks and, above all, try not to damage plants, disturb rocks, or remove branches and leaves that may appear to be "in the way". It is best to shoot in RAW format to allow lots of room for tonal adjustments, as the highlights can be surprisingly bright compared to shadows.

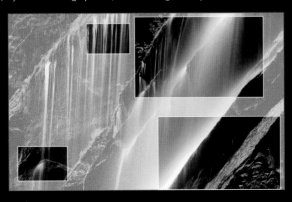

sun-caught splash

A few minutes' observation revealed that an extra load of water would sometimes fall, creating a richer flow. The water flow had to be coordinated with the ever-changing light conditions as clouds passed in front of the sun.

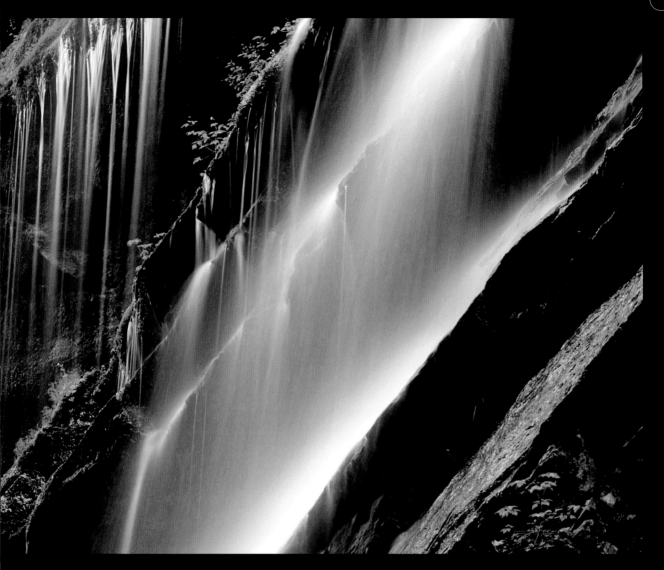

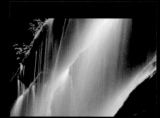

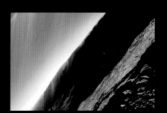

continuous flow
The steady flow of water in this part
of the image will register constantly
no matter when the exposure is
taken. However, it pays to wait for
the sun to shine as the trickles of

flowing blur
As the flow of water is relatively
constant, it's worth evaluating a
magnified review image to see if
the shutter setting is producing the
desired blur effect. A longer exposure

exposure and contrast
The scene is dominated by cool grey
and green tones, while the backlit
plants form the tonal centre. Your
exposure must ensure that the plants
are lit sufficiently to reveal their colour

relative noise

A high level of noise would be barely noticed in the picture of the peacock because of very high frequency, or fine details. However, the watery sky will suffer if any noise is visible.

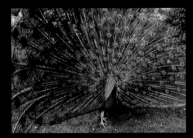

FINE DETAIL

SMOOTH TONES

documentary effect

The original in colour was strong on bloody meat, which distracted from the friendly butcher. In black and white, and with added noise, the gory colour image is transformed into an old-style documentary shot made on fast black-and-white film.

quality settings

Photographers brought up on film are familiar with the fact that faster, more sensitive films bring with their speed an increase in grain. In digital photography, the equivalent of grain is noise – but noise is a very much more complicated matter than grain.

noise | problems and benefits

Caused by many factors, including heat, the nature of the electrical signal, and activity in the sensor itself, the outcome of noise is always the same – irregular, random specks or sparkles that don't relate to specific details in the photograph. In fact, because noise tends to mask detail it is generally regarded as a flaw that should be avoided or reduced. In the same way that many film-using photographers tried hard to avoid grain in their photographs – by working with the slowest practicable films and developing their images with special formulations – so digital photographers continually endeavour to avoid noise.

It is the electronic nature of noise that determines its rapid rise with increased sensitivity. Setting higher sensitivities means that we are amplifying the image signal – making it "louder". However, in the process, we also amplify the errors (the noise) already present in the signal. While the overall level of noise is falling thanks to clever algorithms, it is still broadly true that noise rises with ISO setting, with pixel count, and with the use of smaller sensors.

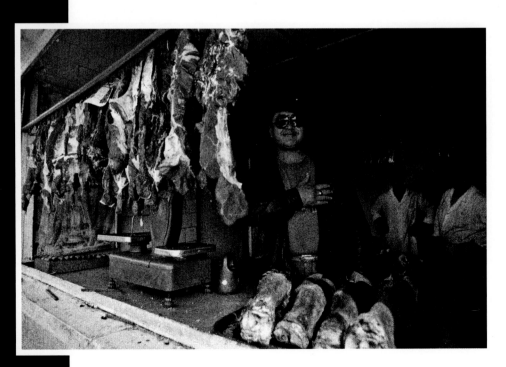

However, noise is not necessarily a bad thing; it can give texture to what is sometimes too smooth and clinical an image plane. It's worth experimenting with different ISO settings to learn about the characteristics of your camera's noise and how to exploit them. If you want to add noise artificially, you will get the best results from specialist software such as DxO Optics, which simulates film grain (see pp. 176–77).

detail | and resolution

Resolution is a measure of how much detail has been recorded to a certain level of contrast. A high-resolution setting, however, doesn't necessarily guarantee a high-resolution image – that is, a high-quality one full of useful detail – it means only that the image contains a large number of pixels. If the camera lens is of poor quality, recording an image with more pixels won't make it any sharper. The practice of calling the largest file setting "high resolution" is therefore slightly disingenuous. In fact, it's vital to keep in mind the difference between measurements, such as resolution, and assessments, such as quality. Unfortunately in digital photography, the word "quality" is also used as a measure, and resolution is sometimes regarded as synonymous with quality.

When you choose a resolution setting, you're making a decision involving more than simply the size of file to save. A high-resolution file needs far more data processing than a low-resolution one, so it takes longer to process each image, slowing the speed of operation – and of course you'll be able to fit fewer large files onto the memory card. If you have a camera that can record 18 megapixels or more, it's useful to try the second-largest resolution setting and compare the results with the largest. You may well find that for your needs the smaller file is perfectly suitable.

compression | and quality

One way to balance the high storage needs of large files with a desire for good quality is to compress the files, thereby reducing the memory space they occupy. The JPEG protocol is able to reduce files to as little as one-tenth of their original size without visible loss in quality, and even more if visual loss is allowed. However, JPEG is a "lossy" scheme, which means that data lost as a result of JPEG compression is forfeited forever. Virtually all digital cameras can save files in JPEG. Some allow you to set the compression or quality level: the best strategy is to set the highest quality (the lowest compression) if possible.

556 KB

16 KB

fine detail
Images combining very fine detail and large areas of soft tones are best recorded with the highest-quality settings available. This will help you resolve details of the fur while also keeping subtle tonal gradations in the out-of-focus areas.

colour settings

There was a time when an army of expert colour technicians – an entire industry – saw to a photographer's every colour concern. Now, of course, you are the master of your own colours, albeit within the limits set by the equipment you use and your own patience and level of expertise.

colour | strategy

One way of understanding the relationship between what you see and the record you make of it is to think of your camera as a second observer, standing beside you and apparently seeing what you see. However, just like another eye, it also contributes different values and alternative perceptions. As with any other fellow observer, you will obtain the best from the camera by appreciating its strengths and limitations. An effective strategy for getting the best result is to ensure a precise white balance. This is the equivalent of making an accurate exposure: accurate white balance gives you the most room to adjust colours, just as accurate exposure gives you the greatest flexibility over image brightness.

settings | colour space

Digital photography makes extreme demands on colour accuracy because we are able to compare immediately the images on our camera LCD panels with the scene we've just photographed. To reproduce on paper the colours that we can see on the LCD requires a system of precisely managed controls that starts with the manufacture of the sensor and ends with the type of paper and ink we use. We also need to ensure correct calibration of the computer monitor and the use of ICC profiles along the way.

The majority of cameras set themselves to sRGB by default because this is a relatively small space, easily reproduced on monitors, and therefore suitable where images are intended for web use and average-quality printing. However, working in the largest practical colour space is central to helping the system produce the richest range of colours. Of the large spaces, the most popular is Adobe RGB (1998), although some photographers advocate Wide Gamut RGB. More and more cameras are offering Adobe RGB (1998) as a working space. The colour space is set in the camera menu, usually under colour settings.

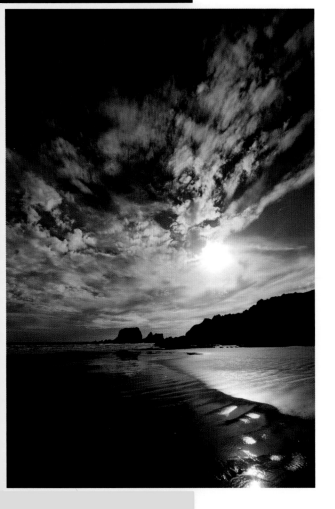

assigned profiles
An image like this, which relies largely on tonal masses and shapes for its impact, can be set to virtually any level of saturation. Weak colours make it a tinted black-and-white image, while strong saturation will still bring out the blues in the evening sky.

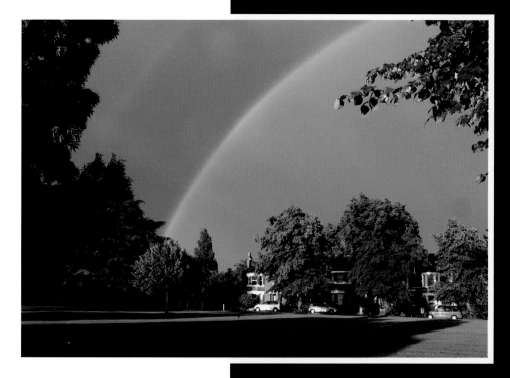

OVER-SATURATED

AS SHOT

colour allure
The temptation here is to boost the colours to make the most of the rainbow. However, setting the saturation too high will also deepen the colour of the sky and the cars, so a balance between all the elements needs to be found.

delayed | decisions

Excellent though the modern LCD screens on the back of cameras may be, they are not the best way to assess the colour quality of your images. The safest and most effective way to evaluate images is on a high-quality monitor or laptop screen that you view indoors, out of direct sunlight. It is an advantage, then, to be able to defer decisions about colour space, profile, saturation, and white balance until after photography has been completed.

The way to do this, if your camera allows it, and provided you have the software application able to process the files afterwards, is to capture images in RAW format (see pp. 184–85). In RAW format mode, the image is not yet processed to deliver full colour reproduction. Only when you open the image in a RAW converter do you apply the colour space profile, white balance, and colour saturation settings.

assigned profiles
This series shows the different appearance of the same image when it is interpreted by different profiles. ProPhoto RGB offers the richest colours but not all of them can be printed. Adobe RGB (1998) has a wide range, much of which can be reproduced. The sRGB and monitor profiles are narrow-gamut, so they give a good indication of final appearance as seen on many devices.

PRO PHOTO RGB

ADOBE RGB (1998)

SRGB

LCD MONITOR

image **sharpness**

You would be forgiven if you are confused by discussions about image sharpness in the context of camera controls and settings. However, in the digital era, while sharpness may be underwritten by lens performance, its contribution to the characteristics of the image is down to the camera settings.

blur | cause and effects

It's an inescapable fact that every step of the photographic process tends to introduce blur – the loss of detail. From using lenses that are imperfectly sharp or imperfectly focused to the use of sensors whose photosites don't perfectly line up with detail being recorded, all processes conspire to create blur.

The lens is the foundation for sharpness: we need optics capable of projecting a detailed image with high clarity. Then we must focus it as precisely as possible, and ensure that during the moment of exposure there is minimal movement of both the subject and the camera – and that the exposure time we have set is sufficiently short to minimize the effect of any movement that may occur.

in-camera | sharpening

At this point, another camera setting may become relevant. If you are recording images with JPEG compression, the camera is likely to apply sharpening to the image. This is the default setting because images that emerge from the camera

locating sharpness

Sharp focus on the acolyte collecting rice straw contrasts with the out-of-focus blur behind him. Although the majority of this image consists of blur, the precise location of the sharpness is essential to its success. And too much sharpness would also be detrimental, because it would distract attention from the boy's face.

FOCUS ON FACE

SECONDARY FOCUS

BLUR ACCEPTABLE

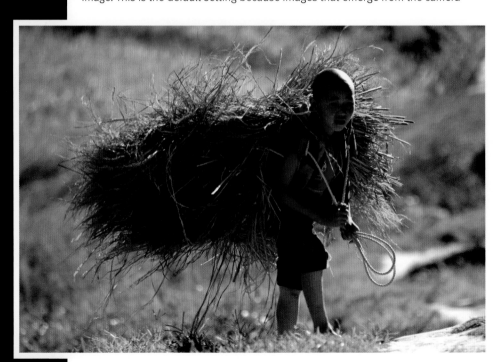

without sharpening usually look soft, even when they are, in fact, perfectly in focus. That's the result of the system tendency towards blur. Rather than risk users complaining about focusing errors in their cameras, manufacturers apply generous sharpening in order to make the images look appealingly sharp.

On the face of it, this intervention seems entirely sensible, but it can actually be the cause of a great deal of manipulation misery later. Sharpening in-camera enhances edge differences between boundaries in the image, for example, the border between a blade of grass and some sand is increased in contrast, which makes it look sharper.

In the camera, this effect is applied globally and indiscriminately. It doesn't adapt either to different types of detail within a subject, or to the nature of the subject. Sharpening would be applied to the blemishes on a person's face, for example, but we may not want to see those details clearly.

Equally, a broadside of sharpening can bring out image noise to make it more visible; another undesirable result. Worse still, over-enthusiastic sharpening can, paradoxically, be very destructive of image detail. And if you attempt to blur or soften over-sharpening effects, that will result in even more loss of detail as well as unnaturally smooth edges.

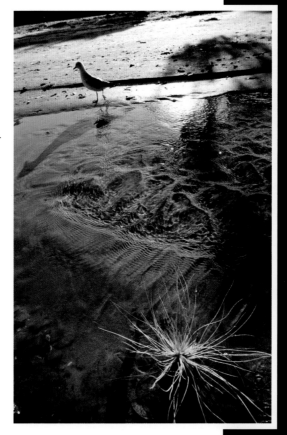

FOCUS ON GRASS

WIDE-ANGLE

WIDEST ANGLE

variable sharpness
In shifting the focus of attention from the grass to the gull that came to investigate, the field of view was zoomed out to a wider one. This helps improve depth of field, but the type of sharpness needed changes from the high-frequency details of the grass, to the smooth outlines of the gull.

leave it | to last

There is also the uncertainty over the size at which an image will be viewed and how it will be viewed. While it would seem obvious that larger images will need more sharpening, this has to be balanced against it being easier to spot sharpening artefacts, such as over-emphasized edges and haloes. On-screen viewing may call for less sharpening than on print, again depending on the final viewing size.

A safe general rule is to leave image sharpening as the last step in image processing. This means that you reduce camera sharpening to the minimum if saving to JPEG or turn it off altogether by saving to RAW (see pp. 186–87).

Another reason for taking sharpening off your camera's hands is that when you sharpen the image manually you can also make choices about adapting the level of sharpening to the type of detail in the image. This is by far the best way to minimize artefacts (see also pp. 180–81).

> **fact file**
>
> To assess the level of sharpening needed, always view the image at 100% or else the monitor itself blurs the image. For printed images, increase sharpening until artefacts are just visible. For on-screen use, increase the sharpening until artefacts are visible then reduce a little.

image **analysis**

The sheer number of settings available on modern digital cameras can seem overwhelming. Many photographers take fright at the prospect of so much choice, and never fully explore their camera's settings. You will find that the default settings suffice for the majority of situations but, to get the most out of your camera's features, you need to be able to move beyond these settings.

workflow | settings

Using the correct camera settings was vital for the success of this shot. The settings are designed to allow you to achieve your preferred level of quality while still having access to all the camera's functions. They should also offer the smoothest workflow. Here, it was essential to use the highest available resolution in order to capture fine details, and the smallest aperture was used for the greatest depth of field. It's always best to avoid using the basic or easy setting, which may disable options such as colour space or choice of white balance. The colour space here was set to Adobe RGB (1998) as it was intended for publication, although sRGB is suitable for most situations. For minimum effort, and to reduce file sizes on location, the image was saved to JPEG. It was important to turn off the flash and set the camera to "intelligent" ISO, which changed the sensitivity to match the lighting conditions.

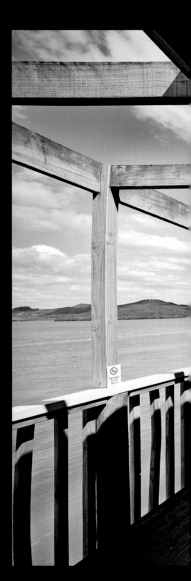

in **detail**

This image, which was taken in Rawene, New Zealand, took little effort to make but rests entirely on the basic set-up of the camera. Colour space was set to Adobe RGB (1998) and it was saved to JPEG at full resolution because the need on location was to minimize file sizes. However, the image – nearly 5,000 pixels wide – holds sufficient data for a great deal of shadow information to be extracted, as well as for very fine details in the woodwork to be fully resolved.

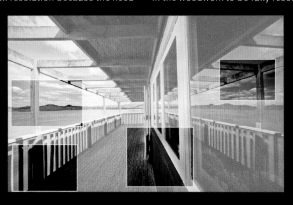

detail capture
Fine details oriented vertically or horizontally are relatively easy for the camera to define, but details at an oblique angle are very demanding. For these, you always need to use the highest available resolution.

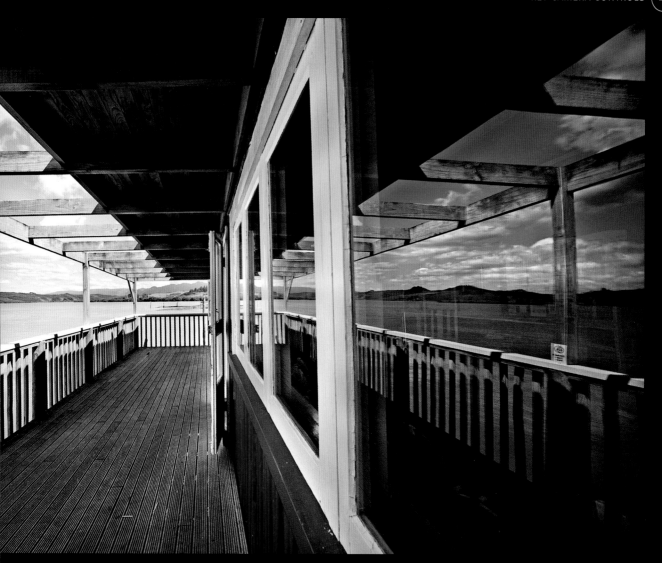

depth of field
Here, the smallest aperture was set because the depth of field needed to be as extensive as possible. The image was made hand-held, so the sensitivity was increased to allow a small aperture with a short exposure.

recovered highlights
The level of information in the highlights, combined with shadow detail, is more than any film could have captured. For the best recovery of highlights, work in RAW format for access to the greatest dynamic range.

retrieved shadows
Retrieving or filling shadow details in the reflection entailed increasing contrast and colour saturation to reflect the deeper colour of the sky in the shadows. Take care not to overdo the fill; keep the shadows dark.

Urban lights at night pose a challenge to any photographer. Exposure is tricky to evaluate as the pattern of light distribution is highly discontinuous. You have to deal with very sharp peaks of bright lights in which you wish to capture colour, as well as lower-range lights and shadows with details that you wish to retain. The fact that the camera's display is easiest to use in dark conditions may give a false sense of security. Bracket exposures freely and test your camera's review against the image on your computer monitor.

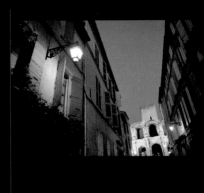

ISO 3200 Focal length 27mm 1/40 sec at f/3.2

the**brief**

Find a location that offers a variety of coloured lights, such as street furniture, shops, restaurants, and offices. Choose somewhere safe to walk around so that you can concentrate on capturing the brilliance of city lights.

Points to remember

- using different sensitivity settings allows you to compare the effect of noise and exposure
- different white balance settings will alter the effect of colour balance
- trying a variety of viewpoints gives you different perspectives
- work fast to capture the colours of the evening sky just before dark
- juxtaposing different elements in the same picture plane adds interest
- varying exposures on the same composition is a good way to learn about tonal variation with exposure
- contrasting sharp details with movement blur emphasizes speed

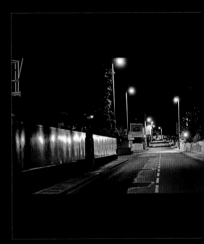

ISO 1600 Focal length 62mm 1/10 sec at f/2.8

must-see masters

Brassaï (1899–1984)
An exponent of the "new objectivity", the Hungarian photographer Brassaï is best known for his pioneering and insightful work on the nightlife of Paris. The virtuosity of his low-light work using relatively low-sensitivity materials is a continuing inspiration.

studies of murder scenes in New York remain unequalled for their power and haunting presence.

Rut Blees Luxemburg (1967–)
This German-born photographer, who studied in London and now works from the city, is one of the leading exponents of the urban landscape as mirror and

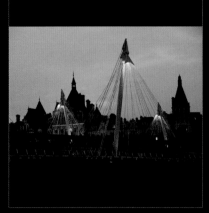

ISO 160 Focal length 105mm 1/2 sec f/6.7

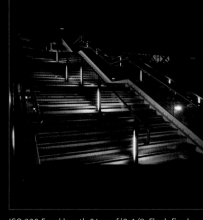

ISO 320 Focal length 24mm f/9 1/8 Flash fired

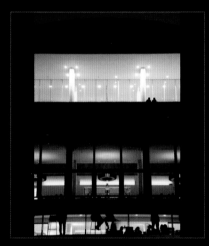

ISO 400 Focal length 50mm 1/30 sec f/5.6

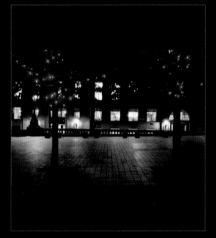

ISO 320 Focal length 22mm 2 sec f/19

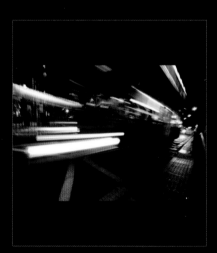

ISO 800 Focal length 11mm 1/4 sec at f/6.3

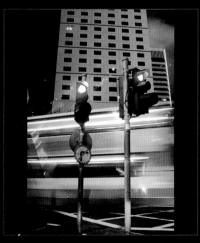

ISO 800 Focal length 6.3mm 1/8 sec f/2.8

1 2 3
4 5 6
7 8 9

light**box**

top**tips**

1 **twilight** | evening colours
One of the most appealing times for photography is the "twilight zone". Between dusk and darkness, colours are resonant and often quite eerie. However, your captured images may not match the visual experience.

2 **colour** | contrast
In the evening, lighting contrasts are amplified by our eyes' increased sensitivity to luminance difference. Here, the soft colours in the sky are a backdrop to foreground lights.

3 **composition** | directing the eye
Careful composition is as important in the dark as it is during the day; it's easy to be seduced by the coloured lights, but they are not always enough to hold a picture together. Here, an active diagonal leads the eye.

4 **night vision** | colour saturation
When your eyes are adjusted to night vision you find it harder to see colours in full strength, but they are recorded strongly in a digital image. Here, the street lamps are a definite orange in the image, but to the eye they appeared yellowish-white.

5 **6** **perspective** | changes
Where surface details are lost in the darkness – as with images 5 and 6 – a sense of space and distance can be created by using the relative size of lights and colour contrasts.

7 **textures** | subtlety
Even at night it's possible to find texture and shadow effects, but they are rarer than in daylight because you need strong light sources near the surfaces. The effects can be both subtle and dramatic.

8 **9** **long exposures** | blur
The long exposures needed in low light can be used to record movement blur. Try different exposure times to suit different vehicle speeds: start with 1/10sec, or longer if you are able to support your camera.

▶ see **results**

light trails
Adrienne Babin

"Because I had to stand to one side of the road it was hard to get the symmetry that I wanted in the shot."

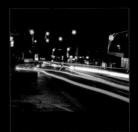

the**critique**

The images submitted for this assignment show that the interplay of the built environment with lighting is a natural subject for photography. While almost any picture taken with lights at night can be attractive, what distinguishes the images here is the use of clear strategies for working with light. From a linear motion-blur of moving lights to blocks of colour set against the darkness, we have light used as a compositional device – almost as pure abstract images. And of course you can directly photograph displays that make dazzling use of light for its own sake.

light trails

The combination of moving lights, long exposure, and dark background makes light trails very unpredictable subjects. This is evident from the different images that Adrienne has made here, where some exposures were too long and caught too much light, while in others, the trail of light was not in the best position. In the main shot, a passing bus placed light trails pleasingly high in the image.

blocks of light

By sinking the coloured lights on the building against a totally black sky, Chris has emphasized the colours at the expense of the context, making an abstract consisting of brushstrokes of colour. Perhaps a hint of colour in the sky would help give shape to the extensive area of deep black.

decorative light

Attending the Italian lighting architecture event in Beijing Juyongguan Great Wall, Kathrin had to contend with large crowds of people plus the low light. By shooting above the crowds Kathrin lost them, but at the cost of losing the sense of occasion. However, the results are colourful and the slight unsharpness is not a huge problem because you can still see the individual lights.

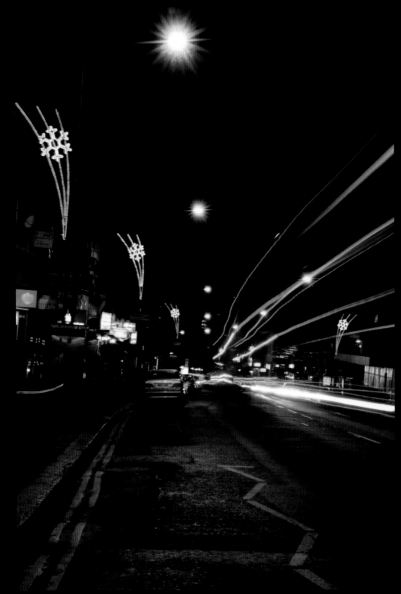

▲ Canon EOS 5D ISO 100 Focal length 70mm 10 sec at f/22

blocks of light

Chris Hopkins

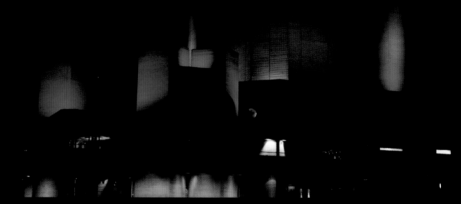

"I had no tripod and because of the low lighting conditions I had to rest my camera on a wall and lift one side to level off the shot."

▲ Canon EOS 5D ISO 640 Focal length 63mm 1/15 sec at f/5.6

decorative light

Kathrin Long

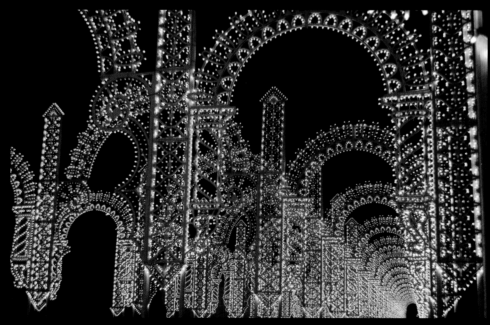

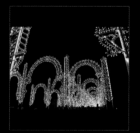

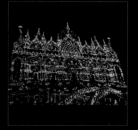

▲ Nikon D50 Focal length 35mm f/4.8

"The challenge is how to hold the camera still with crowds around. I don't think I did a good job as the picture looks blurry."

tutorial 2 | exposure control

One of the great success stories of modern photography is its near-mastery of exposure control. Auto-exposure systems can now measure not only the amount of overall light in the scene, but also where it is dark or light, as well as taking into account the colour. Some systems will even recognize, and adjust for, the presence of human faces.

fact file

Exposure control systems are calibrated to obtain an overall image brightness that averages out to a mid-tone – roughly half-way between the brightest part of the image and the darkest part. Visually this corresponds to our tendency to identify mid-tones as the key or most important tones in an image.

auto-exposure and mid-tones

Automatic exposure systems aim to balance the shutter setting and lens aperture to ensure that the light falling on the sensor records the mid-tone of the scene as mid-tone in the image. The system will also obey commands, such as whether to hold the shutter time fixed, and vary the aperture, or vice versa. Modern systems can vary exposure by altering sensor sensitivity too.

exposure systems | choosing your method

Automatic exposure systems work in three ways: aperture priority, shutter priority, and programme mode, all of which have been with us ever since electronic control was introduced into cameras. A fourth method is also gaining in popularity.

The earliest method that was developed is aperture priority. With this, you choose the lens aperture that you wish to use and allow the electronics to set the shutter time. The correct shutter setting depends not only on the value of the aperture setting but also on the film-speed setting and the meter reading. The latter is usually the last part of the process to take place, immediately before the shutter release button is pressed and the shutter is opened to make the exposure.

> Modern systems can vary exposure by altering sensor sensitivity

Aperture priority is suitable when your first concern is the depth of field you want to achieve, such as maximum for a landscape or minimum for a portrait. Another use is for bracketing exposures with a fixed aperture as preparation for blending images: you will not want changes in depth of field to produce blur between blended images (see pp. 224–25).

Conversely, with shutter priority, you set the shutter time and the electronics determine the aperture. Shutter priority is best when you need the shortest shutter time, for example to photograph fast-moving subjects.

With either mode, it's useful to have an automatic override. Say you set 1/2000 sec in shutter priority, but there is not enough light for your f/4 lens; if there is no automatic override, you have to set 1/1000 sec manually, and that might still not be enough. An automatic override solves the problem.

programme mode | automatic

With programme mode, both shutter and aperture are set automatically. Many cameras programme the shutter/aperture combination to favour shorter exposures to minimize the effects of camera shake. Some can even take into account the focal length in use and adjust the programming.

A further refinement boosts sensor output if light levels drop. This helps to avoid shutter settings that are too long for hand-holding without camera shake.

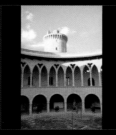
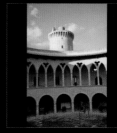
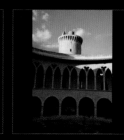
NORMAL EXPOSURE · -0.5 STOP · -1 STOP

+2 STOPS · NORMAL EXPOSURE · -1 STOP

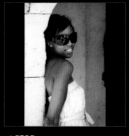
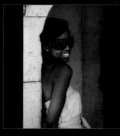

+1 STOP · NORMAL EXPOSURE · -1 STOP

settings
1 2 3 4 5 6 7 8 9

lightbox

Different lighting situations call for different exposure corrections: any rule will be complicated by exceptions, so it's best to assess each situation in terms of what you wish to achieve. In 1 normal exposure is acceptable, but the under-exposure of 2 and 3 are preferable: how much so is a matter of choice. Over-exposure is better in 4 than in 5 or 6, as it brings out the light and airy nature of the grasses. Normal exposure in 8 shows skin tones better than the over- or under-exposure of 7 or 9.

exposure compensation
The sunlit, white-washed wall will be interpreted by the exposure meter as bright light, causing images to be too dark. You could set over-exposure in the camera but it's safer to make the correction during postproduction.

arcade light
The shopping arcade is poorly lit, so a normal exposure of the whole scene would tend to be too bright. This may be an accurate portrayal of the scene, but an under-exposed image ensures the contrast between pools of light and deep shadow is not lost.

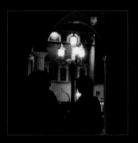

GLOWING LIGHTS

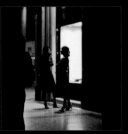

DETAILS REVEALED

DARK SHADOWS

under-**exposure**

You might assume that under-exposure is invariably a fault, but, in fact, it's probably the single most effective way to improve the look of your images, and certainly the easiest. Of course, just as there's a correct level of exposure, there's also a correct level of under-exposure.

exposure | the parameters
The measures that we use to judge exposure are psychophysical – that is, they are a combination of science and majority opinion. Early in the twentieth century, a survey was carried out in which the participants – members of a university campus – were asked to give their opinion on dozens of images printed to different levels of exposure.

The majority of participants preferred the prints that were neither too dark nor too light. Where the overall darkness/lightness of an image averaged out to around midway between the darkest on a print (not a black, more a very dark grey) and the lightest (not quite a white), the print was most likely to be rated correct.

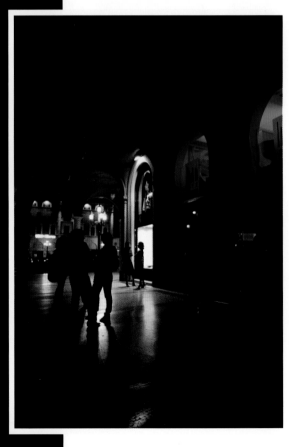

tonal range | mid-tones
It's evident that there is plenty of room for subjective evaluation when deciding what exposure is correct. It is what you want it to be, but should be within the limits of what your viewer considers acceptable.

The highly subjective survey at the university campus does, in fact, match with a technical method of deciding on correct exposure. We know that for either film or sensor there is a range of brightness in which tonal changes are recorded accurately – the mid-tones. So, the correct exposure for a scene is that which places the mid-tone of the scene in the middle of the film or sensor's mid-tone range.

When you expose as your camera suggests, you're essentially lining up the ability of your sensor to record tones to match with the tones in the scene. This way, you can record as much as possible of the tonal range present. For example, if you give too

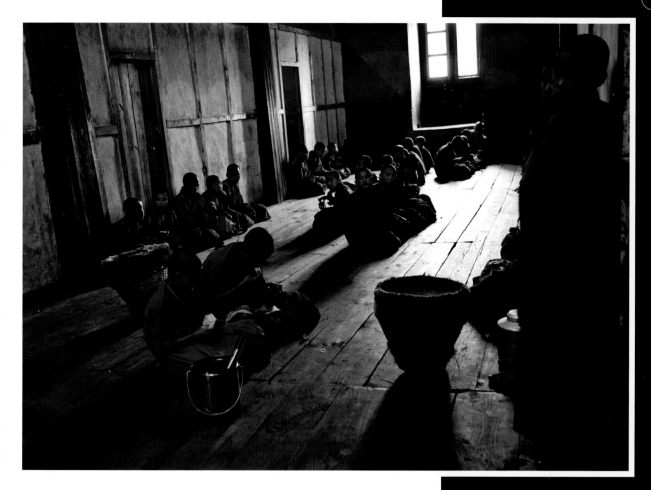

much exposure, your sensor records shadows and mid-tones more brightly than necessary, but as you can't make highlights any brighter you waste the recording capacity of your sensor. If you give too little exposure, you may make your highlights darker, and that pushes the mid-tones and shadows towards black.

under-exposure | enriched colours

Visually, people are more likely to accept the predominance of dark, heavy shadows that are the consequence of strong under-exposure than large areas of over-bright mid-tones delivered by over-exposure. The bonus with under-exposure comes from the chance to "pull" highlights down: when they're given less exposure they reveal their colour. At the same time, mid-tone colours appear richer and deeper.

For the best effects, try under-exposure where your subjects offer a good range of bright and dark tones. Bracket your exposures if you have time, but instead of an over-exposure step, make steps of normal exposure, under-exposure by half a stop, and under-exposure by one stop – then select the best-looking image.

dining room
The bare dining room of a monastery in Bhutan was lit by just the single window in view. A standard exposure (the small image) was too light and did not convey the atmosphere of the room. A darker exposure (the large image), technically an under-exposure, records the scene as it appeared.

image **analysis**

Mastering exposure control can feel like a daunting, even unnecessary prospect, given the advanced auto-exposure systems of today's cameras. By persevering, however, you will discover that not only is exposure control a powerful and creative tool, it's also remarkably simple to apply.

dimming | the sun

It's tempting to leave modern cameras to their own devices, letting them set the exposure for you. However, if you always rely on your camera you will miss out on a rewarding heuristic technique: seeing how different an image can appear when it's exposed at different levels while you are actually taking your photographs. As you can make as many exposures as you wish – up to your memory card's limit – first try exposing a scene at the normal exposure, then with one stop extra, and finally shoot a frame with one exposure stop less than

normal. Many cameras offer automatic bracketing, which you can use to run off three shots of varying exposure. You will discover that where the luminance is wide, as it is here, increasing under-exposure deepens the colours and brings out the hard edges between light and shadow. Under-exposure generally reduces a composition to its essentials – the bare shapes of elements in the image and their inter-relationships – while the lack of shadow detail pushes any coloured areas to the front of the image, catching the viewer's attention.

in detail

With the dark-green background and deep shadows in this shot, automatic exposure systems will tend to over-expose the image to try to get as much of it to reproduce as mid-tones as possible. However, any extra exposure would send the skin tones, which are already very light in the full sun, into featureless highlights. In order to ensure that the key tone – the skin – is properly exposed, the rest of the image must be heavily under-exposed.

clean outlines
Directly lit by the sun with shadowed background, the outlines would always be sharply clear but, with exposure biased to the highlights, the deep shadow throws the hand and sleeve into even sharper outline.

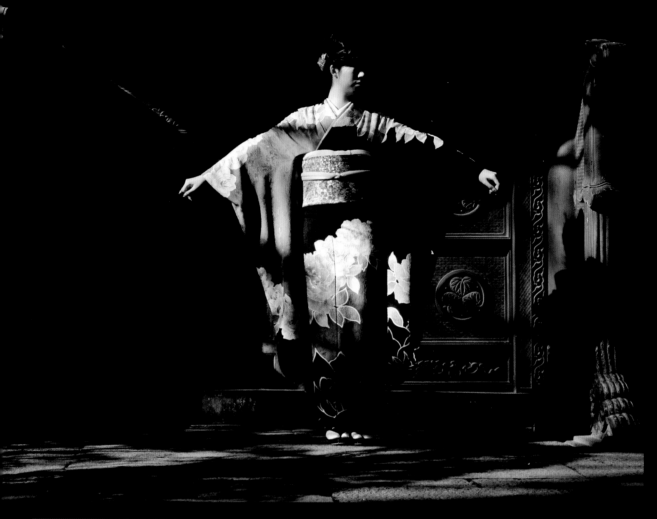

raking light
The steeply oblique light falling on the wall would bring out the slightest texture but, when the surface is carved in relief with the features three-dimensional, the exposure helps to retain a deep, jade-like intensity.

central tones
The visual anchor and reference point for the entire picture is this tiny portion of the image. The delicate skin tones must be preserved at almost any cost: there is very rarely a good reason to lose skin tone.

colour contrast
One might wish for more colour than the palette of green and yellow here, but the formality of the pose, the orderliness of the composition, and the sense of time suspended, would suffer from the distraction of colours.

Arabian lights

On a sunlit beach, normal metering will produce an image whose light and darks average out to a middle grey, which in this instance destroys the sense of a brilliant Gulf sun. A stop's extra exposure, set manually or through "intelligent" metering, produces an image full of light. But +2.5 stops leads to a loss of detail in the water and the buildings in the distance, and weakens all colours.

NORMAL EXPOSURE

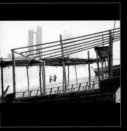

+2.5 STOPS

over-exposure

There are technical definitions of over-exposure, but there is also a simple practical meaning. Given that the correct exposure for a subject is one that produces the image you wish to create, over-exposure is simply giving more exposure than you need, with the result that the image is lighter than desired.

brilliant whites | and mid-tone greys

The reason for relating correct exposure to the type of image we wish to create is to ensure that we keep in mind that exposure has both technical and subjective dimensions. The technically correct exposure for a scene is one in which the averaged luminance distribution – the mean between lights and darks – in the scene is reproduced in the averaged image as a mid-tone grey. However, with some images, we may examine the technically perfect result and feel that a little less exposure would produce a better-looking image: we may want the shadows to be heavier or even black; we may want the colours to be deeper, more intense. That is the subjective dimension coming in. The camera meter is probably not in error – it was simply unable to read your creative mind.

By the same token, with some subjects – typically sandy beaches, snowy scenes, brides in white – a technically correct exposure may look too dark. We want the whites to be brilliant; the darkest greys we wish to see are mid-tones or a little darker; we certainly don't want dark shadows.

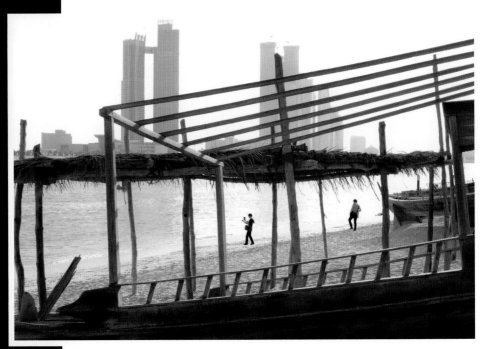

range of exposure
The image on the left can work over a wide range of different exposures, and is able to withstand a surprisingly large amount of over-exposure: this is due to the presence of strongly graphic shapes contrasting with blocks of colour. The key point here is that increasing the exposure brings out the flowers in the foreground and lightens the sky, but has little effect on the silhouetted tree trunks; decreasing the exposure darkens and intensifies the colours but, again, has little effect on the trees.

+2.5 STOPS

+1 STOP

NORMAL EXPOSURE

increasing exposure
In the above series, more exposure lifts shadow details. While the mid-tones become usefully lighter, there is a risk of burnt-out highlights if the effect is overdone.

evaluative systems | override controls

With the knowledge that many subjects are best recorded with "incorrect" exposure, metering systems were developed that tried to analyse the scene to set an appropriate exposure. We know, for example, that in a snowy scene nearly every part has the same high brightness. While normal metering would set too low an exposure, rendering the snow as greyish, an evaluative system increases exposure a stop or more to ensure that it is recorded correctly.

However, the problem with evaluative systems is their inherent conservatism. Because they are designed to suit the tastes of thousands of different users, the manufacturers' aim is not to give convincing creative solutions but to avoid producing images that appear unsatisfactory. In particular, evaluative systems are designed to eliminate the possibility of too much over-exposure, just as white highlights are extremely difficult to adjust to produce an image that looks convincingly real. This is why there's still a need for exposure override controls. Where you have the opportunity, use the override controls to deliberately increase exposure and check out the results on a desktop monitor, not on the camera's LCD. You will be pleasantly surprised at how many images can be greatly improved with even modest overrides.

bracketing | RAW format

You have two strategies for ensuring that you give yourself good flexibility when you're working with a light final image. First, you can bias the bracketing of your exposures. This means you set an override, then bracket. You know you need different levels of higher than normal exposure, so, for example, first set an override of half a stop, then bracket exposures by half a stop. This ensures that you get exposures of normal, plus half a stop, and plus one stop. Alternatively, if you set your camera to record in RAW format, you will give yourself more latitude to adjust exposure than if you recorded in JPEG. The best choice of all is to bracket exposures using RAW format (see pp. 184–85).

using exposure meters

Exposure meters have come a long way from the simple, single cell that took a broad look at the scene for its calculations. Modern meters are imaging devices in their own right, some with over a thousand separate sensors.

metering | patterns

Two strategies guide the use of meters. In the most automated methods, you point the camera at your subject while the system decides which parts of the scene it will measure. These are the evaluative or matrix type of meter. Effectively fully-fledged imaging devices (some use the image sensor itself), they divide a scene into different parts, meters each of them and then work out what the exposure should be. These systems are popular because they give the best percentage of good exposures.

The other strategy requires you to decide where to point the camera in order to obtain the metering reading. For this, you choose from different weightings or patterns of metering sensitivity. The averaging type reads the entire scene equally.

luminance interpretation
Which of these two exposures is correct for the scene depends wholly on your interpretation. The lighter image is full of delicate mid-tone colours that are lost in the darker image. But this gains by revealing contrasts of hue from the lights and depth of colour in the sky.

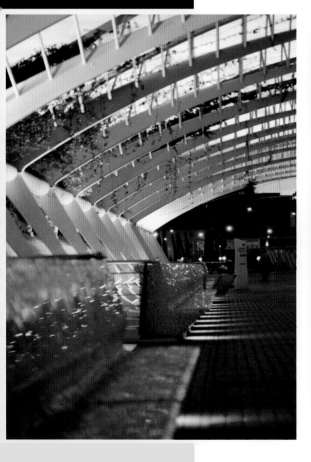

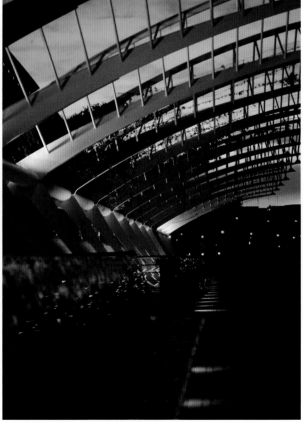

The centre-weighted type concentrates the majority of its attention to the central half- to third-portion of the image. This is good for many situations where a rapid reading is needed; it does not need precise aiming.

The spot-meter type concentrates all of its reading into an even tighter central area – some 5–10 per cent of the image. This is best for high luminance-range lighting conditions, for example a face in the light surrounded by darkness. But you need to aim very carefully.

metering | indications

Whatever the technology, the way to master exposure meters remains the same as ever: use their readings only as guides or indications. Meter calibration on the non-evaluative types is oriented towards averaging the measured area – the central spot or a wider area, according to your setting – to a mid-tone. If you know you want a darker mid-tone, for example when photographing darker skin tones, then dial in some under-exposure. If you want a brighter effect, for example when photographing water, then dial in some over-exposure.

accessorised | meters

Accessories, long a staple of film days, have once again found their way back into gadget bags. The grey card gives you a reference mid-tone value. Place it in the same lighting as your subject, take a reading off the card: this helps ignore subjects that are not themselves mid-tone overall.

If you wish to measure incident light, for example the light falling on the subject, you can place an incident metering adaptor (a translucent disc) over the lens, then you take the reading by pointing the camera lens towards the light-source.

NORMAL EXPOSURE

NORMAL EXPOSURE

-2 STOPS

+1 STOP

metering situations

In the landscape, overriding camera exposure to under-expose records highlight details lost in normal exposure, but we allow shadows to become completely black. A normal exposure of the still life responds to the very bright sunlit area, but overriding by an extra stop lightens the image so that it looks as we saw it: bright and breezy.

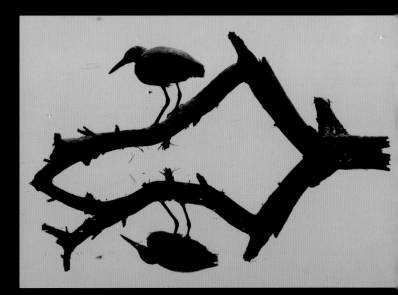

near-silhouette

An averaging metering is best-suited to this subject, which needs to record the water as near white. However, we must not under-expose the heron too much, or we lose the patina of brown on its back.

image **analysis**

As a photographic technique, over-exposure is rarely used to its full potential. Almost always rejected out of hand, it is seldom nurtured; as a result of which few photographers are ever aware of its unique contribution to the visual arts. In the past, pallor of colour was associated with fading, with age and decay. But when filled with light, photographs have a wonderful transparency and delicacy that is unique in the visual arts.

high-key | colour

If we express exposure as the placement of the mid-tones on the reproduction scale of the sensor, then over-exposure is the setting that places the mid-tones near the highlights. This forces shadows to lie at or above the mid-tone, so there are no blacks or deep colours at all. And, of course, the highlights become featureless white. If we rack up the exposure even further, so that mid-tones fall on what are normally the high values with colour, then we obtain the high-key image. There is no black at all, and almost all the image is washed out. This has a remarkable effect on shadows: details lost in darkness emerge as if full of light. Technically, you can achieve over-exposure by increasing exposure time or aperture or both. Use a large aperture to obtain the more attractive out-of-focus blur contours.

in **detail**

In this scene, made at Murawai Beach, New Zealand, a high-key rendering transforms what would otherwise have been a relatively ordinary view into a sun-kissed abstraction full of interesting shapes and delicate tones. Features that had appeared to the eye as simply black silhouettes now reveal their hidden colours. Also, the spatial relationships between people are now clearly seen and the out-of-focus blurs that used to be just muddied shadows now have an evocative, spectral quality.

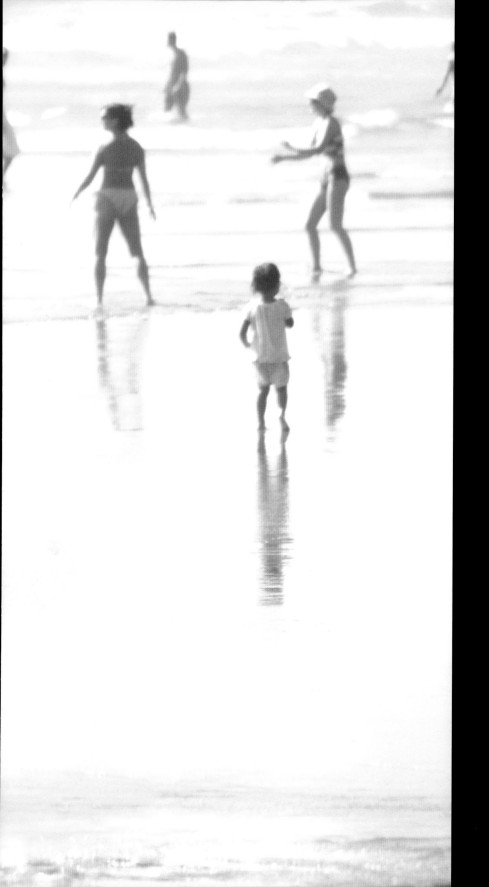

blur bokeh

The quality of the image blur, or "bokeh", is clearest in a high-key image as the contours of the margins are made prominent against the highlight tones. Here, the bokeh is not the smoothest or most even – the sign of a complicated zoom-lens design.

shadow detail

In the actual scene, the majority of swimmers appeared as silhouettes against the bright summer sky and reflections in the water. The high-key exposure reveals colours and forms that are impossible to see where ambient light is extremely high.

highlight detail

The colours just visible as subtle sky tones are all that remain of the water, which was originally a muddy blue. The colours in the shadows may be overlaid by the mid-tone colours, which, when bleached to white, unveil the shadow colours.

Assignment: **still life**

Formerly a favourite genre of photography, still life has faded in popularity as photographers have explored the new possibilities offered by digital cameras to record the wider world about them. Nonetheless, there is still great work to be created on a smaller scale, and shooting a still life at home is a perfect way of expressing your creativity when the weather keeps you indoors. You can work with daylight, reading lamps, or more professional gear, and your still life might be simply a few found objects, sensitively arranged, or a carefully constructed tableau.

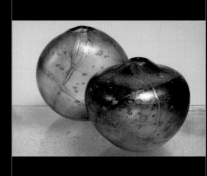
ISO 100 Focal length 60mm 1/250 sec at f/16

the**brief**

Using as many or as few light sources as you wish, create an atmospheric still life. Experiment with the arrangement of every element in the composition, from the objects themselves to the background and foreground, until you find the best picture possible. Control the lighting and shade meticulously so that no manipulation of tone, colour, or object is later needed. Try various exposure settings to learn the effect on tonality of varying the placement of mid-tones.

Points to remember
• use the highest resolution setting on your camera
• if possible, shoot in RAW format so you can make adjustments later
• flat lighting is usually easiest to work with, but choose lighting that suits the subject and don't be afraid to experiment
• use a tripod to ensure the sharpest results
• small apertures will maximize depth of field

ISO 500 Focal length 70mm 1/30 sec at f/16

must-see masters

Beatrice Helg (1956–)
Using a combination of found objects and graphic elements, Helg creates elegant, refined compositions of abstract spaces. Her delicate colour modulations, subtle lighting and soft reflections have produced a unique body of work.

Mari Mahr (1941–)
Using montage and collage techniques of photographs on photographs, and superimposing objects on to a backdrop, Mahr creates distinctive work evocative

of memory, exile, and disoriented identities. She works in both colour and black and white.

Josef Sudek (1896–1976)
Sudek created a vast output from the tiny confines of his garden shed and the surrounding city of Prague, in the Czech Republic. Photographed with large-format cameras, his still lifes are intense and poetic in their approach, attaining remarkable universality through their artful simplicity.

ISO 500 Focal length 60mm 1/8 sec at f/16

ISO 100 Focal length 60mm 8 sec at f/16

ISO 100 Focal length 60mm 8 sec at f/18

ISO 100 Focal length 60mm 4 sec at f/11

Focal length 7.2mm 1/8 sec at f/2

ISO 500 Focal length 60mm 1/25 sec at f/16

ISO 100 Focal length 70mm 1/8 sec at f/8

(1) (2) (3)
(4) (5) (6)
(7) (8) (9)

lightbox

top**tips**

(1) standard lighting | working fast
A plain background with flat, open lighting is ideal for showing off objects, surface texture, and detail. Although it lacks atmosphere, using this lighting enables you to work quickly.

(2) (3) black card | colour and shape
Using a dark background helps to intensify colours and can bring out the outline of light-coloured objects. Here, the objects are placed on a sheet of glass. In 2 the glass is placed on a white card, while in 3, the black card continues under the glass to create a mirror effect.

(4) shallow focus | blending elements
Use a shallow depth of field to concentrate the viewer's attention on the plane of focus. This helps to bring the various elements together without drawing attention from the main object.

(5) abstraction | unusual angles
An unusual angle on the subject will spark the viewer's interest and can create an element of abstraction. In a set of images it can provide a change of tempo from other, more standard views.

(6) atmosphere | a soft approach
Dark, soft textures from draped fabric and deliberate under-exposure coupled with soft lighting create an intriguing, moody image.

(7) (8) exposure | shadows
Raising the exposure will reveal details in shadows, but it may also make any shiny or reflective surfaces that are already bright too light. A lower exposure brings out colours at the expense of shadow detail.

(9) intimacy and warmth | soft light
Candles are not in themselves bright enough to light a scene, but their presence in a still life immediately evokes a feeling of warmth and intimacy.

▶ **see results**

reflections

Erling Steen

"I started taking photos of some wine glasses against a piece of black cardboard and realized that the images looked very much like my paintings."

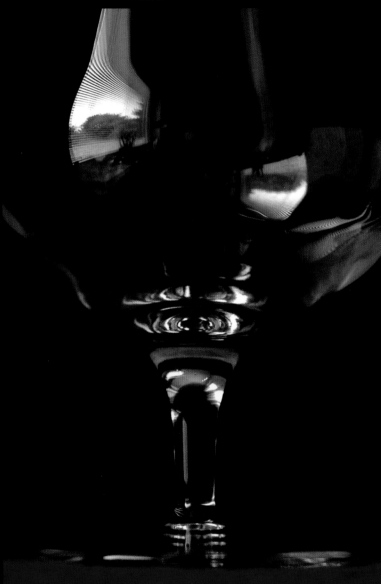

▲ Nikon D70s ISO 1600 Focal length 70mm f/4.5

the**critique**

For some, the great advantage of still life photography is the total control they can exert over the image. But there is still room for happy accidents and unplanned effects. Another advantage of still life is that the necessity to leave the camera on a tripod means you can walk around your subject, exploring viewpoints and the play of light at leisure. Being unencumbered by the camera can be very liberating. Notice that all the images here were shot with a relatively long focal length setting to avoid exaggerating the size of objects closer to the camera.

reflections

While "playing around" with his camera, Erling discovered that the graphic and tonal compression of the LCD display presented his image in a way similar to the simplification that takes place in painting. This shows how important it is to keep your mind receptive and open to little discoveries: they don't shout at you, but if you listen, your photography progresses at a rewarding rate.

hot shoes

To express an intensity of feeling for shoes, Tara used high-contrast black and white. The treatment brings out the gloss and shine of the leather as well as the alluring curves of the shoe's cut. The out-of-focus blur of wood grain is perfectly judged to balance the sharpness of the shoes. This image goes to show how great economy of means can produce telling pictures.

pomegranate and lemon

Sandro and Patrizia have chosen to apply a very warm yellow-red lighting balance for this image, giving it the colour palette of old transparency film. In their controlled conditions HDR should not be necessary, but it pre-empts difficulties in contrast and allows a free choice of colour balance.

hot shoes
Tara McMullen

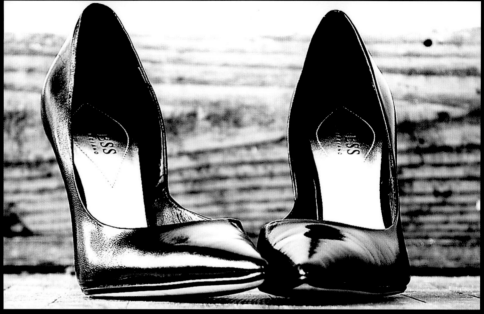

"These shoes were made for a hot night out... Not so much a fetish in the sex way, but a fetish in the must-have-more-shoes way."

▲ Nikon D80 ISO 100 Focal length 70mm 0.6 sec at f/4.5

pomegranate and lemon
Sandro e Patrizia

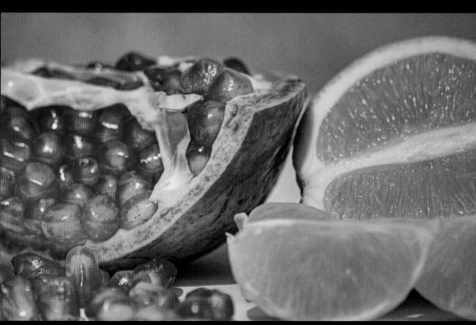

"Three files were created using three different exposures to create the final HDR image using the Photomatix application."

▲ Canon 350D ISO 400 Focal length 300mm 1/60 sec at f/5.6

tonality and contrast

Tonality refers to the way in which an image represents the variations in scene brightness as variations in image lightness (on screen) or in ink density (in print). It depends on both local contrast, between neighbouring areas in the image, and global contrast, between the lightest and darkest areas in the entire image. It also depends on personal taste and preference.

fact file

In the days of film, the characteristic curve described the way a processed film had responded to, and recorded, light. In an analogous way, tone curves describe the way the digitally captured image has been processed in a digital camera to reproduce the subject tones.

increasing contrast

With every improvement in the reproduction of mid-tones, we've demanded an even greater recording range. Thanks to this, digital cameras can now produce images that range from starkly contrasty to those as tonally compressed as watercolour paintings.

understanding tonality | and controlling it

The tonality of your image is not a fixed quantity. From the contrast of the scene (ambient contrast) and the contrast characteristics of the sensor, to the image-processing settings and the characteristics of your monitor screen or printer, image tonality is influenced by a cascade of factors. A small change early in the cascade can produce a large change further down the process.

Each step adds its own tone curve to the input data before that data is output or handed to the next process. Each step is essentially a tone-mapping exercise, which means, for example, that a range of dark to light mid-tones received by one process may be compressed in order to save space in the stream of data. In a subsequent step, these tones must then be uncompressed.

> 🙿 Each step adds its own tone curve to the input data before that is output to the next process 🙾

Therefore, you have many ways to control tonality, starting with the lighting on the scene: you may be working on a sunny day or in fog; you may choose to use fill-in flash or reflectors. Exposure settings also affect tonality, as do any image adjustments. While these impact on the data in the image, any variations in

tonality on screen will not directly affect the image. The danger here is that if your screen is not correctly calibrated and profiled (see pp. 342–43) you may be tempted to manipulate the image to improve its appearance. This may spoil a perfectly good image, hence the importance of being sure your monitor is displaying its image accurately.

shooting RAW | maximum choice

Camera manufacturers are aware that photographers generally prefer punchy, saturated images, but they also know that to supply such images reduces the room for image manipulation. Broadly, their strategy is for point-and-shoot cameras to deliver the punchy images, and cameras for enthusiasts and professionals to deliver more conservatively processed images. That's why images from beginner cameras can look "better" than those from costlier devices. The strategy giving you the most room to alter tonality is to record in RAW format (see pp. 184–87).

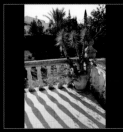
HIGH CONTRAST

AVERAGE CONTRAST

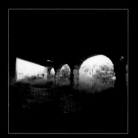
AVERAGE CONTRAST

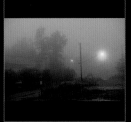
LOW CONTRAST

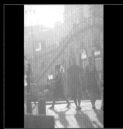
LOW CONTRAST

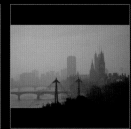
LOW CONTRAST

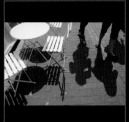
AVERAGE CONTRAST

HIGH CONTRAST

AVERAGE CONTRAST

contrast variations

In **1** the sun and deep shadows means it is a high-contrast scene. But **2** and **3**, despite appearances, are not because we do not need details in the shadows. **4–6** are all low in contrast as the range of brightness in the resulting image is narrow – even in **5**. While **7–9** show a wide range in the ambient contrast, the contrast of the resulting image depends on how much highlight needs to be recovered and how much shadow detail should be filled.

leafy contrast

Some images can tolerate a wide range of tonality – such as abstracts of nature (left). Other images, such as those with facial tones, usually work only within a very narrow range of tonalities and contrast.

dynamic **range**

As photographers have become more proficient in working with digital images, their awareness of dynamic range – the range of luminance in a scene – has grown. In contrast to films, with their built-in responses, digital images can readily be adapted to any scene's luminance range.

luminance | high and low contrast

Our perception of texture and form depends on our being able to distinguish the tones that define them. The scene that we record is essentially a map of tonal variation – dark here, light there, with the boundaries between tones in the image representing physical edges and outlines of shapes in the scene.

The measure of how much light appears to be reflected from a surface is called luminance. Note that lightness makes no reference to the colour of the light; form, texture, and detail can be discerned in black and white. Each scene offers a certain subject luminance range – the range between the brightest part and the darkest part. An image with a high dynamic range has a wide luminance range (described as "contrasty"), while an image with a low dynamic range is characterized by a narrow luminance range (described as "low contrast".)

Our ability to distinguish different shades of lightness in a scene varies with the overall brightness. Subtle differences in lightness, easy to see in bright light, are very hard to make out under low-light conditions. What is of average or low luminance range during the day can appear to be contrasty at night.

How the subject luminance range is reflected in your image depends on the scene and the type of image you wish to make. For example, the scene may be flooded in sunlight, with deep shadows cast from trees and buildings, in which case the luminance range appears to be wide. But if you're using a wide-angle lens, which takes in much of the scene, all the bright and dark elements are small enough for the sensor to react as if to an averagely contrasty image.

deceptive shadows
These two scenes may appear to represent two different dynamic ranges, but in reality the luminance range is identical in both cases, being taken minutes apart on a sunny day. The image with more dark areas appears to offer a narrow luminance range because the highlight areas take up only a small area of the image.

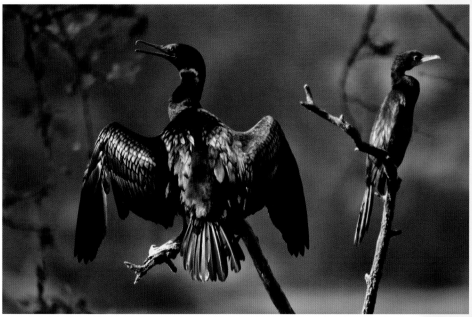

METER FOR DARK TONES

METER FOR LIGHT TONES

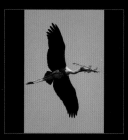

METER FOR MID-TONES

exposure | latitude

Different exposures of the same subject with a wide luminance range may actually yield acceptable images: over-exposure may reveal details in shadows while under-exposure delivers saturated colours against black. So you can get exposure "wrong", yet still achieve an acceptable image. However, there is a caveat to this: in general, viewers will tolerate large areas of black in an image more readily than large areas of highlight that lack colour or detail.

With a narrow luminance range typical of, for example, an overcast day, or indoor scenes that don't include light coming in from a window or doorway, you encounter the opposite. The range of acceptable variation in exposure is limited. In short, you will have to expose accurately because the majority of the scene will need to be rendered as mid-tone: over-exposure will result in a pale-looking image with weak colours, while under-exposure will yield pictures that look muddy because of the lack of contrast.

The range of different exposures that can deliver an acceptable image is called "the exposure latitude". If you have experience of working with colour or black-and-white negative film, note that the rules have changed. As digital photography is positive-working, like colour transparency film, exposure latitude extends much further into under-exposure than over-exposure (see also pp. 226–27).

metering | for mid-tones

Because you have greater latitude in under-exposure, the best strategy for exposure is to ensure that the key tones in your scene – usually the mid-tones or lighter mid-tones such as light skin, or light green foliage – are properly exposed (see p. 30). This will help to ensure that bright areas with colour and detail are not too bright, because if they are you will not be able to retrieve realistic tone or colour.

brightness and contrast

In the top image the reflection of light off the white wings turns dark water into a high-contrast situation, needing 3 stops under-exposure. In the middle image the black bird against light reflected off water makes for high dynamic range that's impossible to fully capture. In the bottom image, the black wings against the sky may look hard to record, but they fit comfortably into normal ranges. In the large image, the dynamic range – between dark feathers and glistening white – is in fact very large but the small areas of highlight do not need to carry detail.

reflectors and fill-in

Some photographers prefer to use strictly natural light and see no need to tamper with it. However, if the luminance range of the available light is too wide for our liking, we can send some illumination into the shadows on nearby subjects by means of reflectors or other light sources.

shadows | and reflectors

For high levels of brightness to offer challenges to the photographic system – that is, to both the photographer and the camera sensor – the light has to be unevenly distributed. Bright light in itself is not the problem, nor does the combination of bright light in some areas of the scene and deep shadows in others present any difficulties per se. The challenge arises on those occasions when you want details both in the highlights and in the shadows.

While there is nothing you can do directly about the bright light, other than waiting for a helpful cloud to pass in front of the sun, you can do something about the shadows. The most economical solution is simply to reflect sunlight into them, and to achieve this any light-coloured object that is ready to hand can be employed, from a newspaper to a white hat. Alternatively, you can use a photographic reflector screen: these roll up into a compact size and are very light, but can pop open to a diameter of over 1m (3ft).

overhead reflector
The aluminium sheet being worked on has reflected light from a source overhead back onto the hands of the children stamping the patterns. It's always rewarding to discover elements within any scene that reflect light into shadows, giving you a multiplicity of light sources.

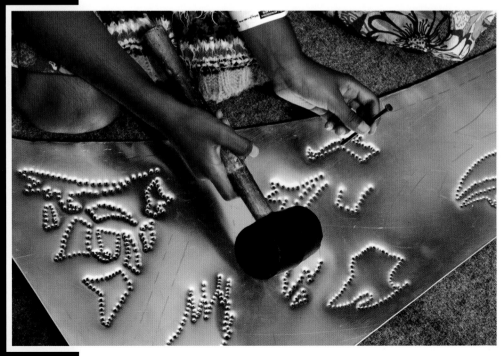

NO REFLECTOR

SHINY REFLECTOR

SOFT REFLECTOR

CLOSE SOFT REFLECTOR

reflectors | and quality of light

When you use a reflector, remember that it's effectively a new light source and will bring different qualities to the light according to its proximity to the subject, its surface qualities, and its surface colour.

To increase the brightness of the reflected light, simply move the reflector closer to your subject. A reflector surface that is coloured will add its colour to the light, while one that is darker may even subtract light. Black card is called a "negative reflector" by studio photographers because it can be used to absorb stray light, and therefore increase lighting contrasts. The final consideration is the surface quality: a shiny reflector, such as a mirror or metal foil, produces a harder, more defined light than paper with a matte texture. You can buy photographic reflector screens that have a metallic silver or gold surface, the latter giving a warm light that is favoured for portraiture.

Compared to introducing flash or other artificial lighting, reflectors produce a very soft light that can lift the quality of an image. However, their range is limited, and unless you are lucky enough to find a handy support on which you can prop them in exactly the position you want, you will find them tricky to use unless you have someone to hold them for you while you take the shot.

flash | supplements

Although flash units built into cameras are a poor choice as the main source of light, they are ideal for fill-in lighting. You need only a low-intensity flash to bring a little light into the shadows. Set your flash to under-expose by two or more stops, and force the flash to fire even when the ambient light is high. A side-effect useful in portraiture is that the flash can reflect off the eyes, giving them a little sparkle – the "catchlight" – that is all-important for conveying liveliness in a portrait; its absence can literally take the shine off an image.

filling in
This series shows how the use of a simple reflector – from one with a shiny surface to a sheet of paper – can improve the lighting from a single lamp. For the main image, a sheet of red card was placed close to the plant to reflect with maximum intensity into the shadow side.

image **analysis**

One of the secrets to achieving photographic mastery is the ability to see in your mind's eye. You must be able to visualize the effect of different exposures on any given image. This leap of imagination is an act of creation, and it makes you a far better judge than any auto-exposure system.

high | dynamics

Lighting conditions that present an extremely wide difference between light and dark are usually the most problematic. Photographers approach lighting situations with a high dynamic range (high-contrast lighting) with trepidation, and the camera's auto-settings struggle. An exposure that is correct for mid-tones leaves highlights too bright and shadows too dark, and means details will be lost. You can, however, use a tool such as Curves (see p. 164) or more complicated procedures such as HDR (see pp. 226–27). These all attempt to compress the dynamic range so that it fits within the limits of the sensor and image processing – although not all wide-luminance-range scenes benefit from such treatment. Part of this image's appeal is the contrast between the nearly graphic white-and-black lines in direct sunlight and the smoother tones in the shade. Although it looks difficult to expose, all you need to do is expose for the key tone (the sunlit leaf) and let the rest fall as it will. Capturing the image in RAW format gives you the greatest flexibility in postproduction.

in **detail**

The ability of modern sensors to capture a large part of the dynamic range in this scene is remarkable, but you need to give it as much help as possible. Use a camera with a large sensor or, if your camera has a small sensor, use modest pixel counts such as six megapixels. Ensure your exposure control is accurate, making bracketing exposures if necessary. Also, if your camera allows, record your images in RAW to store the fullest luminance information.

burn-outs
The sunlit parts are devoid of detail due to the extreme over-exposure. There is no way to recover this lost detail but you may wish to leave it unchanged as the brilliant white speaks of the sun's blinding intensity.

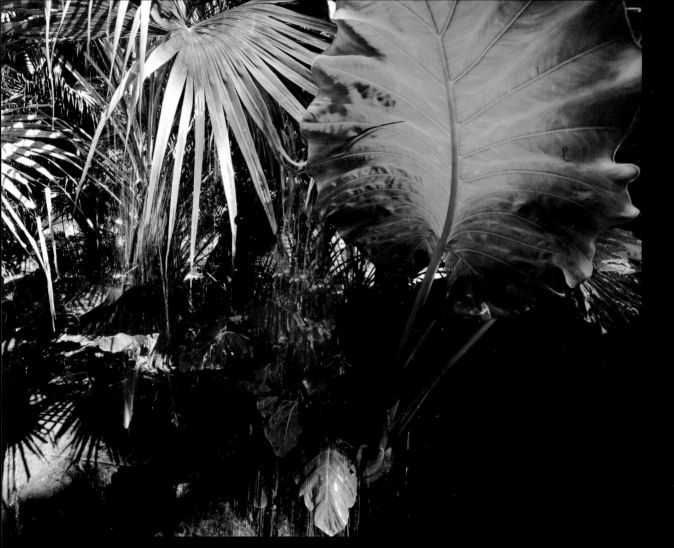

mid-tone preservation
You may be tempted to use tone-compression techniques such as Shadow/Highlight control or High Dynamic Range blending. However, this would mean losing the shiny delicacy of the mid-tones.

colour intensity
The vibrant colour of the back-lit leaf is the heart of the image, so it's vital that this part is correctly exposed. While the shadows may demand over-exposure, under-exposing, as here, usually improves colour intensity.

dark-ground illumination
Much of the liveliness comes from the cascade of water on the plants. The sun was at the wrong angle for a rainbow but the water caught light as it fell against the shadows, which relieves the black areas.

Assignment: **high**

With large films thickly laden with silver, classical landscape photographers were able to record tones – ranging from deep shadows to bright sunlight – with a wide range of subtle mid-tones. That's why their prints can glow with an inimitable intensity. When ultra-miniature films became popular, photographers had to learn to work within the narrow dynamic range available to the recording medium – as is also the case with digital cameras.

ISO 100 Focal length 20mm 1/250 sec f/7.1

the**brief**

Photograph a scene that offers a high dynamic range, exploiting the fact that either the high values will be too white or the shadows too dark. Compose to work with areas of blackness or whiteness against which the mid-tones can shine. Don't make any attempt to control high dynamic range with image manipulation.

Points to remember
- you can control exposure by means of several metering methods
- with exposure overrides you can bracket your exposures over a wide range
- think of blocks of tone and colour when composing your image
- slight under-exposure tends to bring out the saturation of mid-tone colour
- detail contrast tends to fall the further the subject is from the camera
- shots against the light can be dramatic, but you need to either guard against or exploit veiling flare

ISO 100 Focal length 135mm 1/250 sec f/8

must-see **masters**

Ernst Haas (1921–1986)
The undoubted master of colour photography using slide film, Haas would revisit favourite viewpoints numerous times in search of the perfect lighting conditions.

Franco Fontana (1933–)
Fontana's ability to transform the landscapes of his native Italy into vibrant abstract compositions was due in part to his mastery of the transparency medium and a finely honed control of exposure.

Olivier (1958–) & Danielle Föllmi (1953–)
Widely travelled, the Föllmis epitomize the modern humanist photographer with a feeling for ravishing light and a genuine involvement with their subjects, who are always rendered with dignity.

Fay Godwin (1931–2005)
The most significant modern photographer of the British landscape, Godwin's command of darkroom skills and subtle compositions gave her prints an unsurpassed tonal range.

ISO 100 Focal length 200mm 1/250 sec f/5.6

ISO 100 130mm lens 1/320 sec at f/4

ISO 200 Focal length 12mm 1/125 sec f/11

ISO 100 Focal length 20mm 1/250 sec f/7.1

ISO 100 Focal length 85mm 1/250 sec f/7.1

ISO 100 Focal length 20mm 1/125 sec f/8

ISO 100 Focal length 200mm 1/400 sec at f/4

① ② ③
④ ⑤ ⑥
⑦ ⑧ ⑨

light**box**

top**tips**

① **sidelight** | strategies
Scenes with wide luminance range are most easily handled by having the sun to one side so that shadows fall across the subject. Here, the line of prayer flags picks up the sunlight and leads the eye to the distant dzong.

② **③** **contre-jour** | brilliance
If you face the sun directly, and accept veiling flare and internal reflections, you can get a sense of the brilliance of light and its effect on a scene. In 3, a banner obscures the sun enough to prevent internal reflections.

④ **⑤** **faces** | careful lighting
With people in shot, you need to ensure that the lighting is kind to their features. In 4, a silhouette is softened by smoke, while in 5 another silhouette is lightened by the glint in a pair of glasses.

⑥ **over-exposure** | blank areas
If there will be blank, over-exposed areas in your photograph, a handy trick you can employ is to use something in the foreground to obscure them. Here, the near red flag covers much of the sky.

⑦ **backlight** | showing up colours
Another way to work when the light is in front is to look for backlit situations – where the sun lights your subject against a dark background. The prayer flags have the most intense colour where the background is black.

⑧ **under-exposure** | highlights
The most direct control you have over the brightness of an image is simply to force under-exposure, allowing the shadows to fill with black but retaining colours in the highlights.

⑨ **bright conditions** | finding details
Even in conditions that are very bright or have a wide luminance range, it's always possible to find a detail or close-up where the lighting is easily recorded.

▶ **see** results

summer sunshine

Florence Fairweather

"The sunshine was beautiful and the girl is a very bouncy, happy person, so I tried to capture that in the picture."

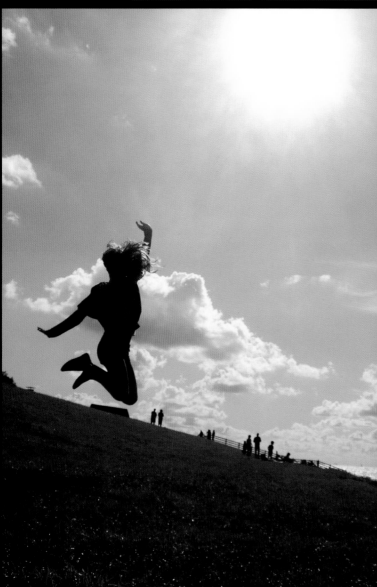

▲ Casio EX-Z700 Focal length 6.2mm f/4.3

the **critique**

Technology has liberated photography in numerous ways. From the physical (tiny cameras are easy to carry around, with no compromise in image quality), to the metaphysical (an image of children playing can reach their grandparents on the other side of the globe within seconds), today's cameras encourage you to try anything and everything. Shooting into the light was once discouraged in the days of film, but now we're not hobbled by such concerns. So face the sun, bracket exposures freely, and take plenty of shots to ensure you capture something special.

summer sunshine

Florence used a yellow filter for her shots of the leaping girl. It imparts the image with a faded, aged look as if it was an old colour print – this gives the image its nostalgic mood. However, the excellent flare suppression and good shadow detail shows that the image is a modern one, benefiting from modern standards of recording wide luminance ranges.

element: air

This image, taken near Lisbon, Portugal, was intended to express the element of air through the combination of silhouetted figure, the silk scarf, and the sun. Indigo has done well to capture just enough shadow detail, but the translucence in the scarf could be brighter to draw more attention, and framing could have been improved slightly by reducing the amount of sky to the left.

Shinjuku Gyoen

Taken in a park in Tokyo, this sensitive shot with its reduced depth of field leaves the viewer unclear about what the figures are looking at. The exposure is correct in bringing the brightest parts to heel, but there is perhaps a little too much darkness in the left-hand portion.

element: air

Indigo

"Making use of the transparency of the scarf against the sun transmits my opinion of light and therefore of air."

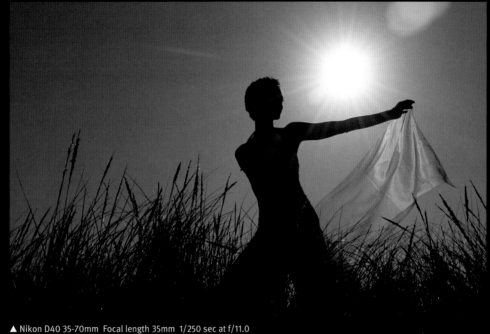

▲ Nikon D40 35-70mm Focal length 35mm 1/250 sec at f/11.0

Shinjuku Gyoen

Tim Keweritsch

"I watched these two sitting for a long time – neither spoke; it was a moment of silence in this fast-moving city."

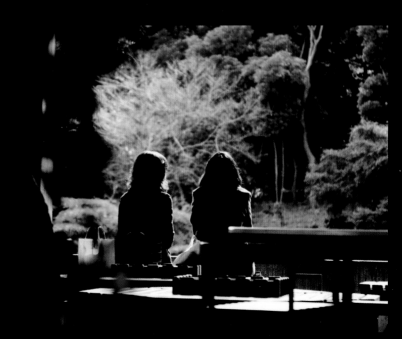

▲ Canon EOS 30D ISO 100 Focal length 105mm 1/200 sec at f/4.0

obtaining the best image

While digital photography has democratized access to fine imaging with tremendous success, it has created its own elite. Even the most expensive films were affordable to amateur as well as professional photographers, but the high cost of the best sensors makes them the preserve of professionals. Others must pursue the best lenses in their ambition to produce images of the highest quality.

fact file

Image sharpness depends on both resolution (how fine the detail is) and micro-contrast (the difference in brightness between adjacent details). A lens can be very high resolution but if its contrast is low it's hard to see the detail, so its images don't look as sharp as those from a low-resolution, high-contrast lens.

lens qualities

The performance of a camera's optics is defined by mechanical and electronic dimensions, as well as optical. A surprising amount of electronics have to function efficiently to enable the modern lens to do its job of projecting a sharp, colour-correct image. Sharp optics should be complemented by smooth focus and zoom movements, with just the right amount of friction.

accomplished optics | image clarity

While camera optics of the past were sturdy tubes containing screwed-down glass elements, the modern optic is a more mobile instrument. Elements adjust to focus and refocus when zooming alters focal length, while image-stabilized lenses compensate for your slightest movement. All are designed to deliver images with fine detail rendered to high contrast, with good colour accuracy and minimal colour fringing.

> ❝ an exciting development is the increasing use of image manipulation to correct lens defects ❞

However, there is more to high image quality than sharpness and colour. As the field of view of a lens increases, the tendency for the corners of the image to be darker than the centre rises very rapidly: this is known as "light fall-off". It can be useful at times for "holding in" the corners of a composition, but is technically undesirable. Only large, well-designed optics are effective at reducing light fall-off. A more common problem is vignetting. It has the same appearance, but this time it's seen in long focal-length lenses or long zoom settings. Narrow lens barrels that obstruct the peripheral rays cause the darkening, which can distort image tones and spoil composition.

lens defects | manipulation

Another aspect of lens quality is the extent to which the lens distorts an image – that is, whether straight lines in the image are shown as curved. This happens because magnification varies very subtly across the lens. For example, if magnification is a little higher in the centre than towards the edge, objects appear barrel-shaped.

An exciting development in digital photography is the increasing use of image manipulation to correct lens defects such as distortion, colour fringing, and light fall-off. This means that lenses can be designed without the expense of full correction of aberrations, because processing after capture can rectify them instead. Manufacturers may then concentrate on making camera lenses with as high resolution (the ability to distinguish fine detail) as possible, since low resolution is one defect that no amount of digital manipulation can improve on. Software-based corrections can also ensure that even very good optics perform to higher standards.

FULL APERTURE

CLOSE-UP

DISTORTION

COLOUR CORRECTION

LIGHT FALL-OFF

VEILING FLARE

BOKEH

SHARPNESS

VIGNETTE

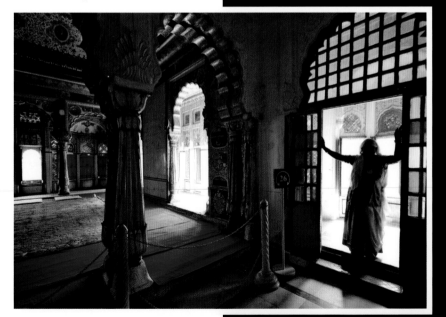

quality parameters

1	2	3
4	5	6
7	8	9

lightbox

For limited depth of field, **1**, good full-aperture performance is needed. Close-up performance in image **2** is a strong point of compact cameras, but distortion, **3**, is a weak point. For long focal-length settings, **4**, colour fringing can be a problem. Darkening in the corners, **5**, is a problem with wide-angle lenses. Zoom lenses can also suffer from flare, **6**, and vignetting, **9**. The best lenses are needed for good bokeh, **7**, and sharpness, **8**.

demanding performance

Your lens has not only to capture the details and colour of each scene accurately, it must handle unfavourable light and control flare, work well at any aperture, distribute the light evenly, and not distort the image. It's a tall order.

methods of focusing

Early attempts to automate the focusing of camera lenses by imitating the way the human eye works were failures. It was only when novel ways of determining focus were invented that auto-focus could become the sophisticated technology it is today, capable of a complex analysis of the image.

auto-focus | one-shot and servo

Modern auto-focus systems can work in near darkness (and in total darkness with the aid of projected infra-red patterns), keep continuous focus with a racing car, and automatically select which part of the scene to focus on. Some systems can recognize faces – or rather can analyse the scene for certain patterns and proportions that correspond to the human face – and give priority to focusing on them. Others can recognize when an element of the scene is moving against a background, assume that's the target and lock focus on it.

However, to make the most of these systems, it's usually necessary to set the camera and lens correctly. There are four modes of working, the most common being one-shot auto-focus, where the camera focuses at half-pressure of the shutter or AF button and will not fire until focus is obtained. This is best for relatively static subjects, when you have the time to focus on one part, then shift your aim slightly for a different composition. A close relative is the follow-focus, or servo, mode, designed for tracking moving objects: focus is continuously monitored and adjusted,

close-up precision
With small and very fast-moving subjects such as this dragonfly, auto-focus is the least stressful method but may force you to compose to keep the subject in the middle of the shot, covered by the auto-focus point, which can lead to poor composition (below). If the dragonfly rests, you can recompose (below middle and main image), but if it's moving (bottom), it's best to keep it centred.

CENTRED

OFF-CENTRE

MOVING

RAPID MOVEMENT

LOW LIGHT

HIGH-CONTRAST BEHIND

and the shutter can be released at any time, irrespective of whether the subject is in focus or not. In this mode, multi-point auto-focusing becomes particularly valuable, because you can track an object that is off-centre.

further precision
Although the geese are far off, the use of a 400mm lens makes accurate focusing a necessity. However, the geese are small, fast, and off-centre. Manual focus or off-centre follow-focus is required.

manual modes | precision and pre-focus
Manual focusing shouldn't be dismissed as archaic. It's still the most precise method when you have the time to focus carefully, and also the best way to focus close-up.

In pre-focus mode, you set the lens to a specific distance – for example on a goal-mouth or finishing line. When your subject enters the area, he or she will be in focus and you release the shutter. While this is essentially a manual mode, some lenses can memorize a pre-focus position: the lens turns to that position in a fraction of a second with the press of a button, so it's almost as good as auto-focus.

optimum performance | equipment and strategy
A photographic milestone was reached when, in the 1980s, an auto-focus system was invented that could focus a lens more accurately at speed than any photographer. However, although performance has substantially improved since then, they are still not perfect. For the optimum performance, use lenses offering the best image quality and the widest aperture, and aim at subjects that have some detail and good contrast. However, you should avoid focusing on subjects with strong regular patterns such as striped shirts, or those with an extremely high luminance range such as shiny metal in full sun. With all but the costliest zooms, it's best to set the focal length you wish to use then focus, as focus can shift with a change of zoom.

common problems
Rapidly moving targets (top) are difficult to focus on, as are subjects in low light (above middle) or where high contrast is behind the subject (bottom): all are best focused manually.

zoom and **perspective**

The quality of an image is more than can be defined by a resolution specification or the science of colour. The great photographer Alfred Eisenstaedt once raised the question, "What is the point of clicking your camera if you don't click with your subject?"

distance | and distortion

For example, if you take a zoomed-in shot of someone from across the street there is a gap and a distance between the two of you. If you would like your viewers to feel involved with your subject, you too need to involve yourself with the subject at the moment of capturing the image.

Wide-angle views in a confined space can appear uncomfortably distorted. If the distortion is noticeable, you are too close to the subject. You may need to walk back or find a better viewpoint – perhaps one that is lower down or higher up.

long focal lengths | loss of quality

Shooting from a distance also has its technical disadvantages. A shot from long to medium distances taken on a slightly dusty or humid day is markedly less clear than one taken from closer to the subject: the murkiness of the air lowers contrast and sharpness. You may find that many travel shots featuring human activity are compromised by being snatched with the zoom at the longer settings to enable the shot to be taken from a "safe" distance. There is a tell-tale lack of clarity and contrast

walk or zoom
Zoom lenses are ideal when your freedom of movement is limited – by natural obstacles or by fences. From just one position, you can obtain a variety of angles of view. If you stay in one spot, however, there is no effective change in perspective.

WIDE-ANGLE

TELEPHOTO

NORMAL

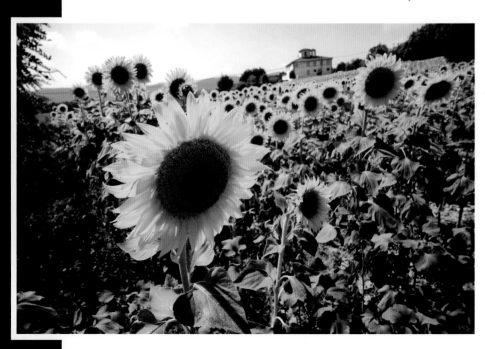

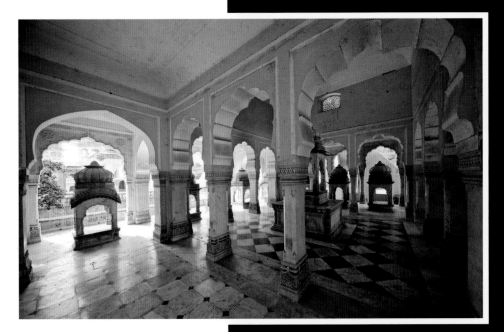

wide view
In confined spaces, it's tempting to use extreme wide-angle lenses but the cost – in regular shapes such as circles at the sides of the image being distorted into lozenges – can be high.

framing decisions
Zoom lenses come in very useful when searching for a composition using a framing device, such as this archway at a former monastery in Cortona, Italy. Find the position offering the best balance between inside and outside, then use the zoom to determine the best view.

in the final result, which betrays the thick layer of dusty air that is present between the lens and subject.

Setting longer focal lengths to magnify your subject also costs you dearly in magnifying any inadvertent camera shake. Modern image stabilization systems are wonderfully efficient at damping the worse effects of camera shake, but the less your images have to rely on stabilization, the sharper they will be.

best distance | getting closer

As you gain in experience you will learn that, for your particular style of photography, there is a right distance for every subject. Some subjects are truly best shot from afar, but for many subjects, the right distance is almost certainly closer than you think. Take care to avoid using the zoom just because of your inhibitions – breaking out of your comfort zone is a vital step in improving your photography.

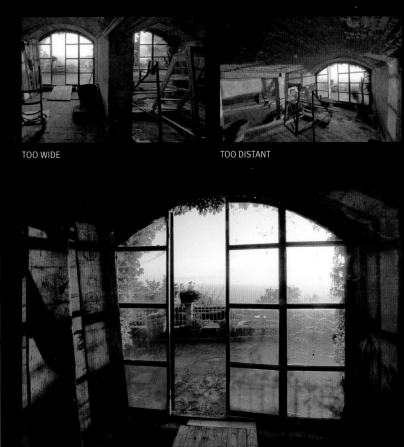

TOO WIDE

TOO DISTANT

BEST COMPOSITION

image **analysis**

One of the never-ending wonders of photography, and one of its greatest rewards, is its ability to record an infinite number of complicated details, which can be perused at leisure later. Our images repeatedly remind us how little we actually see by bringing to light what we've missed.

street | scenes

The way in which an image can be read often hangs on its initial capture. This street scene in Kolkatta, India, could be read as a straightforward travel shot or as a comment on population growth, global warming, and growing urbanization. For the shot to work, it was important to take advantage of elements that all came together in a fraction of a second. A high vantage point was vital for this photograph: it was snatched while crossing a bridge; the soft evening light was another boon; and the timing (it was rush hour) served to concentrate the crowds. All of these factors add to the strong visual impact of the picture. A telephoto view helped to compress distances so that people and cars appear even closer together than they already were. At the same time, the grabbed shot needed a short shutter time, even though the low light demanded a wide aperture and high sensitivity. A high-quality lens was helpful here because it produced sharp results even at full aperture. In this case, the stabilization also helped to deliver a sharp image.

in **detail**

For the greatest impact, a highly detailed image needs to be sharp. This image was shot at a full f/2.8 aperture, but the high quality of the lens (a Canon 70–200mm f/2.8L IS) ensured that details were faithfully rendered, with good colour and contrast. Image stabilization also helped ensure a sharpness at the exposure time of 1/200sec, which is just within the recommended time for obtaining a sharp image with a focal length setting of 200mm.

converging lines
An equivalent of the converging parallels is the reduced spacing of regularly placed objects such as lamp posts, trees, and rows of cars. They give the viewer's eyes numerous clues about diminishing space.

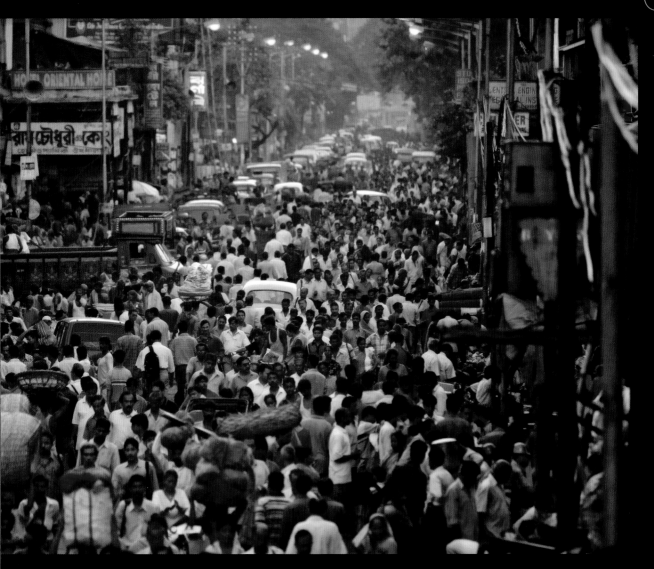

milling masses
The shape of the image is created by the repeated forms, with the milling masses channelled into order by the street. A bright car in the middle of the scene acts as a focus for the eye, and a place to temporarily pause and rest.

aerial perspective
The dust and humidity in the air add a sense of real depth and create perspective. Objects in the distance are less clear and lower in contrast than those in the foreground, giving a subjective measure of distance.

high detail
The image is helped by these wires, which have caught some light and reflected it back to the camera. Their higher contrast helps them appear sharper than they are, and their lines draw the viewer's eye into the image.

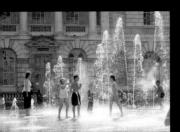

75MM

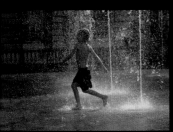

105MM

135MM

200MM

zoom advantages
With a single zoom lens you can cover wide-angle views to telephoto without changing your lens, so you don't miss a moment of fast-moving events or complicated situations with lots of opportunities.

zoom or prime lenses

Prime or single focal-length lenses are now very much in the minority, with zoom lenses dominating the market, but where image quality is paramount, prime lenses are preferable.

zooms | digital advantages

The argument for prime lenses is that they are no-compromise pieces of equipment. As the designers need work only with a single focal length, both mechanical and optical design can be concentrated on producing the best quality for that focal length. They can have large maximum apertures (described as "fast lenses"), are relatively compact, and offer high levels of flare control to produce high-contrast images.

Prime lenses were the major authors of photography's history. In the digital era, however, what was merely a small problem with interchangeable lenses on film-using cameras is perceived as a big drawback to the use of prime lenses – dust. Every time the photographer changes the lens, dust enters the camera, carried in both in the air and on the rear of the new lens as it is fitted into place.

The central ability of a zoom lens is, of course, to cover for several different prime lenses. With modern super-zooms covering ranges from 28mm to 500mm, one zoom lens can replace a bag-full of primes. This helps you to work quickly in fast-changing situations by minimizing lens changes, which in turn helps to keep out dust. Or does it?

Many photographers have found that dust enters their camera even if they don't change lenses. The reason is to be found in the zoom action: the movement of elements back and forth in the lens barrel acts like a piston, sucking in air and

pushing it out with each zoom action. The worst in this respect are lenses with push-pull actions.

Nevertheless, modern zooms can deliver extremely high-quality images, sometimes the equal if not superior to some prime lenses.

close perspective
Small cameras with small zooms allow a perspective that is very close to the eye, therefore enabling the scene to look much as the eye sees it, aiding composition.

prime lenses | shallow focus

Despite their limitations, prime lenses are making something of a comeback. As in the film and video world, photographers prize narrow depth of field. It's frustrating for us to be unable to create shallow focus in our images because the use of small sensors in digital cameras has the effect of increasing depth of field.

The solution is to use dSLR cameras fitted with large-aperture prime lenses and to work at or near full-aperture and at medium to close-up distances. A 50mm f/1.4 lens on a full-frame dSLR delivers a shallowness of depth of field that is markedly and beautifully different from the much smaller apertures and the resulting depth of field typical of zoom lenses on smaller cameras.

The significantly larger apertures of prime lenses are also ideal for those of us who wish to avoid using flash in low light. A further advantage is that the auto-focus can be much faster.

PORTRAIT

ULTRA-WIDE ANGLE

TRAVEL

VISUAL NOTE-BOOK

when to use zoom or prime

The choice of lens depends both on the required quality and subject. For portraiture and ultra-wide angle views, you may prefer a fast prime lens and a prime lens respectively. When it comes to travel photography and visual note-taking on-the-fly, convenience and light weight may be paramount, and therefore zoom lenses fit the bill.

fear of dust

On a blustery, dusty, or rainy day, no one is keen to change their lenses. A zoom lens enables you to cover many different situations, from a wide-angle view of people, to a long view that includes what they are enjoying.

aperture and working distance

Like many other precision devices and instruments, camera optics have an optimum setting that provides a sweet spot of performance, which varies with lens settings. Being familiar with the particular strengths and weaknesses of your optics will help you to get the most from your camera.

aperture | and aberrations

Camera optics reproduce the image perfectly only right on the optical axis – the very centre of the image. If you examine any image closely, you'll find the image will be increasingly defective the further from the centre of the image you look. These defects are caused by optical aberrations, that is, by the way light is bent and interacts with glass: it's a matter of physics. Lens design aims to overcome these defects as far as is practicable. Without these corrections, your images may display strong colour fringes as light of different wavelengths is focused to different focal points – this is caused by chromatic aberration. Your pictures may also be blurred at the edges if the image doesn't lie flat on the sensor, meaning that some parts are in focus while others are not – this is caused by field curvature. Other defects include comet-shaped highlights (coma) and corners that are much darker than the centre (light fall-off and vignetting).

A major problem is astigmatism, which allows details that run through the centre of the image to be focused, but not details that circle around the centre. So, for example, the spokes of a wagon wheel can be focused but not the rim – and vice versa.

Many of these problems are reduced when you use smaller apertures: the smaller hole forces the light to travel nearer to the optical axis, reducing aberrations. However, diffraction effects, which cause a loss in apparent sharpness, become a major factor with the smallest apertures. There is a point at which stopping down no longer improves performance but reduces it, which gives us the concept of the optimum aperture for an optic.

distant relationships

Blur in the closest flowers is due largely to limited depth of field and in part to a loss of performance. Superior image quality can have the effect of reducing the apparent depth of field by showing details sharply.

DISTANT DETAIL

MIDDLE FOCUS

OUT OF FOCUS

wide-angle depth
Reflections are very demanding on depth of field as focus needs to extend from very close to very distant. For the greatest depth of field, it helps to use a camera with a small sensor together with the smallest working aperture.

zone of sharpness
Depth of field is controlled not only by aperture, focal length, and working distance but also by how you align your subject with the available zone of sharpness. When objects are arranged on a plane at right angles to the lens, most can be sharp even if the depth of field is limited. But if objects are lined up along the axis of view, even extensive depth will not render everything sharp.

optimum | aperture

As a result of these aberrations and diffraction effects, it's well worth discovering the optimum aperture for your lens – or each lens if you have several. With zoom lenses, the optimum is often three or four stops smaller than full aperture. With prime lenses, two or three stops – or sometimes only one stop – smaller than full aperture will offer the best performance.

To evaluate your own lenses, place your camera on a support, set exposure mode to aperture priority, then make a series of exposures ranging from maximum to minimum aperture at each of the zoom settings. Examine the images at high magnification to see which aperture gives the best quality, that is, which is sharpest, has the best contrast, and is evenly lit from corner to corner.

Note that distortion – straight lines being imaged as curved – is not affected by aperture setting, although the type of distortion changes with zoom setting. As a result of this variation, settings around the middle of the zoom range usually give the minimum distortion.

FACING LENS

distance | sharp images

Another factor to consider in the search for best image quality is the distance between lens and subject. Many zoom lenses produce beautifully sharp images at very close settings that are far superior to those you obtain with distant subjects. Again, a trial set of exposures at different distances and zoom settings will help you to determine the optimum distance. You don't always have to use your lens at the optimum aperture or distance, but knowing the settings for getting the best out of your optics will give you greater confidence in your photography.

ALONG LENS AXIS

image **analysis**

With modern lenses and compact digital cameras capable of very high image quality, close-ups need hold no terrors for the photographer. Indeed, the zoom lens is designed to focus very close up, and many lenses actually give their best quality in macro mode.

macro | close-up

An image such as this dew-drop clinging precariously to the tip of a flower filament used to call for considerable technical resources to photograph, and great skill on the part of the photographer to obtain at high quality. Digital cameras have changed much of that by bringing together a number of powerful features. Central to close-up photography is the ability of the optics to produce sharp results at close subject distances. Thanks to the use of elements that adjust their relative spacing for different working distances – the so-called floating elements – this long focal-length shot is sharp with wonderfully smooth tones. Another key technology that has made macro more accessible is improved noise-free performance. The fineness of detail, smoothness of tonal transition, and fidelity of colour of modern digital images are on par with, or better than, film. Amazingly, this quality is within reach of modern compact digital cameras with pixel counts of 6 megapixels or more. Also, if your camera offers image stabilization, so much the better: you may be able to set a lower ISO setting for higher quality and still hand-hold with sharp results.

in **detail**

This image exploits what is often decried as a problem with close-up photography: extremely limited depth of field. By using a relatively long focal length of 180mm stopped down to f/8, depth of field is limited to just a few millimetres, which is just sufficient to get the droplet and a few filaments sharply focused. The rest of the image is thoroughly blurred. For this to be effective, you need to make sure that no strong highlights or line of deep shadow crosses the background: this ensures the droplet is not upstaged by distractions elsewhere in the image.

neutral high-key

Much of the sense of delicacy in the image derives from these ne high-key filaments: by ensuring t the highlights are neutral, the ar with slight density can mirror sul hints of other colours – blues, pu and greens – in the scene.

image of an image

The drop of water acts like a lens we see in it a virtual, upside-dow image of the world beyond. To o this effect, you need to adjust yo distance to the drop of water – effectively focusing the image in the drop until it is sharp.

colour accuracy

In the actual scene, the backgro blur was an intense purple, whic was rich and subtly graded on th monitor screen. However, purple lie near the edge of printer gamu so the printed image has lost sor of its richness and brilliance.

Assignment: **urban nature**

As the natural world is increasingly affected by human activity, the fauna and flora that will thrive best on earth is that which can adapt to life in towns and cities. No matter where you are in the built environment you will be able to see signs of nature taking hold, from wildflowers colonizing earth exposed by cracks in concrete, to birds and mammals that have found food and shelter easier to come by than in the countryside. Their presence adds animation and interest to photographs of urban scenes that might otherwise seem lifeless and sterile.

Focal length 14mm 1/60 sec at f/4

the**brief**

Search for juxtapositions of natural forms against man-made structures and try to record them with the very best quality. You can work with general views of the environment or in close-up to focus on details that are usually overlooked.

Points to remember
- use a high sensitivity setting to capture movement
- shoot in RAW format if it is available on your camera
- use lighting that suits the subject: flat lighting is usually easiest to work with
- if using a tripod is awkward, look for any handy support on which to rest the camera to ensure sharp results
- use the full range of focal lengths available to you, experimenting with zoom setting at each perspective

ISO 250 Focal length 117mm 1/320 sec at f/9

must-see **masters**

Andy Rouse (1897–1966)
A popular UK photographer, his work on wildlife in urban environments – many carefully set up and lit – set new standards for such photography, and stand as among his most innovative contributions to wildlife photography.

Britta Jaschinski (1965–)
The haunting work of this German photographer, concentrating on animals in zoos and enclosures, has helped to transform our opinion of animals in captivity. We are encouraged to foster respect for her subjects, and to appreciate their quiet dignity, which is often coupled with an underlying sense of unease.

Paul Raphaelson (1968–)
This New York-based photographer specializes in urban landscapes. His most recent projects show overgrown corners of Brooklyn and Manhattan, and explore nature's ability to re-colonize our forgotten places.

Focal length 7.2mm 1/800 sec at f/4

Focal length 7.2mm 1/100 sec at f/11

Focal length 7.2mm 1/500 sec at f/8

ISO 500 Focal length 400mm 1/250 sec at f/5.6

ISO 500 Focal length 400mm 1/250 sec at f/4

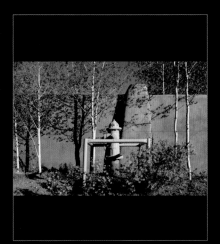

ISO 100 Focal length 28mm 1/320 sec at f/9

ISO 100 Focal length 28mm 1/320 sec at f/9

(1) (2) (3)
(4) (5) (6)
(7) (8) (9)

light**box**

top**tips**

(1) details | shallow focus
A delicate natural form contrasted with the hard urban surface can make a more effective statement than an obviously dramatic composition. Use shallow depth of field to isolate a plant or detail.

(2) (3) wide angle | main subject
Use a wide-angle view with the camera placed very close to the main subject to give it prominence while the background is dynamically shrunk in comparison: this is effective with different depths of field.

(4) contrasts | landmarks
The presence of wildlife brings an interesting contrast to a famous landmark. Here, I waited for the cormorant near Sydney Harbour Bridge to move so that its silhouette offered an strong shape that carries the picture.

(5) close-ups | long-lens work
Many urbanized animals are relatively tame, so with a long focal length setting and a careful approach you can obtain satisfyingly close-up pictures of small creatures.

(6) shapes | scale
It's tempting to try to catch wildlife in a natural setting, but unusual juxtapositions such as this fox with a car wheel gives both scale and an incongruous pairing.

(7) (8) texture | contrasts of form
The contrast between the lively forms of nature and the mechanical regularity of man-made forms offers an endless range of subject matter. Compositions can be quite simple yet still effective.

(9) decay | renewal
The decay of man-made objects is often poignant: you can make an entire project concerning urban, mechanical, and architectural decay and the inexorable return of nature in the absence of human intervention.

▶ see **results**

city tree

Nikolaus Christian Madzar

"The tree was not really visible at first. I noticed it when playing with the focus on the lens and was surprised by what I saw in the viewfinder."

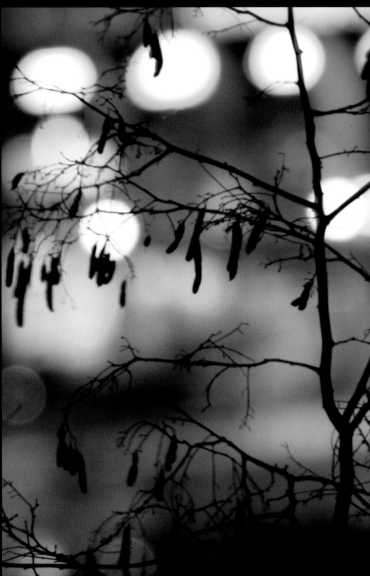

▲ Canon EOS 400D ISO 100 Focal length 200mm 1/15 sec at f/4

the**critique**

When working with images featuring nature or natural objects in the urban environment, the heart of success lies in meticulous observation of detail. Minute changes in focus, in position, or timing and settings can make or break an image. It's no surprise that the most successful images submitted for this assignment were also the most spare, contrasting light with dark, colour with black, and with limited palettes of colours. They are also the reward for observation: lovely images found where hundreds of people have passed and seen nothing.

city tree

In this image, of the main train station in Stuttgart, Germany, Nikolaus saw the broader scene but it was the lens that narrowed his view to the silhouette of the tree and threw the lights out of focus in a way almost impossible to do unaided. The combination of full aperture, long focal length and low ISO setting has ensured smooth outlines to the out-of-focus blurs, while the low sensitivity gives milkily smooth colours.

fragile nature

The economy of this image would make any modernist very proud. Forcing under- or over-exposure, as Milo has done here, can transform an unpromisng scene into a photographically coherent statement. When photographing lights it's worth bracketing exposures so that you minimize digital darkroom work.

supermarket starling

Spotting the starling at work came from sharp observation, but it was the patience to wait for good luck that captured the bird in a position in which its shape could be seen clearly. A shallower depth of field might have helped to isolate the bird and further blur the vertical line so that it's less of a distraction.

"I saw the trees and was fascinated by the contrast of their fragility and roughened bark silhouetted against the glowing yellow lights."

▲ Canon EOS 20D ISO 800 Focal length 85mm 1/80 sec at f/5.6

supermarket starling
Nicolas Bonnet

▲ Canon EOS 5D ISO 100 Focal length 70mm 1/160 sec at f/4.5

"I don't usually take my camera when I go shopping, but on that day I did. It's taught me to keep it with me, always."

obtaining ideal colour

Photographers using colour film used to have to work with, and compensate for, the colour characteristics and limitations of their materials. However, the benefit of film was that industrial standards of manufacture and processing maintained consistency in reproduction. With digital photography, the means to control colour is almost entirely the responsibility of the photographer.

fact file

Digital colour, being a set of numbers, can be organized, interpreted, and expressed in different ways, according to computational and practical needs. While RGB, CMYK, and Lab colours are roughly comparable they are not exact duplicates of each other.

seeing colour

The work of the Impressionists showed us that, if we look closely, we can see every colour of the rainbow in any scene – an exciting revelation for jaded eyes. Not only can we find colour everywhere we look, but with the high sensitivities and low running costs of digital cameras it's possible to have a go at recording almost any situation where there is some available light.

colour spaces | numerical systems

What's so wonderful about working with colour today is that so many different ways of recording and reproducing colours can be combined. Some systems are inherently incompatible – reproducing colours by shining light through filters is diametrically opposed to producing them using drops of ink. However, what digital methods have created is a system in which each type of colour recording or reproduction can translate information from one to another.

> In abandoning film ...we have had to take on ourselves the burden of controlling colour ...

The natural reference for evaluating any colour reproduction is the human eye. In fact, we can see more colours with greater discrimination than any digital system, and the range of colours visible to the human eye defines the colour space by which all other systems are compared, which is known as the "profile connection space".

Digital colour is only a set of numbers. These must be interpreted before they can be seen as colours, and that interpretation is open to our control; the numbers translate into different colours according to the colour space that we work in (see p. 20). While a particular manufacturer's colour reversal film will present you with

consistent results in the way it records colour, when you are working digitally there is no such thing as absolute colour.

colour | discipline

In gleefully abandoning the need to send film off to laboratories to be developed, we have had to take on ourselves the burden of controlling colour accuracy. This is a seismic change in the structure of photography for which few are prepared.

Technological advances will mean that the next generation of photographers will find no difficulty with colour management. For now, to maintain high standards for colour we must handle it in what seems a burdensome way, setting up software to control colour consistently, calibrating monitors to show colours that meet industry standards (see pp. 342–43), and using colour profiles.

However, the correct use of colour profiles is now part of delivering an image – whether to website or printer – and routine checks of your monitor will soon become second nature.

OVERCAST

EVENING SUN

MIDDAY SUN

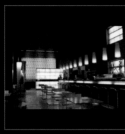

INTERIOR FULLY BALANCED

INTERIOR UNBALANCED

INTERIOR PARTIAL BALANCE

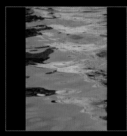

SUNNY REFLECTIONS

PART CLOUDED REFLECTIONS

CLOUDED REFLECTIONS

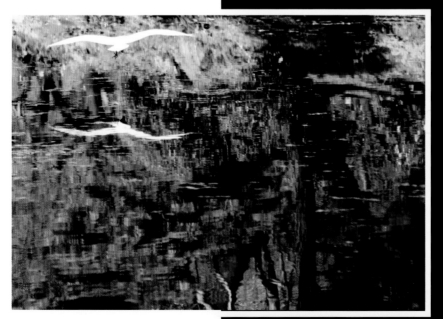

the colour of light
In **1–3** the greens of grasses vary from nearly blue to strong yellows according to the lighting conditions and the angle of lighting. In **4–6** Mixed architectural lighting signifies different moods according to the extent of white balance applied. In **7–9** The colours of water change quickly according to whether the sky is clear or clouds are hiding the sun.

colours everywhere
All the colours of the rainbow are in this scene, from yellows and reds to greens, even a touch of blue. Some types of lighting bring out more colours than others – you match colour reproduction to the mood you wish to record.

white balance

The foundation of accurate colour is an accurate white balance. This is the process of compensating for, or removing, any overall colour in the illuminating light in order that it approximates standard daylight nominally around midday on a half-cloudy day in mid-latitudes.

automatic | versus manual

We had automatic white balance long before digital photography came along: it's of such importance that nature developed complex mechanisms for our eyes. However, it's only with the widespread use of artificial lighting and generations of experience with colour photography that we have become aware that our eyes are constantly adjusting white balance in order to ensure that we see hues as accurately as possible. If they did not, the colours of everything would seem to be changing all the time, shifting with the slightest movement of clouds and the arc of the sun.

Digital camera manufacturers have designed a system similar to that of the eye to give us automatic white balance: the red, green, and blue signals are analysed for any overall dominant colour present in all parts of the image. This dominant colour is removed by varying amounts according to the colour and its strength. If the analysis is too simple, a subject with strong dominance in one colour, such as autumn leaves or an expanse of ocean, would be wrongly white balanced so, in many systems, the highlights and shadows are also analysed and used to temper any removal of dominant colour. Nonetheless, while modern algorithms are very

balanced colours

With a mix of numerous kinds of lights emitting whites that vary from red to blue, no single white balance can be said to be correct or the best. A little experimentation shows that a correction that turns neutrals to true neutral actually causes the image to look too blue, since it allows the blue lights in the scene to dominate. Taste is the best arbiter here.

AS SHOT

PARTIAL CORRECTION

OVER-CORRECTED

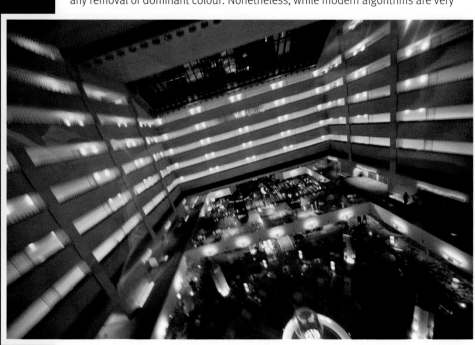

successful, automatic white balance is like automatic exposure control – manual control is more accurate, but less convenient.

hue | accuracy

The majority of digital cameras offer preset values for lighting conditions, such as tungsten, fluorescent, cloudy days, flash, or shade. These often produce results that are superior to that of automatic white balance (see the lightbox images opposite).

Another approach is to make custom white balance settings for each new lighting situation. The procedure is to record an image of a subject that's reliably neutral in colour, such as a white or grey card (use a white card when light levels are low, a grey card in normal to bright conditions). The card is presented to the camera as the calibrating target: essentially you tell it to adjust colours so that the card records to neutral, that is, with red, green, and blue signals equal at all levels.

The image of your card becomes your custom preset, and is a guarantee of accurate colours for as long as you work in the same lighting as that used to make the preset.

There is, however, an important caveat. Colours can be accurate only to the extent that the illuminating light provides the appropriate wavelengths. For example, in order to see blue, you need blue wavelengths in the illuminating light. Therefore, if you illuminate a blue object with tungsten light, which lacks blue – being yellow-red – the object will appear nearly black, whatever your white balance setting.

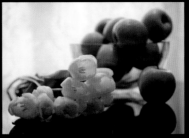

TUNGSTEN

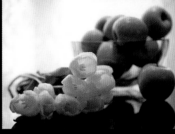

DAYLIGHT

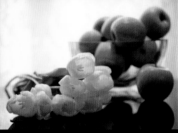

SHADE

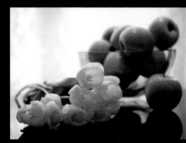

CUSTOM

white balance settings
Given a mix of daylight with some tungsten light, you can use your camera's white balance preset values to produce different moods. Cool tones are the result of the Tungsten setting (top left) and warm tones the result of the Shade setting (above left). In comparison with the Daylight setting (top right), the Custom setting (above right) is subtly more polished and cleaner.

balance and compromise
Image white balance is in part objective control, part artistic decision. Fully correcting the strong blue of the mountains in shadow would lose their sense of chill hostility, and the foreground would become too warm. Instead of depicting a cold morning, the image would then appear to have been taken at sunset.

key **colours**

The accuracy of digital colour capture is affected by numerous factors, the least of which are the settings that you choose to make. Not only do the characteristics of the sensors contribute, so do the properties of the lens, the image processing, and the lighting conditions.

memory | references

Aiming at accurate reproduction of key or "memory" colours such as blue sky, skin tone, and the oranges and yellows of citrus fruits is a good strategy. If these colours are captured well, it's likely that others falling in between will be fairly accurate. With film, colour engineers tried out different combinations of dyes until they obtained a result that, on balance, gave colours that were pleasing and broadly accurate.

With digital photography, the colour filters over the sensors – red, green, and blue, or whatever other colours are used – all impart their own characteristics to the image. For example, the green filters may transmit a little more yellow than is ideal. This can be compensated for during the image processing, and it's here that colour engineers have to make subjective decisions about which colours to favour and which to reduce in strength. Their decisions will always refer back to the accuracy of certain memory colours, and, of course, different manufacturers will pick different colours as their references. However, as digital photography has matured, it's clear that the variations between different manufacturers are narrowing.

skin-tone reference
Having no reference to the original dresses, you would accept them reproduced as virtually any colours: in fact the cyans and pinks (below and below middle) were more brilliant in real life. However the tanned skin tones (bottom) anchor the colour, persuading you that the dress colours are also true.

DEEP CYANS

BRIGHT PINK

DARK SKIN TONES

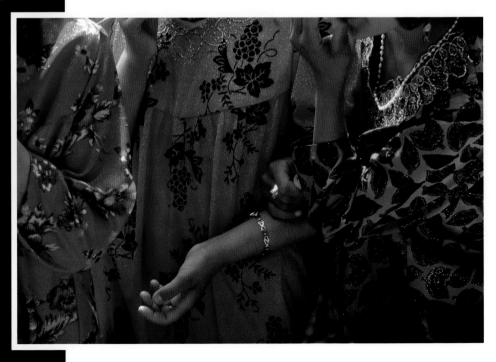

CANON

OLYMPUS

PANASONIC

NIKON

skin tones | a precise reference

The most important of all reference colours is human skin. You may be wondering how that can be, for human skin tone varies from the deep browns of Equatorial races to the palest pink of people with albinism. However, the hue – the colour itself – is surprisingly constant.

mediterranean colours
There is very little room for manoeuvre for the hues of well-known objects such as these oranges against the blue sky on a sunny day. However, a wide range of colour saturation will be found acceptable.

In fact, in video technology a display called the vectorscope offers a single "Face Tone Line": you line up your face colour to it and accuracy is guaranteed. We could do with such a display in photography. Failing that, we actually have a very accurate method of determining skin tone: if it looks right, it almost certainly is.

colour reproduction | personal taste

There used to be endless debate among film-using photographers as to which colour film was best. Some loved the brilliance of Fujichrome Velvia; others were most comfortable with the soft subtleties of Kodachrome. Digital cameras also have their own way of reproducing colour, some giving you saturated colour while others are more muted. At the same time, lenses also make their mark. Some project images with nearly neutral balance, while many tend towards very slight yellow or red coloration. If you find yourself wanting to make colour adjustments to every image, it's probably because your perception of colour doesn't match that of your camera's designers.

profiles | RAW capture

The differences between colour reproduction in cameras tend to be much smaller than those caused by variations in lighting. If you work in studio conditions with consistent lighting, it's worth creating a camera profile to manage colour capture (see pp. 342–43). For general work, camera profiles are of limited usefulness but capturing your images in RAW format will give you good flexibility (see pp. 186–89).

system palettes
At first glance, the standard colour chart rendered by four makes of camera appear very similar. But compare, for example, the light brown at top left of the chart. It is darkest with the Olympus, lightest with the Panasonic. The black — bottom right — is grey with the Panasonic, nearly black with the others.

LOW SATURATION

HIGH SATURATION

MIXED SATURATION

saturation levels
The saturation level should ideally match the subject or at least be appropriate to the scene. Pale colours (top) should remain pale, while strong colours (above middle) can be saturated. A correct saturation level (above) renders mixed saturation in the scene in a balanced way.

colour spaces
The choice of colour space makes a big difference to images such as this, captured in Kathmandua, Nepal. This is because the colours are not only vivid but highly saturated.

saturated **colour**

We have a strong and instinctive attraction to vivid or saturated colours. We associate them with sunlight, warmth, and liveliness as well as with vegetables, fruit, and flowering plants at their peak – for example ripe oranges, or red roses in full bloom. Indeed, the Latin root of the word "vivid" means "life".

saturation | and realism

One of the biggest treats for anyone first discovering digital colour is learning that it's possible to make colours highly saturated, with results that dazzle the eye. But take heed of the word "saturation" – as it implies, you can have too much of a good thing.

When all images are highly saturated, they start to look very alike and the world begins to look oddly dull. The tendency is then to increase the contrast in the images as well in order to keep up the appearance of brilliance. Unfortunately both printer and camera manufacturers have pandered to this tendency because images in which the colour saturation matches that of the scene will attract the viewer's eye less than images that are highly saturated. We will forgive the inaccuracy so long as the image is bright and brash.

Not all subjects benefit from high saturation. One classic error is to over-saturate pictures of white weddings. Here the photography needs to convey a light and airy feel, quite high-key. For this, you can slightly over-expose the images, work with slightly low contrast, and also run the colour on saturation. Architectural interiors, especially in minimalist styles, do not need high colour saturation: the use of tinted whites is very much part of the style, which would suffer with strong colours.

monitoring | limits

Another reason to avoid using highly saturated colours is that while you can see the colours on your camera's LCD or your computer monitor you won't be able to retain them all in print. The problem is not only that the gamut, or range of colours, of a print is less than that of a monitor, the mismatch varies between prints, papers, and inks, so the colours you lose vary according to your printing choices.

The contraction of colours can also cause posterization or unevenness of colour transition. Consequently, keeping to realistic saturation levels is usually the best strategy.

The best way to monitor saturation for safety levels is to check for out-of-gamut colours. You can set software such as Adobe Photoshop to display a gamut warning; this overlays the image with a colour where colours cannot be accurately reproduced by the output device (see p. 170). Another approach is to soft-proof the image: this sets the colours in your monitor to look as they would when the image is output. For this to be reliable your monitor must be calibrated and profiled and the output colour space be correctly allocated (see pp. 348–49).

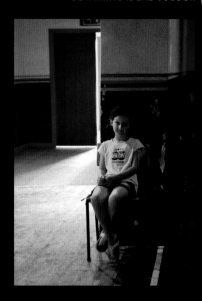

shadow colours
Colours in low-key images – where dark tones predominate – tend to look stronger than they actually are, through simultaneous contrast with the tones that lack colour. You may be tempted to increase saturation further: this may be acceptable with the etched glass (above left), but high saturation would not be appropriate for the girl (above right).

ADOBE RGB sRGB THEATRE FILM STOCK

colour profile assignments
You assign colour profiles when you don't wish to change the colour data in your image but want to see what it would look like in another situation. Note that book reproduction strongly reduces colour saturation. Nonetheless, it is possible to see that the original capture in Adobe RGB (above left) is more saturated than the image seen in sRGB (above centre). You can try out non-standard profiles experimentally; for example, a theatre film stock profile (above right) gives a stunningly different look.

image **analysis**

As colours can be measured objectively, the concept of ideal colour shouldn't be as elusive as that of, say, the ideal picture. However, something that is objectively perfect doesn't always look so ideal. There are variables that can't be controlled, such as the settings of a monitor screen, and the colour of room lights and walls, not to mention individual preference. In the end, the best judge is educated good taste.

colour | subjectivity

By teaching yourself to be a critical consumer of light, you can become more fully aware of colour. If, for example, you are a critical consumer of food, you search for not only the strong and spicy, but also the subtle and delicate. So it is with colour images: they do not need to be full of vibrant, punchy, and saturated patches. This image, for instance, covers a full gamut of colours from blues through yellows and browns to pinks and reds, but all are muted and quiet.

Evaluate it carefully and you will notice skin tones are cool, which suits the pallor of the model and the softness of the light. Objectively it may not be "correct", but consistency with the overall mood is important. A warmer skin tone would take its hue towards that of the antique curtain, which closes the visual gap – not an outcome we would wish for. The strongest colour is in the tiara, but, because it is blue, it does not distract attention from her beautiful profile.

in **detail**

It appears easy to determine the ideal colour balance for this image because the model's blouse provides many neutral colour patches. But look closely and you will see that the collar is tinged with pinks, blues, and cyans, and even a touch of yellow. If you used a tinted portion to set the balance to middle grey, the other areas with the same tint will turn neutral, but other tinted areas will change their colour. The change is often larger than you expect because it takes place against an overall neutrality. However, the most important colour here, as in the majority of portraits, is the skin tone. Your best strategy in this situation is to use your own judgement to set white balance in order to render the skin tones as attractive as possible.

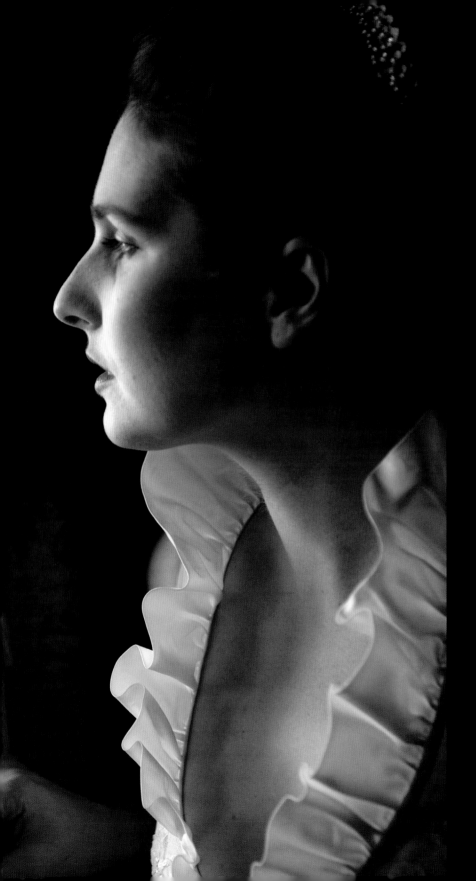

handling highlights

Highlights on translucent cloth can often be used to help with colour balance – but not in this case. These highlights have picked up tints from the model and her surroundings, so you will have to take great care in your choice of an area to sample.

handling blacks

You may be tempted to try to extract shadow detail but, in this case, it's right to allow the loss of detail. The sparkling tiara suffices to give life to the empty space, and indicates her hair despite the total blackness.

creamy skin

To ensure a pleasing rendition of the girl's skin tones, the highest resolution and lowest sensitivity available were used. Recording in RAW format is helpful too, as you can record smooth highlight transitions more easily than with JPEG.

Assignment: **city streets**

Taking photographs in busy city streets with a number of people going about their business presents many difficulties. The main challenge is how to make sense of the swirl and chaos of all the activity. One of the most useful tricks to help structure your compositions is to use strong colours such as orange or red to highlight key elements, while using softer colours such as stone-grey as backdrops to the action. While you are thinking about composition, always try to be unobtrusive and respectful of people's sensibilities.

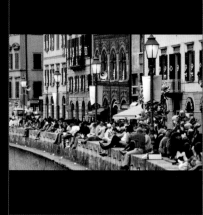
ISO 1600 Focal length 100mm 1/100 sec at f/7

the**brief**

Working in an urban area where there are plenty of people present, try to capture the busy scene in a balanced, well-composed image. You can either record a general view or get in close to take a more intimate shot. Take advantage of colours and shapes when composing and organizing the shot.

Points to remember
- use wide-angle settings from medium distances to capture the general atmosphere of the scene
- long focal length settings will compress space from a distant perspective
- patterns and lines help to organize a composition
- wide-angle lenses used close up to a person or object help to provide a frame and context
- you do not have to show everything in order to be representative – a small but telling detail can be as effective

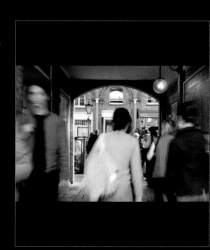
ISO 100 Focal length 27mm 1/30 sec at f/6

must-see **masters**

André Kertesz (1894–1985)
One of the universally acknowledged masters of photography, Kertesz almost single-handedly invented the street photograph through his virtuosic handling of the Leica camera.

Joel Meyrowitz (1938–)
An American master of the meticulously framed large-format colour image as well as candid street photography, his series on flowers in cities is a delight and his work continues to be as inventive as ever.

Constantine Manos (1934–)
Manos is a Greek photographer who has long been an able photojournalist. His more recent work in colour revealed his true talent as a superb observer of life with total mastery of colour composition.

Sherman Ong (1971–)
This Singapore-born photographer brings fresh and constantly investigating eyes to the urban environment. His triptychs of Hanoi and his Monsoon series are inventive and involving.

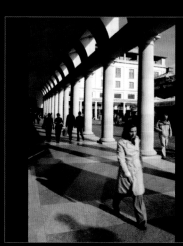
ISO 100 Focal length 20mm 1/125 sec at f/16

ISO 400 Focal length 3.8mm 1/25 sec at f/2.8

ISO 125 Focal length 3.8mm 1/255 sec at f/2.8

ISO 100 Focal length 18mm 1/30 sec at f/18

ISO 100 Focal length 12.7mm 1/60 sec at f/2

ISO 100 Focal length 6.3mm 1/125 sec at f/5

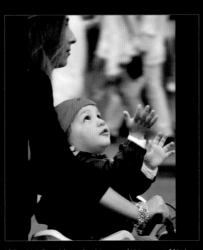

ISO 1600 Focal length 135mm 1/125 sec at f/5.6

1 2 3
4 5 6
7 8 9

light**box**

top**tips**

1 composition | strong lines
Use compositional markers such as the line of this wall and the contrasting lines of the buildings. Here, combined with a long focal length setting, they organize the chaos of colours and multitude of people.

2 3 phone | angles
You can transform the daily commute into a photographic expedition by using a camera phone to record your journey or those of other commuters. The limited colour and dynamic range of these cameras helps simplify the clutter and bustle of city life.

4 5 movement | and colour
Your images don't always have to be maximally sharp: the combination of movement blur with sharpness in other parts of the image is an effective photographic device for signifying flux and change.

6 overview | organize
Views from above always help to organize visual elements, such as the splashes of red here, because they put space between objects that would otherwise be overlapping, allowing them to show their natural grouping.

7 parallels | defining space
The strongest indicators of spatial depth in the city are converging parallels. However, when you are in an area where regularly spaced structures are preponderant, you have to work hard to avoid them dominating your image.

8 framing | looking for structure
You can often find structure in the most unexpected places. Here a pattern of dots on a window give texture to the blank sky as well as helping to organize the mixture of people and colours.

9 telephoto focus | isolating events
A long focal length allows you to follow little dramas from a distance. Use the widest aperture to enable you to set a short exposure time to catch action.

▶ see **results**

seaport shadows
Jeffrey Shay

"I went into the mall for a coffee where there was a deck overlooking the main entrance. I stood watching people enter and exit while the sun set."

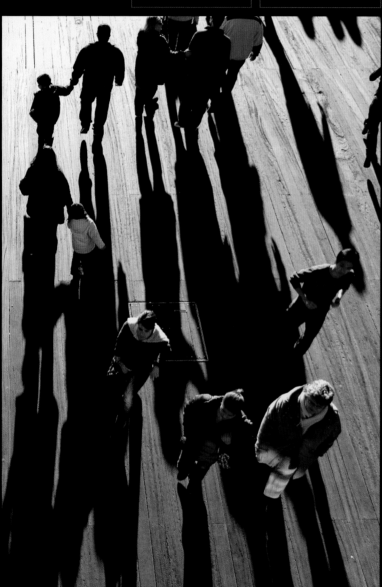

▲ Nikon D70 ISO 200 Focal length 18mm 1/250 sec at f/8.0

the**critique**

The secret to street photography, as advised by Robert Doisneau, is to "walk, walk, and walk again". But that doesn't mean you should be in constant motion; rather it means you need to walk from one vantage point to another, explore different parts of a town, and there lie in wait: for a confluence of light, events, and your own photographic preferences. Aim not to machine-gun – that is, to take numerous photographs – because the perfect shot is often in between sequential pictures. And, when the moment has passed, you need only walk on to find new opportunities.

seaport shadows
While taking a coffee-break during an exploration of downtown Manhattan, Jeffrey did not rest nor did he take his eye off the ball. By continuing to work, waiting for chaos to resolve itself momentarily into a pattern that we recognize as order, he obtained a professional-quality image that combines a sublime balance of composition with glorious light and colour.

Shanghai child
For this image, Tim was exploring one of the older areas of central Shanghai, enjoying "great lighting conditions". His image carries a message about rapid growth leaving people behind. Central to the success of the image is the way that the drab colours of the surrounding traffic contrast sharply with the child's red coat, focusing attention on her.

Buddhist monastery
The rhythm of repeated elements brings order to Bogdan's image, with the significant contrast of postures in the people. For the photographer, the static composition expresses something of the order and serenity of the place: in this way what may be found to be a fault in composition is shown to be appropriate to the meaning intended.

Shanghai child
Tim Keweritsch

"Seeing this child in the middle of this fast-moving modern city, I felt it was a contrast to what people see of Shanghai in general."

▲ Canon EOS 30D ISO 400 Focal length 92mm 1/200 sec at f/4.0

Buddhist monastery
Bogdan Grosu

"Colourfully dressed, with heavy walk the pilgrims radiate a unique inner power that is difficult for the camera to capture."

▲ Canon EOS 350D ISO 200 Focal length 106mm 1/400 sec at f/10.0

The secret of advanced photography is that it's only the fundamentals, but understood in all their breadth and depth. In these tutorials we refine our skills in composition, use of colour, and timing. And we improve our understanding of light. A missed opportunity is serendipity's calling card for the unprepared: by advancing your skills you ensure your readiness to respond.

DEVELOPING
YOUR SKILLS

tutorial 6

mastering composition

Picture composition arises primarily from your choice of camera position. This means that you can change the appearance of a scene simply by moving around, without having to alter the placing of any of the elements within it. This is the wonderful effect of perspective control, which we explore in this tutorial. But first, we look at the foundations for composition – format and proportion.

fact file

Although just about every image seen these days is contained within a rectangle, that does not mean you have to follow suit. The circular or oval frame can be very effective for portraits, full-figure shots, and even landscapes. A lozenge shape is also striking and can work well with architectural and interior views. Even shapes that are irregular may suit some subjects.

format and proportion

There are two ways to control the proportions of an image. Externally, we can vary its format – the shape of the image canvas – by using anything from a square to landscape, portrait, or panoramic. We also have power over the internal proportions of the composition by using framing to control the position of key elements within the image canvas.

format | and balance

While we can take it for granted that images operate within squared-off frames with clean borders of different sizes, we cannot take the proportions of the frames for granted – they are the foundation for the composition within.

With their symmetry, square frames offer a feeling of stability and neutrality, yet many subjects will sit uncomfortably within a square, because a square naturally leads your eye to the centre, which can unbalance the image. Rectangular frames with sides of 1:1.33 to 1:1.5 ratio are the most popular and most versatile, but they are also the

> Proportions of the frames are the foundation for the composition within

most predictable. Formats of greater aspect ratio, such as 16:9 or 16:7, are gaining in popularity: these can be effective for general views but are less useful for portraits.

In the past, picture format was set by the camera and film used, but we now have total flexibility. To make the most of this, it helps to practise visualizing the cropped image within the normal confines of your camera's viewfinder.

proportions | key images

The other fundamental of composition is control over the internal proportions of the image. We achieve this through the placement of key elements within the composition. The main subject of an image has the effect of dividing up the space. We use the proportions of the resulting space to structure the visual response, from perfect balance to tottering imbalance, via a dynamic equilibrium, simply by adjusting the image's internal proportions.

movement | leading the eye

The placement of major elements can also suggest another dimension entirely: movement. A row of columns marching into the distance leads the eye into the depth of the picture. A spiral staircase seen from below pulls the eye into the centre of the image.

By giving the viewer a path to follow with their gaze, we can simulate the effect of movement in an image: the viewer "walks" through it. This is a powerful device which is most effective at larger print sizes.

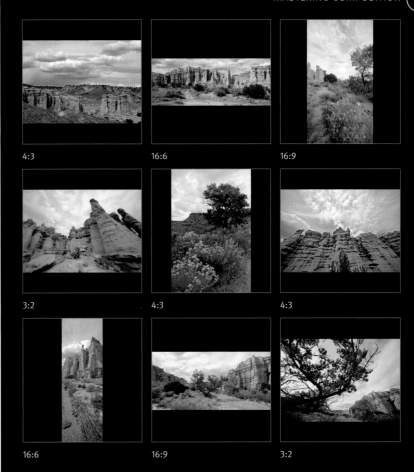

4:3 16:6 16:9

3:2 4:3 4:3

16:6 16:9 3:2

frame and shapes

1, 5 The 4:3 ratio, like the proportions of a domestic TV, is a favourite because it's familiar and suits most images. 2, 8 The narrow letterbox shape is popular for landscapes. 3, 7 Tall, narrow shapes are unusual but this wall-hanging, or banner, style can suit some compositions. 4, 9 The ordinary 3:2 shape has stood the test of time as the most versatile.

light**box**

proportional representation

A composition made up of complicated elements, such as this street scene in Florence, Italy, operates best within the familiar boundaries of the rectangle, and within familiar proportions. This enables the tension of conflicting clues from the planes in the picture to operate effectively.

balance and imbalance

While the proportions of the overall image are obviously determined by the relative length of the sides, these interact dynamically with the proportions of the composition within the image. These in turn depend on the placement of the main subject within the frame.

picture space | key elements

The proportions of a composition are controlled through the placement of key elements within the image canvas. These elements divide up the space by defining their visual hinterland, their subsidiary space. For example, imagine a landscape: we see hills, valleys, and the sky beyond. If we introduce a nearby figure into the frame it becomes the primary element in the image; the space around the figure becomes subservient to it. We no longer see the hills and valleys as the main subject of the image, and thus we can accept its division into sections on either side of the figure.

The image can now be seen as divided into different sectors, which take up different proportions of the whole. We have a kind of geography of the image, and it is one that conveys broad notions to the viewer.

proportions | and theory

When we place the subject centrally, we divide the image into two rough halves. This symmetry suggests stability, solidity, and regularity. A subject placed one-third of the way into the frame results in an unequally divided image space, cut into one-

golden thirds
There are subtle but significant differences between an image divided into thirds (above) and Golden Sections (right). Divided into thirds, the balance is a little precarious, and more dynamic. Golden Section ratios bring the main subject a little closer to the centre, and the result is more stability and equilibrium.

candid proportions

This shot is framed to Golden Section proportions, with a Golden Spiral starting at the eye, looping past the ear then down the line of the chin. While framing is instinctively done, it helps to resist the tendency to place the eyes centrally.

third/two-third portions: this results in an imbalance, so it suggests some tension, a potential for movement.

From this we obtain the much-quoted "rule of thirds", in which the main subject is placed at one of the intersections where the length and width of the image are divided into thirds (see diagram far left). Placed a little further towards the centre, the subject sits at the Golden Section: the ratio of the shorter part to the longer is equal to that of the longer to the whole length, roughly 1.62:1 or about 60:40 (see diagram left). This is the classic ratio for elegant proportion and form, seen, for example, in ancient Greek art and architecture, and is the basis for the proportions of the standard 35mm format.

Finally, we can place the subject very near the edge of the picture: the instability in the proportions is instantly obvious and creates a tension that can either break the picture up or be the dynamic that draws it to the viewer's attention.

THIRDS

MIDWAY

CROPPED

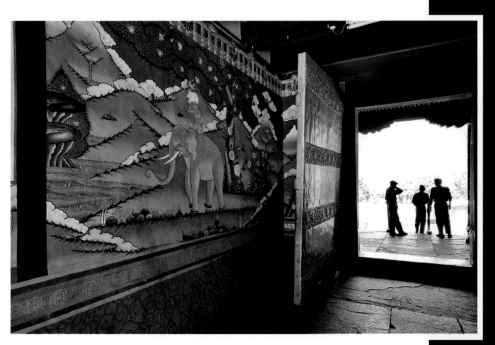

proportional decisions

There are many approaches to photographing a sunset, none more correct than the others. The top view favours the sky but the shoreline rocks are insignificant. The middle image shows the horizon midway through the image space, establishing equilibrium and balance. In the bottom image, zooming in has captured the sky's texture and the landscape forms below are only hinted at.

contained imbalance

By placing the soldiers very close to the edge of the image but framed within the doorway, we emphasize their diminished size and distance, almost pushing them out of the picture.

shapes within the image

The shape of the image consists of not just the outer frame but also the forms that fill the picture plane. The familiar shape of the human face is one of the reasons why portrait photography is rewarding: the inner structure of the image is guaranteed. However, with other subjects we need to work a little harder.

internal forms | working with shapes

When you photograph subjects other than the human face or body, you may have to walk around them and study how the various elements arrange themselves from different viewpoints – objects may line up or take on a more dynamic shape. Alternatively, you may have to wait while living entities organize themselves into a meaningful shape, such as birds wheeling in the sky and assembling into a triangle.

Much of the effort of finding a composition consists of delineating a cogent shape within the picture. This involves careful framing: the more carefully you frame, the less you will have to crop and adjust later, and therefore the more detail you will retain. In general, shapes that are reducible to simple forms – such as a square, diamond, or circle – tend to be the most effective. If images are to be viewed at very large sizes, then you can work with more elaborate shapes.

Another simple way to shape the image is to create a frame within the picture using, for example, a doorway, or the branches of a tree. The frame offers a reference to which less strongly shaped subjects can relate. The lines of this inner frame also create dynamic relations with the straight lines of the picture frame, which adds to their effectiveness.

vignetting | image manipulation

The practice of darkening – or vignetting – the corners of the image is a way of introducing shape during postproduction: the darkening helps to emphasize the central area, guiding the viewer's eye away from the periphery to the heart of the image. The majority of zoom lenses do vignette a little, particularly when they are used at full aperture, so you can exploit this defect in order to help frame pictures that are suffering from loose borders. Darkening the corners of an image is a widespread practice in the darkroom, so there is no reason why you shouldn't also apply the technique digitally using image manipulation software.

curving enclosures
A complicated combination of round shapes and repeated, stepped lines work together to engage the eye, with the central figure being a natural focus of our attention.

practical methods | on location

In the studio you can arrange elements to your own design, but on location, theory may be more tricky to put into practice because there are so many distractions – and spatial relationships keep changing as you move around.

Try looking at the scene with your eyes half-closed, as this blurs the image and helps to reduce the detail, revealing the overall shape. Alternatively, if you are short-sighted, you can simply remove your glasses. It may sound paradoxical, but the less clearly you can see, the easier it is to discern a composition.

Another practical aid to composition is to hold up a small frame and move it around to assess the shape of the subject in your picture. An empty 35mm slide mount is ideal for this, or you can simply cut a rectangle in a piece of card. Move the frame closer to your eye for a wide-angle view and further away for a long focal length framing. Again, it is because you cannot see in great detail what lies within the frame that this technique helps you to see the broad outlines easily.

squared interior
This image offers a strong formal structure of repeated rectangular lines, with the contrasting curves and colour of the drying fabric.

RADIAL

AXIAL

TRIANGULAR

shapes with shape
The radial shape (top) fills the frame with activity and symmetrical dynamism. The leading lines of the parasols (middle) lead the eye through the multiple cues of converging parallels as well as sizes diminishing with distance. The triangular shapes (above) define strong diagonal lines at sharply defined junctions while converging parallels again add to the sense of receding space.

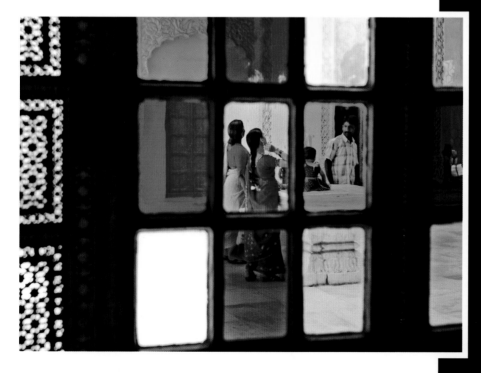

solid framework
The grid in this image holds down the riot of colours, textures, and contrasts between each pane of glass.

image **analysis**

The rules of composition, which sometimes feel prescriptive, don't always guarantee the compositional success of your pictures. They should instead be considered the recipes of composition, and if you follow them using good ingredients, your photographs are more likely to be visually satisfying.

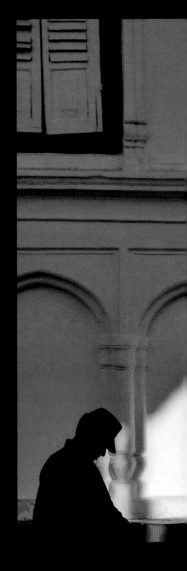

dynamic | diagonal

In this image from Kathmandu, Nepal, the recipe for success is the composition on the diagonal. There is a strong thrust upwards from the lower left-hand corner to the top right, with lots of interestiing elements along the way. While the silhouette of the dog is placed in the exact centre of the image (therefore breaking the "rule" that the main subject shouldn't be in the middle of the picture), it doesn't feel as if it's occupying the centre. This is because of the other points of interest holding the viewer's attention, from the silhouetted man and the associated patch of brilliant red, to the little bird on the corner of the step keeping a wary eye on proceedings. The image also carries the diagonal theme in its colour distribution. The bluish tint of the white walls, lit by the clear sky, forms a triangle taking up one half of the image. Facing it are the steps that form another triangle of colour, this time in dark, warm tones. The river of light defines the diagonal and leads the eye upwards. Fortunately it is full of rewarding detail, such as the relief-work and subtle changes of colour and tone.

in **detail**

This is an excellent example of an image that appears to be under-exposed but is, in fact, exposed perfectly. There is just enough detail in the highlights for the shapes of the relief on the white walls to show, and there is sufficient detail in the shadows to reveal the stonework and the inquisitive little bird. However, the correct rendering of the only mid-tone (the patch of red) tells you that the perfect exposure for the mid-tone is also correct for everything else.

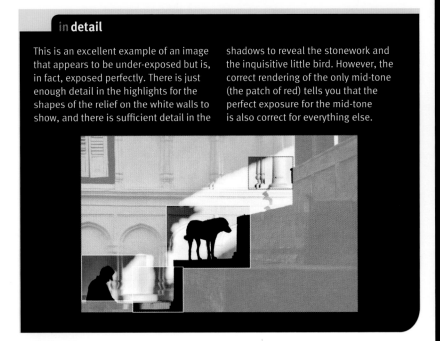

leading movement
We are naturally drawn to human figures in any picture. Positioned in the corner of the shot and moving in the "right" direction, the man leads the viewer into the picture instead of drawing their attention away.

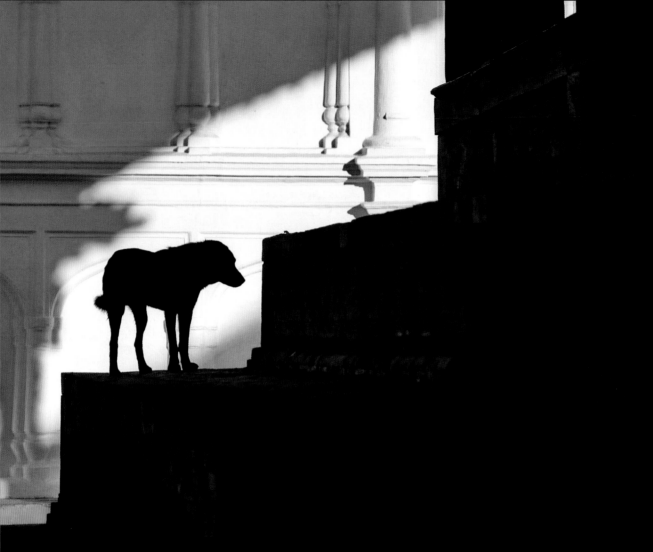

central character
Some things are beyond our control. It was pure luck that the dog decided to present a striking silhouette at the moment the shutter button was pressed. In alternative versions of this shot only the dog's back is seen.

formal details
The wall presents only quiet, formal elements (there could have been loud details such as graffiti or a big poster). These formal details make a perfect background: interesting without upstaging the main characters.

splash of colour
In an image devoid of any other vivid colour, the red panel at the base of the diagonal of light provides a strong focus. It leads the eye from the man to the dog, up the steps to a significant detail: the silhouette of a sparrow.

leafy parade
The ever-decreasing size of the leaves gently leads the eye on a winding "journey" through the depth of the image. It is important that at the end of the journey, the eye can rest on the contrasting strong lines of the tree trunks.

suggesting movement

Although photography is an inherently static medium, there are ways of introducing an internal dynamism to an image. Visual clues are used to draw the viewer into the picture space and to encourage the eye to make a journey around the image rather than looking only at the main point of interest.

size | and space

The sense of space and movement in an image is intimately linked to the rendering of perspective – the way in which three-dimensional space is represented. This is in turn dependent upon viewing conditions and in particular the relationship between the size of the image and the viewing distance.

Where photographs are viewed as prints, we can control this by printing to a certain size. Up to about the dimensions of a book page the print will probably be held in the hand, while larger prints can reasonably be expected to be hung on a wall and viewed from a short distance away.

perspective | and distance

In order to reproduce the correct perspective, small prints taken with normal focal length lenses should be seen close up and large prints should be seen from further away. With prints that are of comparable size, images made with wide-angle lenses should be viewed from closer up than those taken with normal lenses. In the case of a small print or screen image of a view that has been made with an extreme wide-angle lens, you should be viewing from such close quarters that your nose almost touches the image; similarly, for correct rendition of perspective, prints made with longer lenses should be viewed from further away. However, now that we can view images at any dimension from postage-stamp size to the large-scale prints favoured by fine art photographers, these guidelines are widely ignored. Furthermore, some photographers set out to exploit "incorrect" perspectives with the aim of increasing the sense of movement in their images.

winding lines
A road cuts switchbacks in the Uzbek countryside. It is natural for your eye to follow its path and thereby journey through the landscape: subliminally you also take in the details in the background at the same time. By using a long focal length lens, distant objects are brought together, flattening space, so it is important to show movement.

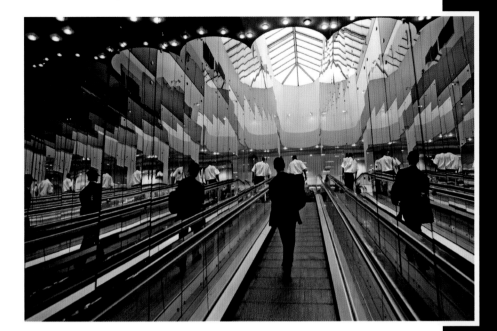

multiplying parallels
Converging parallels over a shor
distance don't look very dramati
even with a wide-angle lens, bu'
here, where they are multiplied
in mirrors, the effect is stronger.
Other visual clues, such as
darkness leading to lightness,
help to emphasize the sense
of receding space.

distributing space
In the image below, the empty
foreground encourages the eye
to move into the picture while
the figures move away from the
viewer, creating visual tension.
The strongly-lit spiral (bottom)
takes the eye from the lower
right-hand side to the top of
the image, but keeps attention
within the picture frame.

EMPTY FOREGROUND

SPIRAL

converging parallels | obvious or subtle

In matters of perspective, photographers have it easy compared to painters, because the camera does all the work of rendering the convergence of parallel lines – that is, the lines of perspective that converge to meet at a single point on the horizon. This the commonest and most visible method used in images to help the viewer to decode information about distance and depth, and it provides the fundamental movement in the photograph.

While this is a familiar concept, it is noticeable that today's viewers like to see increasingly steep and dramatic convergences: these impart a strong dynamic to the image, as if sucking the viewer into the scene.

For added interest within an image, we need to work with variants of converging parallels. Repeated patterns such as leaves or trees and columns of similar size can be used to imply them, without making it immediately obvious that you are deliberately trying to draw the viewer into the picture.

the viewer's eye | proportion and angle

Another technique for suggesting movement is to encourage the viewer's eye to roam over the picture plane. The image appears to change in proportion as attention moves from one side to another, imparting a dynamism to the composition. A road curving across rugged terrain or an aircraft in the sky are examples of movement implied within the image, which in turn leads the viewer's eye across the picture space.

With some subjects, the movement across the image is conveyed by our knowledge of the subject – cars at speed, aircraft in flight, and so on. With such subjects, another control makes itself evident: the angle at which a movement crosses the image carries an emotional weight. By common consent, a movement that appears to cross diagonally upwards is more energetic than one that crosses either downwards or horizontally.

space in Siena

This series shows different approaches to depicting the space around the Torre del Mangia, Siena, Italy. The image below uses converging parallels, while the middle image exploits framing devices. Contrasts of scale in the bottom image emphasize distance. The main image combines converging parallels and a framing device to contain the image.

CONVERGING PARALLELS

FRAMING

CONTRASTS OF SCALE

working with **picture planes**

In the process of transferring three-dimensional space onto the flat surface of the camera sensor, depth in the scene is translated into picture planes. Space is then described by the separation of picture planes, and visual tension created by exploiting ambiguities of placement and position.

linear | basic vocabulary

There are many ways to describe the visual components of an image. The digital image file itself is one way to describe the image: it is comprehensive as far as colour and luminance information is concerned but is completely lacking in distance information.

We can also examine an image in terms of the meaning of its various elements. But what is useful for critical analysis may not be of practical benefit to photography. We know that the complex of eye-brain mechanisms respond strongly to straight lines, particularly those orientated vertically and horizontally. Not surprisingly, then, the pictures we find most satisfying and the easiest to interpret are those that are constructed from strong lines. Sets of lines define the spaces they enclose, and it is from the shape and relative positions of these spaces that we obtain the concept of picture planes. You may find it helpful to try approaching a scene by analysing it into its picture planes: what slopes towards you, what defines a distant end point, or what frames the distant subject.

tonal enclosure

The sense of space in this image derives from the interplay of planes defined by tones and their junctions. The dark, mostly even, tones enclose and frame the pool of light around the acolyte. At the same time, as the dark tones recede while the lighter tones and bright colours tend to come forward, they work here to create a harmonious dynamic balance.

flat space | defined

We are so used to interpreting the clues of three-dimensionality in a picture that it takes a little refocusing to see that the image is like a map: it consists of separate regions bounded by lines or border regions. We deduce from the direction of lines that the space enclosed by them actually represents, say, a receding wall or a path leading into the distance. We can also deduce from the size or magnification of an object and the way lines are interrupted that one object is overlapping another, and is therefore nearer.

Study your own pictures to analyse how they are constructed and the ways in which they create a sense of depth. This exercise will help you to work consciously with these elements.

And when you become confident in using picture planes, you can delight in presenting your viewer with visual puzzles. These occur when the implications of the visual clues lead your viewers to misinterpret or be confused about the picture space.

REFLECTED LEAVES

CAFE CEILING

CAFE WALL

OPEN WINDOW

reflected space

Reflections offer the most effective way to work with picture planes intersecting at odd angles or overlapping different parts of a scene. Elements from behind the main scene are overlaid over it, confusing distance and scale (top left and top right). Viewed at an angle, the street scene intersects an interior view while a passing figure helps define the "real" space outside (above left). With one window fully open and the other partly ajar, the scene is seen twice, but distorted (above right).

image **analysis**

One of the most effective ways of working with highly complicated scenes, such as street life in a city, is to separate the various elements by using picture planes. In this way, you employ the basic visual vocabulary of lines, frames, and blank areas, which helps you to organize the space.

environment | awareness

To create a pleasing composition, you can't, of course, move people, vehicles, or buildings. Organizing the picture's structure is actively passive work: you watch within the frame of your camera while the flux of life arranges and rearranges itself before you. If you don't know what to look for, it's easy to miss the moment when the picture comes together. Thinking about picture planes can help you anticipate this moment and recognize when the elements in a scene form a captivating composition. To capture a meaningful image, you

need to work with the basic vocabulary of lines, areas, and overlap. It's a similar process to learning a new language, when you have a basic sense of some words without appreciating the subtleties of the language. Now and then, however, enough comes together to give you a proper understanding. That moment is similar to seeing an effective composition. You click when the meaning "clicks" in your mind. To see planes at work, you must pay constant attention to what the scene in front of you is trying to tell you.

in **detail**

The picture was taken from inside a tuk-tuk – an open-sided three-wheeled taxi. The hard, straight lines of the vehicle cut through the image and define the nearby space. When these lines are juxtaposed with the people

further away in the distance, a dynamic contrast in spatial relations is created. This helps give a sense of movement, depth, and space. The eye contact of the girl and her mother also helps to bridge the distance.

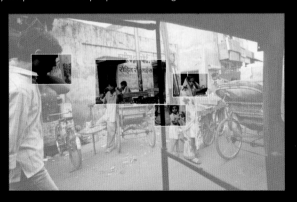

frames within frames
Static elements occupy the centre of the picture. They are made even more static because they are enclosed in mutliple frames within frames: the strong vertical lines, the window, and the back of the tuk-tuk.

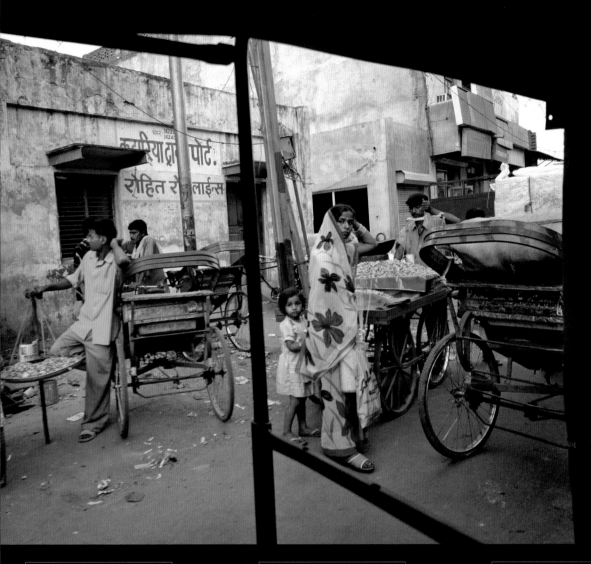

eye contact
Even when the eyes take up a minute portion of an image, the fact that eye contact is being made is obvious – and crucial. It helps to bring the viewer into the picture and creates an emotional bridge to the people.

leading figure
Entering from the far edge, this figure influences the dynamics of the image. The young man defines the near space, and leads the viewer's eyes into the picture as he moves strongly towards the centre of the picture.

focal point
The focal point is centred on the point of dynamic balance for the whole image, known as the golden section. Within the smaller frame of the tuk-tuk, the mother is situated dynamically off-centre.

colour on stone

The startling colours against white marble at the Taj Mahal were explored in different ways. From group views to close-ups, the use of perspective contributes to exploring the relationships between people and colours, and people with their surroundings.

DISTANT AND TIGHT FRAMING

MEDIUM DISTANCE WIDE-ANGLE

CLOSE-UP AND LOW

macro overview

The natural view for this cautiously moving praying mantis is to get as close as possible – not difficult with this insect – for an impressive view of its large eyes. But we would then miss the shadows being cast on the decking. A near-vertical view enables us to make the most of the shadow and it also minimizes the converging parallels of the gaps between the wood. Another advantage is that a flat-on view requires only modest depth of field to keep everything sharp.

position and perspective

The choices we make concerning focal length, the position from which we take an image, and the direction of our gaze are all closely interdependent. If you adjust one of these elements to improve a composition, you usually have to tweak the other two in order to perfect the photograph.

zooming | and moving

One of the most common mistakes that inexperienced photographers make is to think that changing the zoom setting on their lens changes the perspective on the subject. In fact, it simply shows more of the subject if you set a shorter focal length, or less if you set a longer one. The magnification of the subject varies with change in focal length, which gives the impression that perspective too has changed. However, if you haven't moved from your original position, your relationship to your surroundings hasn't changed at all, so perspective is unchanged too.

To adjust perspective, you need to shift your position in relation to the subject rather than expecting your lens to do the job. When you move closer to it, some parts of the scene also become more distant: these relative adjustments are the vital signs of a composition that has been considered.

parallax | eye level

When you change the distance between yourself and your subject, you also cause an apparent change in relationships between objects in the scene. This is an example of the phenomenon of parallax. Its beauty is that you don't have to touch a thing for objects to appear to change position – moving yourself has the effect

clean background

With the camera inches away from this euphonium player, the normal view would be at face-level. Not only would this have been unwelcomed by the musician, it would also have shown all the other band members, leading to an image full of distractions. By kneeling on the ground, my close presence was tolerated, and the background was instantly improved.

of moving everything around you. Also, when you approach a tall subject, such as a tree or a building, you may be forced to turn your gaze upwards to see its top. Alternatively, if your subject is small and at ground level, such as a flower, you may be able to look directly down on it as you close in. This gives you another control: looking downwards tends to increase the foreground, while looking upwards tends to isolate the subject against the sky.

If you wish to experiment with views from unusual angles, use a digital camera offering a swivel-and-twist LCD screen. These are available even on some SLR cameras. You can then easily hold the camera high above your head or low down and yet be able to view the image to frame your shot accurately. Ensure that you hold the camera steadily or, if it's available, turn on image stabilization to ensure your images are not blurred from camera shake.

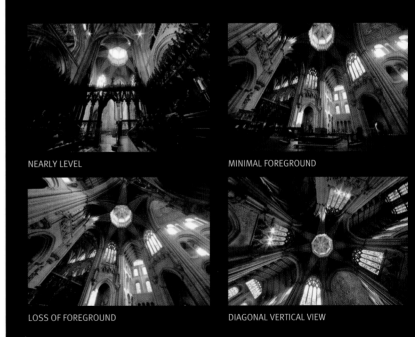

NEARLY LEVEL

MINIMAL FOREGROUND

LOSS OF FOREGROUND

DIAGONAL VERTICAL VIEW

looking up

This series explores the great octagon capping the crossing of Ely Cathedral in England. The elaborate screen of the choir benefits the foreground (top left), but the overall scene is better conveyed with less foreground (top right). However, the strongly converging verticals are distracting. Losing even more foreground (above left) improves the sense of drama but does not accurately record the visual experience. The vertical view upwards (above right) best conveys the powerful symmetry and awe-inspiring architecture.

composing with colour

We first learn about colour as a definable property of the surfaces of objects, describing a bright red apple, for example, or a blue door. However, colours are much more complex, appearing quite different in juxtaposition to each other and influencing our perception of space.

colour | relationships
In the natural world, and in much of the man-made world too, we never see colours in isolation. This may seem too obvious for comment, but the consequence is rather interesting: it means that we experience a colour – strictly a patch carrying that colour – only in relation to other colours within the visual field.

emotions | and dimension
We work with colour quite instinctively, following one of two broad approaches. We may use strong colours that are complementaries or primaries – for example, the red of geraniums against green foliage or the yellow of daffodils against the blue sky. Such compositions are lively and energetic and tend to jump off the page.

 Alternatively, we can choose to work with neighbouring colours, those that are close relatives of each other – such as the cyans and greens of the sea, or the yellows and browns of fallen leaves. These colours sit easily with each other, so that the image avoids visual tension.

compositional schemes
Different colour schemes offer varying impact on a rainy day sightseeing. The first image below is dominated by neutrals while the middle one offers deep contrasting colours. The bottom image is colourful, but the blank area of sky behind is too large. The main image best combines colour contrasts and lively composition.

NEUTRAL COLOURS

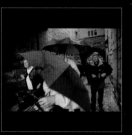

DEEP CONTRASTS

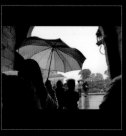

RAINBOW

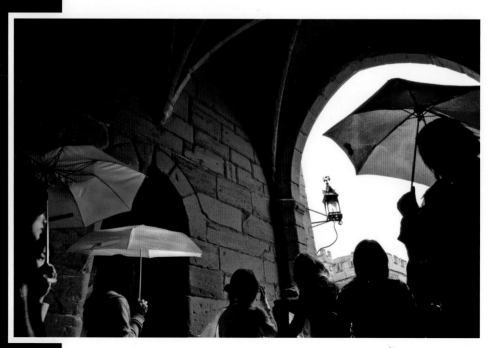

We can also exploit the phenomenon of colours appearing to give a third dimension to a two-dimensional image. Reds and oranges are described as warm colours, and as our eyes are more sensitive to them they appear to advance and move forward in the picture frame. In contrast, blues and cyans are cool, receding colours. Bright and saturated colours leap forwards to the viewer, while darker ones sink into the page. Working together, these two colour forces modulate the picture surface, creating a terrain of prominent and recessive colours that shape the image.

As colours come alive for you, so will your photography gain in richness as you learn how to work with them. To explore this, try composing an image based entirely on colour criteria. By treating colours as subjects in themselves, and ignoring the substance of the objects in the image, you will sharpen your appreciation of colour.

colour | associations

There is yet another dimension that colours can impart to our photography – their intertextuality, that is, the meaning they have for viewers.

This varies in different cultures and societies. For example, the colour red is associated with heat and danger in some countries but represents good fortune in others. Similarly, white is a symbol of purity and innocence in the West but represents death and mourning in Eastern societies.

The combination of colour association with actual objects – the use of red flowers to represent blood, for example – can be exploited as a powerful element of composition.

monochrome contrasts
Although there is almost only one hue in the image – red – in all its variety of saturation and brightness, the luminance contrasts, such as the red cloth in the sun against the deep shade, keeps the image lively and dynamic. The contrasts in shape and texture between the ironwork and the woman also enliven the composition.

contrasts in hue
While our eyes are greatly attracted by masses of brilliant colours, in photographs, a multitude of hues over-stimulates the eye and appears chaotic. In contrast, if you situate a strong colour amongst a field of weak colours, or surround it with a contrasting hue, the colours of both are psychologically intensified. It's a useful exercise to look for images with just two main colours in frame. The rust-red of a gasometer is brought out by the surround blues of the sky and fence. By the same token, the red life-buoy is brilliant again the pallid sky.

image **analysis**

As a photographer, the greatest control you can exert over your image has nothing to do with camera controls or the quality and specifications of your lens – or even the zoom setting. The most powerful weapon in your arsenal is free and readily available to anyone who searches for it. The essential foundation for every image you make is your choice of viewpoint.

structure | and position

The ability to look beyond the immediate situation or space within direct reach is the cornerstone of the mastery of photography. This is why photographers on the prowl appear not to be present – they're not, they're looking into the future. Thousands of passers-by may have seen this row of taxis, for example, but a photographer realized that a view from above would collapse the cars into a stack of repeated elements and colour for the strongest

visual impact. Once in position, it would be clear that the image lacked movement – someone walking between the taxis perhaps, or a pedestrian on the walkway. It is then a matter of framing up and waiting for the right moment. It may be a long wait, and the taxi rank is bound to thin out, but it will be worth it – especially when elements such as the adjacent colours of the repeated rows of paving stones and regular shapes of the taxis hold together so well.

in **detail**

The range of hues in this image is surprisingly limited considering how colourful it appears. Apart from one blue cushion visible in the nearest taxi, all the colours lie between red and yellow. In fact, only 20 different hues are needed to make an image that's almost indistinguishable from the original, and just 46 colours if the cushions in the first taxi are included. Our positive response to the image is largely due to our instinctive preference for warm colours. An image using only 20 bluish hues, for example, would look pale and monotonous in comparison.

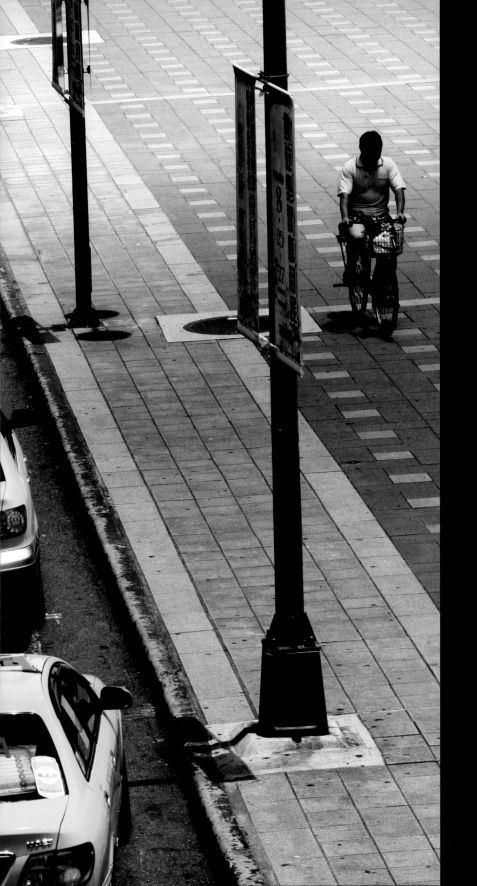

rhythmic repetition

The repeated patterns of rectangles of light-yellow paintwork and dark windows build up to reinforce the visual effect of each element, and there is enough variety and variation to maintain our interest.

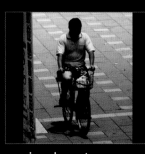

passing element

It pays to be patient as a passing cyclist brings a lively element to the scene. The short shadows place the person's face in the shade and render him unidentifiable, which, happily, is important for securing stock sales.

strong line

Any composition is helped by strong lines that divide the picture into regions of interest. This virtually unbroken line is almost too strong. Luckily, shadows falling across it at regular intervals help define depth.

Assignment: composition on location

When you are out on location in search of the perfect composition, everything that seemed clear when you were reading up on it at home can turn into a confusing tumult of ideas. You are now faced with organizing composition in three dimensions, and every step you take changes the view. If you try to assess every possibility you will soon exhaust yourself, but experience will train your eye to see what is important.

ISO 100 Focal length 24mm 1/200 sec at f/7.

thebrief

Imagine that a photography magazine or website has asked you to illustrate a feature on the techniques of composition and choose a famous landmark as your main subject. Use every trick in the book to produce an unusual interpretation of a well known local feature.

Points to remember
- try out every viewpoint you can reach; crouch down for a low angle and clamber higher too, if possible
- hold the camera at different angles – don't limit yourself to just vertical or horizontal
- use only a single zoom setting for a while, as this forces you to move around more to make a composition work
- vary your exposure – in bright conditions this will emphasize different parts of the scene, thus changing your composition

ISO 200 Focal length 28mm 1/250 sec at f/1C

must-see masters

Alexandr Rodchenko (1891–1956)
Best known for teaching the world to see the everyday from totally new perspectives, the Russian constructivist Rodchenko influenced film directors and artists with his sometimes startling compositions.

Jay Maisel (1931–)
Renowned for his use of colour in available light, this American photographer epitomizes the ultra-real, glossy corporate style of photography.

The best examples of his work are object lessons in how to compose with a sure, if not always subtle, touch.

Michael Kenna (1953–)
One of the few photographers whose work has achieved an instantly recognizable style, Kenna's work is spare to the point of minimalism, moody, and always eloquent. He works exclusively in black and white and the majority of his images are in square format, which emphasizes his economy of means.

ISO 100 Focal length 12mm 1/125 sec at f/9

ISO 100 Focal length 170mm 1/320 sec at f/7.1

ISO 100 Focal length 12mm 1/160 sec at f/10

ISO 100 Focal length 16mm 1/125 sec at f/10

ISO 100 Focal length 100mm 1/320 sec at f/8

ISO 100 Focal length 13mm 1/200 sec at f/11

①②③
④⑤⑥
⑦⑧⑨

light**box**

top**tips**

① making plans | a distant view
You can start thinking about possible compositions from the moment you first see your subject. An oblique reference or distant perspective may prove to be more interesting than a closer view.

② wide angles | symmetry
An extreme wide-angle view from a medium distance or up close is usually most effective with symmetrical compositions, as the space is balanced and large differences in size are minimized.

③ long focal lengths | abstract views
By bringing the viewer's attention to small parts of the scene, long focal lengths abstract patterns and shapes from the whole. Ensure less busy portions are well balanced: here, the lower left-hand corner is a little too large.

④ convergence | effects
The extreme convergence that results from shooting upwards from close quarters can make a structure seem even taller and more impressive.

⑤ ⑥ shadows | strong shapes
Strongly shaped shadows are invaluable for balancing a composition and filling otherwise empty areas. Their effect can be enhanced with selective tonal manipulation.

⑦ ⑧ context | and perspective
With a wide-angle lens, foreground objects provide a frame that leads the eye towards the distant subject. With a longer focal length, space is compressed and foreground objects seem closer to the subject than they are.

⑨ extreme views | distorted scale
An extreme wide-angle view can further distort the relationships of size and space, this time by exaggerating the dimensions of foreground objects.

▶ **see results**

Selfridges building

Gaston Laurent

"The sharply angled old church was an obvious juxtaposition with the smooth, flowing lines of the new building."

▲ Nikon D2X ISO 100 Focal length 65mm 1/500 sec

the**critique**

You can generally tell those who have walked the furthest, as they obtain the most interesting or successful compositions. You can develop your on-location skills, and minimize time spent searching for the best positions, by learning to imagine how a scene will look from a new viewpoint. In this selection, it is clear that the photographers actively explored their subject, trying dfferent positions and working with a variety of zoom settings. There is also another element: the photographers waited for the best light, within the time they had.

Selfridges building

Gaston took the picture of the Selfridges building in Birmingham, England, early in the morning: "the saturated blue sky was the perfect way to set off the highly polished metallic discs". By using a mid-telephoto setting, he contrasted old and new, while keeping both elements sharp: any blur in either the shiny modern building or the sharp lines of the church would detract from the image.

Delhi tower

Amy wrestled with a very difficult subject: the tall tower appears as a needle without the frame of the archway, and the archway is empty without the tower. But to capture both requres a wide-angle view and an awkward tilt upwards. It helps give stability to the image to hold the camera perfectly horizontal, so that what is vertical in reality remains truly vertical in the image.

Leeds Castle

David's struggle was with the presence of many other tourists. He chose a distant viewpoint that shows the proportions and brings in the lake and the reed-bed. But the cost of taking himself away from the main subject is to isolate it and become less emotionally involved.

"Either one of the two elements did not have as much strength as the combination of the two, so I worked at that."

▲ Konica Minolta DiMAGE A2 ISO 100 Focal length 7.2mm f/9.0

Leeds Castle
David Summers

"From across the lake the many people in frame are reduced to specks, and the full scale of the castle can

tutorial 7 perfecting your timing

Photography brings together two opposing forces: the moment, which is ever-changing, and the image, which is static. As a result, we obsess about timing, especially of the split-second, decisive-moment kind. But that's only part of the story. As we work over minutes and hours, our attention moves from the minutiae of composition to light in transit and the shifts of a landscape's mood.

fact file

To ensure your camera is as responsive as possible, never turn it off while you are out photographing. Instead, let it enter sleep mode. Keep the lens cap off and force the flash to stay off. Turn off the auto-focus and auto-exposure where practicable. Using a small file size can speed up series shooting.

catching the moment

The basic premise of photographic timing is that changes are cyclical. A portrait sitter is tense: we help them to relax and we can work until they tense up again. If the light on a lake is dull, we watch for a cloud-break to provide the sparkle we want. The sky is empty but, if we wait long enough, perhaps a flock of birds will fly over and fill the void.

advance planning | careful checking

Photography calls for a deep and subtle mastery of time. We are required to respond to the charge of a cheetah in a fraction of a second and the action could be over in two seconds, yet the wait preceding the moment could have lasted weeks. And it could have taken months to prepare for the expedition that took us to the animal's habitat.

> " We are required to respond to the charge of a cheetah in a fraction of a second "

Underlying this, we have to consider our photographic equipment. Is the camera switched on, so that we can take a picture as soon as we press the shutter button? Can it focus quickly enough to capture the moment? Will the exposure be accurate – are all the settings correct? These questions remind you that being prepared is an essential requirement of timing. I will always remember the moment that we climbed up a cliff after only a day's tracking and suddenly came within a stone's throw of a rhinoceros mother and baby. This was extraordinarily lucky – others had searched for three weeks without a single sighting. Only then did I realize that I had the wrong lens on the camera.

preparation | anticipation

A further element of being prepared is understanding the conditions you are working in. The trackers knew we had no chance of approaching a rhino on open ground; we had to surprise it by emerging from the cliff. But I didn't know that, so I wasn't prepared. If you understand the weather you know whether you're in for a long wait before the clouds clear or whether it's better to search for a shot that doesn't rely on direct sun. If you know where and when the sun rises, you can be in the right position at the right time for a shot of the dawn breaking.

You also need to know your kit. If your camera needs more than a tenth of a second to respond to the shutter button, you're likely to miss the moment. While you can minimize the shutter lag on the camera by turning off automatic functions such as auto-focus, reducing shutter lag is technically very difficult, and only the most costly cameras respond instantaneously. For others, you have to do something counter-intuitive and press the shutter button the moment before you need the exposure.

STEADY CHANGE 1

STEADY CHANGE 2

STEADY CHANGE 3

PRECISION TIMING 1

PRECISION TIMING 2

PRECISION TIMING 3

RANDOM CHANGES 1

RANDOM CHANGES 2

RANDOM CHANGES 3

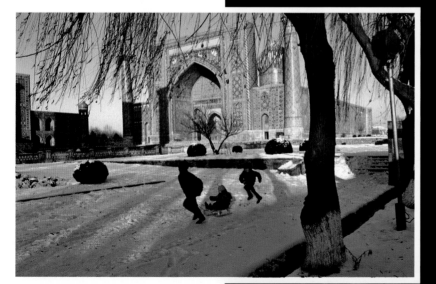

1	2	3
4	5	6
7	8	9

light**box**

composition and speed

1–3 As the sun drifts across a room, different pictures emerge, each calling for a different composition. 4–6 Airshow shots call for good auto-focus speeds from the camera and quick reactions from the photographer. 7–9 Birds will fill blank photographic spaces but your timing must be instinctive to keep up with the random changes, and focus is best set to manual.

snowy moment

What could have been a standard, postcard view of this monument has been enlivened by a little action caught with good, if imperfect, timing. Ideally, the face of the leading boy in the foreground would be in the light, but it was more important that the red hat was lit.

image **analysis**

Photographers often make sacrifices for the privilege of working with low light, getting up early in the morning and working late into the night. Low light also demands careful techniques and use of a tripod. However, the rewards – rich colours, long shadows, and soft tonalities – are well worth the effort.

timing | subtle light changes

If responding with the minimum of delay to rapid changes in a scene is one problem, another is being able to respond when the changes are steady and subtle. As the day emerges from the darkness of the night, or when the sun sets in the evening, the light in the sky steadily changes its balance – with light in the foreground or from lamps in a built environment. When you observe the changing balance between evening sky and foreground lights, your eyes adapt to the changing colours and dimming light at about the same rate as the quality of the light changes.

You may think little is happening when, in fact, the scene is changing all the time. The obvious danger is failing to make the exposure in time because you register the change too late – and suddenly it's too dark. One tactic is to make exposures at regular intervals, while another is to face the other way for a few moments then turn back to assess the scene. You may be surprised how different the scene looks the second time. If in doubt, make the exposure anyway – it's likely that the colours you see are less rich and vivid than the colours you will capture.

in detail

If there is a single element that makes this image a visual treat, it is the richness of colour and tonal variation of the sky. This is not wholly due to luck. The sky in the other direction was not as interesting but the architecture offered a better view.

So the task was to find a view that showed off the architecture and made use of the sky. In an ideal world, it would have been preferable to exclude the ziggurat-like structures and other buildings behind the palm tree.

rich blues

In the same way that an evening sky can look too blue when seen from a room lit with tungsten bulbs, so a white balance aimed at correcting the yellowish lamps in the foreground makes the sky register as a deep blue.

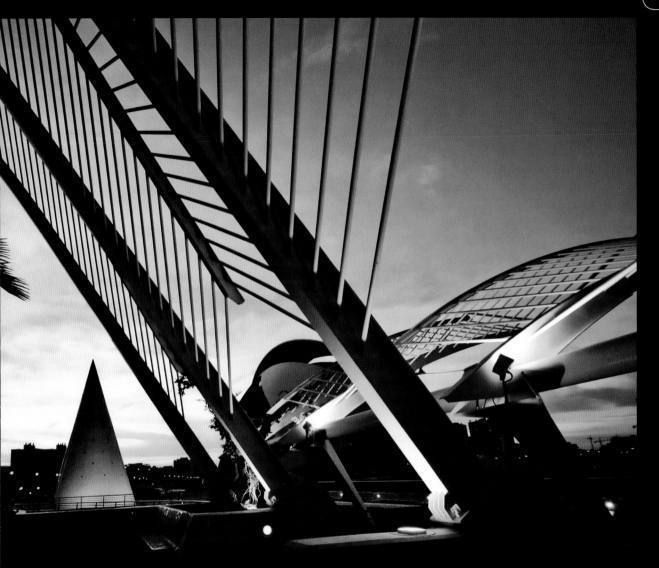

silhouette
The near total blackness of the palm tree is caused by the exposure being correct for the sky. It may be tempting to light the palm with a spot of flash but I like the filigree shape against the high-tech steel.

key light
This area is crucial for the exposure – it needs to be brilliant but still hold tone. If the sky were allowed to get darker, greater exposure would be needed, which would cause the hard illumination on the metal to burn out.

highlight colour
In successful twilight shots, highlights are coloured, not white. Here, the sun is behind thin cloud, which, together with air pollution, produces a yellowish glow. In fact, the true colour is that seen in the far right of the horizon.

time of day

When working outdoors, photographers must be constantly aware of whether the sun is shining or not, and if it is, how strongly; how long the cast shadows are, the direction they point in, and therefore the position of the sun. Contrast and colour temperature are also affected by the time of day.

shadows | and light

The more you photograph outside on location, the more aware you'll become of the relationship between the time of day and the nature of the light and shadows that will be present. This means, of course, that you'll be better prepared to make the most of photographic opportunities, as you'll know which parts of the day will offer you the kind of light you like to work with. Conversely, if you can't pick your preferred moment, an understanding of the conditions you have to deal with will help you adapt technique to circumstance.

We are all aware that shadows are longest at the beginning and end of the day, and that they are consequently shortest at midday. Less obvious are the changes of the scene luminance range (contrast) through the day, both in overall lighting and in detail. These result from the changes in shadow.

When shadows are long, the luminance range in the foreground tends to be low: the sun is oblique to most surfaces, light is weak and shadows fill the textures. As shadows shorten, the surfaces receiving light increase in area and they also become brighter. However, the shadows don't lighten at the same pace. The result is an

seeking colours

With the colour temperature of illuminants pulling in different directions – the blue of the sky and the yellows of tungsten light – colour accuracy is sacrificed for colour contrast. In this image the sky would look too blue if the whites were fully corrected, whereas the whites would be too red if the sky were to be correct. In the process, greens suffer, losing their usual brightness.

SKY

TUNGSTEN

SHADOW

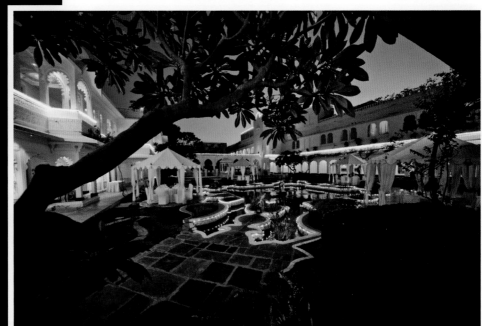

increase in the difference between bright areas and shadows; that is, the contrast increases.

At the same time, as the sun rises in the sky its brightness increases very rapidly – far more quickly than the brightness on the ground. This increases the overall luminance range of the scene to the point where it's difficult for sensors to hold both highlight and shadow detail. This is why, in the majority of locations, photography is tricky during the middle of the day (see also pp. 48–49, 226–27).

colour | atmospheric scattering

The movement of the sun through the sky causes the wonderful and varied daily changes in the colour of daylight. The phenomenon underlying the change is called "Rayleigh scattering". This describes how short blue wavelengths are scattered around more by air molecules than are the long red and yellow wavelengths.

Around midday, light appears white, in part because any colour looks white when it's bright enough; the sky is blue because the molecules in the air scatter more blue light than red. However, when the sun is low in the sky it's less bright as a result of atmospheric scattering and it's also redder, because blue light has been scattered out and away from the solar light rays, leaving red and yellow also predominant in the surrounding sky. Salt particles in the air contribute further to the orange of sunsets at sea.

These changes in the colour of light can be compensated for by white balance control. This has the effect of making the whites neutral, while blues will be intensified.

MORNING MID-AFTERNOON EVENING

daily variation
The character of a landscape can change wonderfully over the course of a single day. In this sequence, the prominence of a lone poplar tree growing beside a vineyard waxes and wanes as the sun moves through the sky, lighting the tree from different angles and then leaving it in shade.

AFTERNOON FAIR WEATHER

STORMY SUNSET HIGH CLOUDS

scattering the sun
The phenomenon of Rayleigh scattering causes the sky away from the sun to appear bluish, but, closer to the sun, light appears increasingly yellow/red. The sun's colour also changes according to its height from the horizon and the amount of dust and moisture in the air. Every new hour offers new opportunities for photography.

the **waiting** game

One of the trickiest photography skills to acquire is how to do nothing yet maintain a state of high alertness all the while. In many genres, from landscape to documentary, and, most of all, in wildlife photography, you can prepare all you like but in the end you can do nothing else but wait for the moment to arrive.

potential | pre-visualization

The photographer who is constantly on the move in search of pictures is destined to cover a great deal of fruitless ground. It is more productive to regard travel as the journey from one waiting place to another.

Your search is not for serendipitous photographs that you will be able to snatch spontaneously – though of course some opportunities do arise that way. More frequently, you will have to wait for chance to turn a mundane situation into an image-making event.

What you have to be able to spot is the potential – the picture in the making. For example, an urban composition may be missing the vital element of someone moving down a street; a dramatic veldt sunset may need an elephant to walk across the field of view to turn a pretty shot into a stunning one.

This calls for powers of pre-visualization –you have to "see" the picture before it appears. It's not as paradoxical as it sounds. Think of how you read the road ahead while driving in order to anticipate events a few seconds ahead of time; if in your

testing phase

Traffic light phases provide variations in mood and lighting. By exploring the merits of each (shoot freely at the time and assess later), we can arrive at the composition which works best. Here, the solution was to move down the·street a little, thus catching more light in the trees, gaining greater clarity in the road markings, and opening the vista. The combination of hot and cool colours completes it nicely.

FIRST SHOT

EXPLORING

TIMING

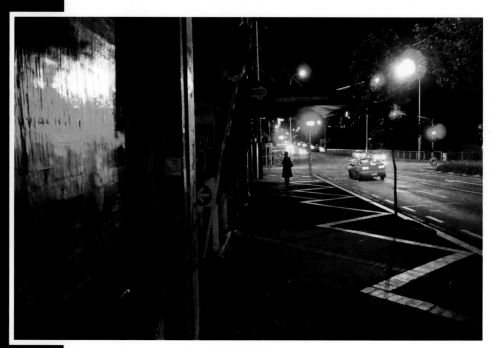

hare and hounds
Wildlife photography combines the worst elements of the waiting game: the long-term – it could be weeks before your "prey" consents to appear – and then you may need to time the shot with sub-second precision. Animals with regular habits, like this hare, are easier to work with as you can set up and focus in advance. It also helps if they're indecisive about their next move.

mind you drove only a short distance ahead of your car, you would soon be in trouble. Photographically, you employ similar skills – knowledge of the way the world works, of the behaviour of an animal you are hoping to photograph, the movement of the sun across the sky. With experience, you may just get a feeling in your bones that there's a picture to be made here; all you have to do is wait until the potential is revealed to you.

preparedness | and alertness

You may have only ten seconds to wait before someone walks down a street to give scale and movement to a scene, or you may have to wait hours for an animal to wander across the horizon. What puts you on your mettle is the fact that often there is no advance notice of the event; then it is over in a blink.

Therefore, while you wait, you must have your camera turned on and prevent it from taking a nap by occasionally touching the shutter button. Pre-focus on the spot where you hope something will happen, turning the focus to manual if possible. Sort out the exposure settings while you wait and adapt them continuously to changes in the light. If you have a tripod, use it to hold the camera for you. Set the camera for rapid burst shooting so that you can take many shots in a short time, if necessary – for the maximum rate, you may need to set an image size smaller than the maximum.

Finally, unless you expect the wait to be hours, don't sit down, as the more you relax, the less alert you will be. Few eventualities are as frustrating as waiting hours for your shot, then missing it because your attention has wandered.

STILL WATERS

WINDSWEPT

restless waters
Only a few minutes separate these shots, illustrating that it's not just the quality of light that can change with little or no notice. The ruffling of the water wipes out the reflections in the estuary, radically restructuring the image by creating a dull open area in the lower part of the image.

image **analysis**

Successful action photographs are the result of careful preparation, from initial research to positioning and equipment set-up, plus a good dose of luck. Modern technologies, such as follow-focus, auto-focusing, and rapid-series exposures driven by motor or electronics, are also an enormous advantage.

key | moment

The event is the Independence Day Celebration in Kyrgyzstan, which takes place at the Hippodrome in Bishkek. With the acts due to perform in front of the presidential stand, it was relatively easy to predict the best position from which to shoot. The equipment was set up with the expectation that there would be little time to react. Series exposure was set to maximum rate on the camera, which was only three frames per second in this case. Auto-focus was set to servo- or follow-focus (to continually focus just ahead of the subject) so that the subject would move into the plane of focus at the moment of exposure. As the lighting was constant, manual exposure was set to the shortest time, allowing for a usable depth of field. The hardest trick was pressing the shutter button just before the action. With a dSLR, you are blind at the moment of exposure, so remember the old adage: if you see it, you've missed it. Keeping the shutter button pressed in the hope of catching the moment usually fails. You must be quite deliberate about pressing just before the action peaks.

in detail

Using the shortest shutter time is not a high priority in this type of action image because the movement is at an angle to the view. It is more important to ensure that the camera is as responsive as possible, and that the exposure is set correctly. After that, it's a matter of timing. You will probably shoot many near-misses before you succeed in capturing the peak of action. Never review your images in the field while rapid action is going on around you.

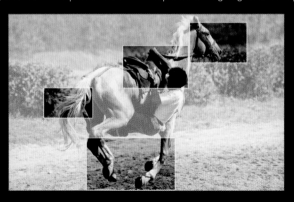

hooves in the air
Catching this horse in full gallop took many shots, most just missing the moment. And even with an exposure time of a mere 1/500sec, the hooves are moving so quickly that they still appear blurred.

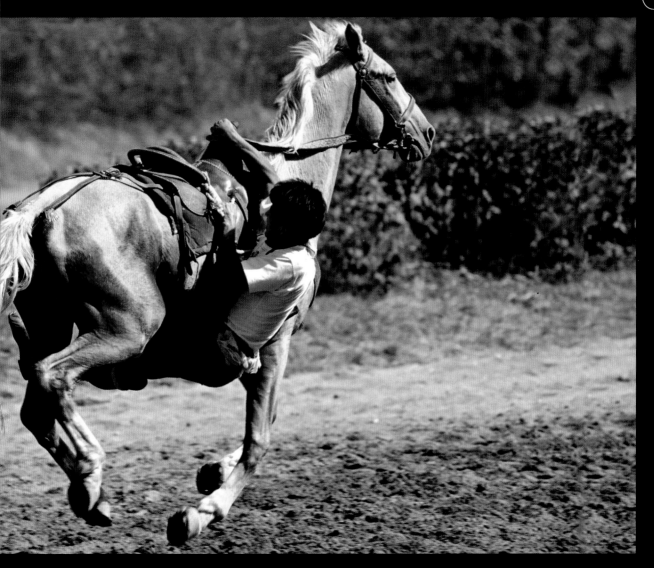

whole length focused
Horses are surprisingly long animals,
so it is only possible to have the
whole length sharp when they are a
long distance from you. This image
was taken with a zoom set to 400mm,
just filling the frame.

sharp details
The impact of this picture is
enhanced by the contrast between
the sharp detail of the tail, which was
caught thanks to accurate focus and
a very short exposure time, and the
blurred softness of the hedge behind.

running at an angle
The horseman's arm muscles grow
taut as he pulls himself up to mount
the saddle. The horse was running
at a slight angle to the camera so its
effective speed was slow enough for
the follow-focus to work well.

Assignment: **pet portrait**

Even with all of today's technological advances, taking a
portrait of a pet can still present a considerable challenge
to the photographer. Few animals will pose obligingly, and
in terms of their behaviour there's a fine line between a
characterful portrait and a mundane shot. Getting in close
and maintaining focus on a fidgety animal tests the patience
of both the photographer and the subject – then the right
moment arrives and is gone again in a blink of an eye, so
both photographer and camera must respond very rapidly.

ISO 400 Focal length 55mm 1/320 sec at f/5.6

the**brief**

Obtain a telling portrait of a pet animal to convey its character, charm, or
features. If possible, work with an animal that is lively and has an expressive
face. Aim to capture more than the expression or gesture – remember that
the composition and lighting should be attractive too.

Points to remember
- set the lens no longer than normal focal length (the equivalent of 50mm)
 to get quite close to the animal
- use an assistant to direct your subject
- set the largest aperture to help throw the background out of focus
- turn off auto-focus and auto-exposure to make the camera respond more
 quickly to pressure on the shutter button
- avoid getting too close to an animal's face – you may distort features as
 the parts close to the camera will look disproportionately large

ISO 200 Focal length 48mm 1/85 sec at f/4

must-see masters

Yann Arthus-Bertrand (1946–)
Famous for his aerial photography,
this Frenchman also loves dogs, which
is shown in every exquisitely lit and
observed pet portrait he has made.

Jane Bown (1925–)
The famed British portraitist for the
Observer national newspaper is almost
equally famous as a cat-lover, and her
gentle studies of her own cats and
others she has encountered are both
document and visual essay.

William Wegman (1943–)
Basing almost his entire reputation
on dressing up his Weimaraner dogs,
Wegman's studio portraits of his animals
are witty and skilfully executed. Some
have achieved classic status.

Hans Silvester (1938–)
Another cat-lover, Silvester has spent a
lifetime chasing the waifs and mongrels
in Mediterranean streets and elsewhere
in the world. His are among the most
widely distributed posters of cats.

ISO 400 Focal length 7mm 1/8 sec at f/4 Flash

ISO 400 Focal length 7.2mm 1/8 sec at f/2

ISO 200 Focal length 7.2mm 1/20 sec at f/7.2

ISO 400 Focal length 7.2mm 1/20 sec at f/8 Flash

ISO 400 Focal length 7.2mm 1/20 sec at f/8 Flash

ISO 200 Focal length 7.2mm 1/8 sec at f/2

ISO 200 Focal length 48mm 1/85 sec at f/4

1 2 3
4 5 6
7 8 9
light**box**

top**tips**

1 long lens | keep your distance
At first, an animal may be very interested in what you are doing: use a long lens from further away to get them accustomed to the attention and to the sound of the camera.

2 3 experiment | unusual angles
Don't be afraid to experiment with less predictable views: they may not be ideal as the single, most characteristic portrait, but they are still a record of the animal's character and behaviour.

4 toys | pros and cons
Giving your pet a toy to play with may be an effective way to keep them on the spot, but it can also be counter-productive: they tend to become frisky and fast-moving, and don't always look their best.

5 6 eyes | catchlights
The catchlights in the eyes are a sure way to draw attention to a portrait. If you are too far away, as in 5, the catchlights are too small to see; get up close for best effect.

7 flash | choices
When working indoors with flash, avoid direct flash, as seen here, as the lighting is unnatural and shadows are hard. If possible, bounce the flash, but take the picture anyway to avoid missing the moment.

8 domestic light | white balance
Indoors, you may be able to use the available light together with a high sensitivity setting – but make sure you use the correct white balance to avoid the colour cast seen in this image.

9 expression | magic element
The most rewarding experience is catching a telling expression on your pet – but the usual need for careful composition still applies.

▶ **see results**

dog peeking
Sandro e Patrizia

"The original background was removed using the Background Eraser tool and was replaced by the photograph of the lake."

the**critique**

Being able to make informal snaps of our animal friends is actually a triumph of technology. Cameras must respond and focus rapidly and be easy enough to use to seize the moment. Here we see a range of approaches, from the direct portrait of the rabbit and the compositing of the dog portrait through to the most photogenic of all pets, the domestic cat, caught in a moment that contrasts the cute with its true carnivorous nature. Just as with portraits of humans, you need not flatter or insist on showing only the charming side of a pet's character.

dog peeking
Sandro and Patrizia explain that this image was taken on the balcony of the dog's home (top right), a split-second shot as he peeped round the door. They pasted the lakeside view (top left) and removed the urban background with the Background Eraser tool. They say they enhanced the contrast but that does not look necessary from the original shot. The slight dislocation in perspective makes this image unusual.

tortoiseshell cat
Dennis was woken at 5.30am by his cat showing off a mouse she had caught. With great presence of mind, he grabbed his camera, flash-gun, and remote flash-trigger and followed her to where she was hiding. He lit her by bouncing the flash – triggered by the flash on the camera – giving beautifully sharp and well-lit images. It's tempting to prefer the other, rather cute, pictures but the main image offers by far the greater depth.

ideal sitter
A docile animal can be almost too cooperative, lacking variety in pose and expression. Vicki has made the correct decision to convert her images to black and white as this not only suppresses irrelevant colours, it helps control image contrast.

▲ Canon EOS 350D ISO 400 Focal length 48mm 1/200 sec at f/9.0

"I shot in RAW for greater leeway in post-processing, took plenty of pictures – and eventually got the one I wanted."

▲ Olympus E-1 ISO 100 Focal length 135mm 1/180 sec at f/5.6

ideal sitter
Victoria Fevre

"He's so cute, every picture's a winner. I thought black and white was best – green grass was too strong a contrast to the white fur."

▲ Canon 5D ISO 100 Focal length 85mm 1/60 at f/4

tutorial 8 using available light

Photography's progress may be measured by its increasing mastery of darkness. Once exposures needed several minutes in full sunlight, but now we can work in fractions of a second, even under moonlight. At the same time, digital photography has also improved its handling of wide luminance ranges, both at the sensor and camera processing level and in the digital darkroom.

fact file

A sensor's sensitivity depends on a number of conflicting factors. If we boost the signal from the sensor, it becomes more sensitive, but noise in the signal is also increased. Modern sensors aim to reduce noise before the signal is boosted. This technique has led to sensors offering ISO speeds as high as ISO 102,400, producing acceptable results.

low light levels

Photography in low light is complicated by the widening of difference between what the human eye sees and what the electronic eye of the sensor can detect. While there is a fairly good match between eye and sensor behaviour in ample light, the eye's response to low light causes a change in the way that we perceive colours.

human vision | the colour of darkness

The human eye adapts to lowering light levels in a wonderfully neat way. The light-sensitive layer of the eye can be said to be made up of two types of sensor – those that work in good light and register different colours, and those that work in low light and can register shapes but see colours only poorly. When the latter set of sensors takes over, there's a shift in the quality of our perception. We don't normally notice this because we take it as natural that we can't see colours well in darkness, simply because there is little light. However, photography can show us the error of that way

> ❝ Colours are as bright and vivid in darkness as they were in full light ❞

of thinking. In fact, colours are as bright and vivid in darkness as they are in full light – the colours themselves have not changed. To see colour in low light we only need a way to accumulate enough light for it to be fully exposed – and that's what a long or high-sensitivity exposure does. The result is always amazing: what we remember as dull darkness becomes richly coloured.

minimum noise | fast lenses

So far, we have a win-win situation: not only can photography work into the darkness of night, it can deliver up colours and tonal richness that are impossible for our eyes to perceive. In doing so, photography has quietly overcome the limits to our vision.

And there's more. While high-sensitivity films suffered from very obtrusive grain, poor colours and tonality, and unpleasantly high contrast, modern sensors – particularly large sensors of the CMOS type – can be remarkably free of noise even at sensitivity settings as high as ISO 6400. The latest cameras offer settings up to ISO 102,400 with acceptable levels of noise. Furthermore, with image stabilization being increasingly used, it's possible to work hand-held with relatively long exposures.

If you use a dSLR body, it's worth investing in a fast prime lens such as the 50mm f/1.4: these are a full two stops faster than the fastest zoom lenses available. The result is that you will need to rely less and less on using electronic flash for low-light photography.

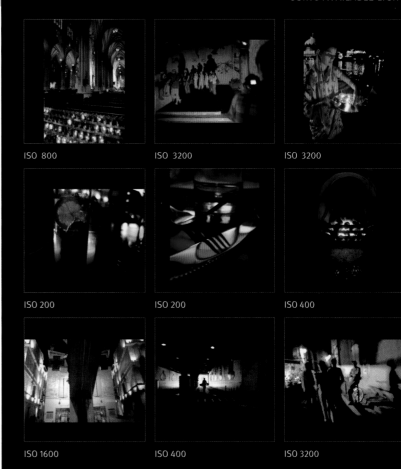

ISO 800	ISO 3200	ISO 3200
ISO 200	ISO 200	ISO 400
ISO 1600	ISO 400	ISO 3200

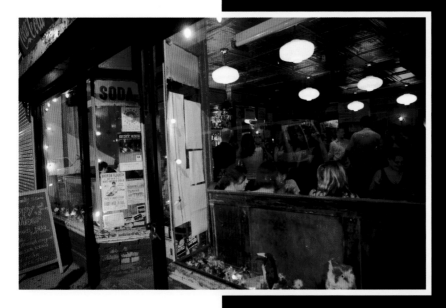

ISO choices

① ② ③
④ ⑤ ⑥
⑦ ⑧ ⑨

lightbox

The ISO is not too high in 1 in order to retain quality, and because there is little movement. 2, 3 are set with the highest available ISO to capture movement. In 4, 5 a mid-range sensitivity is sufficient because the camera is rested on the table. In 6 ISO 400 is sufficient because we plan to under-expose by two stops. In 7 and 9 high ISO is needed for action, while 8 calls for an average ISO to maintain quality.

night-life

Lighting conditions that used to call for tripod, big lenses, and specialist techniques, can now be recorded by point-and-shoot cameras. Those with image stabilization give measurably superior results in low light than those without.

image **analysis**

The Diwali, or festival of light, celebrations in India present an irresistible photographic opportunity. The candles carried on trays by men, women, and children almost seem to float through the darkness. However, it is nearly night-time, and the technical fire-power of high sensitivity and fast lenses is needed to capture any images at all from this extremely dark scene.

sensitivity | pros and cons

Earlier digital cameras with small sensors give high-sensitivity settings a bad name. These chips are so packed with circuitry that they are inherently noisy – full of the unwanted background chatter of electrical activity. Pushing up sensitivity is then like turning up the volume of a badly tuned radio – the song is louder but so are the crackles. The latest digital cameras suffer much less from noise. You can set many of these cameras to ISO 1600 and even higher. For some photographers, noise gives the image a texture akin to film, although the low-light performance of modern digital cameras far surpasses the best fast films. For the best results, record images in RAW format – some modern software can remove noise before the RAW processing, yielding wonderfully clean images from the most testing conditions. If the scene is mostly black, remember that you may need to override the auto-exposure by reducing exposure by half to one stop to ensure that blacks are dark and highlights are not burnt out.

in **detail**

A girl carrying a tray of candles turns around, waiting for her family to catch up with her. That brief pause was essential for capturing the image at all, as the exposure times of around 1/15 sec to 1/30 sec were too long to freeze movement.

Sensitivity was set to ISO 1600, while the zoom lens was used at its 70mm setting and at a full aperture of f/2.8. The image was noisy, which was most disruptive on the girl's face, so it was imperative to reduce noise using specialist software.

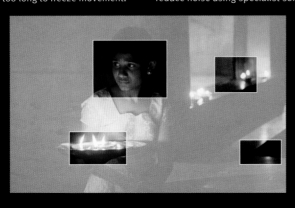

noise removal
This close-up shows the importance of noise-removal from areas with smooth tones – noise in mid-tones is very undesirable. It is a price you have to pay for high sensitivity but it does enable you to work in low light.

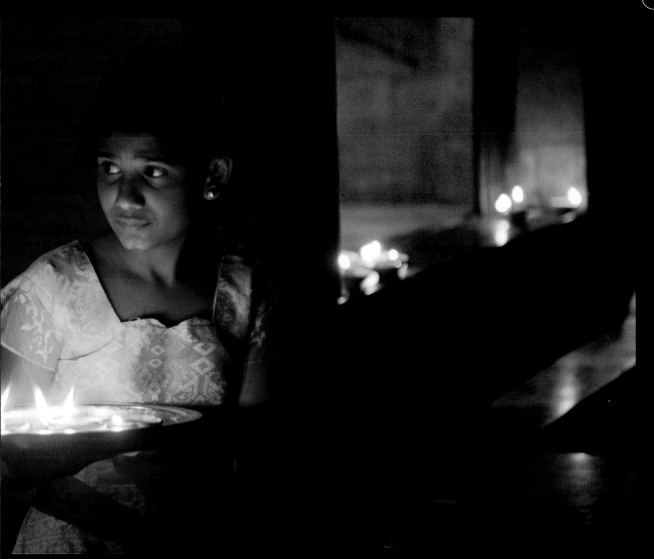

out-of-focus highlight
The candles are rendered as attractive, smooth blurs thanks to a good quality of blur from the lens. Noise could have disrupted the outlines here, but removing noise also helps smooth out the blur.

eye catchlights
The most important lights in the image are the catchlights in the girl's eyes. It was essential to make sure her eyes were in focus and not moving as, for this picture to really work, it is vital that they are sharp.

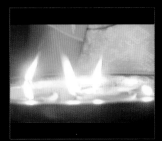

candle flare
Detail has been lost because the exposure was aimed at capturing some texture in the shadows, which has left the highlights burnt out. This, however, is acceptable, given the darkness of the scene.

hard and high light

Hard, sharp, stark – the words applied to bright light conjure up unease. Indeed, photography's relationship with this type of illumination has long been one of troubled compromise. We love bright light, but working successfully within the range of what the technology permits calls for skill and application.

high contrast | sensor capability

The brightest light that we usually encounter is direct sunlight which is hard and contrasty. The rays of light are essentially parallel to each other – described as collimated – and thus arrive on your subjects from the same angle. One result is that shadows have clean edges. The lack of light scatter means that little light falls into shadow areas, so edges are not softened and the depths of shadows remain relatively dark. The combination of dark shadows and bright areas exposed to sun results in a high dynamic range – a considerable difference between the luminance of shadows compared to highlights. Cameras with small sensors typically cannot record a wide dynamic range: a difference of around three or four stops of exposure between light and dark is their limit. Those with larger sensors and more sophisticated image processing can handle much larger ranges, up to around eight stops, while the top-end professional cameras may record as much as 11 stops of luminance range.

However, the effective range seen in digitally enhanced images is somewhat wider than the range visible on the actual captured image.

tonal extremes | manipulation

It's your call whether to fight dynamic range that is greater than your camera can handle using techniques which are designed to bring shadows or highlights into the visible, mid-tone range. You can control dynamic range by using supplementary lighting such as flash or reflectors to fill shadows (see pp. 146–55), or you can process the image to extract hidden detail (see pp. 224–27; also p. 221). The alternative strategy, and one that's

blinding light
Light in mountain regions, such as in this shot from Kathmandu, Nepal, can be so bright only photographic images can capture the colours with consistency. But the price of accurate colours in bright areas is almost complete darkness and lack of colour in the shadows.

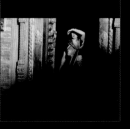

FOREGROUND SHADOW

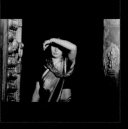

ZOOM IN

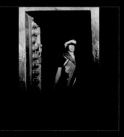

FRAMED BY DOORWAY

creatively more rewarding, is simply to work within the limits of your equipment. That is, allow shadows to go black if that is the price of obtaining highlights with detail. Take your exposure readings from bright areas, and allow shadows to be totally under-exposed (see opposite).

You may also expose for the shadows to ensure they retain detail, while allowing the highlights to burn out. This powerfully conveys the sense of blinding, bright light because mid-tones are rendered very light and colours lose solidity. This reduction in colour saturation usefully reinforces the sense of light emerging from within the image, so don't be too keen to boost them back to normal levels using saturation or vibrance controls.

You can now photograph in the brightest, most contrasty situations with the expectation of achieving a good image. Select RAW for these demanding lighting conditions, if your camera allows you to. Whether you record your images in RAW or JPEG, the key to success in very bright light is to ensure that light mid-tones such as fair skin are exposed to mid-tone or light mid-tone; that is, you need to err on the side of under-exposure. This ensures that highlights are not pure white: if they are, it's difficult to recover any colour in postproduction.

virtuous necessity
Sun reflected in a colander makes for a dynamic range which a camera phone cannot record fully. So we make a virtue of the loss of highlights by over-exposing, filling the image with light.

direction | working hard

While the choice of exposure is the foundation for true colours and highlights that don't look too white or washed-out, there is another powerful way to handle hard, high lighting conditions that does not involve image manipulation at all. It is simply to work with the highly directional nature of the light. Small changes in your position relative to your subject or light-source make differences in the distribution of lights and darks in your image. To obtain a back-lit or strongly-articulated outline, position your subject between the light-source and yourself. You can "hide" in the person's shadow to obtain rim lighting, or work the light until it just peeps around the edge of your subject, throwing a flare into the image. If you turn away from the sun, you see the light rakes the surface of objects to bring out textures and undulations. Turning further away, shadows diminish until – where you are between the sun and your subject – shadows are at their minimum, offering "flat" or textureless lighting.

One final refinement may help if you wish to avoid the surface sheen given by bright light on reflective surfaces; a polarizing filter will remove the sheen from most surfaces (but not metal or metallic paints), and help improve saturation of colours.

hide from the sun
Consciously framing with shadows helps to divide up the image into tonal regions (top). These buildings were in full sun, but turning away from the sun helps to flatten contrast (middle). Shooting directly at the sun, but benefiting from some of the sunbeams being blocked, this shot exploits rim lighting while leaving shadows deep and dark (bottom).

WORK WITH SHADOWS

BACK TO SUN

BACKLIGHT

direction of light

An experienced photographer remains constantly aware of the light – its strength, its colour, its quality, and the direction it's coming from. The direction of light determines not only the form and intensity of shadows, it also governs the tone and contrast in the scene being photographed.

the sun | and technology

Photographers' ability to work in relation to the position of the sun has been determined in part by a specialized area of photographic technology: lens flare suppression. Early photographers couldn't point their lenses towards the sun because stray light entering the lenses was poorly controlled and bounced around, causing chaos in the image. Contrast was badly reduced by veiling glare, internal reflections confused the details and exposure was misread.

As lens coatings, internal baffles, and low-albedo (dark) diffused coatings improved, flare suppression became so successful that photographers could allow a full sun into the image and still be able to capture images. In fact, it's possible to follow the progress of technology in this respect through photographers' increasing confidence when working contre jour (against the light). The result has been a subtle enrichment in our visual vocabulary: essentially our light-source can shine in any direction in our visual field and we can now work with it.

light | shade, and contrast

The more we angle the camera towards the sun, the shorter shadows appear. And when the light-source itself appears in the image, it may cause flare – which you may be able to exploit for its pictorial effect.

At the same time, we tend to see more of the shadowed side of objects. The net effect is to raise contrast – combining sun and shadow in view gives rise to a very extensive subject luminance range. This is the sphere in which we see shapes – and can work with colour masses. Determining exposure can be tricky.

working the sun
With fast-moving action, you may need to wait for your subject to orientate itself to the sun for the best lighting. The light on the gardener's hands varied with the angle of the hand: the aim is then to catch the best combination of angle of light and hand position.

HANDS TOO SMALL

TOO MUCH SHADOW

TOO MUCH SUN

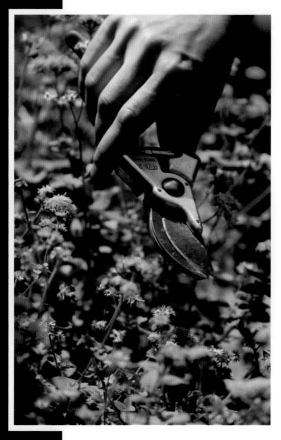

We can force under-exposure, so that we work with deep shadows contrasting with intense colours that are created in the resulting mid-tones, or, with static subjects, we can make bracketing exposures in preparation for HDR techniques (see pp. 226–27).

In turning away from the sun, we work with increasingly large areas of shade with the sunlit areas: this is the sphere of textures and form, where capturing subtle tonal transitions dominates the technical requirements. Exposure metering (see pp. 38–39) is generally less technically demanding the further from the sun we turn.

With the sun to our backs, contrast generally drops: the lighting is flatter and we see less shadow. Early and late in the day, you may find your own shadow is sufficiently long to enter the picture, so you may need to hide behind the shadow of another object such as a building or tree. It's difficult to obtain high-contrast effects in all but the brightest lights, but exposure metering is usually not difficult.

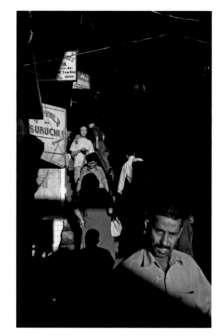

front lighting
A brilliant stream of evening sun breaks through closely packed buildings in Gangtok, Sikkim, to illuminate passers-by. The result is an unusual combination of front lighting with intensely dark shadows.

walking around
Exploring a monument is to dance with light. You step around shadows, work to avoid large flat areas without tonal variation, duck down to use a building feature to shade the sun, and control exposure to record as much as possible.

AGAINST THE LIGHT

SUN AT BACK

SHADOWS DOMINATE

TOO MUCH SHADOW

TOO LITTLE SHADOW

shadow play
In bright light, composition can be regarded as balancing areas of shadow with areas of bright light – the crescent of light in the main image proved the best of the three compositions.

using **shadows**

Photographers generally regard shadows as less interesting than highlights. However, highlights are nothing without shadows to define them.

darkness | and detail
In photography there are some shadows that we are interested in – those that carry detail – and others we are prepared to lose, that is, those that are so dark no useful detail can be seen in them. Much of the tonal underpinning of a photograph depends on the quality of the shadows.

On one hand, they need to be dark enough to be convincing: in the majority of pictures you need some area, however small, which appears not just dark but black. On the other, some areas of shadow need sufficient contrast to reveal details – but if too much detail is revealed, or if the colours look too bright, the image starts to look unnatural.

exposure | highlight priorities
The first half of photography's history could be characterized as "negative working": almost every photographic process started with a negative image. For these processes the priority when calculating exposure was to ensure the shadows with detail received adequate light. In the digital era, sensors are "positive working": they record brightness as light and darkness as shadow tones. The exposure priority is reversed to that of film: we need to ensure that highlights with details are not burnt out, or "clipped", to pure whiteness (see also p. 163). The primary reason is that it is not possible to recover details from highlights rendered pure white, but it's more interesting than that.

The explanation is two-fold. Even very low quantities of light can evoke a signal on the sensor: so long as that has some resemblance to the subject, even if the colours and precise tonalities are inaccurate, we will accept that as detail suitable for shadows. Even if the shadows are too dark, you will be able to extract sufficient detail with your image editing software (see pp. 224–25), but it will not be possible to find detail by burning in over-exposed highlights. The other reason is that we see less detail in shadows than is actually present, because when we look at a subject with tonal contrast we tend to favour seeing detail in bright areas over detail in shadows. Thus, we often fail to notice the fascinating shapes of shadows, the way they run over a surface to define its texture and grain.

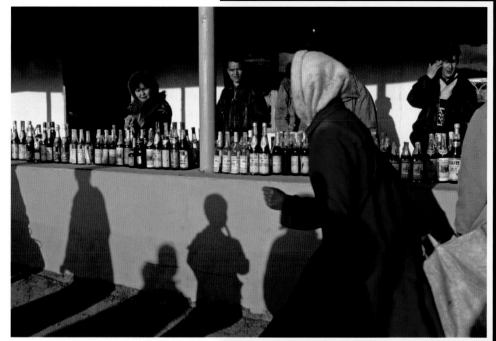

PEOPLE SHADOWS

drinks stall
This image combines the stillness of shadows – almost representing people in the negative – with the harried movement of the passer-by moving energetically through the image. Notice how the shadows carry a blue tint as the light reaching shadows comes from the sky.

colour | exposure for saturation
Another reason for shadows being underestimated is the notion that they are dull grey or black. In fact, shadows can be strongly coloured. On clear, sunny days, the colour of shadows is blue, reflecting the sky, and that blue can be surprisingly intense.

It's perhaps surprising that the colours in shadows can be more saturated than those in full light. This is because shadows receive their light from diffused or reflected sources: the soft light does not create the shiny highlights (reflected images of light sources) that tend to weaken colour saturation.

However, you will only obtain these intense colours if you give the full exposure to the shadow area. Where the exposure is correct for the mid-tones, the colours in shadows are under-exposed, which means that they look dark and lack saturation. Don't be tempted to correct this, as high saturation in under-exposed areas would look artificial.

INVERSE LIGHT

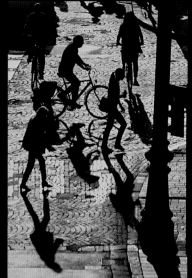

MULTI-DIMENSIONS

shadow shaping
Shadows are picture elements at least as important as the objects that cast them. Shadows define not only textures but space, and the planes on which they fall: for instance, straight-running shadows (above left) tell us the surface is flat. The use of a special effect border from a camera phone app gives extra texture to the image. Deep and long shadows (above right) indicate an uncompromisingly intense sun sitting low in the sky.

image **analysis**

Light doesn't reveal things indiscriminately, it's quite selective about what it chooses to reveal. Direct light, in particular, can point out details and highlight shiny areas or shape textures as if it were teaching you how to see. However, light can also cause flare in the lens and reduce contrast in shadows.

light | and shadow

Advice stating that you should avoid photographing directly into bright light can be traced back a long way into the annals of photographic history. Early lenses couldn't cope with veiling glare and ghosting, and photographs would appear as if the camera had been blinded if there was a light source in or near the field of view. Today, however, photographing into the light, or "contre-jour", is not only well within the abilities of any modern lens, it is a very quick way to achieve certain visual effects. The key to success, however, is

to catch the light at just the right time. Usually, the best times to do this are early in the day, late in the afternoon, or in the early evening. Light travelling at an oblique angle to the Earth is more likely to enter windows at this time, and will throw long shadows. You have to be careful with exposure as the camera may have a tendency to under-expose. However, the benefit of this is that under-exposure usually helps to retain highlight detail. You can usually retrieve shadow detail in postproduction but, if in doubt, make bracketing exposures.

in **detail**

What caught my eye here was the set of whorls in the ironwork of the gate that were picked out by the light. The sinuous shapes are echoed in the shadows cast on the stone floor, and are repeated with numerous details scattered throughout the image. The main technical hurdle to overcome was to ensure that the camera meter was not unduly influenced by the very bright light from the windows and the reflection of the sun from the stone floor. However, the pale stones reflected back much of the ambient light, so more details were revealed in the shadow areas of the image than were visible to the eye at the time.

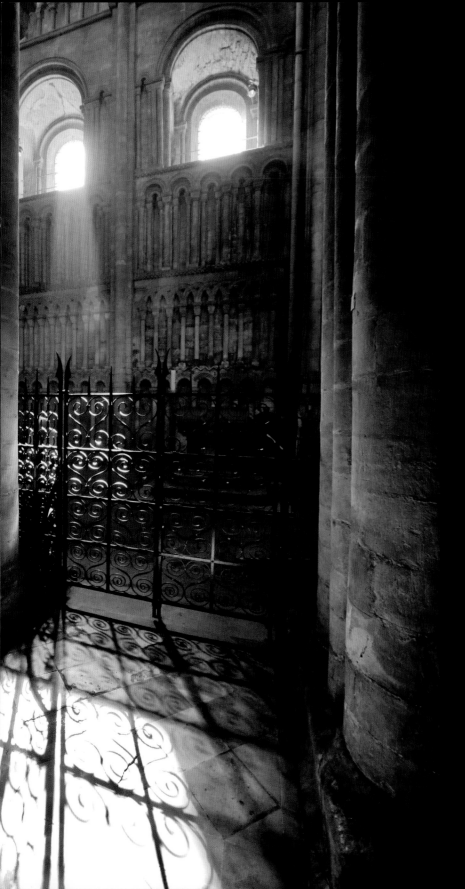

aberrations

There is evidence of colour fringing at the edges of the image. This is a combination of lateral chromatic aberration from the lens, and errors in image processing – which are caused by high levels of light causing overload of the sensor photosites.

accurate verticals

With an extreme wide-angle view, it is essential to hold the camera precisely aligned to the vertical. Even the slightest error will be greatly magnified by the wide-angle view, which would disturb the dignified tone of the composition.

recovering highlights

The sun is shining on the floor as well as being reflected into the camera. A polarizing filter may have reduced the reflection, but attempts to retrieve detail are likely to make the shadows too dark.

Assignment: **light and shadow**

One of the very first photographs ever created – Henry Fox Talbot's picture of a broom leaning against a door, which dates from 1844 – features a distorted shadow whose strong lines almost steal the show. While all photographs are, by definition, a record of light and shadow, photographers ever since Fox Talbot's day have sought to exploit these intrinsic components of photography as subjects in their own right. In this sense, to photograph light and shadow is to aim for the most abstract kind of image.

ISO 200 Focal length 100mm 1/400 sec at f/9

the**brief**

Photograph the interplay of the built environment with lighting effects from natural or artificial sources or a combination of both, indoors or outdoors. Look for close detail, an unusual angle, an intriguing composition, or a combination of colours for their own sake.

Points to remember
- use high-contrast and high saturation if it is available on your camera
- keeping your zoom lens at one focal length will help you to concentrate on composition
- a low ISO setting will ensure the best colour quality and clean blacks
- keep the camera square on to the subject to eliminate converging parallels – unless you particularly want them
- for minimal distortion, the middle of a zoom range is usually advisable
- use apertures in the middle of the range for the best image quality

ISO 100 Focal length 32mm 1/250 sec at f/8

must-see **masters**

Ray Metzker (1931–)
Metzker is one of the most inventive observers of the environment, his innovative work exploring every formal possibility of the monochrome image. He has been an unacknowledged influence on generations of photographers.

Alex Webb (1952–)
Although his concern is not primarily with the formal qualities of light and shade, Webb's humanistically motivated photography – much of it created in the harshest tropical light – displays a virtuoso command of highlight, shadow, and colour.

László Moholy-Nagy (1895–1946)
Perhaps the most brilliant of a generation of brilliant artists and photographers, Moholy-Nagy was an innovative polymath. He was a versatile artist, but it's his photography that has left a lasting influence – one that's far out of proportion in relation to his comparatively small output.

ISO 500 Focal length 20mm 1/25 sec at f/5.6

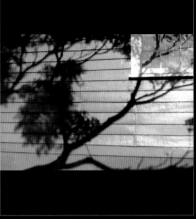

ISO 100 Focal length 32mm 1/250 sec at f/8

ISO 200 Focal length 7.2mm 1/400 sec at f/4

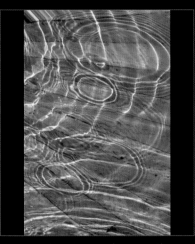

ISO 160 Focal length 46mm 1/720 sec at f/8

ISO 250 Focal length 24mm 1/25 sec at f/2.8

ISO 200 Focal length 7.2mm 1/60 sec at f/4

ISO 200 Focal length 7.2mm 1/400 sec at f/4

① ② ③
④ ⑤ ⑥
⑦ ⑧ ⑨

light**box**

top**tips**

① ② **shadows** | constant change
One of the challenges of dayllight shadows is that they move with the sun. Their quality also varies considerably according to latitude and atmospheric conditions, so you need to watch and follow.

③ **texture** | and contrasts
Man-made objects present very hard shadows and clean-cut textures, but to ensure that they stand out from the background, use a large aperture so that distractions are minimized. Here, even the second ring of the gear teeth is soft and the background is heavily blurred.

④ ⑤ **light** | and water
The key to photographing the effect of light with water is to use the shortest possible exposure times to cut movement blur to a minimum. In 4 there is perhaps too much blur compared with the clean lines of 5.

⑥ **indoor** | lighting effects
Many possibilities are offered by domestic lamps and shades. The lighting effect may not be obvious unless you deliberately under-expose the image by half a stop or more.

⑦ **perspective** | in shadows
A prosaic subject, such as the shadow of this lantern against a blind, can be turned into a haunting abstract by exaggerated perspective.

⑧ **shadows** | oblique meanings
Shadows are a sign of a presence, so, while they can be used for their abstract qualities in a composition, they also carry some meaning, no matter how oblique that meaning may be.

⑨ **depth** | of seeing
Where the thrust of an image is abstract, out-of-focus blur is often a hindrance. For images with receding patterns, it's important that depth of field extends to the very end.

central lightwell

Michael McCauslin

"Just about every time I visit the San Francisco Museum of Modern Artspace, I take a shot looking up towards the skylight."

thecritique

As a subject for photography, the interplay of light and the built environment is almost a given, if only because architecture from as far back as Mayan times has exploited the relationship between light and blocks of stone. But the accidental can also be a rich subject, particularly where light has a focused quality that causes shadows to be sharply defined. This is one reason photography in the Mediterranean or Australasia is so rewarding: shadows show extremely clean edges with good density, thus contrasting with neighbouring areas of flat tone or colour.

central lightwell

Persistence paid off for Michael, who says he photographed the central lightwell at the San Francisco Museum of Modern Art on many occasions. He found he would either have glare from the sun causing blown-out areas in the image, distracting elements such as signage, or "a less-than-exciting compositional interplay of the shadows and architectural geometries". As he says, the day he made this shot, he "found a nice combination of 'good' parts and a relative lack of the 'bad' ones". His image also demonstrates that a good composition can make up for lack of a wide-angle lens.

homely fence

The key to this kind of image is simply observation: you can pass a scene a hundred times but if your attention is away with the fairies, you will miss even the most elegant calligraphy of shadows. Also, of course, Nick had his camera with him.

Beijing

The geometric elementalism of this image is admirable. Note that, even if you cannot frame this kind of shot square-on to the wall, it's important to square up the sides to avoid sloping lines.

▲ Sony DSC P200 ISO 100 Focal length 7.9mm f/5.

homely fence
Nick Jones

"I'd passed this fence every day for years but this was the first time I noticed the lovely shadows – almost like calligraphy."

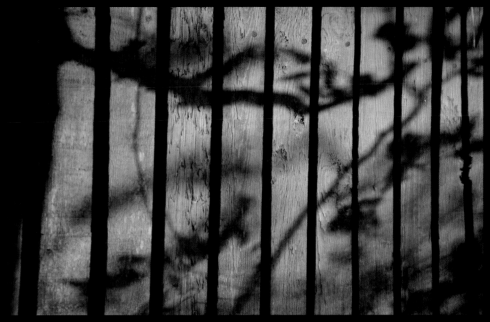

▲ Canon EOS 5D ISO 100 Focal length 48mm 1/125 sec at f/5.0

Beijing
Bogdan Grosu

"Some photos are strongly anchored in the moment, with a strong sense of place, others could have been taken anywhere."

▲ Canon Powershot A40 Focal length 16.2mm 1/400 sec at f/4.8

tutorial 9 portable sunlight

The invention of electronic flash opened new worlds to photography. Suddenly deep caves, moonless nights and after-dark revelry could be photographed. Then it was discovered that electronic flash was also excellent for freezing motion into a sharp image. In the digital age, high-sensitivity recording opened up the possibility of exploiting even the weakest source of light.

fact file

Flash units are tuned to output light with colour that is close to daylight. This means that in the majority of situations the light looks too blue, and is much too blue when used indoors. You can adjust it by using your white balance control, place a warming filter over the flash, or balance with available light.

full and fill flash

Many photographers regard flash lighting as bad lighting. With the improvement in the capabilities of software to handle shadows, they are turning away from using flash altogether. However, it's still a technique of great value.

flash lighting | and bad lighting

While flash comes into its own where there is no light at all, ambient lighting is easily destroyed by it. Worse, the majority of flash units in use are built into cameras. The list of unwanted effects this creates is long, but can be summarized as hard directness. Features look flattened out, surfaces appear white because they reflect light back, and hard shadows are thrown behind the subject. Additionally, the light falls off rapidly, producing over-lit objects or faces near the camera with darker ones behind – a particular problem when you're photographing a group of people.

However, the problem is not intrinsic to the flash unit itself – it's the way it's used. The first step towards handling flash effectively is to reduce its power so that it supplements ambient light rather than overpowering it: you use the flash mainly to fill in shadows. Because ambient light still contributes to the lighting, the effect remains softer and the colours more natural.

> ❝Moving the source of light away from the lens axis is an essential first step❞

Another approach to lessening the artificial appearance of flash is to turn off the built-in unit and use an accessory flash mounted on the hot-shoe or on a bracket to one side of the camera.

improved lighting | larger lights

Moving the source of light away from
the lens axis is an essential first step to
improved lighting. However, unless you
take the flash unit off the camera – a
compromise that's awkward to handle –
you have to find another way to improve
flash lighting.

The softer the light the kinder it is to
flesh tones, and the larger area from
which light flows the softer the effect will
be. It follows that one strategy is to turn
your shoe-mounted flash unit into a large
source. To achieve this, you can add
accessories such as translucent sheets
or balloons which attach to the flash.

Alternatively, you can bounce the
light. This means that you point the flash
away from the subject but towards a
nearby wall or ceiling. The light reaches
your subject after reflecting off that
surface: as these cover a large area,
the light from them is soft. It's helpful
if the surface you're bouncing the light
off is white or warm white in colour.
The more powerful your flash, the
further away the surface can be and
still provide usefully bounced light.

FULL-POWER

FULL-POWER

FULL-POWER

AUTOMATIC FLASH

AUTOMATIC FLASH

AUTOMATIC FLASH

BOUNCED FLASH

BOUNCED FLASH

BOUNCED FLASH

flash settings

1–3 call for the flash's full
power because the subject
is relatively distant: notice
that the flash does not
reach far. On-camera flash
used on automatic is best
for the lively street carnival recorded in **4–5**,
as it can instantly adapt to the differences
in distance. Indoors **7–9** flash is best used
bounced from a white surface, or a shiny
subject like the mirror-clad model.

invisible flash

It's not obvious that flash was used here,
until you realise this was shot into the
sun, so normally the foreground would
be in darkness. The flecks of light from
the ground give away the use of fill-in
flash to light the nearest plant.

off-camera lighting

Detaching the flash unit from your camera will considerably improve your lighting and give your images a more professional appearance. However, holding and aiming the flash while also keeping control of the camera can become tricky unless you are working in a static situation.

off-set flash | bounced light

If you wish to distinguish yourself from thousands of amateur photographers using built-in flash, the most immediate way is to take the flash away from the camera. To do this, you will obviously need to disable any built-in flash.

The most popular solution to improving flash lighting is to mount the flash on a sidebar: this is generally favoured by wedding photographers and the paparazzi. Usually off-set to the left of the camera, the flash provides lighting that falls 45–60 degrees to one side of the subject at medium to close distances.

This lighting models the face to much better effect than flash aimed directly at the subject because it casts sufficient shadow to give a little light and shade to the shape of the nose, cheeks, and eyes, avoiding the flat effect of built-in flash.

In addition, a side-mounted flash allows you to bounce light from a wall behind you without your body obstructing the light. Flash that is bounced from a side or rear wall produces much better modelling on your subject's face than light bounced off the ceiling, and, of course, you can position yourself closer to a wall. However, the disadvantage of off-set flash is that the camera becomes awkward to handle.

stands | and hands

When you are working in just one spot, a stand that holds your flash can give you the best of both worlds: flexibility in lighting plus a well-balanced camera. Any object, from a tree to a chair, can be pressed into service as a stand if you have a simple spring-loaded or screwdown clamp, although proper light stands are the most reliable support and allow you to fit accessories such as umbrellas to soften or shape the light. The least expensive solution is to use a connector

shaping the shadows

A large flash unit mounted on top of a camera will give results that will appear more off-camera when the camera is held for a portrait-format shot than when held level. This has been exploited in the main image, which is working with repeated circular shapes, including that of the shadow from the cartwheel.

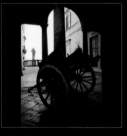

NO FLASH

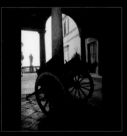

WEAK FLASH

WEAK FLASH

that slots into the hot-shoe then runs a cable to the flash-gun: this limits you to holding the flash at arm's length, or as far as the cable reaches.

For greater freedom of movement, synchronize your camera to your flash by using an infra-red transmitter. The transmitter connects to the camera at the hot-shoe and sends a signal when you make the exposure. The flash then instantly responds.

transmitter | set-ups

Using a transmitter opens another avenue for sophisticated lighting. The single transmitter can coordinate more than one flash unit – some systems allow for up to four groups of flashes, each with one or more flash units, to be fired at once. Each unit can be aimed at different parts of the scene and set to varying powers, even carrying coloured filters, producing on-location effects that rival those possible in the studio.

The cost of this versatility is the need to carry more equipment, which then takes longer to set up, but the gain in portability and freedom from reliance on mains electricity is very liberating.

overhead flash
In the image below, flash from above and aimed at the plate holding the flowers transforms the shiny surface into a secondary light source.

SIDE BOUNCE

LOW DIRECT

MID-HEIGHT DIRECT

FAR BACKGROUND

lighting angles
This sequence shows how much variety of lighting can be achieved simply by using the flash while holding it separate from the camera. Here, a single flash was attached by cable to the camera. It was held at different angles and distances from the subject, and fired at varying powers. For the main image, a weak flash from the right of the camera position fills in the shadows with a deft touch, preserving the natural lighting.

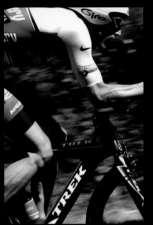

mixed lighting
Flash and daylight can combine effectively to take light into shadows and ensure the sharpness of areas primarily lit by flash, while also allowing motion blur from a long exposure.

NO FLASH

FLASH

evening mix
The very strong bluish cast from the evening light dominates the scene despite the presence of tungten and fluorescent lamps. A small amount of flash relieves the deep shadows of the palm.

multiple lights

In art there is nothing new about using more than one source of light on a subject, but it has been photographers who have fully exploited the power of using multiple lighting. This can come from studio lamps fitted with a range of accessories or from something as simple as the screen of a mobile phone.

lighting set-ups | shadows

Photographers who take the trouble to master lighting using more than one light source are generally those who abhor featureless shadows. Their instinct is to introduce enough light to bring colour into them and reveal some detail, but without destroying the essential character of the shadow.

When you are planning lighting for a subject, the strategy to keep in mind is that a viewer's eye is generally drawn to the mid- and lighter tones. Therefore, a shadow retains its visual effect by being darker than the lower mid-tones – should it be any brighter, it will compete with the main subject.

At the same time, you will generally not wish any added lighting to draw attention to itself: its role in the photograph is to lead the viewer to an appreciation of the subject, not to admire your lighting skills.

alternative lighting | improvising

The documentary photographer W. Eugene Smith defined available light succinctly as "Any darned light that's available." A table lamp or candle – even the light from a television screen – can be used to supplement your flash. With luck, these alternative light sources can even replace it. The result of this opportunistic

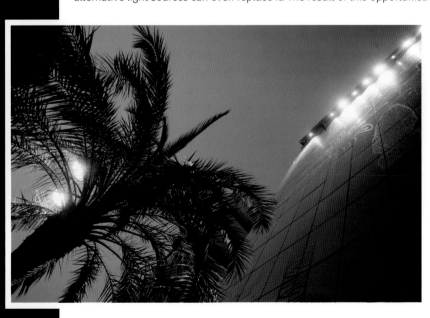

approach will be that you will learn to exercise creativity over how to exploit the various light sources available to you: your fluency in the use of lighting is as much part of your photography as the way you handle your camera and lens.

colour temperature | white balance

Colour photography opened our eyes to the allure of mixed lighting, in which lights of different colour temperatures contribute their various hues to a scene.

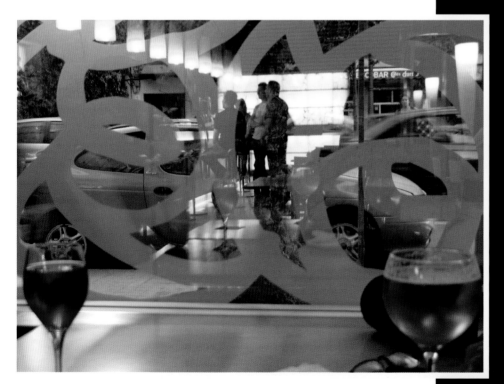

This can be taken further by white balance control. Electronic flash produces a cool white light, so a white balance set for flash will make incandescent sources such as domestic or quartz halogen lamps look more red than usual. Alternatively, you can set white balance to the incandescents, which makes the image more neutral overall, but contributions from flash or daylight will appear strongly blue.

With digital photography, automatic white balance can respond to the overall colour of the light. However, you may still have to decide how to handle situations in which you have illuminants of different colour temperatures adding to the lighting; it's up to you to decide whether to ensure that different sources are balanced to one another or to allow a particular source to dominate.

improvised lighting
If any light is good light for photography, any source of light is useful. In very low light, the glow from a tablet or screen can act as the primary light-source. Here the tablet glow is the secondary source, adding a contrasting cool tint to the warm ambient lighting.

controlling contrast
Here, a direct shot into the restaurant would have to handle the bright panel of light in the background. But a reflection tones down the light to a manageable level, with a resulting improvement in overall tonal balance.

ZOOMED IN

NORMAL FOCAL LENGTH

image **analysis**

Despite the fact that we are used to seeing the effects of flash lighting on thousands of images, we still find this harsh, flat form of illumination unattractive. It seems we have never been able to accept flash as a way to light an image, and that we will continue to prize subtle lighting.

balanced | flash

The popularity of flash, and therefore its status, goes through cycles. Even inexperienced photographers, tired of harsh lighting from point-and-shoot cameras with flash-tubes right next to the lens, are turning off their flash altogether. Instead, they are aiming to achieve a more relaxed, natural-looking "lifestyle" quality. When you use a shoe-mount flash, however, a whole world of lighting techniques is yours to explore. Here, a performance of fast, whirling Rajasthani dance meant that some flash lighting was a necessity. In order to avoid the flash dominating the lighting, two types of setting were used. First, the flash coverage was set (there is a zoom lens in many modern flash units) to focus the light on the main dancer. Second, the unit was set to under-expose by 1.5 stops. This was effective because auto-exposure flash units rely on flash reflected from the subject in order to measure exposure. This unit would only register a tiny amount of reflected light so, unless prevented, it would pump more light into the scene, causing over-exposure.

in detail

A 32mm setting on the zoom covered a moderately wide view of the scene, which was well lit by the many small sources of light scattered about. The dancers' faces were constantly moving and often in the dark, however, so flash was needed. Flash was adjusted to focus light on a small area – the flash coverage sufficient for a 70mm lens. The flash-gun was forced to under-expose by 1.5 stops to ensure a good balance was obtained with the available light.

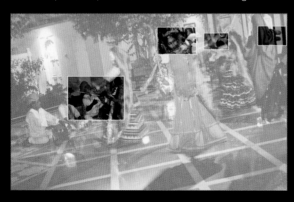

flash and blur
The long exposure (1/20sec) caused fast-moving elements, such as the dancers' arms, to blur. The more static musicians are acceptably sharp. The shutter time is just long enough to avoid camera shake.

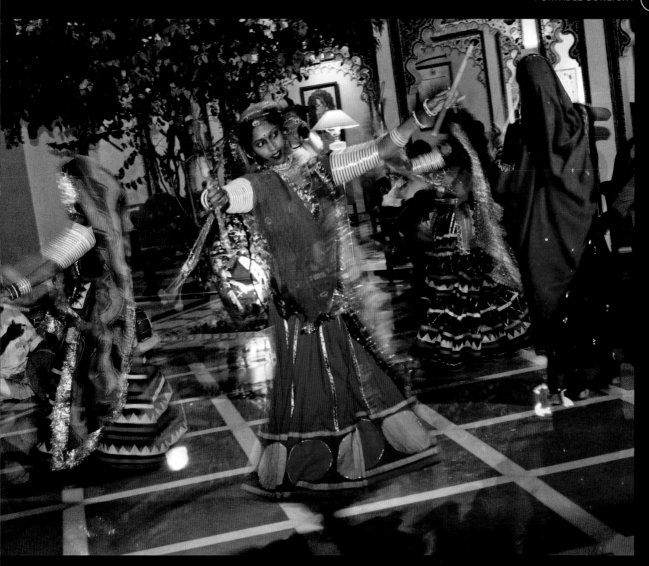

tell-tale shadow
Through sheer luck, the only clue that a flash was used is the shadow cast on a wall by a waitress passing by at the moment of exposure. Place your subject away from the background in order to avoid hard shadows.

colour variations
One of the joys of working with mixed lighting is the unexpected colour combinations that can occur, such as the purple hues from a keylight used in the interior design. The mix of blur and sharp image is also visible here.

colour balance
Due to the dominance of tungsten light in this scene, the colour balance of the flash appears bluish despite being neutral. A warming filter should be placed over the flash to reduce the difference in white balance.

Assignment: **flash portraits**

Thanks to our constant exposure to sophisticated lighting in fashion, advertising, and editorial portraiture – some of which may have taken an entire day to set up, with an army of assistants to shift the equipment around – our expectations of lighting are now higher than ever. Nevertheless, you don't need elaborate lighting and professional equipment in order to achieve satisfying results. The essential thing to remember is that when you use a flash with your camera in ambient light, you have two light sources at your disposal.

ISO 100 Focal length 50mm 1/250 sec at f/1.8

the**brief**

Using on- or off-camera or studio flash, create a portrait that benefits from flash lighting – for example, a shot that is strongly backlit, or one in a dark or dimly lit location. Consider the whole composition, making use of the background and ambient light if this is appropriate, and ensure that the quality of light on the face of your subject suits both the style of the portrait you wish to create and the setting.

Points to remember
• you can make use of any available surface to bounce or diffuse the light
• a warm-up filter over the flash or lens will reduce the blue colour of flash
• set manual exposure control so that you can vary the balance of the flash with ambient light
• using an off-camera flash, linked by cable or by slave-release, gives you the chance to light the model from different directions

ISO 100 Focal length 40mm 1/60 sec at f/2.8

must-see masters

Diane Arbus (1923–1971)
Author of a uniquely moving corpus of work, Arbus used unsentimental encounters and uncompromising lighting in order to create her often unsettling portraits.

Nobuyoshi Araki (1940–)
One of Japan's leading photographers, Araki has taken direct, almost exploitative portraits of Tokyo's "water margin" – its hidden nightlife – that have turned the flash-snap into high art.

Eva Mueller (1965–)
Modern, stylish and sometimes starkly lit, Mueller's work is a good example of modern editorial photography in which narrative and comment are combined with a dark and humorous twist.

Suki Dhanda (1969–)
A versatile editorial portraitist, Dhanda seems able to obtain telling portraits under any lighting conditions and yet make the result look candid, effortless, and natural.

ISO 100 Focal length 50mm 1/60 sec at f/2.8

ISO 160 Focal length 52mm 1/250 sec at f/14

ISO 100 Focal length 48mm 1/13 sec at f/2.8

ISO 100 Focal length 50mm 1/200 sec at f/2.8

ISO 100 Focal length 48mm 1/60 sec at f/2.8

ISO 100 Focal length 70mm 1/200 sec at f/2.8

ISO 160 Focal length 70mm 1/13 sec at f/4

1 2 3
4 5 6
7 8 9
light**box**

top**tips**

1 **fill-in flash** | and ambient light
A touch of fill-in flash can bring a pleasant light to the face. In this shot, the greenish colour cast of the ambient light caused by the trees has not been entirely eliminated by the flash.

2 **backlighting** | flash strategy
With two stops extra power, flash can light a subject even when there is backlighting from the sun – but the effect can look unnatural if the face is too bright. Beware of shiny highlights on the skin, lips, and teeth

3 **modern concepts** | strong flash
The blasted-out look has become fashionable as the visual vernacular of the web gains acceptance. The lively colours of the background and lack of shadow ensure this image works.

4 **5** **direct flash** | positioning
Flash used from a position close to the lens leads to flat and usually unflattering lighting. By using off-camera flash you can achieve softer, more attractive modelling or dramatic effects with strong shadows.

6 **balanced light** | improvising
A balance of flash and strong available light is usually the easiest to improvise and opens up many more possibilities. The warm incandescent light in this shot has balanced the cold flash light.

7 **8** **shadows** | good and bad
Your first instinct may be to avoid casting shadows with the flash, but they can be intentional and add to the mood, as in 7. In 8 they are accidental – stand your subject away from walls to avoid this kind of shadow.

9 **local colour** | bounced flash
You can allow ambient light to dominate but use flash to pick up local colour. Here flash was bounced off a red wall to give a strongly warm cast to the image.

▶ **see** results

wedding party
Annabel House

"The party was in a dimly lit room and my friend was willing to be photographed but it was tricky to find a way to light that did her justice."

▲ Nikon D70 ISO 200 Focal length 50mm 1/60 sec at f/5.0

the**critique**

Working with flash teaches you, if nothing else, the value of previsualizing the shot. Think about where the flash is pointing, where the other light is coming from, the balance between the sources of light. The selection here all demonstrate a thoughtful application of flash – from the deliberate and precision lighting in a studio setting to the improvisations on location. One tip is to avoid the temptation of looking at the image review after every shot: this not only slows you down, it prevents you from building the experience needed to be able to predict the effect of your lighting.

wedding party
With a pretty and willing portrait sitter, Annabel was right not simply to point her flash and grab a shot. Instead, she directed the flash away from the subject – almost always the best thing to do with on-camera flash – and tried different bounce angles. The main image was shot with light almost all from one side – bounced off a wall – which gave a dark background. This is as an alternative to lighting from above, from a ceiling. The conversion to black and white was a good move too, since colour is otiose here.

by a lamppost
Although Tim says he used the street lamp as the main light, with flash to fill, it looks as though the flash dominates over the available light. A balance that favoured the street light would have given the image a quite different flavour – a little moodier and more raw, adding to the already ambiguous impression of an eye-catching shot.

my friends
The brilliant colours, precise shadows, and delicate catchlight all indicate a studio set-up. Perhaps a little filling in of the shadows to the right would benefit the image without detracting from the impact of the make-up and gaudy hair.

by a lamppost
Tim Keweritsch

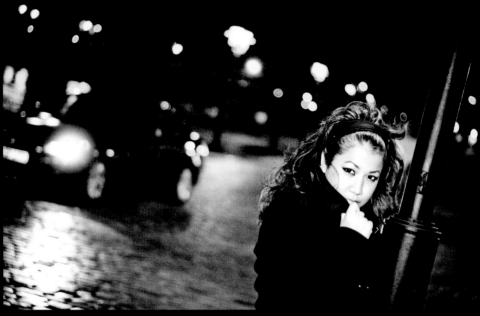

"It was really dark so I used the light of the lamppost from above as a main light source and a flash to brighten up the face."

▲ Canon EOS 30D ISO 800 Focal length 50mm 1/60 sec at f/1.8

my friends
Monika Madej

"The project was about showing my friends: who they are for me and how others see them, using studio lighting."

▲ Nikon D70s ISO 200 Focal length 50mm 1/60 sec at f/4.0

Capturing the image is only the start of a long chain of creative interventions that lead to the final, glorious photograph. In the following tutorials, we advance our skills in digital manipulation to use the essential tools to perfect the presentation of the image's content. We then look at more advanced techniques aimed at effecting profound transformations.

THE DIGITAL
DARKROOM

tutorial 10 perfecting the image

One of the many advantages of digital photography is the increase in precision of our control over all aspects of the image. From framing to exposure control, from colour balance to the size of the output image, all parameters are only a click or two away. The corollary is that any imperfections in the final image can easily be traced back to decisions that you made at an earlier stage.

fact file

A consensus is emerging that enhancing or perfecting an image comprises exposure correction, colour balance, removal of dust specks (but nothing larger), minimal sharpening, and minor dodge and burn. Some accept cropping, others do not.

shape and crop

The ability to frame images precisely marked an important advance in photography. With rear viewfinder displays and live view in dSLRs, we can now frame and compose to the very edge of the image. This was all but impossible for film-based photography, yet the un-cropped image was sacrosanct. Ironically, our respect for the un-cropped image is fast dissolving.

cropping | the practicalities

The issue of whether or not to crop an image is at heart a question of how much you value its integrity. In eliminating parts of the original image, a crop changes the meaning of the picture: indeed, that is the main motivation for doing it. We remove what we regard as distractions, focusing attention on the subject by jettisoning parts of the image that we consider superfluous to the message. There are costs, however: an off-centre crop distorts perspective by shifting viewpoints, particularly in wide-angle shots, and crops reduce image quality by discarding image data.

> The issue of whether to crop or not to crop an image is at heart the question of how much you value the integrity of the image

You can resist cropping or accept it as a fact of life, particularly if you wish to see your images published: image proportions don't necessarily match the spaces allocated in page layouts. However, the best, middle, way is to try to frame your images with as much precision as possible: few things are as simply satisfying as a perfect framing that needs no alteration. Then, if you really have to, crop away. However, avoid crops which remove a large portion of the image as this will

significantly reduce the image data available, and therefore the image quality when it's enlarged.

distortion | and compensation

Digital photography allows you unprecedented power over the smallest details of the image, and that starts with its precise shape (see pp. 92–93). While you may not want to change the overall shape of the picture frame, it's still possible to change the shape of the picture within it by means of image manipulation. This is useful for modifying the distortion of the shape of an object caused by the image being projected at an angle to a sensor surface. This can happen whenever your camera is aimed obliquely towards a flat surface: part of the surface in view is closer to the camera, so it appears larger than parts of the image further away (see pp. 174–75).

A simple compensation, to increase the size of the part of the image that is furthest from the camera, not only makes an image look neater, it actually looks as it appeared to the eye at the time of exposure.

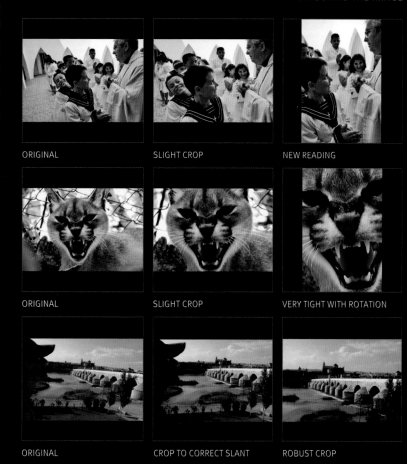

ORIGINAL SLIGHT CROP NEW READING

ORIGINAL SLIGHT CROP VERY TIGHT WITH ROTATION

ORIGINAL CROP TO CORRECT SLANT ROBUST CROP

crop and shape

1 is the original frame, cropped 2 to eliminate wasted space on the left, or cropped 3 for a completely different reading. 4 The original frame is improved by a tighter crop 5, but truest to spirit of the shot is a very tight crop 6 with slight rotation. The bottom row shows two ways of cropping a holiday shot with tilted horizon 7. You can keep the original image proportions and 8 crop on an angle to correct the slant, or 9 crop more vigorously to change the content radically.

reassessing priorities

The main attraction of cropping is to correct for framing that was too generous, or for accommodating second thoughts regarding the important elements in an image. In this case, we could choose to concentrate either on the boy alone or the girls together.

lightbox

exposure priorities

An image with a good range of contrast and colours can be exposed in many ways. In the left side of the split-screen below, one stop brighter than normal reduces contrast and brings out details in the top row of bottles. In the right side of the split-screen, normal exposure also produces acceptable results.

STOP EXPOSURE | NORMAL EXPOSURE

expose for highlights

An exposure for the highlights – that is, to keep highlight detail – offers the best result overall as the shapes of the bottle are clearly outllined against the intense colours of the lighting.

histograms

Digital cameras now give us as standard a tool never before available to photographers: statistical analysis of our images in the form of the histogram display of levels.

statistics | and LCDs

Many photographers pay attention to the histogram of an image only when they adjust image levels with the Levels control. In fact, because the histogram display shows the relative numbers of pixels covering the whole range of brightness values, it's a very valuable indicator of an image's ability to tolerate manipulation.

You may think that you need only look at an image to tell whether it is under- or overexposed; you don't need a histogram display to tell you. However, when you look at an image on a camera's LCD screen you see only a small subset of all the pixels making up your image. Even on a computer monitor, what you view is nearly always no more than a sample of pixels. These pixels have been averaged out (dithered) from the whole image, which can conceal problems. As a result, your image may look perfect when in reality it is full of noise and missing values.

histograms | irregular displays

Before you commence work on an image that involves tonal or colour changes, it is always good practice to check the histogram display. Where histograms show gaps with missing brightness values – that is, with no pixels – tonal transitions may be uneven. If you change contrast or saturation, smooth tone may separate out into bands – the effect is posterization. However, you can work safely if your image is full

of fine detail and does not rely on large areas of smooth tone.

It's often said that the ideal histogram shape is smoothly rounded, but there is no reason why luminance distribution in reality should be so even. However, if the histogram shows many spikes rising above a general shape, or if there is no overall shape, then your image is full of noise. This is seen most often with high-sensitivity images straight out of the camera.

Another kind of histogram display looks similar to the noisy histogram in having irregular spikes, but this time in a pattern or with discernible shape. Often called the "broken comb display", it's caused by excessive image manipulation, either in-camera or on the computer. An extreme form of the "broken comb" shows very few spikes or teeth: this is a sign of posterized

or indexed colour (limited colour palette) images. These use very few colours to make up the image, and the amount of manipulation you can do successfully is very limited.

clipping | compressed tones

The distribution of tones at the extreme ends of the histogram can reveal a different problem. If the histogram is heaped up at the left extremity it indicates clipping in the shadows. This means that a large number of pixels are pure black (with RGB values of 0, 0, 0): these can retain no detail, no colour, no tonal differentiations. Any attempt to shift values to the right – that is, to lighten the pixels – will result in a mush of dark grey, and usually reveal image noise. In practice, shadow clipping is not as difficult to work with as highlight clipping, as it's easier to accept completely black shadows.

Highlight clipping occurs when the histogram piles up on the extreme right edge, instead of trailing off towards the edge. This shows that a large number of pixels are pure white (with RGB values of 255, 255, 255). You may obtain this deliberately when making high-key images, but it's best to avoid in general photography as it's not possible to recover details from clipped highlights.

exposure | and contrast

In the Levels control, you can set exposure – the overall brightness – by changing the position of the middle slider, which also changes gamma – the contrast of mid-tone values. The Levels control also allows you to alter the clipping – moving the maximum white or the maximum black value closer together – which has the effect of increasing contrast. You can also change the black and white points to lower the image contrast.

healthy histograms
The image and histogram below shows an image full of mid-tones, and little else. Its slight lean towards the left suggests a little under-exposure. The night scene and its histogram (below middle) shows the predominance of black and lack of white appropriate for the image. Similarly, the large blank areas of white in the image (bottom) are correctly reflected in the extreme right-hand peaks of the histogram, with a few darker mid-tones.

histogram warning
The image below looks full of colour and detail, but its broken-up histogram shows that it is in fact very deficient in data, offering limited scope for manipulation. The image of the dog (below middle) also looks healthy, but its histogram reveals the result of heavy manipulation: what was once richly populated has now broken up. The histogram for the bottom image is dominated by clipped highlights; in-camera over-exposure has eliminated shadow values, indicated by the empty left-hand portion.

ALL MIDTONE SPARSE DATA
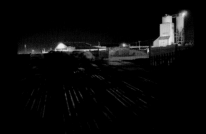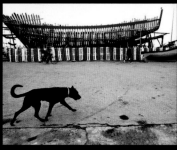
ALL DARK OVERWORKED
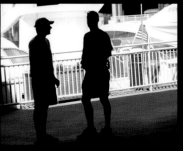
TOO HIGH HIGH KEY

rendering skin tones
The left side of the split-screen
below shows an exposure that is
strictly correct for the dark skin of a
school-teacher in India, but is overall
too dark. Using Curves, we retrieve
the white hair, as seen in the right
side of the split-screen, but the face
is too bright. We then clip the
highlights by forcing the white
values to hold a little density.

DARK LOOK | HIGH CONTRAST

curves and tone

It's a measure of how popular digital photography has become
that the Curves control, which was formerly a tool for the experts,
is now used confidently even by those with little experience in
image manipulation. Its appeal is not only in its ease of use, but
in its capacity for highly dramatic effects.

transfer function | pixel values

The Curves control is more accurately called the "transfer function" control.
It determines how the values of the pixels you start with (the input values) are
to be changed or transferred to become the output values.

Dark pixels can be made lighter, and the lighter ones made darker. This is why,
when you open the Curves control, it shows a 45-degree straight line: there is no
change between the input pixel values and the output values.

The Curves control can be set up so that the axes indicate the lightness or
brightness values: starting with black in the lower left-hand corner, progressing to
white. This is most useful for those working entirely with on-screen images, and is
most familiar to digital camera users. You can swap the axis around to indicate ink
density: the axis starts white in the lower left-hand corner and becomes black at the
far end of the scale. Working with ink scales is the most intuitive for those who
output to books or a desk-top printer.

When you change the shape of the curve, you can
change, for example, pixels input at the value 100 to
the output value 125. Depending on the way you have
set up the axes of the Curve control, with a higher
value your pixels may become lighter, or alternatively,
the ink density may be greater.

The result is that you change the way the image
reproduces tone – not only the actual brightness
value of each pixel, but also the rate of change
between them, changing the contrast. When you
draw a steep line in Curves, the contrast is increased:
this means that there are few intermediate tones
between light and dark.

colour | modes

While you can work with individual channels to
alter colour balance, you will commonly be working
with the combined RGB channels, since this changes
the overall tonality of the image. However, the
disadvantage of using the combined RGB channels
is that the combined three channels of RGB do not
amount to quite the same as the luminosity values
for the image. This means that, although you are

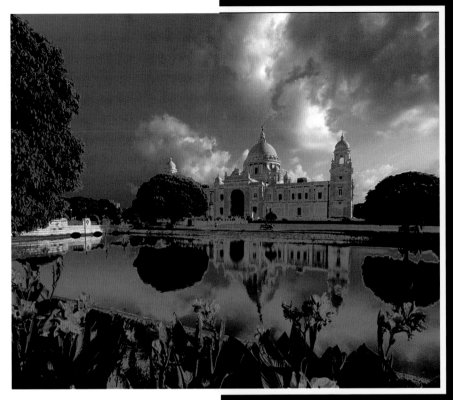

working in Lab mode

In Lab mode, the three channels are made up of three parts. The Lightness channel contains purely brightness information. The other two channels carry the colour information. As a result, manipulating the L channel in Curves only changes the tonality: even with quite extreme changes to the curve shape in the original (above), the new image (left) is largely free of colour artefacts.

changing all three RGB channels equally, because they do not contribute equally to the image, the effect of your changes on the colours of the image is not equal.

With the majority of images – where you do not wish to make drastic changes to tonality – this doesn't present a problem. But where the image is already compromised – perhaps because you exposed it incorrectly, where the luminance range is wide for the sensor, or the file is too small – even gentle changes in the shape of the curves can cause colour artefacts.

One method for avoiding luminosity artefacts, and also to provide more precise tone control, is to work on the Curves in Lab mode. Change your RGB image to Lab mode, then call up the Curves control and manipulate it as usual. Naturally, the axes will show Lightness. Once you have obtained the desired tonality, convert back to RGB.

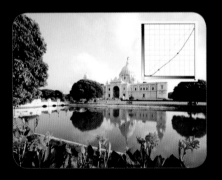

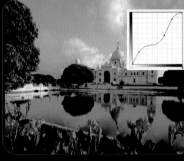

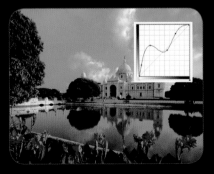

working in RGB mode

Using the normal RGB mode limits you to less drastic or dramatic changes to the image, as altering the RGB curve affects colours differently. The above left image was adjusted to appear as it was seen. Applying the strongest changes without introducing false colour gives the above right image. If we apply to the RGB image the same curve that delivered the main Lab mode image we obtain the distorted colours seen in the image left.

burn and dodge

The terms "burn" and "dodge" belonged to the photographic darkroom and were included in image editing software as a concept that would be familiar to photographers. Burning, or burning-in, meant darkening the image (or some part of it) by giving the paper extra exposure to light, while dodging made it paler by reducing the exposure to light.

dodging spheres

The original image (below) was taken during a partial break in the clouds on a dreary day. A gradient set to Color Burn applied from the top and bottom of the image dramatizes the sky but dulls the reflections in the polished steel structure (below middle). Heavy-handed application of burn to the skies and dodge to the structure leads to a striking image (bottom), but the colours are distorted and unconvincing. Modest amounts of burn and dodge improve the drama of the picture, while appearing true-to-life (main image).

tonal values | contrast

The Levels and Curves controls are powerful ways to control the tonality of images overall, and you can limit their effects to small areas of the image by using selections or masks. But the most convenient way to work on small areas is by using "brushes" – tools that apply effects just where you place them, and nowhere else.

It's useful to think of the Burn and Dodge tools not as ways to darken or lighten areas of the image, but rather to adjust their tonality or contrast. It's in the nature of our perception – described by the Weber-Fechner Law – that very dark or light areas in an image tend to appear low in contrast. The result is that, tonally, these areas appear dull or flat. When you burn-in you intensify density in a particular part of the image, thereby increasing its tonal separation from lighter areas – in other words, you increase local contrast. The same thing happens when you dodge.

using the tools | tricks and tips

There are two main secrets to mastering the Burn and Dodge tools. The first is that you must work with very low pressures; if your setting is in double figures it's probably too high. I seldom use pressures higher than 5, and for the image on this page the highest pressure used was 3 – most were at 1. This does mean that the effect builds up very slowly, but a slow build-up is the key to realistic gradients, and essential for avoiding overdoing the burn or dodge.

The other secret is to choose the opposite tone band to the one you wish to change. This means that if you want to darken a highlight, rather than setting Highlights for the Burn tool set Shadows or Midtones instead. If you wish to dodge

ORIGINAL

GRADIENT TOP AND BOTTOM

TOP AND BOTTOM DODGE

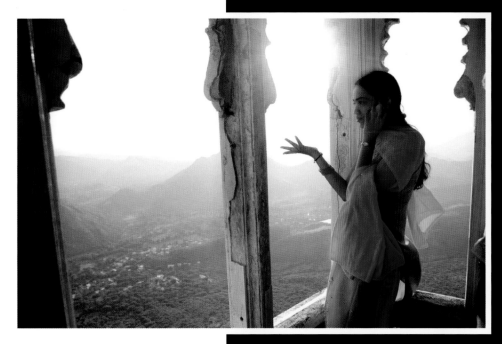

afternoon call
The tones of a mobile phone ring out in a castle high above the hills of Udaipur, Rajasthan, India. The shot has to be grabbed without any preparation – into the sun, flare hides detail and downgrades colour in the young woman's face and clothes. Careful burning-in brings colour back to her face and dodging brings out the airiness of her shawl. The countryside below was also very delicately darkened.

shadows, don't set Shadows for the Dodge tool, set Highlights or Midtones. And if you wish to alter the mid-tones, try setting the Burn tool to Shadows or the Dodge tool to Highlights. This technique maintains or enhances local contrast, whereas the obvious settings tend to lower – and muddy – the contrast.

Here is an extra trick: change your brush size frequently to adapt to the area you are working on. The temptation is to use a broad brush size to cover large areas quickly, but this smudges details and you will find yourself having to return to correct small areas.

advanced | blend modes
Another, more advanced technique is to paint your image with the brush set to a suitable blend mode. For strong burning-in effects, use a dark grey colour for the brush and set Color Burn or Linear Burn mode or any other darkening effect. For strong dodging effects, use a light grey and try Color Dodge or Linear Dodge mode, or any other with a lightening effect.

HIGHLIGHTS BURN

SHADOWS BURN

HIGHLIGHTS DODGE

SHADOWS DODGE

burn and dodge | settings
For darkening bright areas, Burn set to Highlights is too strong (top left); it is best set to Midtones. However, if set to Shadows (top right), the burn strongly increases contrast. When you set Dodge to Highlights (above left), contrast and sparkle is increased where tones are mid-tone and brighter. Conversely, Dodge set to Shadows and applied to tones at or darker than mid-tone (above right) causes contrast to drop rapidly, as the blacks are lightened to values that are too high.

white **balance** correction

Just how accurate your colours will be is not purely a matter of the available technology – it depends on how discriminating you are and how much trouble you are prepared to take. After all, you are the final arbiter of the ability of your system to record colours faithfully, from camera to print.

from shade to daylight
Here, the colour balance as shot captured the blue of the sky but failed to register the yellow-reds of the shop-window lighting. The balance was made overall warm, then blues were boosted using the Hue/Saturation control. The first small image below shows the colour balance as shot: it's a little on the cool side. If the white balance is changed to the Shade preset (7500 K) there is a pleasant warmth, but not exactly what was seen. Using the Daylight preset (5500 K) produces a colour balance that's too cold. In the main image, a sample was chosen that placed the balance in between these extremes.

AS SHOT

SHADE PRESET

DAYLIGHT PRESET

monitor display | accuracy
Even if you have taken a great deal of care over your colour settings, the colour balance of your image may not be as you would like it. The first step is to make sure that your monitor is displaying colours correctly. For this, it needs to be correctly set up (calibrated) and the system informed (profiled – see pp. 342–43). Make sure there are no lights shining onto the monitor, and that the surrounding walls are a neutral colour. Unless you have seen to these basic matters you cannot expect to be able to evaluate the colours in your image with any accuracy.

profiles | options
Before you judge the colours of your image you should also confirm that your colour management settings are suitable for the intended purpose. For the highest-quality work intended for publication, you should process your images as 16-bit colour in ProPhoto RGB space. However, many colours in ProPhoto RGB space can neither be displayed nor printed. The space most often requested by publishers is Adobe RGB

sampling points
Here, the black bag was
a surprisingly poor patch to
sample, giving very different
results according to where
the sample was taken. This
can be clearly seen in the
colour of the water. The white
domes of the Sydney Opera
House gave even more
inconsistent results. The
final image, left, was based
on a sample from the
tourist's white hood.

AS SHOT

BLACK BAG SAMPLED

OPERA HOUSE SAMPLED

OPERA HOUSE SAMPLED II

(1998) with 8-bit or 16-bit files. However, for the majority of users, sRGB gives the
most reliable results and is easiest to handle because all modern monitors can
display all sRGB colours. This means that you can expect the colour in a print to
match the image on your monitor.

white balance | mid-tone grey

Assuming your monitor is displaying colours accurately, you are now in a position
to correct the white balance. Ideally, you will have a patch in your image that is mid-
tone and spectrally grey, that is, one that reflects all colours equally. The best way
to guarantee this is to take a shot of a photographer's grey card at the beginning
of the shoot so that the light falling on the card is the same as that of your subject.

 With the image open, call up the Levels or Curves command and choose the
mid-tone dropper tool. Click this on the grey patch: if it is mid-tone there will be
no change in the brightness of the image, but colours will be changed to make
the patch grey, with all other colours in the image shifted round to match. In some
software, if the patch isn't mid-tone the dropper will also change the exposure so
that it becomes mid-tone. In others, the mid-tone dropper is designed to adjust
only the colour balance.

 If the tool requires a mid-tone target, you need to redefine the target colour. First,
measure the brightness of your grey patch, then set up a new target grey, one that
is not mid-tone: usually this requires a double-click on the mid-tone dropper for an
adjustment dialogue box. Adjust the grey point until it matches the brightness
of your patch. Click OK to set the dropper, then sample as before.

AS SHOT

GENTLE COLOURING

SUPER SATURATED

GAMUT WARNING

variable saturation

The top image, as shot, shows an acceptable range of colours. The second shows that an image doesn't have to be gaudily coloured to be effective. The super-saturated image catches the eye, but the red overlay in the bottom image shows that many of the colours in this version cannot be printed reliably.

hue and saturation

Of all the colour controls, Hue/Saturation is the most dangerously alluring. It's possible to create brilliant and gaudy effects, but in print the results would be disappointing.

colour | global and limited changes

The Hue/Saturation control also includes another control – Lightness. Together, these parameters are the most intuitive way to fully describe colour: hue (the colour name), saturation (the depth of colour) and lightness (how much white or grey is present in the colour). Hue/Saturation is, in fact, a method of correcting colour. However, the way colour is coded as RGB means that this control cannot easily remap colours around a central point such as a mid-tone grey.

The strength of the Hue/Saturation control, and its cousins in RAW converter applications, is in being able to make global colour changes very quickly and intuitively. Using the Hue control, you can shift the entire range of colours towards reds and violets in one direction or towards greens and blues in the other. The changes are based upon positions on the colour wheel, so the extreme positions on a slider will give the same result.

You can select limited bands of colour to change; according to the software, you can adjust the size of the band and also the transitional area where changes are less strong than in the central area. A note of caution, though – combining narrow bands of colour and large hue changes can cause artefacts and unwanted colours to appear.

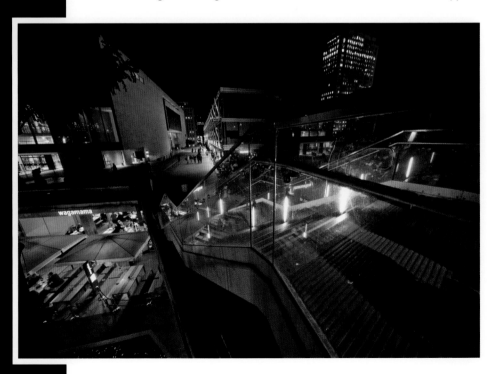

selective hue changes

When we shift the Hue to -20, reds and yellows are boosted nicely. In the opposite direction, the yellows turn green and foliage is boosted. Although the background appears devoid of colour, boosting cyans and blues shows that they are present. For the main image, cyans and blues were dialled to zero and all other colours boosted, giving a brighter result than the image as shot.

AS SHOT

HUE SHIFT -20

HUE SHIFT +20

HIGH CYAN + BLUE

saturation | controlling exaggerated colour

The Saturation control is a prime cause of strange colours in digital images. It's all too easy to crank up the saturation so that colours look amazingly vibrant on screen. Unfortunately (or maybe fortunately) these colours cannot be printed out. This can disappoint expectations of brilliantly coloured images and lead to disenchantment with the printing process or, worse, unnecessary anxiety that the printer is faulty.

Two techniques have been developed to deal with this. The latest is to limit the effect of the Saturation control to avoid clipping or the loss of strong colours. Going by other names such as Vibrance, some high settings avoid boosting colours that are already strong and also, specifically, skin tones, but continue to boost weaker colours. The older software response is to warn if the colours cannot be printed.

checking gamut | warning colours

Colours that cannot be printed (or displayed by a monitor) are said to be "out of gamut" for that device. You can check whether colours are out of gamut before you print your image. Within software such as Adobe Photoshop, set up for proofing (previewing on your screen the appearance of the printed image) and select the profile for your printer/paper combination. Make the changes in Edit > Color Settings.

You can now choose View Gamut Warning. If you have any areas which are over-saturated, these will be overlaid with a warning colour – often a bright red. Don't be too alarmed, even if your image shows large areas covered in warning colour: you may need to lower saturation only by a small amount to reduce the colour to within gamut.

Open the Hue/Saturation control and tone down saturation: you will see that the areas of warning colour shrink. However, if you reduce saturation until they all disappear, you will find that colours which were well within gamut are also reduced in saturation to an undesirable degree.

step by step: **enhancing tone**

The aim of this exercise is to learn how far you can take changes of the tonality and colour of an image yet maintain a sense of reality, that the image could have, in effect, been dramtically lit with a wonderful contrast of colours. The task is to create a possible world that is amazing yet could be true.

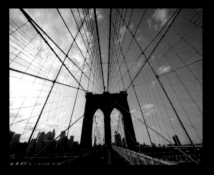

ORIGINAL IMAGE

1 appraising the original
For dramatic changes in contrast, colour, and exposure it is obvious an image such as this, of the Brooklyn Bridge, New York, is highly suitable as it offers clean lines and expanses of varied tone. Not so obvious is the need for high resolution and good exposure, in order to allow plenty of room for tonal manoeuvre.

RULER TOOL | TRANSFORM

2 correcting the horizon
First, extend the canvas so that the image can be rotated without being cropped. Select the Ruler Tool and draw a line along the picture's horizon. Next, go to the Edit menu and select Arbitrary in the Transform option. The dialogue box will show the angle that the picture will be rotated to. Select OK.

CROP TOOL

3 re-framing the image
Because correcting the horizon rotates the image, the picture will require cropping. Use the Crop Tool to make a selection of the desired aspect ratio – remove any unwanted parts of the canvas and frame the elements in position as you would when composing an image through a camera viewfinder.

SHADOW AND HIGHLIGHTS

4 improving highlight details
The sky in the left-hand side of the picture is over-exposed, but detail can still be recovered. Apply the Shadow/Highlights control on a duplicated layer. The shadow setting can be reduced to 0% but the highlight setting needs increasing until some detail in the cloud is recovered.

GAUSSIAN BLUR ON BLUE CHANNEL

5 boosting saturation
Noise is a particular problem in areas of continuous colour, such as sky. Software filters can reduce the impact, but an alternative is to slightly blur any noisy channels within the image. Slightly soften the Blue Channel, which usually contains the most noise, with Gaussian Blur, and leave the Red and Green channels alone.

SELECTIVE COLOR ADJUSTMENT LAYER

6 using colour selectively
To make the image more interesting and striking, Selective Color can be used to adjust the sky. By specifically selecting the blue and cyan tones in the Selective Color dialogue box, you can change the strength of colours that make up the tones. The results can be as subtle or as exaggerated as you want.

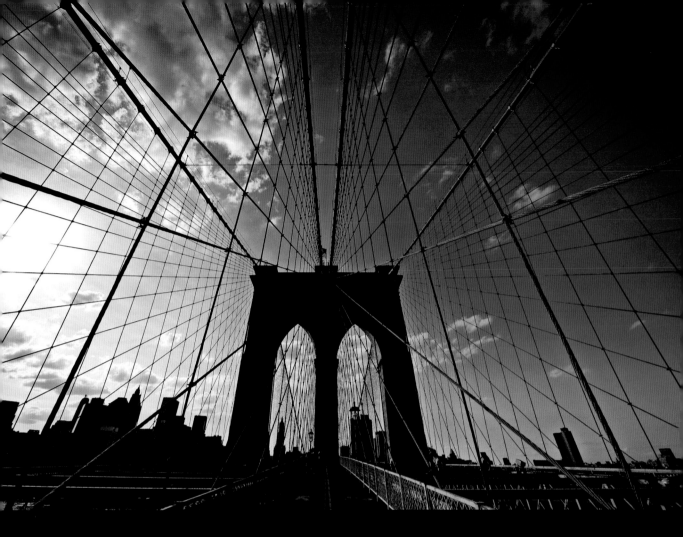

GRADIENT TOOL

MAGIC WAND

DARKENING WITH QUICKMASK

7 colour gradient

To enhance the sky, place a coloured gradient over the sky, and set blend mode to Multiply. The orange tones burn into the light shade on the horizon and colour the foreground elements of the bridge, while the purple strengthens the purples created

8 enhancing silhouette

Using the Magic Wand (or Pen Tool if you're feeling very meticulous), make a selection of the bridge and buildings on the horizon but avoiding the sunlit parts of the bridge. Apply a Curve to the selection to darken the bridge and emphasize the

9 applying a vignette

To improve the framing of the image and draw the viewer's attention into the centre of the frame, apply a vignette to the edges. Make a selection of the areas you want to frame using Quick Mask, or use an adjustment layer-mask with a feathered edge, and then

step by step: **adjusting shape and colour**

The ability to adjust the shape of an object is not new in photography. While the darkroom technique was difficult to do well, it is very simple and effective to adjust shape with digital manipulation – although it is no substitute for being in, and shooting from, the correct position in the first place.

ORIGINAL IMAGE

1 **appraising the original**
There are situations when the only way to get all of a building in view is to point the camera upwards. The resulting leaning effect can be corrected in a few simple steps.

EXTEND CANVAS

2 **enlarging the canvas**
First, make room for the transformations you need to make by extending the image canvas. Give yourself plenty of room so you will be able to easily use the transform tools.

DISTORT TRANSFORM

3 **adjusting vertical lines**
Select all of your original image, then select the Distort command. Pull the handles of the Transform box until the vertical lines of the building are parallel.

CLONING AND HEALING TOOLS

5 **filling the foreground**
The change in angle from the original has caused gaps to appear at the bottom of the image. Use the Clone Stamp Tool (S) to fill the gaps, taking parts of the ground that already exist and placing it in the gaps.

SELECTING AND DUPLICATING

6 **extending the building**
The building is missing elements on the left of the image. Reconstruct them using elements from the right-hand side. Select the areas, flip them, and then blend using a layer mask and a soft brush set to a low opacity.

OVERLAY | BLENDING MODE

7 **enhancing detail**
To bring out more detail in the stonework, duplicate the image to a new layer and set this to the blending mode of Overlay. This boosts darker tones and lightens the pale ones. Adjust the opacity as needed.

FREE TRANSFORM

4 **setting the axes**
The correction of the vertical in the image still leaves the building looking a little squashed. Select All and use the Free Transform tool to stretch out the vertical and horizontal axes, without sideways distortion.

SELECTIVE COLOR

8 **enhancing colour**
Use a Selective Color adjustment layer to bring out more of the yellowish tones in the stone work. This enhances the shadow areas to make details stand out. Lighten the neutral tones to further bring out the paving.

AS SHOT

NOISE REMOVED

reducing noise
The top detail is as shot, and shows a high level of noise typical of a high-resolution small-sensor camera. A strong application of noise reduction smooths out the noise, but doesn't increase the amount of detail in the image.

low light noise
The noise level of this image is very high due to the high ISO setting needed. But at this size the image doesn't suffer because it's packed with detail – high-frequency data that isn't much larger than the noise itself.

noise and dust

All digital photographers have to deal with noise and dust. Noise grows as a problem when sensors become too small for their pixel count and as we set ever higher sensitivities. Dust has become a nuisance only with high-resolution sensors: in the early days of digital, we didn't even notice it.

noise | and image quality
The bad news is that noise is an integral part of the genesis of the digital image. We cannot get away from it any more than we could obtain a grainless film. Noise arises from, among other things, the nature of the electrical current, and the fluctuations of heat energy interacting with electrons as well as interactions between electronic components.

The effect of noise, even where it isn't very visible, is to decrease image clarity – its random nature, independent of image features, muddles and confuses detail. It also tends to decrease colour saturation and reduce the maximum density

attainable in a print. Noise is generally more evident in lower mid-tones and shadows, and in areas of even tone, than in lighter or detailed areas. Not only is it undesirable in itself, it has the unwanted side effect that image files are also much larger than those with less noisy images.

Now, when we increase sensitivity by using a higher ISO setting on the camera, we are, in essence, amplifying the signal to the sensor. This process tends to increase noise further by making it more visible.

software | solutions
While the best modern cameras are extremely successful at reducing noise, even they cannot eliminate it altogether. Many less sophisticated cameras produce very noisy images, which increases rapidly with increased sensitivities. Consequently, software applications are designed to reduce noise by applying algorithms that analyse the image to preserve true detail while removing random artefacts. The

noise reduction
In the sequence below, which shows an enlargement of a small portion from the lower edge of the main image (left), noise in the original image (below) has been reduced by Noise Ninja software but with good detail preservation (middle). Simple red and blue channel blurring (bottom) reduces noise but loses detail.

The problem is that as image resolution improves, image noise is around the same size as fine detail. Therefore reducing noise tends to reduce fine detail as well.

Modern image manipulation software offers noise reduction filters, as does all RAW converter software. The program DXO Optics Pro takes a different approach to the problem by removing noise before it applies the colour processing. You can also use specialist software such as Noise Ninja: this is based on the noise profiles of a range of camera models. By basing noise reduction on individual sensor characteristics, the algorithms can apply a very light touch to noise reduction.

dust | pre-empting the problem

The key to dust reduction is to try to avoid it altogether. This is one of the big advantages of using cameras with fixed lenses. If you use dSLR cameras, dust is a part of life, even with cameras incorporating sensor cleaning systems. Dust does not lie directly on the sensor but on the protective plate, so specks are not sharp-edged but usually appear as blurred dots. As a result, they may not be immediately visible when you open an image.

The best strategy is always to assume there is more dust on the image than you are able to see. The smallest specks remain invisible until you apply sharpening or increase image contrast. You can pre-empt the problem by increasing image contrast using an Adjustment Layer to reveal the dust specks as dark dots.

invisible mending | dust removal

The standard tool for removing dust from an image is the Clone Stamp tool. However, copying an adjacent part of the image onto the dot easily produces artefacts. Tools have been developed in modern software which sample the contiguous area – immediately around the dot – and fill it with the contiguous pixels. This produces invisible mends but it creates artefacts if the speck lies on a pattern such as netting or near a hard edge. For these dust specks, the Clone Stamp is best. You can set its blend mode to Lighten, instead of the usual Normal blend, when removing dots lying on light areas.

AS SHOT

NOISE NINJA

CHANNEL BLURRED

sharpness and blur

When mathematicians learned how to simulate the effect of a darkroom technique by using numbers, the now-vital technique of image sharpening was born. While all physical processes tend to blur the image, sharpening helps reverse the appearance of blurred images.

sharp | techniques

The darkroom trick involved creating an unsharp copy negative of the main image, then printing the negative held in register with the unsharp negative. This acted as a mask – the unsharp mask – which helped emphasize edge detail. While images can be improved with sharpening, they can equally be spoiled by oversharpening, which causes the appearance of artefacts such as haloes around objects, and leads to the creation of exaggerated noise.

The first rule of successful sharpening of the whole image is to use only the Unsharp Mask (USM) filter in your image manipulation software: this allows sharpening effects to be matched to the characteristics of your subject. USM works by applying small contrast increases at object boundaries. These contrast boosts applied over a larger area can enhance contrast in a way difficult to obtain by any other means. You simply set a high Radius but very low Amount.

When using USM, the control with the largest effect is the Radius setting. If your image is full of details, set a small Radius. If, on the other hand, it has large areas of smooth tone, set a larger Radius. A good starting point is an Amount setting of

sharpening settings

In the split-screen image below, the left half shows the effect of Sharpen More – there are too many artefacts. The right half shows Unsharp Mask applied to the image, which gives a cleaner result but some artefacts.

SHARPEN MORE | USM

AS SHOT

sharpness and size

The image as shot (above) is slightly soft due to the long exposure, but a viewer will judge it to be sharp provided that a few sparks and details of the welder are rendered sharp. For the main image, Unsharp Mask was applied using an Amount of 111%, a Radius of 11, and a Threshold of 1, applied to the L channel in Lab mode, which gave the best overall result.

AS SHOT

sharpness and size

As shot on a point-and-shoot camera (above), the details of the building conflict with the statue. A blur would bring the sculpture into prominence. First, select all but the sculpture. As the background exists at an even distance, you can apply a uniform blur to obtain a realistic effect. Allow the very edge of the sculpture to blur a little too: it should not be too sharp.

111, a Radius of 1, and a Threshold of 11. To refine the effect of USM further, apply it to the Lightness channel in Lab mode. This concentrates sharpening on the channel carrying detail, thus helping to minimize artefacts and reduce the sharpening of colour noise. For this to be possible, you need program software that can work in Lab.

sharpening | lightness channel

Assuming your software can work in Lab mode, change your image mode to Lab, choose the L channel in the channels palette, apply the USM to just this channel, and then return the image to RGB mode. A disadvantage of this method is that you have to judge sharpening effects with a black-and-white image as the L channel shows only brightness distribution.

USM should be applied only after you have completed all other manipulations. This is because USM sharpening, paradoxical as it may sound, actually destroys image data, which cannot afterwards be regained. This is why in-camera sharpening is not a good strategy for the highest-quality images. After you have applied USM sharpening, you should recheck Levels and adjust if necessary.

positive blurring | useful situations

While sharpening techniques are aimed at reducing blur, there are times when it may be useful to increase blur. For example, you may wish to achieve an apparent decrease in the depth of field to make the subject stand out more from the background. To do this, select the whole area behind the subject and apply a small amount of blur. For parts of the background that are further away, select those parts and apply a stronger blur. Increasing the blur of the background can also be used to make softly focused subjects appear to be sharp by comparison.

AS SHOT

BLURRED

reverse tilt blur

Applying strong blur to reduce the apparent depth of field by unusual amounts has the effect of making a scene appear to be a scale model, consistent with the reduced depth of sharpness. Use a gradient mask to protect a central area to be left sharp, then apply a strong blur.

refined **sharpening**

Sharpening techniques reduce the blur effects caused by the picture-making process – imprecise focusing, movement of the camera or the subject, or alignment of the sensor with detail. But because sharpening can also make visible some unwanted features, we need to sharpen selectively.

scanned image

The image of an Independence Day parade in Bishkek, Kyrgyzstan, scanned from a 35mm transparency, was sharp but grainy (below). It needs more sparkle, but without causing the grain to be emphasized at the same time. So we need to limit sharpening to the edges of important detail, as outlined by the Find Edges filter (below middle). The result of applying an Amount of 200 and a Radius of 5 is seen in the main image. If we were to apply these settings globally to the image the result will be a very grainy image (bottom).

USM | selective sharpening

Suppose your image contains large areas of sky or water that are cleanly separated from fine detail such as trees and grass in the foreground; you don't wish to sharpen the clouds, only the foreground. You can achieve this by selecting the foreground with the Marquee or Lasso tool, then applying Unsharp Mask (USM) sharpening. Alternatively, you can apply a gradient with maximum in the sky reducing to zero just below the horizon, where the foreground details begin.

Selective sharpening is essential when working with portraits, as you will not want to sharpen any blemishes. To sharpen eyes, for example, use Quick Mask mode and use a soft brush to paint round the eyes. Exit Quick Mask and invert so the selection is on the eyes. Apply light amounts of USM to sharpen the eyes and eyelashes. While we most frequently work with softly feathered selections when sharpening, with portraits it may be necessary to make quite precise selections to avoid artefacts being created at the edge of your selected areas.

GRAINY AS SHOT

FIND EDGES

GLOBAL SHARPENING

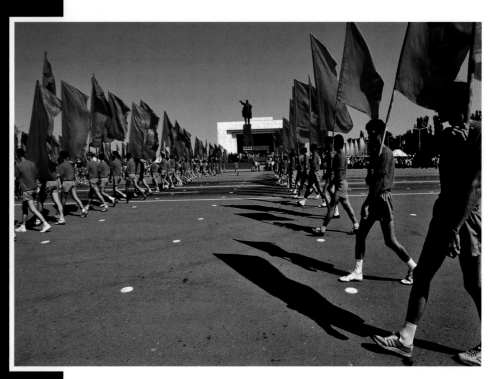

find edges | limiting the effect

A useful way to limit sharpening effects to edges is to use the Find Edges filter. This locates and highlights edges in the subject, creating a selection that limits USM to the major subject boundaries while leaving other areas untouched.

Before applying Find Edges, duplicate the background layer. In the duplicate layer, select the channel carrying the spatial information (usually the green), then apply the Find Edges filter. This produces quite sharp lines, so soften the Find Edges image a little, using Gaussian Blur.

Invert the image you have just softened so that now the white areas define the areas to be sharpened. Then load this as the source of the selection (menu: Selection › Load Selection). The black areas are masked while the white areas – unmasked – are selected. The selection may fail to load if contrast is too low: if so, use Levels to make a high-contrast, clean-cut mask where black is black and white is white.

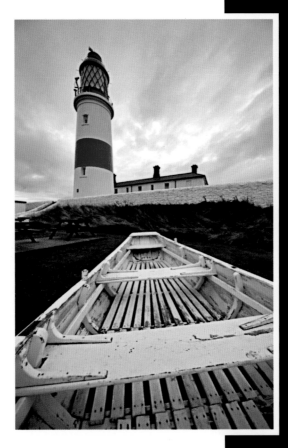

Now apply USM sharpening – it will be limited by the selection to the edges of your image and will ignore all other parts. This technique is particularly useful for sharpening scans of transparency film as it avoids sharpening the film grain.

high-pass filter | sharpening fine detail

To mask out low-frequency data (large areas of tone are low-frequency) and to let through only high-frequency data, that is, only fine detail such as edges, use a High Pass filter. The strategy, again, is to limit sharpening to the fine detail, but this time using a blending mode which works with the masking effect of High Pass.

First, duplicate the background image. Set the blend mode of the duplicate layer to Overlay. Next apply the High Pass filter to the duplicate layer: the image is likely to look immediately sharper. Adjust the Radius setting and Opacity to control the effect. You may also try different blend modes such as Soft Light or Pin Light for softer sharpening, while Hard Light or Linear Light give very hard results.

Using High Pass is very useful on images with high JPEG compression, as you can easily evaluate the balance between sharpening artefacts and true image detail by watching the changes as you alter radius and opacity. You can also add to the High Pass layer by painting with a mid-tone grey to remove areas from sharpening. The disadvantage of this filter is that it usually causes a tonal change, so you will need an additional step to return its tonality to the original state in Levels or Curves.

ORIGINAL IMAGE

HIGH PASS | RADIUS 5

HIGH PASS | RADIUS 20

HIGH PASS | RADIUS 10 OVERLAY

high-pass sharpening

The original image (top) offers both detail, and large plain areas. High Pass Filter on a duplicate layer selects the edge of high-frequency detail. A small radius closely defines edges, while a larger radius creates a halo effect. With the duplicate layer set to Overlay the sharpening effect is obvious. For the final image (above left), the Vivid Light mode reduced to 34 per cent opacity was used.

step by step: **clean up and sharpen**

Sharpening images by using sharpen filters, unsharp mask, or other digital techniques will come to you so easily that you must be careful to master the tendency to over-sharpen. Doing so makes an image look less natural and more manufactured. Equally, cleaning up an image can be taken too far, with the result that your subject can look scrubbed and polished.

ORIGINAL IMAGE

1 appraising the original

This picture is full of subtle textural variations. The soft fur has lots of detail in it, as does the bark of the tree. This contrast of soft and sharp can be further enhanced to give the image greater clarity. At the same time, the distraction of the netting in the background can be reduced.

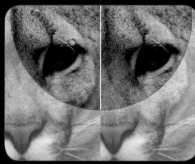

HEALING BRUSH | CLONE TOOL

2 cleaning up the image

First, clean the image using the Healing Brush (J) and the Clone Stamp (S) tools, removing unwanted items such as the tick above the puma's eye. When working on such a complicated surface, take your time and work at high magnifications to avoid blurring the texture of the fur.

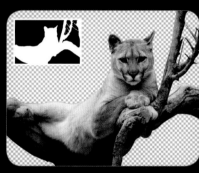

PEN TOOL

3 separating the elements

Separate the foreground from the background to make it easier to apply adjustments to specific parts of the image. Duplicate the original image, then draw a path around the foreground elements with the Pen tool (P). This makes a selection that can then be turned into a layer mask.

IRREGULAR SHAPED BRUSH

4 softening the mask

To make the blend between foreground and background elements look realistic, you need to rough up the edge of the mask to allow the fur to show through. Use an irregular shaped brush called Grass. Painting with this brush along the edge of the mask mimics the irregularities of the fur.

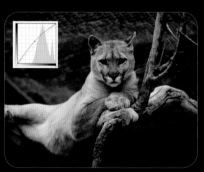

CURVES

5 darkening the background

Now that the foreground and background are separated, it's easy to adjust the colour of the specific parts. In this case, darken the background using Curves. This brings the puma out of the background and further into the foreground of the image, where all attention can now be focused.

MORE CURVES

6 adjusting eye colour

The colour of the cat's eyes are quite flat, being hidden in a brooding shadow. Give the yellow colour more impact using a Curve. Limit its effect by using an adjustment layer and a mask. This allows very localized colour adjustments, which can be corrected again later if needed.

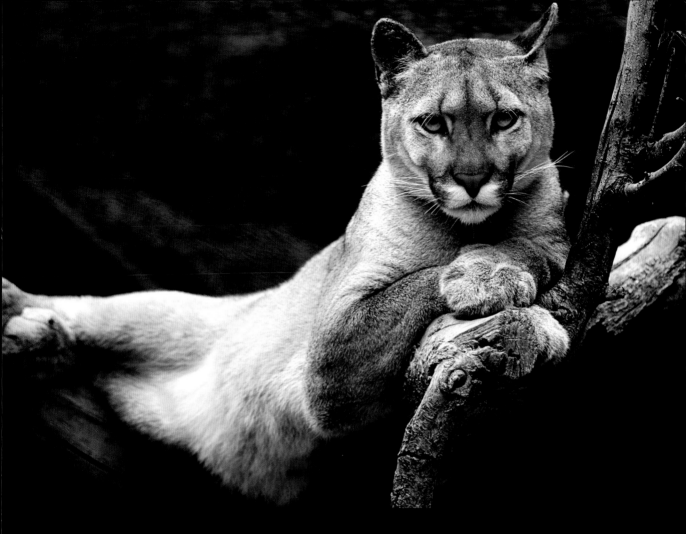

SELECTIVE COLOR

DODGE AND BURN CURVES

HIGH PASS SHARPENING

7 using selective color

Bring out highlights in the fur, eyes and tree trunk by using the Selective Color control to reduce levels in the white tones. Boost the yellow tones to bring more out of the eyes, and to warm up the colour of the fur. By reducing the cyan tones, the picture gains a warmer overall feeling.

8 balancing tones

Create two Curve adjustment layers (one set to darken and one set to lighten). Using a soft brush on the mask of the lighten Curve, dodge highlight areas in the fur and eyes. Use a brush on the darken Curve to burn shadow areas and the background. This balances tonality to bring the cat forward.

9 sharpening the edges

Apply the High Pass Filter to a copy of the image. Within this image you can begin to make out the edges of the textures in the images. Apply this layer to those beneath by setting the blending mode to either Overlay, Soft Light, or Hard Light. Apply the texture within to give the impression of increased sharpness.

RAW options

As shot (below) this image of a city street is accurate enough but lacks impact. The next image below shows Fill applied to lighten the shadows. This was then combined with Recovery to put density into the highlights. By increasing the Brightness settings (bottom) we increase density and mid-tone contrast without losing details. The fully processed image (main) has strengthened colours with good details, both in shadows and highlights, as well as sharpness.

AS SHOT

FILL

FILL AND RECOVERY

RECOVERY AND BRIGHTNESS

working in RAW

The subject of RAW files generates perhaps more controversy and confusion in digital photography than any other. Exaggerated claims are made for RAW's advantages and it certainly has great merits, but working in RAW slows down operations and there's potential for misjudged conversions.

RAW image | unprocessed data

A RAW image is like research that's waiting to be analysed. Imagine that you have just completed a survey: you have piles of data to analyse before you can draw any conclusions. Crucially, someone else could study your data and reach slightly different conclusions, provided the data is intact. A RAW image file follows the same principles: the data is waiting to be processed, but different processes can extract slightly different results – some obtain better colour, others more detail, and so on.

To continue the analogy, just as only you know exactly which pile of files contains particular data from your survey, so the RAW files created by cameras have their own way of organizing the information. As a result, there is no single RAW format; each camera may have its own particular methods.

The DNG format has been proposed as a common platform for RAW files. In fact, it does not reorganize the data, but just wraps it with information about its structure – rather like putting all your research files in a big envelope with a contents list.

RAW conversion

Working in RAW appeals to those who examine images in close detail. Not only can RAW converters recover tones in what appear to be blank highlights (below and middle) but the combination of smooth tones and fine detail is unrivalled (bottom).

BURNT HIGHLIGHTS

HIGHLIGHTS RECOVERED

DETAIL AND SMOOTH TONE

advantages | and disadvantages

We have seen that whenever you want the greatest flexibility with an image, the best strategy is to set your camera to record RAW files. You work with the largest file your camera can muster, and don't commit to white balance, colour space, or sharpening. Some cameras store RAW data with more detail than the usual RGB file, that is, with 30 or more bits of data instead 24. This again allows more room for manipulation.

However, the files are much larger than even the highest quality JPEG equivalents. You need to convert the files before you use them, and some cameras become very slow when recording in RAW. In short, the flexibility gained from working with RAW files is balanced by the slower and more labour-intensive workflow.

The need to convert RAW files before the images can be viewed is a nuisance. To work around this, many cameras save a small JPEG version alongside the RAW file to allow you to view it on the LCD screen or your monitor. This preview image applies standard camera settings and, typically, the result is bright and cheerful – in contrast to the unadjusted RAW image, which may give the impression that the JPEG file is superior.

RAW | conversion and saving

To make the most of RAW files, you need to convert them into a standard image file in TIFF or JPEG. RAW converters vary in their features such as ease of use and speed, and – because their interpretation of the data varies – also in the quality and character of image they produce. Some work conservatively, producing relatively flat-looking images; others produce punchier, more colour-strong results. They also vary in their workflow methods: some require files to be accessioned into a library, while others work directly on files in their current location (see also p. 343).

Finally, a vital point: the original RAW files should remain untouched throughout all your changes. When you save them it must always be to a new file – the processed image. It is at this point that you tell the file which colour space to operate in. This means you can return to the original RAW file and make new adjustments without fear that your earlier adjustments may have compromised the integrity of your image data.

fact file

There are two types of colour fringing seen in digital images. One is due to chromatic aberration, which causes the red-yellow image to be a different size from the blue-green image. The other type is caused by defects in the way the electronics calculate the colour information.

artefacting details

This scene, in Bhutan, is hugely demanding on the equipment: it contains both extremely fine details, such as the stalks of rice, while the scene luminance range is wide – from dark clothes to directly sunlit areas. Details seen in digital images may not truly represent features in the subject: fine, repeating patterns may be doubled up or shift in colours. The varying handling of fine details by RAW converters is shown below.

ADOBE CAMERA RAW

APPLE APERTURE

DXO OPTICS PRO

PHASE ONE CAPTURE ONE

processing RAW images

The steadily growing popularity of working with RAW images has created a lively technology. Aimed at delivering the best in image quality together with ways to make the process easier to understand and more fully automated, modern RAW converters are a new secret weapon of photographers.

RAW converters | demosaicking

In the majority of digital cameras, when the image is first captured, each pixel carries data only for either red, green, or blue. The process of obtaining a full triad of colour data for each pixel is called "demosaicking". Missing data is calculated from an analysis of other, neighbouring values that are known. There are many ways to do this, which results in the varying flavours of image produced by RAW converters.

However, these differences are clear only at high magnifications – 100 per cent or more with large files. As the basic premise of working with RAW images is that you wish to obtain the best possible quality, you need to choose your RAW converter with care. The software programs featured in the test shots here are all generally accepted as capable of producing professional-quality results.

batch | processing

Another important feature of modern RAW converters is their ability to apply one setting to a number of images automatically, which is known as batch processing. It does take some confidence and experience to apply one setting to dozens of

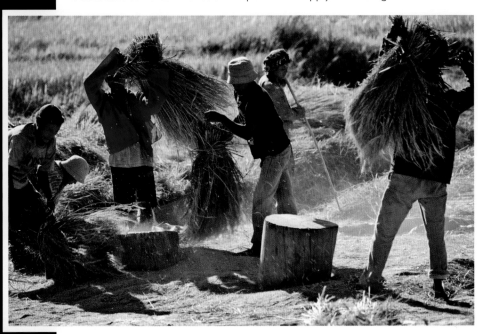

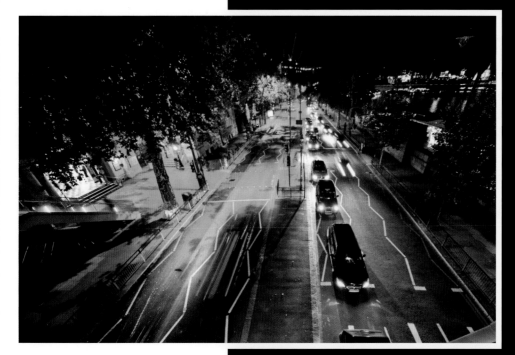

high sensitivity
Combining the extremely high sensitivities of modern digital cameras with the ability of RAW converters to remove noise gives us unprecedented quality in low light levels. However, as noise strongly erodes image detail, it's important to work with the largest possible files as the file size itself helps reduce the effect of noise on the final image.

images, but the rewards are well worth having. The first step is to work out the best settings for one image, knowing that the others were shot in similar circumstances. Save the setting, then choose the other images and process them all in a single batch, applying the settings – exposure, contrast, fill and recovery, white balance, sharpness, noise reduction, and so on. You will create a new set of files that will look far superior to those a camera produced – and so they should, for you have made all the decisions yourself.

Most importantly, the original files remain, so if you change your mind you can always return to the originals and reprocess them for a completely different result. In fact, as RAW converters improve, it may be worth taking the trouble to reprocess previously satisfactory images in order to obtain even better images, with less noise and more sharpness. Therefore, while you should be careful about deleting any file, you absolutely should not delete a RAW image file.

AS SHOT

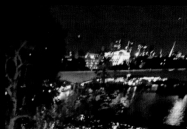

DXO OPTICS PRO

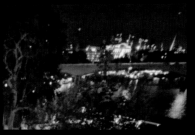

ADOBE LIGHTROOM

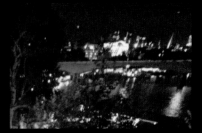

DIGITAL PHOTO PROFESSIONAL

handling noise
This detail (top left) shows the high level of noise in the original image. DXO Optics Pro (top right) shows highly effective noise reduction with good detail retention. When processed by Adobe Lightroom (above left), the black point suffers a little, giving the appearance of a "thin" image. Lastly, Digital Photo Professional (above right) shows relatively poor results.

Assignment: **basic image enhancement**

The ideal to aim for in any type of photography is the image that needs no work whatsoever – no enhancements, no improvements, no tweaking for personal preferences. This way you can spend your time on more creative things than sitting in front of a computer. While images that emerge from modern cameras actually need remarkably little work, it is right to give in to the urge to improve them just a little more.

ORIGINAL

the**brief**

Start with a photograph that looks promising but is flawed in some way – for example, it might be under-exposed, poorly composed, or was recorded with an incorrect white balance. Use basic enhancement tools (Levels, Curves, Color Balance, etc.) to make it "perfect", including suitable sharpening and removal of minor blemishes.

Points to remember
- Learn the keyboard short-cuts to access commonly used commands to save yourself time, effort, and reduce risk of repetitive strain injury
- Work on a calibrated and profiled monitor screen
- Work with a screen free of clutter from palettes
- Use a plain grey wallpaper background for your screen
- Use Adjustment Layers, if available in your software, to avoid loss of quality with cumulative changes

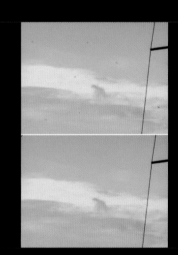

HEALING

must-see masters

Colour experts
While colour correction in image manipulation software is a central concern, few truly understand the inter-relation between software, visual psychology, and creative vision as well as Bruce Fraser and Dan Margulis. Their works on colour are highly recommended.

Retouching experts
There are numerous highly skilled retouching artists in the world, but few who are able to communicate their skills and are willing to explain their work processes. These authors offer varying approaches: Bert Monroy, Karin Eismann, Suzette Troche, Steve Caplin.

Photoshop experts
Being called a Photoshop expert was once a rare accolade, and while there are now numerous experts, few have a broad command of the software. For this, consider works by David Blatner, Scott Kelby, or David Biedny.

HIGHLIGHT

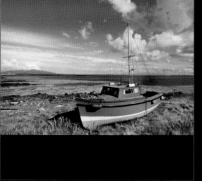

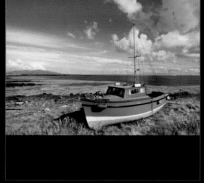

LEVELS

COLOUR BALANCE

CLONE TOOL

SHADOW

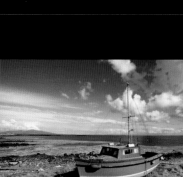

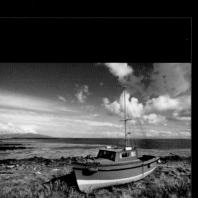

top**tips**

1 **landscape** | view
This autumnal scene was captured in a shot that was slightly over-exposed, but otherwise offered promise to be improved by a more varied palette of tonal contrasts.

2 **levels** | adjustment
The Levels control is the fundamental control for the exposure or lightness of the image. The mid-tone slider adjusts exposure without affecting black or white points.

3 **colour** | balance
The evening light of the original image gave an overall warm colour cast. By correcting this using the grey dropper tool or Color Balance, the sky blue is intensified and the autumn leaves now appear brighter.

4 **5** **removing** | defects
Examined closely, the image has small defects in the sky which we clean with a Healing tool, and a speck-sized boat which we remove with the Clone tool set to Darken.

6 **shadow** | fill
The boat's shadow is a little too heavy for the airy atmosphere of the shot. We use the the Shadow/Highlight control to fill the shadows with a little light.

7 **8** **highlight** | recovery
In 7, we recover a little density into the white using Curves, but are careful not to clip the whites. To balance this, we select the foreground 8 and lighten it by applying Curves.

9 **finishing** | touches
The image looks a little too evenly lit, so we select the Dodge tool to lighten the sea and use the Burn tool to darken parts

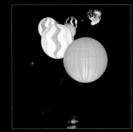
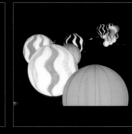

It's worth repeating that the best way to enhance or perfect an image is at the time of photography. This does not exclude recording in RAW format, because you can set up pre-sets to process your images automatically. The key is to control as many elements as possible so that just a few seconds' work at the computer – a burn or dodge to improve the tonal balance, an application of Unsharp Mask to the Lightness channel, a slight adjustment of the white balance or exposure, and so on. That is all the attention your image requires.

Singapore harbour front

Max worked hard for this shot. He used a tripod from a nearby bridge in order to shoot with a long lens and small aperture for good depth of field. Due to the low light and resulting long exposure he had to wait for gaps in traffic on the bridge to avoid movement of the bridge causing camera shake. But that was only the start: the right exposure had to be chosen to allow just enough shadow detail to capture the mood of the people sitting by the water without blowing out the light of the lanterns. A little touching up in postproduction perfects the image.

fountain portrait

The key to this shot is the apt choice of exposure: just perfect to capture a little motion blur of the water without the individual drops blurring into a milky mass. But the initial exposure was a little too light, so it was necessary to darken the water slightly without darkening the girl whose skin is already quite tanned. The result is beautifully balanced.

bluebell baby

A distant portrait of a child is an obvious candidate for a crop that takes us closer. On the sunny day the face was overshadowed by the sun hat, so Annabel lightened and improved the contrast and colour of the baby's face.

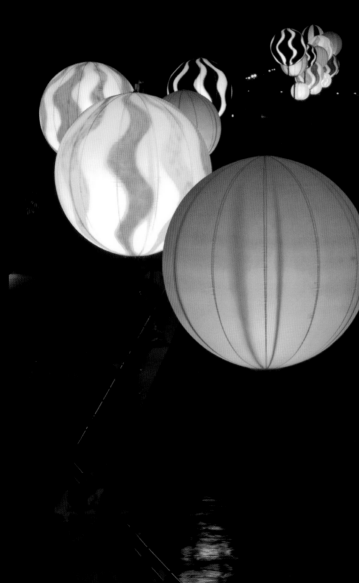

▲ Canon EOS 350D ISO 200 Focal length 200mm 0.8 sec at f/20.0

fountain portrait
Janet Baker

"The light on the water was fantastic and it was so hot and my friend said 'Wouldn't it be great to stand under that'."

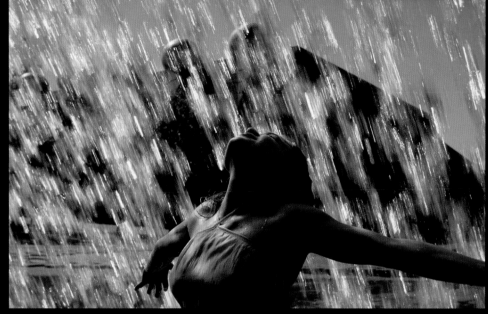

▲ Nikon D7 Focal length 35mm f/5.6

bluebell baby
Annabel House

"Every time we tried to get closer, he'd crawl away, then look back to see if we'd followed. We took the shot from a bit of a distance in the end."

▲ Nikon D70 Focal length 70mm f/4.5

manipulating the image

There is some irony that the digital era is when we discovered more subtleties in the black-and-white image than were ever apparent in the heyday of film. Central to this is the way we define and describe colour digitally. This has opened the image up to more ways of being altered – and simply played with – than offered by all the previous darkroom processes put together.

fact file

The red, green, and blue channels in your image (or cyan, magenta, yellow, and key black) are essentially greyscale images. You can assign any colour to them or swap them around – the resulting image will be different in colour but identical in outline, showing that the channels are actually grey.

colour to black and white

The earliest photographs converted the colours of our world into a map of lightness and darkness: every hue was turned into a tone of grey. At first it was assumed that all colours were equally reduced but it was soon discovered that there were sharp differences in the response of, say, greens and blues – and films varied in how they recorded them.

hue | and grey

Although we are now surrounded by billions of colour images, the attraction of the monochrome image is as strong as ever. The native, or natural, image in digital photography is in colour – and starting with colour gives us wonderfully powerful ways to vary how we convert to black and white.

> ❝ the attraction of the monochrome image is as strong as ever ❞

Monochrome conversion is a way of mapping values of colour to a greyscale from full black to full white, with all the grey tones in between. Different colours in the image can become the same grey when converted to greyscale. So, for example, a bright green can be mapped to the exact same grey as a bright red, or a light blue, which means that the distinction between colours can be lost or greatly reduced on conversion. The film-based technique to prevent this was, we now realize, extremely crude: we placed filters – fixed in colour, naturally – in front of the lens so that it would darken colours that were complementary to the filter. Consequently, a red filter made deep blues appear nearly black, for example. The digital equivalent is to vary the brightness weighting assigned to a colour.

RGB channels | controlling weighting

The standard way to convert colour to black and white is to give different weightings to the RGB channels, recognizing the fact that green colours appear the brightest, while blues appear darkest. Typically, RGB images are converted to a ratio of around 30:60:10 RGB – 10 per cent of the value is derived from blue, 60 per cent from green and 30 per cent from red. Conversion to greyscale isn't the same as desaturation, which reduces all colours equally to grey.

Naturally, the standard conversion doesn't suit all subjects. If you would like red flowers to be brighter than the leaves, use a weighting that favours the red channel and downplays the green. One way to control the weighting of channels for conversion is to use Channel Mixer, which, while primarily a colour adjustment tool, can output monochrome images. Varying the red, green or blue channels allows you to alter the overall exposure. With some conversion tools, you can alter the balance of yellow, magenta and cyan conversion for an even greater range of effects.

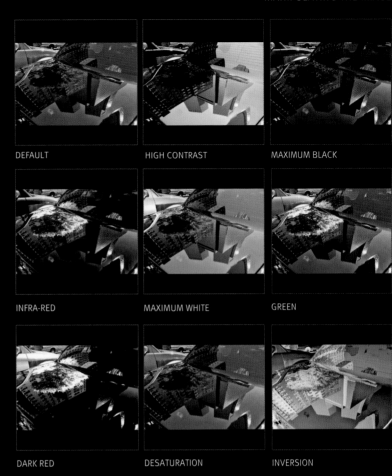

DEFAULT

HIGH CONTRAST

MAXIMUM BLACK

INFRA-RED

MAXIMUM WHITE

GREEN

DARK RED

DESATURATION

INVERSION

monochrome effects

① ② ③
④ ⑤ ⑥
⑦ ⑧ ⑨

light**box**

The above set of variations displays the range of black-and-white effects from a colourful image. The default conversion **1** is changed by darkening reds and brightening blues **2** to obtain high contrast. **3** results from allowing all colours to be dark. **4** simulates infra-red by minimizing blues and emphasizing reds. **5** allows colours to be light, giving maximum white. **6** simulates a green filter and **7** a dark red filter. **8** weakens the colours before converting to monochrome. **9** is the inversion of the default conversion **1**.

colourful original

The more colourful the original that you convert to monochrome, the more variation you can produce with the Channel Mixer or Black & White tool.

black-and-white settings

The original colour image was first converted to black and white in the Black & White adjustment control. The first image below shows the result of Auto plus sepia. The second shows the result of setting cyan and blue to maximum strength and green to minimum, while the third uses a balance of yellow and green. The bottom image imitates a gold tone with strong red and magenta values settings. The main image results from imitating the behaviour of infra-red film, which renders greens brightly and records blues as dark tones.

SEPIA

CYAN-BLUE

YELLOW-GREEN

GOLD

toning the image

The darkroom technique of toning was invented to enliven the consistently grey tones of the silver gelatin print. By replacing the silver in the print with various metallic compounds, prints could be given a range of colours from reds and browns, through to blues and even violet.

toning | the basics

In the darkroom, prints have to be made in the first instance with the planned toning effect in mind, because toning changes the image's tonal values (its high and low contrast) in different ways, depending on which chemicals are used. Digital toning has similar effects. Some methods strongly alter greyscale contrast; others do not, but appear to do so because of the visual effect of the colours. As much more variance in toning is possible digitally, the skill lies mainly in working to apply the colours with sufficient subtlety.

Broadly, the process involves converting your image to black and white in RGB mode. You may need to reduce contrast and put a little light into shadows because black will remain black whatever colour you apply. By the same token, remember that white highlights will also remain white when you try to apply colours. Use Levels to reduce White Point to, say, 230. Then apply colour: you can use the Color Balance or Channel Mixing controls for the most flexibility. For the simplest and most repeatable results, use the Photo Filter control.

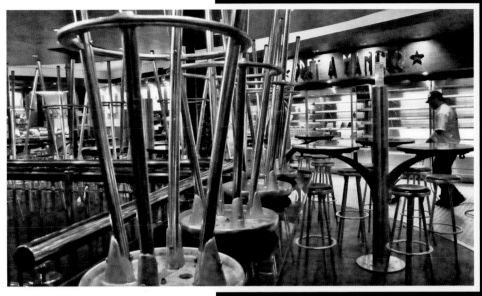

RED/GREEN/YELLOW

BLUE SHADOWS, RED HIGHLIGH

split toning | colours and controls

In the wet darkroom, photographers often turn to split-toning, which occurs when a mix of toning effects has been used. The effects are subtle and satisfying. The strength of digital split-toning is in its freedom of colour combinations and effects, but it can easily become garish and if your colours are too vibrant they may not print out as you see them.

The easiest way to experiment is to use the Color Balance control, which allows different colours to be assigned to the Shadows, Midtones, or Highlights tone bands. Thus, cyan in the shadows with yellow in the mid-tones and red in the highlights gives you a cool-looking image that has warm high values.

For more control, use Layer Blending Options. First duplicate the black and white image. Apply colours to, say, the shadows of one image and different colours to the mid-tones and highlights in the other layer. Then change the Blending Options of the top layer, altering blend modes and opacity in General Blending, and experiment with the Blend If control to obtain the desired effect.

metallic surfaces

A café closing down at night presents a forest of metallic objects, which lend themselves well to split-toning. The contrast of the original scene was first reduced to accommodate the toning. The small image at the top has red, green, and yellow applied in the Shadows, Midtones and Highlights respectively. The small image above shows the effect of blues in Shadows and red in the Highlights. The main image is the result of cyan, yellow, and magenta lightly applied.

MIDTONES CYAN SHADOWS RED HIGHLIGHTS YELLOW

colour balance settings

Split-toning works best with images offering a full range of tones from shadows to highlights. The split-screen image above show the effect of applying different colours and colour strengths in the order Midtones – Shadows – Highlights. The Midtones setting has the strongest effect on the image colour and exposure, and can be used to modify the strength of other colours applied to the Shadows or Highlights.

DUOTONE LIGHT | DUOTONE STRONG

TRITONE

QUADTONE

duotone mode settings
The above images contrast the range of effects available from duotone and multitone modes. Top are duotone colours applied lightly or strongly. Tritone effects (above middle) can show a strong tint overall, or apply the same tint just to the highlights. With quadtones (above) the effect can provide a rich subtlety or a split tone, with a gold showing in the highlights. The main image (right) uses quadtones of different dark inks to achieve a lusciously rich range of tones.

duotone and multitone

The Duotone mode is a special image mode in its own right. Based on the printing technique of applying two or more different inks to different density ranges in the image, this mode offers photographers the highest level of control, repeatability, and reliable colouring.

standard colours | accurate printing
Thanks to its ascent from the print industry, Duotone mode works exclusively with colours based on industry-standard sets of colours. In other words, colours are guaranteed to print accurately. However, to take full advantage of this, you will need to print your images on an industrial printer. Nonetheless, even when they are converted to RGB space, the colours will be within the gamut of any recent mid-market ink-jet printer. This guarantee is not available with other toning methods, where colours are easily made too saturated.

A central advantage of working in Duotone mode compared to other toning techniques is that you can manipulate the transfer curve for each colour. The shape of the curve tells the printer how much of the ink to apply, according to the image density. This makes Duotone mode highly controllable and capable of effects from the extremely subtle to the most vivid, covering a much greater range of effects than any other toning method.

curves | and density
Just as the Curves control shows you how the input is changed for the output, so curves in Duotone mode tell you how the input lightness and darkness of the image results in the output density of ink for each colour used – and that includes the

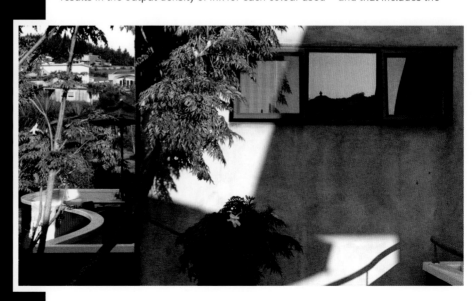

black ink. Use black to set the overall tone and darkness of the print, though you may have to adjust this when you add the other inks. On using Duotone, you can choose the ink colour, from a large variety of industry swatches.

You can also change the shape of the curve: one with a very low slope applies the duotone ink very gently, but you can clip highlights so that ink is applied only in the shadows or clip the shadows so that ink is applied only in the highlights.

saving | experiments

Tritone and quadtone ink effects multiply the already great potential of this control by offering you the chance to work with colours chosen from an effectively infinite range. You can produce extremely subtle effects by working with combinations of grey inks – warm and cold, dark and light. These are likely to give you the most rewarding images in the long run. The technique works well for landscapes and still lifes as the reintroduction of colour can be controlled to point to a feature that you wish to make prominent.

Or you can experiment with wilder colour combinations: these usually work best with subjects offering strong, simple shapes such as the example shown on this page. This is because the tonal and colour distortions often seem to clash or work at odds with representational images.

As you gain experience you'll learn that the possibilities of this control are wonderfully diverse, but retracing your steps to repeat an effect you like can be all but impossible. When you find a combination of colours and curves that work for you, it's a good policy to save the settings so you can use them on other images. These settings take up very little memory and build into a valuable library of effects.

When you reload a saved setting to reapply it to a new image, you can expect to have to make small adjustments in the curve shape of each colour, particularly those strong in the mid-tones, to suit the tonality of the new image. In order to make use of your images, you need to change them from Duotone mode to a full-colour mode – either RGB or CMYK. If you are printing to a desktop printer, it is usually best to convert your multi-tone image to RGB.

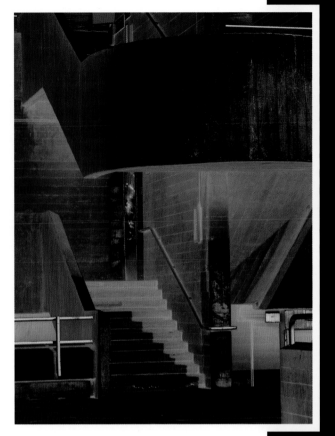

ORIGINAL

abstract colours

The main image uses a split-complementary colour scheme of blue against yellow and red. Unconventional curve shapes were applied to three inks to achieve the effect: the yellow curve was normal, but the curves for the other colours were inverted. The two images below show the effect of different sets of curves being applied.

QUADTONE ALTERNATIVE

QUADTONE ALTERNATIVE

step by step: **converting to monochrome**

Digital manipulation has revealed that monochrome is not a second-class citizen to colour, but a full universe of imaging possibilities in its own right. Whatever you do, ensure that you keep the original file – the colour original allows you to remix the monochrome conversions at any time.

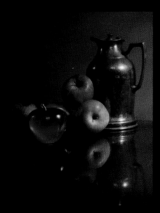

ORIGINAL IMAGE

1 appraising the original
Almost monochrome already, the actual colours in the original seem almost superfluous and a distraction to the still-life, making the image a good candidate to be turned into black-and-white.

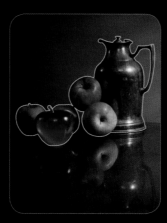

PEN TOOL

2 cutting out
To localize tonal changes, make a path around the objects using the Pen tool (P). The objects are hard-edged so a small amount of feathering will allow more convincing colour adjustments later on.

CURVES (LIGHTEN)

3 lightening the foreground
With the selection made, create a Curves layer mask to lighten the tones of the foreground objects, so that they lift out of the background. Using a soft brush, give additional lightening to the reflections.

CHANNEL MIXER

5 desaturating colour
There are many different way to remove colour information from an image. The easiest way is to use Desaturate. Set the Channel Mixer adjustment layer to Monochrome to give you more control over the conversion.

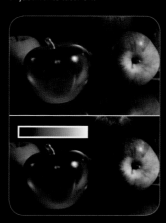

GRADIENT MAP

6 adjusting the gradient
Set a Gradient Map to apply a gradient of your choice, so that one end is mapped to dark tones and the other end to the light tones. This produces subtle colour shifts corresponding to your image greyscale.

DODGE TOOL

7 heightening contrast
Using a soft brush and Curves adjustment layer mask, dodge the highlights of the objects (and their partners in the reflection) to heighten contrast from the darker areas of the image.

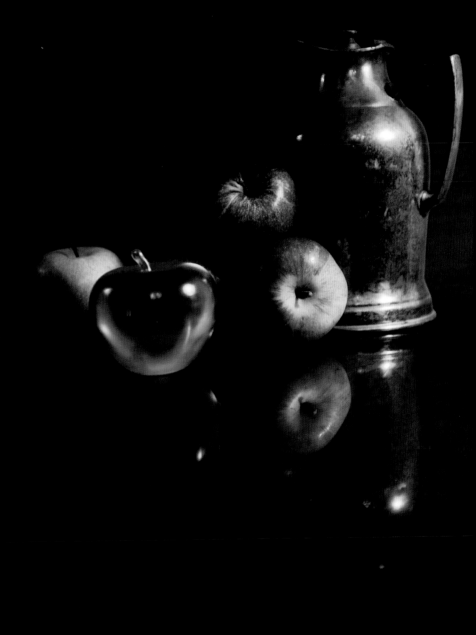

CURVES (DARKEN)

4 darkening the background

Using the same path, make a selection and then invert it so that the background is now the affected area. Make the shadows darker with a Curves adjustment layer.

BURN TOOL

8 enhancing shadow

Similarly, a Curves adjustment layer can be used to burn the darker areas of the image even further. Apply this to the edges of the fruit and jug to give the impression that some were hidden in shadow.

▶ other **effects**

monochrome filter **effects**

Monochrome filter effects are designed to imitate coloured filters used with black-and-white film. The most commonly used films were known as panchromatic: they were more or less equally sensitive to all colours. If you place a coloured filter, say a red, over the lens, it passes only red light which causes light of green and blue wavelengths to be rendered under-exposed.

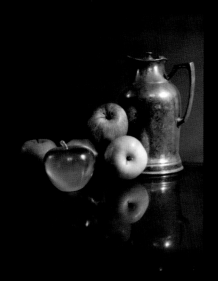

PHOTO FILTER | RED

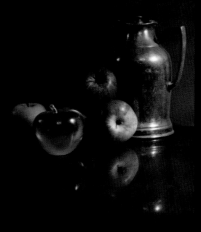

PHOTO FILTER | YELLOW

PHOTO FILTER | GREEN

ORIGINAL | RED FILTER

red filter
The red filter effect has a relaxed cut-off, meaning that it actually passes a wide range of colours. But its effect is clearly strongest on the red apple which has been transformed to such an extent it appears nearly white.

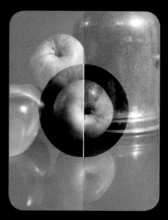

RED FILTER | YELLOW FILTER

red and yellow filter
A red and yellow filter broadens the range of colours which are passed and therefore reproduced lightly. This causes this image to look too light. But it's darkened here to obtain the best pictorial balance of tones.

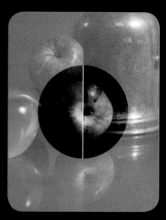

YELLOW FILTER | GREEN FILTER

yellow and green filter
As the image is overall warm in tone with many warm colours, the application of a yellow and green filter cuts out many colours, which causes a loss of contrast over and an overall darkening of the image.

duo and multitone **effects**

The most straightforward approach to duotone and multitone effects is to move straight into duotone mode from your colour image. But a little experience with this will show that you may lose out on colour differences that can help to define image contours. Try using the monochrome filter effects to define image boundaries before converting to duotone.

DUOTONE

TRITONE

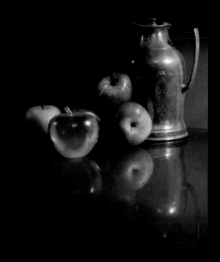

DUOTONE OVERPRINT COLOUR

IMAGE MODE | DUOTONE

IMAGE MODE | TRITONE

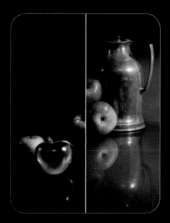

DUOTONE OVERPRINT COLOUR

duotone

The basic duotone mode uses black and another coloured ink, which could be a slightly toned black. It is best to print out samples to check rather than depending entirely on the monitor to assess the image.

tritone

With three inks, you are essentially applying a sophisticated gradient map which you can finesse with great precision. Experiment with variations which are barely visibly different, and save all the settings.

duotone overprint colour

The overprint colour gives you a way to tone down or flatten the visual effect of using duotone inks. You can define an entirely new colour – one different from the other multi-tone inks – for even more variation in image tone.

AS SHOT

centre of attention
The background to the boys enjoying the sun and the fountain was too sharp because the bright light called for a relatively small aperture, giving an extensive depth of field. There is no need to eliminate the background – just to blur it to make it less prominent helps push the main subject of the image to the viewer's attention.

MAXIMUM BLUR

LESS BLUR

SHARPEN

removing distractions

Given that the camera will record everything in a scene, the ability to remove unwanted elements is very valuable. Making substantial changes to pictures has always been possible, but with film that meant a skilled retoucher working painstakingly, using single-hair brushes and a microscope.

clone stamp | and remapping
In the digital era, the ability to change, remove, or replace objects that are spoiling the image is much easier and is taken for granted. The key tool for removing unwanted details is the Clone Stamp. This works by copying pixels from one part of the image onto another. The new pixels may also be placed with different blending modes and strengths – for example, to avoid applying light-coloured clone areas in dark areas, use Darken mode to improve the match.

However, replacing pixels is seldom the only task that's required. You may need to adjust tonality and ensure that the process of cloning onto an area doesn't smudge noise and other incidental detail. This is particularly difficult when you are working with scans from film, as the film grain is very easily destroyed when it is overlaid with film grain from other parts of the image. It may help to add noise to the cloned area to disguise the appearance of cloning.

Sometimes it's enough to make distracting details less obvious rather than removing them altogether. In portraiture, it may be appropriate to desaturate the background so that it loses some or all of its colour. Reducing local contrast, for

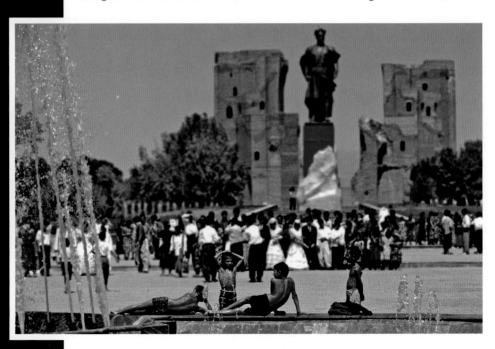

example, in the case of bright lights in the background, may also help to keep the viewer's attention on the subject's face.

Another effective technique, which is particularly useful with digital cameras using small sensors, is to reduce the apparent depth of field by selective blurring of the background |as shown in the images on the left (see also pp. 178–79).

For all these techniques, use a feathered Lasso tool to select the background – setting a narrow feathering band where there is much fine detail and a broader one where there is less detail – then apply the blur effect. Remember to check the appearance of the image both at a high magnification of 100% as well as the overall appearance at print size.

power | and responsibility

With digital manipulation, we can easily make major alterations that are invisible to even the aided eye – they are detectable only with sophisticated mathematical analysis.

However, with power comes responsibility: in contexts where the viewers expect images to represent the subject as it was seen at the time – the image as a truthful representation – any change in the content or meaning of the photograph should be signalled. This principle is obvious in news photography and documentary photojournalism, but even advertising agencies have been reprimanded for using manipulated images without informing the viewer. Broadly, it is accepted that enhancements of tone and colour do not need to be announced, but removing elements or changing focus as seen here certainly should be.

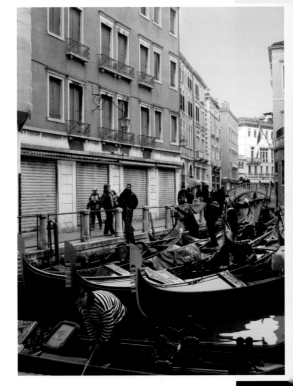

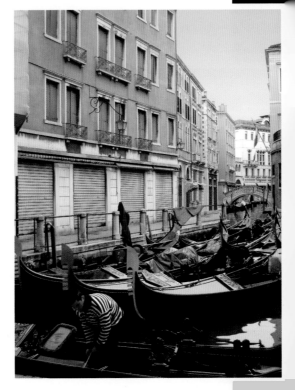

practical **filters**

Filter effects are associated with radical transformations of the image, which initially wow the viewer but leave little lasting visual impression. However, certain filters are used so commonly that they have ceased to be regarded as effects but rather as standard tools for image enhancement.

noise | texture and masking

Although noise is generally undesirable, it does have value provided we introduce it only when and to the extent that it's needed. Noise helps to give texture to high-resolution images which can, ironically, look too perfect. It's also useful where smooth tonal transitions are too fine for a printer to handle: a small amount of noise, effectively invisible, can help to make print irregularities less obvious.

Noise can also be used for masking the smoothing effect of cloning, healing, and other operations in which pixels are transferred from one part of the image to another. But just as there are different types of noise, so there are different types of filters, from those that randomize colour to those that randomize brightness or simulate film grain.

sharpen | and blur

We use a sharpen filter of one sort or another most of the time – if only because cameras will apply one if they are not set to record in RAW. It is worth becoming acquainted with the different effects of each type of filter: unsharp mask is not the

noise on noise
The original image in colour looked almost too clean and clinical for the edginess of this documentary-style picture. In black and white, and with added noise, it comes alive thanks to the texture of "film grain". This suggests that an originally noisy image would have worked equally well.

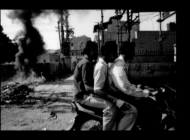

MID-TONE GRAIN

HIGHLIGHT GRAIN

only useful sharpen filter. The cousin of sharpen is blur, and that's a filter you will discover more uses for as your experience grows. We have seen that it's useful for helping objects stand out from the background (see pp. 178–79), and it can also be employed to give the feel of movement where the image is a little too sharply static. Again, there are several types of blur, each giving a different effect.

A variant of blur is pixellation, of which Mosaic is the most obvious effect, dividing up the image into visible squares of colour.

film | filter effects

There are also filters that imitate films such as Kodachrome and Fuji Velvia by reproducing colours according to a film's colour palette and typical gamma (mid-tone contrast). Some are stand-alone applications that can open an image and apply the effects directly.

ORIGINAL

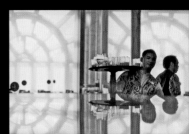

CROSS-PROCESSED

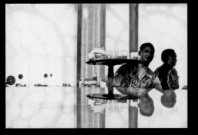

POLAROID

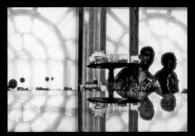

POLAPAN

old film school
Using filters from Alien Skin Exposure or DxO FilmPack to simulate the colour palette and tonal character of silver-based films gives you a one-step technique for creating a readily identifiable visual signature, and need not be as subtle as imitating a classic such as Kodachrome. Cross-processing distorts colours in a strangely acceptable way (top right). The restricted, glowing palette of Polaroid 669 film is well suited to people and fashion (above left). The chalky, gritty character of Polapan works with people, urban scenes, and architecture (above right).

filter **effects**

Although they were initially regarded by many people as one of the most enticing aspects of digital photography, filter effects soon lost their appeal through over-use. However, handled with restraint, they are invaluable stages towards advanced manipulations.

changing pixels | filter effects

All digital effects are essentially mathematical operations, changing the numbers describing each pixel. With image enhancements such as tonal and colour controls – Curves, Hue/Saturation, and Duotones, and so on – we alter the values of pixels, but generally not their position.

Filter effects are radically different from enhancement tools in that they alter the position of pixels in systematic ways. For example, pixels a certain distance X from the centre are moved by distance Y, those at X+1 are moved a distance of 2Y, and so on. Filters may also change pixel colour values, and, furthermore, pixels or groups of pixels may be identified and treated as separate objects, which can then be multiplied, reduced or distorted, or moved around.

Clearly, what can be done with pixels is limited only by the programmers' imagination and their ability to write the code. There are literally thousands of effects available, and when different sequences are put together, the possibilities are truly infinite.

handling filters | shortcuts

For some types of work, filters are an extremely efficient shortcut to desired effects. Some of the art or texture filters such as Cut Out or Water Color can produce serviceable images after only a click or two.

The most successful results come from choosing a filter that suits the image, understanding what its tonal effects will be, and preparing the image to suit. For example, the Water Color filter works very well on pictures featuring water, and the Art Materials filters often work well with

textures
Images with strong shapes such as this, of the coast near Sydney, Australia, are generally best for receiving texturizing filters. These examples show two useful effects, plus the Solarization filter for the main image.

GRAIN

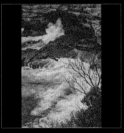

GRAIN CLUMPED

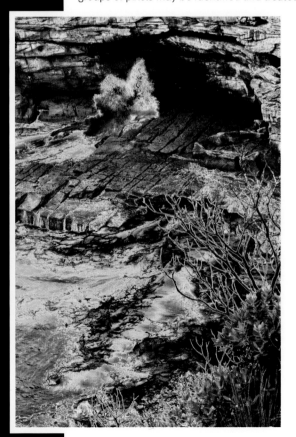

animal pictures. The result of the majority of filter effects will call for further work on colour and levels needed to make the image usable.

In scriptable software such as Adobe Photoshop, you can set up an Action that employs the filter and the various tonal adjustments so that manipulating an image can be turned into a single-click operation.

smart filtering | subtle effects

It's obvious that filters are very destructive to the integrity of image data. You should always work on a copy of the image in case you accidentally save the changes onto the original.

If you are simply experimenting with filter effects it's worthwhile reducing the file size, since even with today's powerful computers many filter effects will take seveal seconds to calculate when applied to large image files. It is also a useful to make snapshots of intermediate images, in case you decide that an earlier version is most promising.

With some software, you apply the filter to a proxy copy of the image so that you can adjust the filter effect after applying so-called Smart Filters. If you work extensively with filters, this is a very valuable facility. Remember that filters can be applied within selected areas, and if you take the trouble to match filter settings to the level of detail or tonality in different parts of your image the effects can look much more convincing.

As with many digital effects, the real power comes from applying a sequence of different filters, creating a cumulative effect. Suppose you soften and posterize an image using Water Color, then apply the Colored Pencil effect: the result will look more like a representational artwork than if you were to apply only one filter to the image.

NEON GLOW

COLORED PENCIL

ROUGH PASTEL

WATER COLOR

art textures
The Neon Glow filter has been applied to the original image, with cyan and brown as the foreground and background colours (top left). In contrast, Colored Pencil gives a sharply outlined effect with good sky textures (top right). The pleasingly colourful and nearly realistic image is the result of the Rough Pastel filter (above left). As expected, very soft results can be obtained from the Water Color filter (above right).

SHEAR

POLAR COORDINATES

distortions
Filters which distort generally do not change the colour values of pixels, but move and redistribute them. The Shear filter (above left) is a very simple effect that warps images, often in a not unrealistic manner. In contrast, Polar Coordinates (above right), derived from mapping technology, causes a dramatic change which is useful when seeking inspiration for graphic effects.

step by step: **recasting an image**

The creative flood-gates are opened when you accept that an image need not be an exact facsimile of the scene. It is an educational and fun exercise to work with a fairly plain image, to see how much you can transform and improve it without losing its identity in the process.

ORIGINAL IMAGE

1 appraising the original
This scene attracts for its under-stated, quiet mood, but the recorded image lacks focus and impact. Its sharpness and precision also impede the sense of timelessness – a painterly feel is required.

GAUSSIAN BLUR | MOTION BLUR

2 blurring the image
Duplicate the original image onto a new layer and apply Gaussian Blur, followed by vertical Motion Blur. This gives the effect of a very soft-focused image, much like that achieved with a cheap plastic toy camera.

BRUSH TOOL

3 adding detail
Apply a layer mask to the layer you just blurred, then use a soft brush to paint back areas of detail from the original image. These will become the focal point – choose areas of interest, such as the boat and window frames.

SOFT LIGHT BLENDING MODE

5 softening the image
Place a copy of the original background layer above the blurred layer. Apply a Soft Light blending mode – the luminosity of the original will mix with the layer below, achieving a soft effect that retains areas of sharp detail.

SELECTIVE COLOR

6 exaggerating colours
Concentrate on exaggerating individual colours. Using a Selective Color adjustment layer, pick out the most vivid colours and boost them even more. Push the greens and oranges to a point where they almost glow.

QUICK MASK | GAUSSIAN BLUR

7 blur vignette
To frame the image, vignette the edges by applying even more Gaussian Blur. To do this, merge a copy of the image onto a new layer, apply Gaussian Blur, and then mask so the layers below show through the centre.

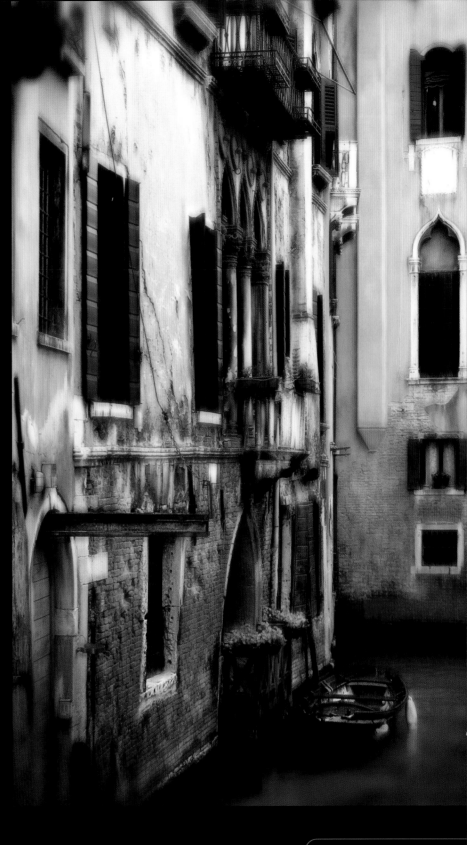

HUE/SATURATION

4 boosting colour

Apply a Hue/Saturation adjustment level in order to boost the overall amount of colour in the image. Realism is not your objective so it could be increased by a lot – but be careful not to go so far that you lose detail in the colours.

CURVES

8 darkened vignette

An alternative method of darkening the edges is to apply a Curves adjustment layer. This creates an overall effect in keeping with the pictures taken with a cheap plastic lens cameras, such as the "Holga".

darkroom**effects**

One of the rites of passage successfully navigated by digital photography was the demonstration that virtually all darkroom effects based on the interaction of chemicals and light with sensitized paper could be simulated by image manipulation effects. While the work lacked the rewarding "touch-and-feel" of craft skills as well as the exquisite subtlety of results, this was adequately compensated for by the clean-working predictability and repeatabilty of digital effects.

CROSS PROCESSING

NEGATIVE COLOUR

GRADIENT MAP

CROSS PROCESSING WITH CURVES

DESATURATE | INVERSE | COLOUR ADJUSMENT

GRADIENT MAP | BLENDING MODE

cross processing
Processing colour negative film as transparency or vice versa is notoriously unpredictable, but the effects are well worth the effort. Curves can perfectly mimic cross processing results, and even match specific film characteristics.

negative
Turning an image to the negative is tricky in the darkroom but elementary on the computer. Better still, it is easy to add colour, especially in the light (formerly shadow) areas, to give convincing results.

gradient map
Compared to the risk process of dark-room toning, where it is easy to ruin a perfectly good print, digital toning is many, varied and gives instant feedback on results without any need to work with poisonous compounds.

artistic**effects**

While the notion of artistic effects in digital photography is somewhat oxymoronic for some, it's nonetheless fascinating that the polished perfection of modern digital images can be roughed up and textured to look as though they were artist-drawn. The filter effects were created by analysing the way artists' materials abstracted the colour and spatial information in the image: where there's a rule there's an algorithm, which is what the filter applies to the image.

WATER-COLOUR

CANVAS

DISTRESSED

POSTER EDGES FILTER | BRUSH

DISPLACEMENT MAP

HUE/SATURATION | CUSTOM BRUSHES

painting in the image

Artistic effect filters seldom work well by themselves, but applying a Water Color filter to some parts and the Poster Edges filter to others calls for almost as much artistic intervention as a true watercolour painting.

canvas

It is possible to give many different textures to an image: such as burlap, canvas or paper, tiles, or stonework. Textures can be made more convincing with a Displacement Map that shifts pixels according to the underlying texture.

distressed

Some effects need good draughtsmanship, even imitating the look of a creased print. You can alter the colours using Hue/Saturation control, then erase the edges and "scratch" across the image using custom, uneven, brushes.

Assignment: **image effects**

The line between enhancing the image to bring out its inherent qualities, and manipulating it creatively to give it new character and features, is both broad and blurred. However, there are numerous changes to the image that are undoubtedly manipulations. These range from changing shapes overall and within the image, rotating image orientation, and simulations of art materials and textures, to drastic alterations of tonality and colour and methods of exploiting layer and blending modes.

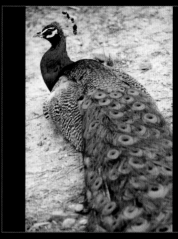

ORIGINAL

the**brief**

Starting with any image that you choose, transform it using any controls and tools. For example, you might turn it into black and white, change the shape of elements, remove unwanted parts, substantially change the colour, apply filter effects, and so on. But don't use elements from another picture. Aim to create a convincing, self-standing new image.

Points to remember
- you will achieve results more quickly if you plan the general appearance of the final image before you start
- working at full size will slow you down: if you are only experimenting, work with small-sized files to try out effects
- save regularly, and save separate versions if they look promising
- flatten the image before you output it to print or web

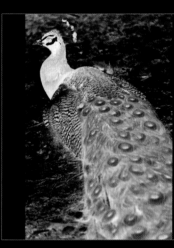

INVERT COLOURS AND TONE

must-see **masters**

Pedro Meyer (1935–)
One of the most inquiring and innovative of photojournalists, his images are not obviously manipulated and are more of a critical investigation – of the meaning of manipulation and its ethics and issues of representation – rather than merely a body of images.

Art Wolfe (1949–)
One of the best-known of wildlife photographers, with over 50 books published, he has used manipulation in some of his work to create patterns of animals such as zebras and penguins that appear too amazing to be true – and are not.

Maggie Taylor (1961–)
Typical of the new generation of artists who make free use of whatever tool seems appropriate – from scanners as digital cameras, to combining illustration with digital images – Taylor creates mythic worlds that owe much to the influence of Surrealism.

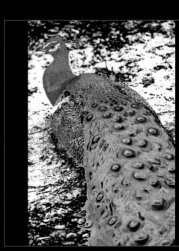

WILD CURVES ON INVERSION

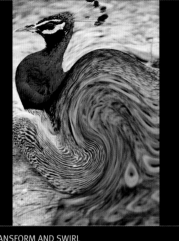

TRANSFORM AND SWIRL

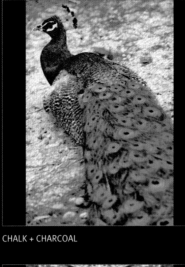

CHALK + CHARCOAL

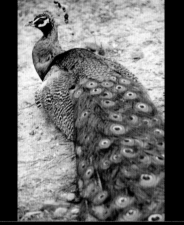

INVERT COLOURS

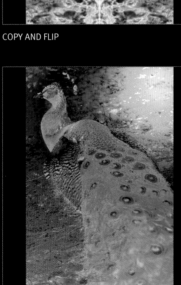

COPY AND FLIP

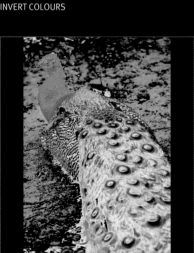

WILD CURVES

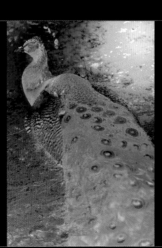

LIGHTEN BLEND MODE

1	2	3
4	5	6
7	8	9

lightbox

top**tips**

1 **original** | simplicity
Images with simple outlines, clear shapes, and a limited range of colours usually make the best subjects for manipulation. In fact, their plainness may be the very reason you choose to spice them up.

2 **distort** | shape
Changes or distortions of the image do not alter the tonal or colour qualities, they only displace pixels from one position to another. It's probably easier to apply distortions before imposing other changes to the image.

3 **art** | materials
The quickest way to remove the photographic nature of an image is to apply an art effect filter: these make a drastic reduction in the range of colours and apply an overall texture that mimics artists' media.

4 **5** **inverting** | tones and colours
Striking changes to the image don't all need special effects filters. You invert tones using the Invert command or Curves 4 or reverse only the colours using the Hue/ Saturation control.

6 **self** | reflection
Simple effects such as doubling and mirroring the subject can be very effective indeed. Here it has been combined with a blending mode of Difference, causing the squarish central shape.

7 **8** **extremely** | curved
For image enhancement, Curves are a standard tool, but when the Curves are drawn into wavy forms, the colouring and tonal changes are hard to predict but can be effective at producing striking results.

9 **double** | promise
When you duplicate the image, alter it and blend it with the original, you open up a surprisingly large range of possibilities – and you are still working with only one image.

colour and light

Erling Steen

"A major challenge was the contrast between the bright sunlight and the deep shadows of the narrow streets."

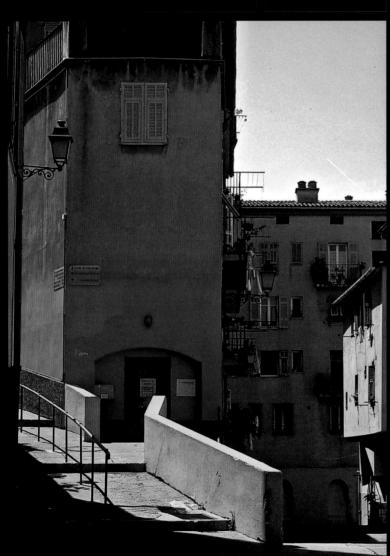

the**critique**

The rapid maturity of digital photography and image manipulation can be measured by the response to the brief to "be creative". In the early days of manipulation, the results of such a brief would be very weird and seldom wonderful: each image would receive a panoply of effects, whether they were appropriate to the image or not. Image effects are to help you communicate visually with more effectiveness by bringing out the image's character. This selection shows modest characterizations of the photographer's intentions.

colour and light

Erling explains that he took hundreds of shots of the architecture of Nice, France, in his explorations. In order to deal with the challenge of the high luminance range of the lighting and to catch the details in the light he "deliberately under-exposed in order to have as much information as possible to work with on the computer". Subsequently he clearly boosted colours and contrast in order to emphasize the blocks of colour and light, almost turning them into abstract compositions.

steam railway

Paul's enthusiasm for the subject is evident in his images, which show a drive towards a recreation of childrens' book tonalities and colour schemes. This is so successful it's easy to believe the images were constructed entirely on the computer. A little more shadow detail would help to lift and lighten the overall atmosphere of the images.

old fairground

On a dull day, colours can be more intense than on bright days, but Dan was right to bring out the colours even more in post-processing. Against the

steam railway
Paul Self

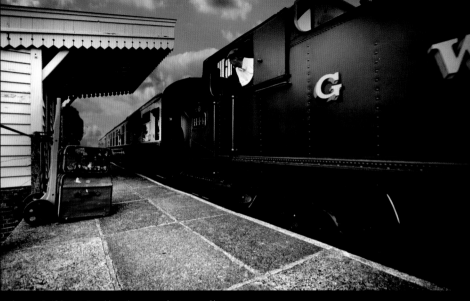

"The colourful trains and fluffy clouds in the fairy-tale station were just too good to be true; so I made the images like that too."

▲ Canon 5D ISO 200 Focal length 17mm 1/125 sec at f/8.0

old fairground
Dan Powell

"The weather on the day I came across this graveyard for fairground rides was grim, but I wanted to recreate the colour of their past glory."

▲ Nikon D50 ISO 200 Focal length 20mm 1/125 sec at f/6.7

Image manipulation makes a substantial leap forward in complexity when, instead of working with a single image, you overlay one on top of another. The software simply sees another image as another set of numbers but, for us, stacking pixels opens up infinite possibilities of interaction between them. The potential of these techniques was once limited by technology, but that is no longer the case.

fact file

The modern age of image manipulation may be dated from the day we could manipulate image layers (Photoshop v3, 1994). From the instability with just two or three layers, today we can work with thousands of layers at a time. The real limit is how many you can cope with and not get thoroughly confused.

the **power** of **layers**

Layers are not new to photography; films and papers are all layered in structure, so it's natural that the metaphor for the anatomy of a digital image is also the layer. By the same token, overlaying digital images is comparable to the practice of sandwiching different negatives in the darkoom, which has an equally exponential effect on imaging potentialities.

background | and layer

In order to understand the layer, it's important to understand what it's not – that is, the background. Images transferred from a camera or scanner or downloaded from the web are all opened on the background. This is locked: its opacity and blend modes can't be changed, and you can't place another layer beneath it. Essentially, it's like the print on a piece of paper. You can't alter the print's transparency or place anything under it as you won't be able to see the layer

> 66 The background is like the print on a piece of paper... you can't alter its transparency or place anything under it 99

underneath. If you want to work with the image on a print, you first have to lift it off the paper support – the background. In other words, you need to turn the background to a layer, like a coloured transparency sheet carrying the image.

Once your digital image is a layer, its opacity can be changed so that it's more or less transparent, its blend mode or options can be modified, and you can freely place layers below it or move it above other layers.

controls | and effects

You can exercise two kinds of control over a layer. The first type, a direct control, changes the layer without reference to any layers below it. You can change the top layer's opacity to affect how much you can see of the layer immediately below. You can also choose to make the layer visible or not, and duplicate it if you wish.

The second type of control, for blend modes, determines the interactions between adjacent layers. When you change the blend mode of the top or "source" layer this changes the appearance of the image in the lower or "destination" layer, as seen through the source layer. Some software may also allow you to control the extent of the blend, so that the amount of blending varies according to the grey level of either the source or the destination layer.

You may also apply effects such as shadows, frames, and glows to the upper layer, which visually separate it from the lower layer. Some software programs also have controls that apply tonal changes to the destination layer.

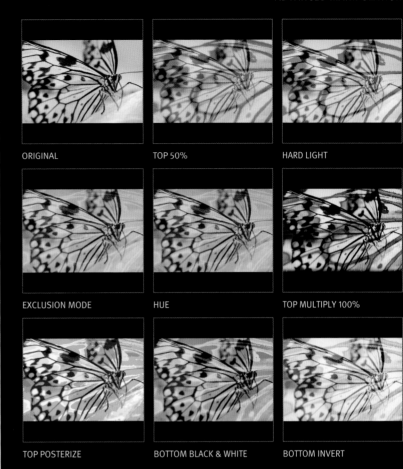

ORIGINAL

TOP 50%

HARD LIGHT

EXCLUSION MODE

HUE

TOP MULTIPLY 100%

TOP POSTERIZE

BOTTOM BLACK & WHITE

BOTTOM INVERT

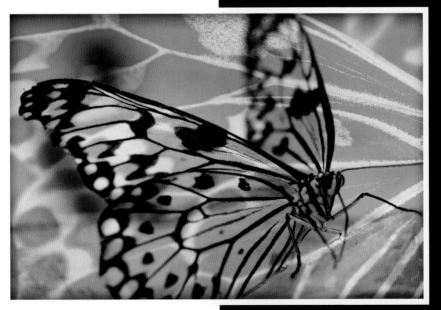

layer modes

1 2 3
4 5 6
7 8 9

lightbox

A wide range of effects are available with just two image layers and using only three controls – opacity, blend options, and adjustment layers. The top layer **1** is at 50 per cent opacity in **2**. For **3** we set blend mode to Hard Light, showing its similarity to reduced opacity. **4** uses Exclusion and **5** uses Hue, both giving subtle blends. For a more contrasty blend, try Multiply **6** or use an Adjustment Layer to Posterize **7**. More restrained looks employ black-and-white **8** or tonal inversion **9**.

simple graphics

Working with Blend Options and Adjustment Layers, it's possible to create highly graphic effects quickly and easily – it's also simple to adjust the balance between component images.

ORIGINAL IMAGE

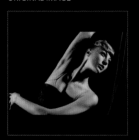
ORIGINAL IMAGE

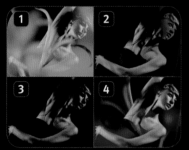
BLEND MODES

layer **blend** modes

Often explored but seldom actually used, layer blend modes are best known for their ability to produce striking results – but most useful is their repertoire of subtle effects.

combining images | blending

Working on the principle that the top source layer determines the appearance of the bottom or destination layer, blend modes are essentially ways of mixing two images together. Colours in the destination layer can be enhanced, suppressed, or reversed according to the colour of the pixels in the source layer.

Layer blend modes may seem to be solutions in search of a problem – and indeed, while few are essential tools in the image manipulation toolbox, the smart user of image editing software is familiar with their effects in readiness for the day when a problem arises that they can solve.

adjustments | multiple layers

There are two main ways to adjust the effect of a layer: opacity is the most obvious, but it acts only to weaken the effect. You can also adjust hue, saturation, contrast, and exposure to vary the impact of a layer.

According to the blend mode you choose, the result of applying a control may be the opposite of what you expect. If possible, make the adjustments by creating an adjustment layer. This enables you to return repeatedly to fine-tune an effect.

As you work with more and more layers, you will find that changing one of them will call for adjustments and compensations in another. A useful trick is to keep as many elements on separate layers as possible. This gives you the most flexibility and

exploring blends
Blend modes are most useful where the background of an image needs a radical change. The choice of blend mode can introduce both tonal and colour changes at the same time. 1 shows Lighten with the flower as the destination layer, 2 displays Darken with the flower as the source layer. 3 illustrates Color Burn mode; 4 shows the result of Pin Light mode. The final image was created with Overlay mode.

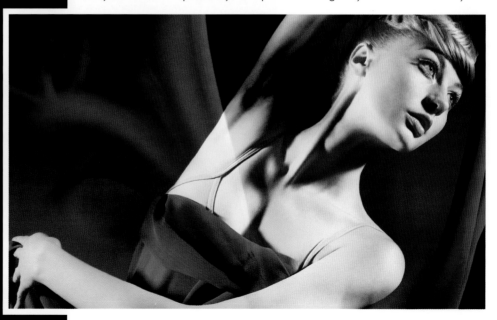

linear burn

Turning the layer carrying yellow and blue gradients into Linear Burn blend mode intensifies the colours as well as darkening both the sky and the foreground, giving a depth that the original lacked. Apply the gradients to selected areas of the image for greater control.

makes adjustment much easier. If you want to apply a blue gradient for the sky and an orange gradient for the foreground, for example, place them on separate layers; you can then adjust the opacities, saturation, and brightness of each individually.

tonality | and colour

The group of blend modes that burn (e.g. Color Burn or Linear Burn) or dodge (e.g. Color Dodge or Lighter Color) are very useful for substantial changes to the tonality of an image. What's more, they can give a stronger effect than, say, Curves, yet they reduce the risk of causing artefacts such as posterization.

The Color blend mode is a favourite because it enables you to tint a black-and-white image with colours so that tint is taken up in proportion to the image density; this means you retain the image detail. Modes such as Soft Light and Overlay are useful when you are blending two or more images together.

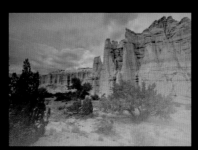

NORMAL

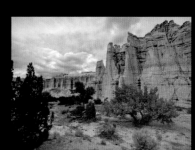

COLOR DODGE

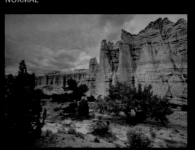

DARKER COLOR

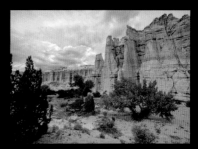

SATURATION

blend modes for tonal control

This set shows how blend modes control image tone. Normal blend shows the blue and yellow gradient colours, giving a foggy effect (top left). With Color Dodge mode (top right), shadows are lightened. The Darker Color mode tints and improves contrast (above left), while Saturation mode (above right) delivers a big boost in vividness.

fact file

In Adobe Photoshop, the extent of feathering a selection is not displayed. Other software, such as LightZone, display the centre line as well as the inner and outer extent of a selection.

complicated selections

For an image like this grass – with fine detail against a plain background – selecting the blue colour would take hours and produce poor results if we could not use Magic Wand or the Replace Color tools to select all the blues in one click. The Fuzziness slider sets the threshold for "blueness". For this exercise, it was deliberately set fairly low. Once an area has been selected you can change the colour. One option nearly desaturated the sky, then turned it to a light brown. A more dramatic image results from desaturating and darkening the sky. Note that the blue that was not selected now shines against the dark background.

AS SHOT

DESATURATE SKY

masks and **selections**

The power of effects that apply indiscriminately to all pixels is tremendous – but think how much more potential these effects have if we can apply them to some areas and not others, then apply different effects to yet other areas. This is made possible by the duality of masks and selections.

limiting effects | protect and cut out

Modern software offers many ways to limit the action of filters and other effects. It can be a confusing subject, the key to which is to understand that a mask and a selection are different ways of expressing the same thing.

A mask obscures an area so that it is protected from an effect such as a colour change. This is easy to see when you are working with large areas or want a feathered or graduated effect. A selection does the opposite: it confines the action of an effect to the pixels gathered within its limits. Selections are good for cutting out objects from their backgrounds where they are not too complicated and where selections can't be made automatically, for example, by colour.

Selections are easy to edit: holding down modifier keys such as Alt/Option or Shift can subtract or add to them. However, they are unable to show the limits of any feathering, only joining up the mid-point of the feathering – that is, as if the feathering were set to zero.

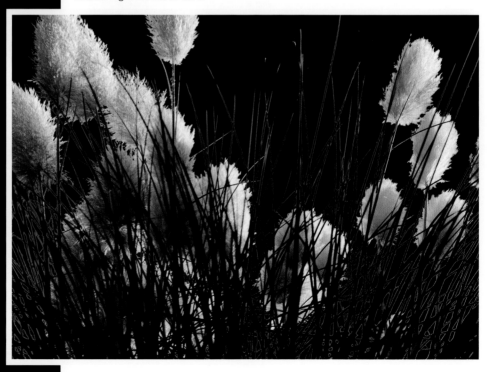

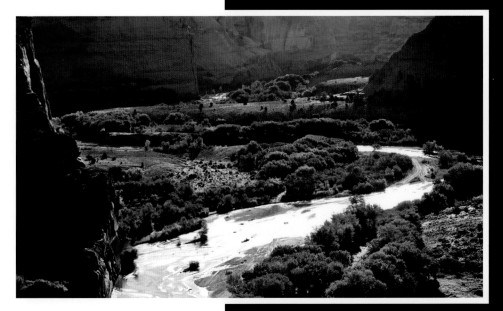

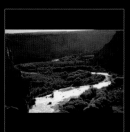

AS SHOT

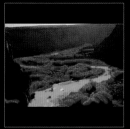

QUICK MASK

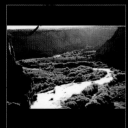

WITHOUT MASK

selections | different methods

There are two ways to select pixels. One is by hand, using a Marquee or Lasso tool. The selections can cross image boundaries and ignore colour similarities. The best way to work is with a graphics tablet, although a modern laser-pointed mouse is almost as precise. The other approach is based on colour similarities between pixels: it's excellent where a single colour is broken up by small areas of different colour.

masks | and extractions

Rather than drawing round the object to be masked as in Selections, you paint your mask on. Enter Quick Mask mode, then paint it on by brush or by using the Gradient tool. You can erase painted areas to refine your mask. When you exit Quick Mask, it's turned into a selection and you can then apply your effect.

A specialist type of mask is the Extract filter, in which you define the boundary area and the area you wish to keep. The filter then extracts the kept area, combining the functions of mask and selection tools.

snaking contrasts

The sunlit river trees in the Canyon de Chelly, USA, shine against the shadowed walls of the canyon. If contrast was boosted indiscriminately, the result would be garish and clumsy (bottom right); we therefore need to protect the areas which are already bright and colourful from our enhancements. In Quick Mask mode, we cover the river and trees (middle right): the red areas are turned into selections which we invert. The results (main image) amply repay the effort of applying enhancements selectively.

ORIGINAL 1

ORIGINAL 2

sheltering sky

The skyline of an Italian hill town is too dull (top left), so we use Magic Wand supplemented with the Quick Selection Tool in Photoshop to select it. Once the sky is selected, we reverse the selection as we wish to preserve the landscape, and then drop in the sky from Brisbane, Australia (bottom left). Yet the effect is too dramatic, so we match the tonality of the sky to the Italian landscape by making it lighter and less saturated (main image).

step by step: **hand-colouring**

The art of hand-colouring is almost as old as photography itself. Falling somewhere between the black-and-white photograph and the full-colour original, hand-colouring is most effective when it is applied in a restrained way, creating an image whose colours are subtly hinted. Colour accuracy of hue is then not crucial, as long as the image as a whole is visually convincing.

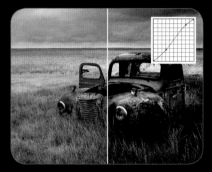

CURVE ADJUSTMENT LAYER

1 boosting mid-tone contrast

The original image was taken on a flatly lit day and the result feels lacking in mid-tone contrast. Create a Curves adjustment layer and manipulate the curve to an S-shape that is steeper in the mid-tones to separate them, while leaving shadow and highlight areas largely untouched.

MAKING SELECTION WITH PEN TOOL

2 selecting the car

To colour parts of the car separately from the background landscape you will need to select the car. The technically superior way is to use the Pen tool (P), since this is the most accurate and easy to edit. But you may also use the Lasso tool (L). View at 100 per cent and select the car, taking time to be exact.

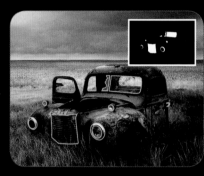

FURTHER SELECTIONS WITH PEN TOOL

3 selecting details

If you drew paths, you will need to change them to masks. Draw further paths around details that will need colouring individually later. In effect, you are creating digital stencils that block out areas you don't wish to colour. This makes it much easier to apply the colour.

CLONING AND HEALING TOOLS

4 cleaning up

The best way to get to know your image is to do some work on it. When you're familiar with it, check it for anything that does not contribute to the final image. Remove any litter, or dust on the sensor, and so on, with the Healing (J) or Clone Stamp (S) tools. Take care to avoid softening areas around removed details.

COLOR BLENDING MODE

5 colouring the ground

Pick a colour from the Color Palette, create a new layer and set its blending mode to Color at an opacity of about 30 per cent. Make a selection from the path you drew earlier and fill the area using the Brush (B) tool. The Color blend mode adds colour and saturation to the underlying luminosity, so details are preserved.

SCREEN BLENDING MODE

6 colouring the car

Repeat the process for the car's paintwork but experiment with the other blending modes in the Layers palette. Here, the Screen blending mode worked better with the colour chosen as Screen lightens areas that are less than 50 per cent grey. This helps to emphasize the rusty look by creating crunchy detail.

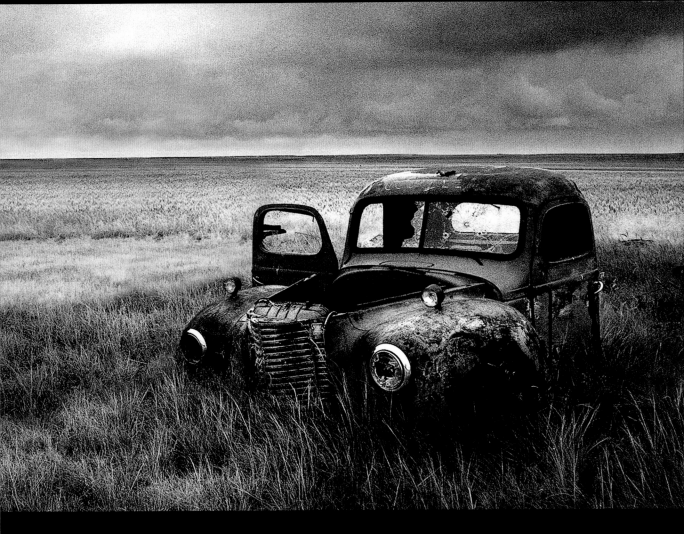

COLOR BLENDING MODE

GRADIENT MAP

COLORIZE AND MASK

7 working the details
Make the paths you drew for the details in the car into a selection and create a new layer ready to receive colour. If you use only one colour for reflective surfaces, the result will look unrealistic. For the chrome and glass use light blues and yellows to simulate the colours that would be seen in the reflections.

8 mapping the sky
You can colour the sky by hand, but applying a gradient gives a smoother result. You can do this by creating a Gradient Map on an adjustment layer. This maps highlights to one end of the gradient, and shadows to the other, so you can experiment with different colour combinations for best effect.

9 fixing the sky
Set the blend mode of the gradient to Color so that as you try out different gradient colours you can immediately judge their effect on the image. Next, look for any areas, such as the foreground, that appear incorrectly coloured, and remove unwanted areas of the mask with the Eraser tool (E).

RAW processing

The best chance for recovering highlight and shadow detail in scenes with extended luminance range is given by recording RAW image files. The original (below) reveals a great deal of shadow information with maximum fill. Shadows improve with maximum fill (next below). Combined with recovery of highlights, the image is greatly improved (third below). The addition of extra saturation (bottom) provides the finishing touch. The main image results from an overall adjustment of Levels.

AS SHOT

MAX FILL

MAX FILL, MAX RECOVERY

ADJUSTED

highlights and shadows

With photography's drive to miniaturize, the ability of films and sensors to record a long tonal range was necessarily compromised. Today, however, we are fortunate to have software techniques that can recover more highlight and shadow detail than was originally thought possible.

luminance | range

Capturing an image is essentially to draw a map of the distribution of the various different areas of brightness or luminance that comprise a scene. When we record in colour, we also measure the various levels of brightness through colour filters to create the separation channels of colours such as red, green, and blue. In photography we work with a luminance range between the darkest area with details and the brightest area with details.

When we capture an image, we want to know how much of a scene's luminance range can be recorded by our camera. A luminance range of around 8 or 9 stops is relatively small in real life but is too large for many cameras to record. The result is that whites become blank and shadows turn black.

Don't despair, however: an area may look white, but can still carry a little detail. Our eyes are not able to discern small differences in the brightness of bright areas. Similarly, what looks black on screen can actually carry a lot of detail: with this promise, we can put software to work.

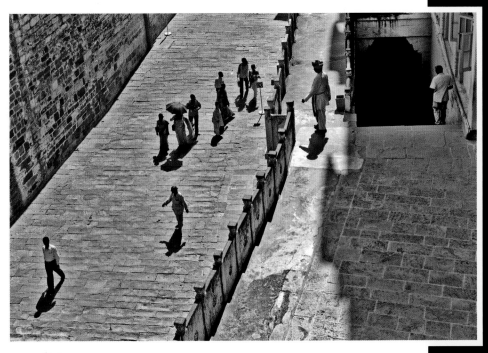

AS SHOT

PARTIAL HIGHLIGHTS

FULL HIGHLIGHTS

equalizing | tone

In the early days of image manipulation, it was a revelation to learn about how global controls such as Curves could darken highlights and simultaneously lighten shadows. Taking the idea further, we use curves with S- or double S-shapes to increase contrast in the shadows but reduce it in the highlights, and leave it untouched in the midtones. Curves are, of course, still available to extract details from the tonal extremities.

Other tools such as the Shadows/Highlights controls work on smaller regions of the image. These tools operate by comparing pixels over a certain distance, then reducing differences: this produces effects which adapt well to details in the image. Nonetheless, it is possible to make unnatural-looking effects by exaggerating the fill of shadows – so they become almost as light as mid-tones, while highlights are recovered to be mid-tones too. The effect enjoys painterly conceits, but remains an exaggeration.

shadows/highlights | tone and colour

The Shadows/Highlights control consists of three main parts. The first part pulls out shadow details by progressively lightening pixels: the further they are from the black point, the more they are lightened. The Tonal Width setting determines the range of tonal values that will be affected: the larger the tonal width, the more of the image is lightened. The Radius slider controls the spread of the lightening effect: it is essential to prevent haloes from appearing around objects in the image.

The Highlights part is similar to the Shadows control but darkens the high-value pixels. Similarly, setting a broader Tonal Width darkens more of the image. The third part of the control enables you to improve the colour vibrancy or saturation: the control is designed to apply more saturation to greyer pixels than to already saturated pixels. Finally, the Midtone Contrast slider adjusts midtone gamma by applying an S-shaped curve to the image.

shadows/highlights

The original image (top) has lost colour in the brightest parts, and some shadows are too dark. A partial recovery of highlights and fill in the shadows has created a slightly flat image (middle). A full highlight recovery (bottom) looks unnatural, although some mid-tones are good. The main image shows a partial recovery of highlights, and shadow fill, with a gain in colour saturation and mid-tone contrast.

fact file

The dynamic range of cameras – the difference between the darkest and lightest parts of the image – is typically around five stops. Post-processing can recover perhaps another two stops of dynamic range, while working in RAW stretches the range to around 10 stops.

RAW power

Because of the fast-moving clouds, only a single image of this scene was possible. However, a RAW image can be converted to yield two images – here, one optimized for shadow, the other for the clouds. Using Layer Blend Options created a flat image initially, with shadow detail darker than was wanted. Adjustments using Levels and very light Shadows/Highlights correction gave an image with a good balance between details in the clouds and the brickwork.

S SHOT

INCREASE LIGHTNESS

DECREASE LIGHTNESS

high **dynamic** range

The digital renaissance of an old darkroom technique has excited the photographic world. It combines two or more images of the same subject but at different exposures to record scenes with very wide luminance ranges – a return to the deliciously long mid-tone range produced from large-format cameras.

taming | luminance

A sensor is said to be unable to record a scene's full luminance range when there is no exposure setting that allows you to capture both the highlight details and the shadow details in one shot. If you work in RAW, it may appear that the camera is recording a wider luminance range because you can extract more highlight/shadow details than from the equivalent JPEG file. In fact the extracted information is exactly that: in RAW, brightness information is recorded in a deeper, richer data space – with millions more colours than JPEG can record. But this does not increase the dynamic range of the image, it merely maps a greater brightness range onto the middle, visible, tones. The result will look superior to a single image that has had controls like Curves or Shadows/Highlights applied to it.

field | methods

To simulate the extension of a sensor's effective dynamic range, you need a set of images captured at different exposures. Minimally, you need an over-exposed shot – about 1.5 stops more than normal – for shadow detail. And you need an

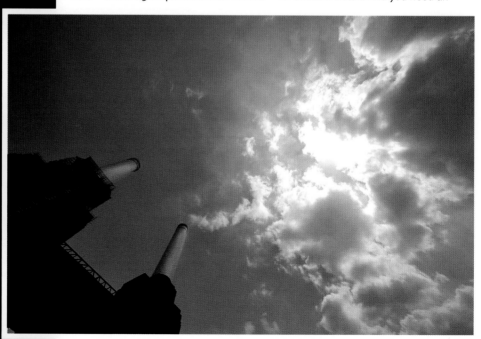

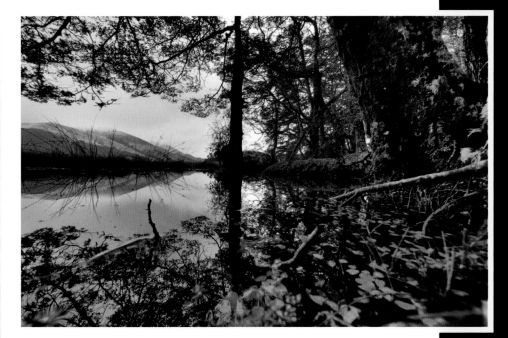

NORMAL EXPOSURE

EXPOSED FOR SHADOWS

EXPOSED FOR HIGHLIGHTS

BASIC BLEND

under-exposed shot – about 2 stops less than normal – for the highlight detail plus a "correct" (or normal) exposure. This gives you an extra three or four stops of exposure range to work with. If you shoot more, at smaller exposure intervals, and over a wider range, the end result can be more tonally convincing.

It is best to work with a tripod and with static subjects because you need images that are in perfect register: any movement between images causes some margins to be fringed when images are overlaid. If your camera can shoot at 5 frames per second or better, you may be able to get away with hand-holding the camera. Set your camera to aperture priority, and to bracket by, say, 1 stop and at the highest shot rate. Make your bracketing exposures: three is the minimum, while seven assures best quality in any scene, and is needed with scenes offering very wide luminance range. At the computer you will need to open all the files you shot to use software specially designed to create HDR images, such as Photomatix or Nik HDR Efex, or use the HDR features in your favourite application.

tone-mapped | blends

The reason for making the different exposures is to obtain records of highlights and shadows as mid-tones. The HDR algorithm then combines these crucial mid-tone data from each contributing image to output the final image. That's why having more exposures gives better results: the software does not have to guess at intermediate values. The initial HDR image usually looks rather flat because it's the result of blending mid-tones. You then need to apply tone-mapping – essentially a Curves control – to the blended image to make the whole image look detailed and colourful. At this stage, you can apply a tone-map which makes your image look natural, or highly unnatural, with exaggerated mid-tone contrasts. Whatever the final result, you are compressing a high dynamic range scene into a very narrow range of tones.

HDR blending
Three bracketing exposures were made, hand-held, in less than a second. The initial basic blend (above) is too flat but it actually contains all the details we need because it combines data from all three shots. When we apply tone-mapping to the data (main image), we bring the tones to a normal range of contrast while retaining details in the trees as well as the distant hills. Most rewarding is the emergence of colours in the foreground details.

step by step: **elaborating the landscape**

Compositing or montage techniques – the mixing or blending of different images together to create a new one – is the closest photographers approach to painting. Composites can consist of hundreds of different components, or just a handful. The essential foundation is a clear vision of the final image – even if the fine detail is lacking – which will guide and steer the many steps needed to arrive at the final composition.

1 appraising the originals

The original impetus for a composite may come from wishing you could capture a scene in a different light, or when the creative what-if question occurs: what if I put those flowers with that landscape in that light? For this image, the abandoned house (in Spain) is suited to being seen in a more nostalgic light than that of a clear sunny day. The sunset (from England) proffers a sunset and watery sky. The flowers (from Chile) are ideal for adding colour to the foreground in front of the house, while the mountains and bush may be suitable for adding interest. It's best to keep an open mind while montaging – you may find that you need further elements as the montage develops.

CROP TOOL | CANVAS SIZE

2 extending the canvas

To give yourself lots of room to manoeuvre, work on a large canvas. Choose Canvas Size from the Image menu, and make a large canvas so the elements can be positioned freely, giving space for them to be transformed and rotated without losing any portions from the canvas edge. The horizon is from the sunset image, and is combined with mid-ground elements from the mountain image, which is perfect for adding details later on. Position and resize the sky, ready for masking and blending.

PEN TOOL

3 masking the horizon

Using the Pen tool (P), trace the horizon of the mid-ground image with a path – this allows you to pick up all the fine detail, but also gives a selection that can be edited later on if needed. With the mid-ground image placed above the skyine, load a selection from the path in order to create a layer mask to separate the required parts – the fore- and middle ground – from the unwanted mountains. Masks can start rough, and then be refined and perfected later in the process.

CURVES | GRADIENT TOOL

4 colouring the mid-ground

To make the blend between the two layers more natural-looking, the horizon needs to be darkened so that the black skyline silhouette from the background image merges convincingly with the bushes of the front image. To do this, use a Curves adjustment layer on the green hills to strongly darken all of the mid-tones. Make a gradient mask with the Gradient Tool on the layer mask to gradually restore the original colours in the foreground of the green field.

PEN TOOL | BRUSH

5 masking the flowers

Next, drop in the flower image – the extra canvas space will prove useful. Mask the flowers using a layer mask. The flowers can be cut out in a number of ways, some taking much longer than others. If you have the patience, the Pen Tool makes a very detailed selection. Alternatively, use a soft brush on the layer mask to paint away any unwanted parts of the picture until the flowers are left. This approach works here because the colours from source and destination image blend well.

DUPLICATE | TRANSFORM TOOL

6 duplicating the flowers

To make the flowers look more abundant, duplicate the layer with the flowers. This duplicate layer can then be placed behind the original layer, before resizing using the Transform Tool to give the impression of receding space. The Distort function in the Transformation options may prove useful in this task, since it allows a greater amount of freedom when scaling. Because the layer mask is also copied when the layer is duplicated, you can use it to remove unwanted flowers.

CURVES | SELECTIVE COLOR

7 colouring the flowers

Next, tone the flowers to improve the blend with the other elements within the picture. The exposure of the original image was a little too high, so use Curves to reduce the midtones and darken the greens. Since the colours of the flowers are dulled by this adjustment, brighten them selectively by using Selective Color in the Image Adjustments menu In the Magenta colour field, reduce the levels of cyan and black, which has the effect of making the pinks more striking.

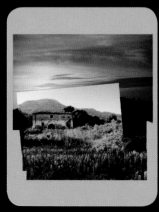

RULER TOOL | TRANSFORM TOOL

8 straightening the house

Copy the house image and paste it into the composite, and then correct the horizon. One method to do this is by using the Ruler Tool: draw a line parallel to a horizontal element of the image, such as the roof of the house. Once the line is drawn, select the Rotate Canvas Arbitrary option from the Image drop-down menus. This will automatically rotate the picture to the new horizon. Alternatively, you could use the Transform Tool and straighten the image by eye.

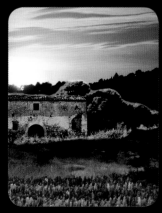

LAYER MASK | BRUSH TOOL

9 positioning the house

Next, you need to give the impression that the house has been part of the landscape for years. Apply a blank layer mask to the house image, using the Brush Tool to create an approximate cut-out. This mask can be refined later, but for now, it is more important to get the house into position. It is also useful to determine how much of the trees that are attached to the house should be included in the montage – you can experiment with this by manipulating the rough mask.

BRUSH TOOL

10 embedding the house

Once the house is in place and scaled to the correct size, it's time to clean up the layer mask. For the margins around the trees and hedges, use an irregular shaped Brush Tool to simulate out-of-resolution blur, giving a realistic outline to the trees. For the base of the house, blend the ground from one image to another. Use a soft Brush with a low opacity to clone the ground from one picture into that of the one below, using both images as the source for the other.

ADDITIONAL IMAGE

11 adding another element

After reviewing the composite, it's clear that another element is required to fill the somewhat empty space on the right-hand side of the image. The above image looks promising, with a tree partially in outline and close to the foreground, sitting on grassy ground. The tree's bare branches will provide an interesting outline for the orange of the sunset, and will also help to link the upper part of the image to the lower part, helping to integrate the composite.

DISTORT | QUICK MASK

12 positioning the tree

Flip the tree image so that it is laterally reversed, since the branches need to reach into the sky from the right-hand side. Then, in Quick Mask mode, paint a generous selection of the tree, turn the mask into a selection, and then copy and paste it into the composite. Position it and adjust its size and shape as necessary using Distort under the Image menu. It may look as though you will need to remove the whole of the mask, but some of it will disappear with a change of Blend Mode.

MULTIPLY

13 outlining the tree

The branches of the tree mean that cutting it out using the Pen Tool would be very time-consuming, while using another method, such as the Magic Wand, would prove to be very inaccurate. Fortunately, because we are using the tree as a silhouette, another method can be applied. By setting the Blend Mode of the tree layer to Multiply, all of the highlight colours are blended into transparency, whilst the darker tones are turned to black to leave out the tree branches.

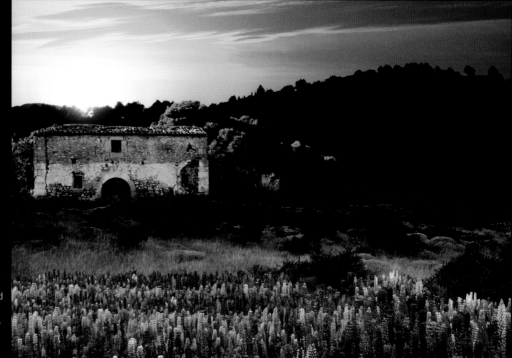

INTERIM REVIEW ▶
It's prudent to review the progress of your image from time to time. Remove all the palettes (press Tab), sit back, and take a critical look. In this image it's clear that, apart from balancing exposures, the right-hand part of the image is too quiet.

BRUSH | ERASER TOOL

LAYER MASK | SOFT BRUSH

DODGE TOOL

14 cleaning up mask
Although setting the Blend Mode of the layer carrying the tree to Multiply will speed up the process of placing the tree, it isn't a perfect solution. Some of the tones in the sky between the branches are close to the tones of the sunset sky, so remain after the mode change. Use a layer mask and Brush away the parts you do not want. Alternatively, apply the Eraser Tool directly on the image. For both, you will need a hard-edged Brush when working near the

15 recovering detail
The Multiplied tree provides a good shape for the foreground of the composite, but it now lacks any detail within the tree. To recover detail, duplicate the tree layer and turn this new layer's Blending Mode to Normal. Apply a layer mask to this new tree layer and fill the mask with black. Now with a soft Brush, paint back on the mask in the areas where you want to reveal some of the original detail, concentrating on the trunk and some of the

16 adding fine detail
Still working on the duplicated tree layer, choose the Dodge tool and apply it gently – with very low pressure and a Midtones or Highlights setting – to the tree trunk and larger branches. This will further open up some of the details in the tree bark that were dark in the original, source image. Make sure that you don't over-do it though – keep in mind that in the composite image, the sun is setting behind the hill, and you are working on the shadow-

QUICK MASK | CURVES

17 lightening the tree

As the image nears completion, it's a good idea to flatten it so that tonal changes are applied across the whole image. First, save the layered composite, then save as with a new file name, and flatten this new file. Looking at the new file, it's clear that the tree is still too dark compared to the rest of the image. To correct this, cover the whole image in Quick Mask mode, then remove the tree with a soft Brush. The resulting selection can then be inverted, so that the tree can be lightened in Curves.

BURN | SELECTIVE COLOR | LEVELS

18 fixing the levels

It's time for another interim review, which reveals that the main area for improvement is tonal balancing – ensuring that individual areas of the picture carry the right weight of density, colour, and contrast. Burn in the house to darken the stonework, boost the flowers' contrast in Levels, and thicken the shadow areas of the hills and mountains using Selective Color to increase the Black values. Make selections with large feathering to target certain areas for the tonal changes.

GRADIENT MAP

19 colouring the image

It can be surprisingly tricky to get components from different images to meld convincingly by adjusting contrast and exposure alone. One effective method is to use a strong colour to swamp the tonal difference. Apply a strong red-to-yellow gradient map across the entire image, using the hues present in the sky. Set the gradient map to multiply at an opacity of 36 per cent. The whole image warms up gratifyingly, as if bathed in the deep orange glow of sunset.

MASK | HUE/SATURATION

20 adjusting sky graduation

Looking at the image more critically, the sky lacks impact and doesn't balance the lively colours seen in the foreground. In preparation to correct this, apply a gradient mask to limit the changes to the sky, which gradually fades into the foreground so that the transition from the horizon to the top of the picture is smooth. The gradient can, however, be quite steep, since the sky should be more saturated. In Hue/Saturation control, boost the saturation in reds and yellows.

GAUSSIAN BLUR

21 creating depth of field

All of the elements in the composite were sharp images, so the sharpness appears unrealistically extensive. Not only does this cause the flowers to distract from the house, but any sense of depth-of-field is lost. To direct more attention to the midground, select the foreground area of flowers and gently knock them out of focus using Gaussian Blur. You can refine the effect by giving lots of blur to the nearest flowers, re-selecting, and applying less blur to more distant flowers.

LASSO TOOL | UNSHARP MASK

22 sharpening

In contrast to the blurring of the foreground elements, the midground details need to be sharpened up to draw the viewer's attention into the picture. As usual, limit the effect by first selecting the active area – in this case, between the distant flowers and up to the house, using the Lasso Tool set to a feather of 10 pixels. Apply Unsharp Mask, setting an Amount of 150, a low Radius of 1, and, because we do not want to accentuate noise in the image, set a Threshold of 20.

ORIGINAL IMAGES

step by step: **portrait makeover**

The fine art of portraiture has been a hybrid of flattery, visual spin, and misrepresentation from the time of Holbein (if not before) to the present day. Digital image manipulation adds little that is new but does makes the entire process of control over a person's image all the more complete and vastly easier. To the extent that, now, it is safe to say that few celebrities actually look as they appear in images from their press releases.

◄ ORIGINAL IMAGE

1 appraising the original

The easy access to tidying images up allows a certain looseness in photographic practice, and enables speedy studio work. In this image, more effort could have been expended on tidying the hang of the clothes. An effort could have made to apply light make-up on the model. But the key elements – the pose and the expression – were what the art director wanted, and any changes could be easily applied with digital techniques.

BRUSH TOOL

5 painting skin

The darkish rings under the eyes could also have been reduced with make-up, but they are easily removed by painting over the dark areas. With a small, soft-edged brush set to a low pressure, click on pink skin near the eye with the Alt (Option) key held down: this samples the colour and sets it as the colour to be applied. Paint with this, selecting slightly different pinks to give variety.

HEALING TOOLS

2 cleaning blemishes

The first task is to remove blemishes such as tiny freckles or moles on the skin. As there are few strongly defined boundaries, we use the Healing Brush tool to touch up the spots. Work at high magnification to avoid creating artefacts. Where details are close to a sharp change in density of colour, such as near the teeth, proceed with more care and use the Clone Stamp tool.

CLONE TOOL

3 cleaning hairline

The art director likes to see a clean hairline as that is a key characteristic of a more youthful model. Thanks to the even, flat lighting of the portrait session, you can use the Patch Tool to replace the area of thin hair with the evenly lit forehead texture. Proceed at the highest magnification to tidy up at the roots of the hairline to give a convincingly sharp margin.

CLONE TOOL

4 filling in eyebrows

Similarly, we need to tidy up the eyebrows. Using a combination of the Clone Stamp tool with very light applications of the Brush tool, we build up the gaps in the eyebrows hair by hair. Work at high magnifications but frequently zoom out to assess the effect of your changes on the overall balance of the image. Apply painted lines to a new layer if you lack confidence in your draughtmanship.

PEN TOOL / CLONE TOOL

6 cloning jaw

The art director decides that the line of the lower part of the face has been slightly lost by the flatness of the lighting. And, given the pose, a slightly more distinct jaw-line would be more appropriate. So, use the Pen Tool to define the shape required; then create a selection, which can be later altered if necessary. Finally, use the Clone Tool to fill out the jaw-line.

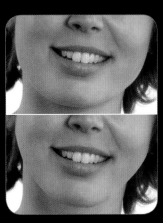

BLUR TOOL

7 jaw (before and after)

The result of filling out the jaw-line to the selection edge is quite sharp-edged and looked unnatural. So there is a need to soften the edge to simulate the falling away of focus. Use the Blur Tool with a generous radius and very light pressure to work at the edge so that the part furthest away is most blurred. But the amount of blur must be less than that of the neck, which is further away.

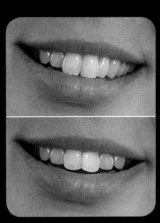

MARQUEE / TRANSFORM

8 mouth (before and after)

The details of a mouth are often very tricky to capture perfectly. In this case, the gap between lips half-covered the teeth. Using the Marquee selection tool, the smile very slightly increased in size. Then the teeth and the gap were reconstructed – very slowly and carefully – using a combination of Clone and Brush tools to give a fuller smile and perfect outline to the teeth.

MASK / CURVES

PEN TOOL / CLONE TOOL

CLONE TOOL /BLUR TOOL

9 removing lens flare – curves

Not only are imperfections found in the subject of a photograph, they are also the result of technical flaws. Here, the camera has captured a lens flare resulting in a discolouring in the black of the vest. To repair this, we could try cloning or using the other healing tools but, because of the texture of the top, this may prove difficult. The easiest solution is to make a selection of the problem area, and then apply Curves to merge with the surrounding fabric.

10 moving vest down

For a tidier appearance you should change the length of the vest. This is a similar process to that of reshaping the jaw – but in reverse. Firstly, draw a path for the new target shape of the vest and then make a selection. This time, the selection will act as a barrier so that only the contents of the selection are cloned into. Once again, the direction of the texture of the fabric is followed in order to create a realistic finish.

11 removing belt

With the vest now extended, the belt underneath is an unnecessary distraction. Using the same path drawn for reshaping the vest, a selection is made. This time, however, it's inverted so that the areas outside the selection are affected by the cloning rather than the inside area of fabric. Using the Clone Tool, follow the texture of the jeans and remove the belt, softening any sharp edges caused by the selection using the Blur tool.

◄ INTERIM REVIEW
Before going too far, it is worth asking for a second opinion on the progress of the changes. If you spend a long time working on the tiniest details, the likelihood is that you fail to see the image for the pixels.

BACKDROP FILL

15 selecting background

As a result of the interim review, we decide the image is looking a little too clinical. We select the white background with the Magic Wand tool set to Contiguous and click on the main background as well as the space between arms and body. From this create a mask for the body and try different backgrounds to see which works best: the palest polls the most votes, so that is adopted for the next step.

PATCH TOOL

LAYER MASK / BRUSH

LIQUIFY FILTER

12 removing rip in jeans

Another way to remove an unwanted area – as an alternative to the Clone and Heal tools – is to use the Patch tool. This allows you to draw a selection in the same way as you would with the Lasso tool but, after it has been made, you can then drag it to an area of similar texture and colour and effectively "patch" over a much larger area. The edges of the section blend in with the surrounding area and can quickly remove an unwanted object.

13 masking armpits

Toning down the creases of the armpits with the Clone tool is a difficult job. Similarly, just painting a solid colour over the creases would result in a fake, plastic effect. The quick solution is to make a selection of a similar area of skin (such as the shoulder) onto a new layer and than place it over the armpit. With an adjustment mask, gently blend the layers together to slowly reveal some of the original detail from underneath the armpit.

14 liquifying

Thanks to the flat lighting, the model looks unflatteringly flat-chest. The art director asks for that to be remedied. The Liquify filter is a powerful tool for reshaping objects in ways that Cloning or Transform can't. As the name suggests, the filter allows pixels to be warped, smudged, made spherical, and puckered, as if the picture were fluid. A grid is applied to the image, which is then manipulated to produce new contours before it's applied to the image.

FILL COLOUR / BRUSH TOOL

PEN TOOL / BLEND MODE

BRUSH TOOL / LAYER MASK

16 creating pale background

The background chosen for the picture is going to be a clean, pale blue/white colour. In order to do this, a new document is created to the same dimensions as the original portrait. Once this is created, the background layer is filled with white and the Brush tool is selected with a light blue colour and a low opacity, which is then used to paint over the desired areas.

17 overlaying cutout

The original portrait is copied onto the new background image for cutting out. With the Pen Tool, a path is made around the body. A layer mask is made from this path and the image is placed on the Overlay blending mode. Since the original image background is light, using this blending mode means that it isn't necessary to cut out the hair as it's blended into the new background.

18 brushing in hair

The portrait layer now needs to be duplicated and placed on top of the Overlay version. The blending mode on this new layer is set to Normal and the adjustment mask is filled with black. Now paint with a white brush to bring back the original detail and colour from the portrait, although it isn't necessary to go to the edge of the hair as the Overlay will blend into the background.

SELECTIVE COLOR

19 darkening hair
We use Selective Color as an adjustment layer to darken the hair. As the model's hair is made up of a variety of tones – yellows, magentas, and neutals – it is necessary to spend some time getting the balance right. It's worth remembering that you can use Selective Color more than once to achieve the desired effect. Here, it's used to affect the highlights as well as the hair roots.

SELECTIVE COLOR / CURVES

20 enhancing eye colour
The colour and contrast of the eyes can be enhanced – but gently – by making a selection with a Quick Mask and then either playing with individual colours by using Selective Color (the blues, cyans, and whites in this case), or by using Curves to bring out highlights and boost the blue channel. Be careful not to apply too strong an enhancement to the area.

LASSO TOOL / TRANSFORM TOOL

21 enlarging the eyes
Since the model was leaning back slightly, her eyes appear a little too small relative to the jaw. To enlarge the eyes, make a selection, one eye at a time, using the Lasso tool. You can use the Transform tool to adjust the size of the eye while holding down the Shift key: this restrains the proportions of the selection, thus preventing unnatural stretching or distortion.

DODGE TOOL

22 whitening teeth
Everyone wants to have white teeth but it's important not to make them appear unnatural. A quick way to give the subject a whiter smile is to use the Dodge tool with its range set to Highlights on a very low pressure. This will only affect areas that are already light, so the lips won't be affected if you accidentally brush over them.

CURVES / DODGE TOOL

23 finishing overall colour
To finish off the colour of the image, use a combination of the techniques described here. Curves are used to globally boost the contrast as the original image had weak shadow areas. Also, the Dodge tool is used to bring out some of the highlights on the shoulder, neck, and cheeks. This all helps to give more shape to the image.

BLUR TOOL

24 blurring edges
The final step in the process is to clean up the edges of the portrait. When the background image was combined with the model, the cutout used meant that there was a hard edge around the model's body. To correct this, and make the blend more effective, the Blur tool is run along the edges to soften them slightly.

Assignment: montaging images

It's significant that the most important early exponent of montaged imagery, John Heartfield, used the technique to convey a very specific political and ideological message – one that was often far removed from the elements that made up the montage. The essence of montage – or the compositing of several images together – is to use image manipulation to manipulate meaning. Now, however, the composites can be made to be completely seamless and invisible, or the use of different elements can be made very obvious.

COMPONENT IMAGES

thebrief

Use two or more different images in combination to create an entirely new image by using any techniques you wish, such as cut and paste, layering, and clone/stamp. If you are not used to this kind of manipulation, just superimpose any two images and play with different sizes, layer blend modes, and so on.

Points to remember

- be bold with the choice of images and with the changes in meaning
- use elements with simple outlines, which are easy to select, together with fairly plain backgrounds
- keep your various components in separate layers so that you can alter the order and blending at will
- reserve global tonal, colour, and other enhancements, such as sharpening, until you are satisfied with the final composite

COLOR DODGE AND MOVE

must-see masters

Catherine McIntyre (1961–)
An artist producing some of the most sensual composites extant, making full use of a virtuoso command of compositing techniques and blend modes to combine nude studies and natural forms with other-worldly effects.

Steve Caplin (1958–)
One of the pioneers of Photoshop and

rather the manipulations combine realism with caricature to create a unique body of political and social satire that is well-aimed and cuttingly funny.

Joan Charmant (1978–)
Producing work that ranges from the glossy science fiction through the mythic and fantastic to the weirdly humourous, this artist uses Photoshop with

PASTE AND STRETCH

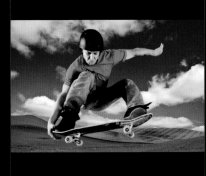

INVERT BACKGROUND COLOURS

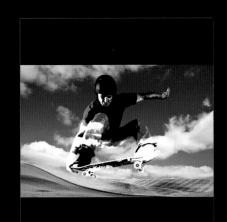

HARD MIX AND LEVELS

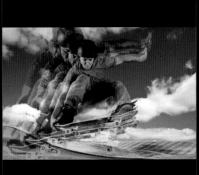

DUPLICATE AND VARIOUS BLEND MODES

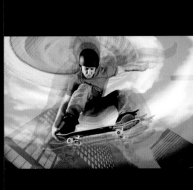

① ② ③
④ ⑤ ⑥
⑦ ⑧ ⑨

light**box**

top**tips**

① component | images
We start with two simple images,
one which offers a plain shape that is easy
to select, with clear outlines. The background
is varied enough to be interesting but not too
complicated in shape or colour.

② copy | paste
Firstly, select the main element
using any method – here the background's
uniform colour suggests Color Range. Invert
the selection and copy/paste the skateboarder
onto the sky.

③ colour | lower layer
If the change in shape is not promising,
try changing the colour of the bottom image by
altering the hue. We can make colour and tonal
changes to a background layer without having
to turn it into a floating layer.

④ ⑤ blend | modes
Experiment with the different
ways in which two layers can interact: for
example, compare the soft effects of Color
Dodge to the graphic results of Hard Mix,
to learn how they work.

⑥ duplicate | and blend
We obtain greater potential when
we duplicate the image onto separate layers,
then set each layer differently. Separating the
images allows independent changes in size
and position.

⑦ ⑧ background | work
Remember that you free the
background layer to accept changes such
as distortion filters when you change it into
a layer. Only then can you apply changes to
shape, and so on.

⑨ the third | element
When you consider that just two
components can produce an infinity of different
results, the addition of a third element multiplies
the potential of an image in wonderful ways.

industrial field

Harvey Roberts

"I like the contrast of my friend in his suit against the muddy puddles and dead grass caused by huge vehicles on the land."

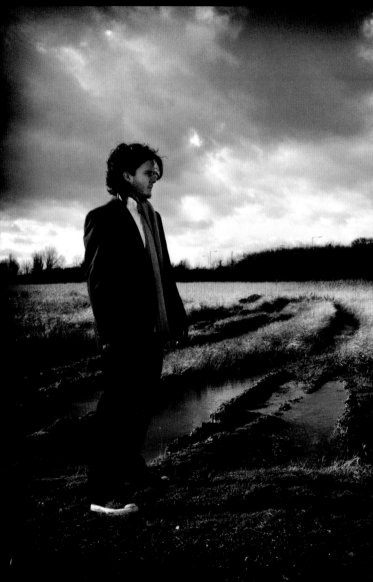

▲ Ricoh GR-Digital ISO 100 Focal length 28mm

the**critique**

Mathematicians may amuse themselves with speculating by how much the possibilities of an image grows when, already infinite, the original potential is combined with that of another, different image. It's a useful exercise to take any two images at random from your library and see what you can do with them to make them work. You might be surprised how quickly you can arrive at a workable image using even fairly basic effects and controls. In this selection, the photographers have shown admirable economy with their means.

industrial field

Harvey says he nearly lost a boot in the muddy field, but the result was worth the risks he took. He first combined shots of his friend and the ploughed-up field: it was essentially a case of selecting his friend in one shot and pasting it onto another shot with a better view of the puddles in the ground. Shadows and mud were added to the shoes to make the figure "sink" into the scene. Then tints were applied to the sky and ground to give the hand-coloured feel to the final image.

Ardali, New Sardinia

Sandro and Patrizia have done a good job of bringing two very different images into a tonal fusion. They placed the image of the ruins over the sky and erased the sky of the ruins to reveal the more interesting skyscape beneath. A golden tone over the entire image helps to unify them, but the direction of the light is convincing yet not entirely correct, suggesting entry into a strange world.

railway station

Ayush used HDR (High Dynamic Range) and tone mapping techniques to combine five different exposures: the result is oddly realistic and yet otherworldly – a typical effect of HDR images.

Ardali, New Sardinia
Sandro e Patrizia

"The ruins were in the wrong light but we wanted to make it as we might have seen it, so we used a sky from the same area."

▲ Canon EOS 350D ISO 400 Focal length 18mm 1/250 sec at f/10.0

railway station
Ayush Bhandari

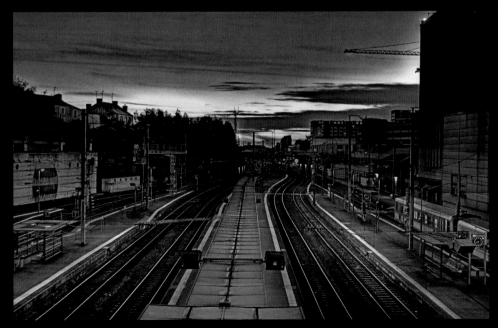

"These images were taken at the Gare de Rennes in France. I used split toning to reveal hue in the shadows."

▲ Sony DSC H9 ISO 100 Focal length 6.9mm 1/15 sec at f/2.8

For many, the most important question of all is how to cross what seems to be the yawning chasm between enjoying photography as an enthusiast and operating as a professional. In this section we interview outstanding photographers who generously share their hopes, secrets, and experiences. Their insights can take you further than a dozen technical handbooks.

ADVANCING
YOUR PHOTOGRAPHY

tutorial 13 travel photography

Travel has been a favourite genre of photography ever since new technology first enabled photographers to leave the studio – and now that professional-quality cameras are more affordable and globe-trotting is easier than ever before, travel photography has almost reached saturation point. Fortunately, there is still room for the thoughtful innovator.

substance over style

The attraction of travel and the opportunities it offers also present the greatest obstacle to taking your photography further. It is no longer enough to successfully convey the colour and beauty of a place that is magical and exotic to you; it has almost certainly been photographed before. To take your photography beyond the predictable, you need to reveal fresh insights.

dream | and reality

As we set off on our journeys we share similar ambitions to the very first travel photographers – although, unlike them, we don't need to take along a wagonload of equipment. We all want to record new sights and to be able to share them, and maybe sell them, when we return home. It is the dream of many people to combine travel with professional photography but, with almost every niche of the world accessible to tourists and hundreds of millions of travel snaps being taken each year, what hope is there of succeeding?

> ❝ It's a great help to be passionately involved with your subject ❞

If you harbour such a dream, it's not an impossible one. You may take comfort in the fact that the overwhelming majority of travel photographs are essentially records of the destination snatched at first sight. A large percentage of the remainder are the result of a more considered exploration of the area, with an attempt to find the best viewpoint combined with appealing light. But there's a further step to make: observing what is before you with sympathy and intelligence in order to lift your photograph beyond the purely visual.

skill | and passion

As a result of over-exposure to travel photography, only pictures that offer more than one dimension will succeed. The foundation is naturally a stunning composition, a fabulous play of light, or a beautiful subject. If you can also capture a human emotion, tell a story in which one picture entices the viewer to look forward to the next one, and inform as you delight, then you will make a breakthrough. This takes considerable skill. Obviously, you need razor-sharp reflexes to respond to changing circumstances – your subjects moving unpredictably, the shifting light in situations that are unfamiliar to you. This calls for well-practised camera technique, and equipment that can react quickly. You also need acute sensitivity to the friendliness or antipathy of your subject, and to the cultural and social subtleties to which you are a stranger. It is a great help, too, to be passionately involved with your subject. Above all, you need to be propelled by a desire to delve below the surface to obtain truly revelatory insights.

NEW YORK STREET 1

NEW YORK STREET 2

NEW YORK STREET 3

NEW YORK STREET 4

NEW YORK STREET 5

NEW YORK STREET 6

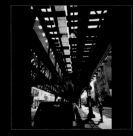

NEW YORK STREET 7

NEW YORK STREET 8

NEW YORK STREET 9

street project

1 2 3 4 5 6 7 8 9

lightbox

The journey from airport to final destination can furnish a project. 1, 3 and 6 explore the almost ubiquitous traffic light and its relationship with other street furniture and local buildings. 2, 5 and 7 make use of the architecture of bridges to frame featureless skies. 4 starts a new project on reflections, while in 8 and 9, we continue to work into the night.

tourist sights

Other tourists taking photographs at famous sites are themselves potential subjects for photography. Here at the Taj Mahal, the brilliant sari against white marble provides a refreshing change to the usual views.

in **conversation**

Q | **Clay, what first drew you to photography?**
A | I took a photography class at high school – but that was more of an excuse to fool around in a darkroom with girls! Only when I got to college did things begin to gel. I had two tremendous teachers there who showed me the potential of the medium. I have them to thank.

Q | **What happened next?**
A | I majored in film and photography at college, but my attention gravitated towards the simplicity and power of the still image. While filmmaking has its allure, I loved the idea of being able to make images by myself without a crew and lots of gear. Also, the notion that you can stumble across a strong image is almost unheard of in film. With photography it's expected, and who doesn't love a happy accident?

Q | **What aspect of photography is most challenging?**
A | Printmaking. While Photoshop has sped up the process, I still find making prints a challenge. I don't like sitting in front of a computer and, these days, that's where we seem to spend vo much time.

Q | **I guess that's reflected in your attitude to software?**
A | That's right. I use just Photoshop CS2, for now, and Lightroom. Keep it simple, I say.

Q | **I know you don't like to be pigeon-holed, but your travel photography has a character that really stands out.**
A | I can't say that travel's my specialty, but I do love to travel and the camera is my constant companion. For as long as I can remember, I've been enamoured with leaving my comfort zone and exploring places far from home.

Q | **Such as in this picture, for example? I like the way the boy's eyes grab you, yet your attention is pulled down the length of the train.**
A | Yes, I made this by hanging out of the door of the train. I simply reached out as far as possible – making sure that nothing was coming along to knock me off. Trains are natural studies in perspective but the real coup was having the boy with a shaved head staring back at me. He was remarkably nonplussed by my behaviour and simply looked back for a moment. I snapped the photo and he carried on looking forward – it was a lucky frame. I used my 17mm lens.

Q | Please tell us about the equipment you use.

A | I own three Nikon D200s; I love their size. I use the 80–200mm f2.8, 17–55mm f2.8 DX, 85mm f1.8, and 50mm f1.4. I have five 1GB CompactFlash cards, and various flashes and lights (but open shade is my best friend). My computer is an AppleMac G4 with a 23in cinema display. I love digital cameras, but you can't fall in love with your camera like in the old days. Now you can just love your lenses: my 50mm 1.4 is the best.

Q | How do you approach your assignments? Do you think your approach is what makes your work special?

A | If someone wants highly produced or contrived scenes, I'm not their guy. I'm always in the middle of the action and that's what comes across in my pictures. Everyone who raises a camera to their face brings a unique vision to the table, so I don't think my work is special. Everyone can do this; everyone should do this. Nowadays cameras are so accessible, and there are so many photography resources on the web, that someone with good discipline can be an expert in no time. Charge people with making artistic images instead of snapshots and we'd be living in a wondrous world of creative expression.

Q | What do you think about image manipulation and image effects – are they central to your work?

A | Image manipulation is as old as photography itself. The digital world simply makes things easier, so our visual vocabulary has become rife with clichés. I think there is a place for image manipulations, but only to make an image distinctive or "ownable". We all have the same chips in our cameras. There are no emulsions or push or pull processing techniques any more, but I do like to give my images a unique "digital emulsion" that makes them mine. I do this image-wide in Photoshop. It's quick, easy – and secret!

Q | So, what's your workflow?

A | I came to RAW reluctantly but now I would only shoot that way. I think you should keep things simple in post-production. For me, the magic happens when the shutter clicks, not afterwards on a computer screen.

Q | Finally, what do you hope to achieve with your photography?

A | To inspire others to do the same.

images **in depth**

passer-by | Vietnam

Q | Did you wait for someone to complete this shot?

A | I recall walking past this woman, in Hue, Vietnam, and turning to make the shot rather quickly. I could feel a nice balance of light, colour and action that resonated with me at the time of the shot. It's not a perfect picture by any means but it has a nice balance that somehow satisfies. There are times when I may find a place and wait for a shot, but this wasn't one of them. The whole country of Vietnam is remarkably photogenic, so to wait in any one place would mean denying yourself photos elsewhere.

street scene | still cow

Q | Please tell us about the thinking behind this shot.

A | If only photos could capture noise! That's what I was struck by: car horns and the motion. I like the way a still photograph's limitation can also be its strength. We can't make movies so we do the next best thing: long exposures. I hand-held this shot standing on an island in the middle of the street. The cow's stillness was a nice complement to the hustle and bustle around it. I shot three frames but only this one had the cow adequately visible.

> ❝ I love the way photographs and the medium of photography have certain codes and limitations... long exposure tries to address elusive properties such as motion ❞

rickshaw | pedaller's foot

Q | This is quite a masterful shot for me. What can you tell us about it?

A | To be honest, I'd had a few beers when I took this shot and it's the result of a whole series of pictures. I was in the back of a rickshaw with a friend and couldn't quite compose the shot in the way I wanted – partly because I couldn't get low enough. I was just reaching down and clicking away. I loved the guy's foot and the fact that he was pedalling all three of us through the streets seemed completely crazy. Finally, when he stopped at a light, he lifted his foot onto the frame of the bike and I could steady the shot enough to get something usable.

alleyway | Varanasi

Q | **I like the rhythm of the colours and shapes here.**

A | I rounded the corner of this alleyway in Varanasi, India, and was immediately struck by the quality of light and the unified yellow palate. I ended up waiting 15 minutes just to see what would come round the corner. However, this is one of the first: within seconds of finding the scene, the woman appeared in the doorway. Later, a cow came through, then a biker, and finally some monkeys. After all that, I returned to this shot as a favourite.

train tracks | worker and passenger

Q | **This is a smashing shot – one that has movement, spatial ambiguities, and compositional tension.**

A | The camera often attracts a certain amount of attention when travelling abroad. This can be either a blessing or a curse depending on how you manage it. Finding myself with a few hours to wait for a late train gave me time to explore both the social and compositional challenges afforded by being in one place for a long time. Crowds of people would continually gather and disperse, curious at my efforts to make

photographs. By the time I made this shot, the blurry train-worker on the tracks had already had his portrait taken. I'd been down on the tracks too, and the man on the right had been watching me for long enough that his attention had started to wane. I was deliberate in my composition here. I squatted and adjusted for a good 10 seconds to make this shot and having to hand-hold it only made the effort more focused. I don't travel with a tripod; relying instead on found objects or very deliberate breathing to steady the shot.

Assignment: **a revealing angle**

Capturing an image that reminds you of what you saw and experienced on your travels is easy. It's much harder, though, to create an image that catches the attention of the viewer and arouses their curiosity about the location, its inhabitants, and their culture. In part, this is because we see so many travel images in magazines and newspapers that our eye becomes jaded. You will know you have mastered travel photography when people want to learn more about a place or, even better, sigh and say, "I want to go… Now!".

ISO 800 Focal length 35mm 1/250 sec at f/8

the**brief**

Try to convey a sense of discovery and involvement in what you see and feel on your travels. Think about the photographs you have already seen of the locations and try to imagine how you could frame a composition or use perspective differently in order to reveal a little more.

Points to remember
- gain as much local knowledge as possible so that you can be a guest rather than a visitor
- learn a few words of the local language to communicate and create relationships
- use the short or wide-angle end of your zoom as much as possible
- catch people's eye and win permission to take a photograph
- work on thematic or project-based lines
- follow your own path and take photographs where no-one else does

ISO 400 Focal length 43mm 1/100 sec at f/8

must-see **masters**

Raghu Rai (1942–)
Rai's coverage of the Indian subcontinent is unrivalled for its depth, breadth, and virtuosity of vision. At their best, his images are object lessons in intelligent composition. His approach shows the advantages of in-depth local knowledge.

Paul Harris (1956–)
Harris is one of the most travelled of contemporary photographers in the genre, unwaveringly socially conscious,

and a generous teacher. His work is widely reproduced and he is in demand to accompany and record expeditions to all parts of the world.

Felice Beato (1825–1908)
One of the greatest travel photographers of all time, Beato journeyed throughout the Crimea, the Mediterranean, India, Japan, and Burma, photographing all the way and without pause. His 14-year record of Japan is the most important and complete of the country in that era.

ISO 100 Focal length 7.2mm at f/5.6

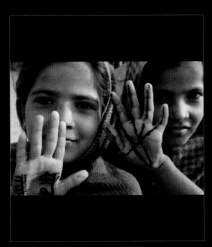

ISO 100 Focal length 18.4mm 1/60 at f/4.5

ISO 200 Focal length 5.3mm 1/100 sec at f/8

ISO 100 Focal length 12mm 1/400 sec at f/4.5

ISO 400 Focal length 20mm 1/30 sec at f/11

ISO 400 Focal length 11.2mm 1/320 sec at f/4

ISO 400 Focal length 9.1mm 1/50 sec at f/4

1 2 3
4 5 6
7 8 9

lightbox

top**tips**

1 portraits | relationships
It may be tricky but it is ultimately most rewarding to form relationships with people – if only a smile and a nod – before photographing them. Your job is to capture their dignity and personality, not their discomfort.

2 invitation | participation
Children everywhere love to be photographed, so you need to find ways to make the image more interesting and informative than the norm. If the children want to show you something, take their lead.

3 depth | encompassing the whole
The depth in images is not just about depth of field but the bringing together of as many elements as possible. Here, the stillness of the man, the movement of the boat, and the skyline convey a sense of relaxed calm.

4 signs | and patterns
Often attractive, signs are also usually self-explanatory. Keep your eyes open and look for something special and different – for example, the insistent repetition seen here.

5 6 themes | and statements
Groups of images covering the same subject in different ways or in different locations, such as these on the roads of India, build up to a far more powerful statement than a single, isolated image.

7 extra elements | light and shadow
The juxtaposition of animals with decorative buildings makes for an attractive subject; combine that with interesting light and shadows and you will start to lift the image from the ordinary to the inspirational.

8 9 famous views | new angles
Great cities such as Venice have been so fully photographed it seems doubtful that fresh views are possible, yet the more you look for new angles the more you will find.

Varanasi, India
Napoji

"The colour of the wall matching the boy's shirt was so stunning I thought it was deliberate – it sure worked to get my attention. "

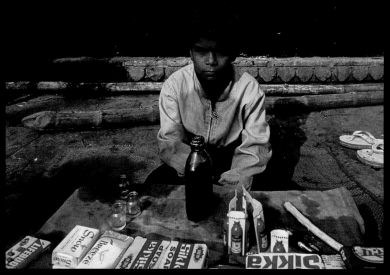

▲ Canon A40 ISO 200 Focal length 7mm 1/200 at f/7.0

the**critique**

While travel photography is one of the most popular subjects, and travel is a wonderful source of images, it is a far greater challenge to convey more than the immediate impression. As a result, the great stream of travel photographs for the briefing did not materialize. This is a sign of an important advance and change in attitudes because it shows that we are moving from the celebratory and superficial observation to the investigative and the documentary. We want to understand and convey our understanding, not merely snap the touristic, pretty view.

Varanasi, India
This is one image for which colour is essential. Napoji is correct to compose it very simply, with a straight-on framing. It might have been beneficial to choose a lower viewpoint, however, which would reduce his shadow on the front of the boy.

tiger reserve
Rahul was on an excursion at dusk in the Jim Corbett National Park, a tiger reserve, when he saw boys clambering on a tree above him. He had to tackle the problem of photographing from the right position to keep the plain blue background without anything in the way. He descended a hill and quickly found a position where the leaves did not obstruct the boys as they were not going to wait for him. He managed four shots before they dispersed, but by then he'd got his image.

Vietnam waterway
The problem with photographing from a small boat is that unless you're in the prow, your forward view is always obstructed, and if that person is rowing you can't ask them to move. Dmitry tackled this problem by some dangerous leaning to one side. His best image caught a glimpse of the boat ahead at the moment his boat went slightly sideways.

was dusk and seemed
if the boys on the branch
re trying to have one
t glimpse of the dying
nge ball."

▲ Sony DSC H5 ISO 125 Focal length 21.1mm 1/50 sec f/5.6

etnam waterway

nitry Dudin

"It was very hot and we
were attacked constantly by
mosquitoes, so it was hard
to keep concentration but

portrait photography

More than any other genre, portrait photography has clearly demarcated areas of work. Once the preserve of professionals, it became popular with the public when cameras became a mass market product. In response, the profession developed niche categories – pet, child, celebrity and so on – and even niches within a niche, such as portraits of specific musicians or actors.

fact file

If anything is axiomatic in photography it is that portraits are better if you capture the catchlights of a sitter's eyes. For one thing, it means you are close enough to see them, which brings you closer to the subject. It also means you have focused sharply on the eyes – another "must". And of the two eyes, general practice is to prefer the nearest eye to be in focus. Almost everything else can be a blur, and some portrait styles exaggerate this, but if the near eye appears sharp the whole image is regarded as acceptably sharp.

new **faces**, new **clients**

The most reliable demand for professional services in photography is in portraiture. From corporate reports to passports, from newsletters to magazine profiles, and from graduations to engagements, everyone needs a portrait at some time – and many people like to have them made regularly to document their own lives and those of their growing children.

personalities | and practicalities

The quintessence of portrait photography is best summed up by the advice given by Alfred Eisenstaedt to ensure that you "click" with your subject before you click your camera. Eisenstaedt could click with anyone on the planet, from desert nomads and heads of states, to the most testy of film stars, as a result of which his output of telling portraits is prodigious in number and stupendous in quality.

> ❝ Form a relationship with your subject ...
> no matter how powerful or busy they are ❞

Admittedly, Eisenstaedt also had a knack of being in the right place at the right time, which is a part of successful portraiture. The photographer needs to time a portrait session for the earlier part of the day, before his or her subject has become stressed or tired. The lighting and position should be checked with a stand-in to save time when the subject arrives, and also to iron out in advance any technical problems, such as obtrusive backgrounds or the balance of lighting. Experienced portraitists spend enough time with their subject to form a relationship, but not so much that the subject becomes impatient. Establishing and maintaining eye-contact is important – no matter how powerful or busy the subject may be.

equipment | and styles

Portraiture is ideal for photographers who wish to work with the simplest technical means. Some of the greatest portraits, such as those created by Irving Penn, Robert Doisneau, and Cecil Beaton, were made on a Rolleiflex camera on which the standard focal-length lens was permanently attached. The veteran British newspaper portraitist Jane Bown carries her kit in a shopping bag.

With modern technology, and especially with digital cameras whose very high sensitivity settings produce noise-free images, it's possible to work entirely with available light. Alternatively, you can choose to light your subject with multiple sources and produce a dramatic effect impossible to achieve naturally.

Contemporary styles also allow for the use of a greater range of perspectives. Working in a studio limits the maximum distance that you can be from your sitter, but it's easy to communicate and give instructions. On location, where you can often move further away, personal contact is harder to maintain, but you have the chance to use a longer lens.

ENVIRONMENTAL BABY CHILD

SELF CHARACTER EDITORIAL

CLOSE-UP DOCUMENTARY FORMAL

portrait genres

① ② ③
④ ⑤ ⑥
⑦ ⑧ ⑨

light**box**

You can approach portraiture by showing someone's environment **1** or by getting up very close to them **7**. You can show their character as a baby **2** or child **3** or by catching them in documentary style **8**. Character photographs can be caught candidly **5**, or you can pose and position your sitter **6** and **9**, or just catch yourself **4**.

impromptu portraits

Some people like to have their photograph taken – or to give their likeness to you. With others you have to work harder to build a relationship and gain trust. Personal skills are just as important as photographic skills, perhaps more so.

eolo perfido

Nationality Italian
Main working location Italy

A graduate in computer science, Eolo went on to specialize in interactive graphics and multimedia development. Moving from Italy to London, Geneva, Las Vegas, and San Francisco, where he took on various different jobs, he returned to Rome aged 26 to work on software development. At the age of 28, helping a friend on a photographic shoot turned him on to photography. Since then, he has run a studio that has developed a growing reputation for advertising and editorial portraiture. He has also assisted renowned photographers such as Steve McCurry, Elliott Erwitt, and James Nachtwey on photo shoots in Europe, Africa, Asia, and South America.

see more of Eolo's work at:
www.eoloperfido.com

in conversation

Q | **You started relatively late in photography – how did you get into it?**

A | I was 28 when I discovered photography. I watched a photographer friend taking pictures and I was fascinated. I found myself constantly thinking about photography and it was an incredible experience to discover that, with some attention, my pictures were actually quite nice! I also understood that study and discipline, as well as raw creativity, are needed to take good pictures.

Q | **How did you come to specialize in portraiture?**

A | As well as taking nice pictures, my biggest joy was coming into contact with people. This was something I missed when I worked with computers. I'm fascinated by people, and to be attracted by portraits was a natural consequence of this feeling.

Q | **What aspect of photography do you find the most challenging?**

A | To be able to always remain contemporary, to maintain good image quality, and to be able to develop my style while on commercial assignments. Keeping up with the enormous technological changes that face our work is also a challenge.

Q | **What cameras and lenses do you use in your studio?**

A | Right now we use two Canon 5D bodies with Canon 24–70mm f/2.8, Canon 100mm f/2.8, Canon 50mm f/1.8, Canon 70–200mm f/2.8, and Canon 85mm f/1.8 lenses.

Q | **How do you approach your assignments?**

A | Good preparation is key. We dedicate as much time as possible to understanding what's needed, and preparing the set and models. When I shoot portraits, I try to find out as much as I can about the subject beforehand.

Q | **Tell us about this image. The portrait is so strong and direct – is there a good story behind it?**

A | I have to say that I love hands and I always try to observe how my models use them. In this case, I asked the actor, Marco Giraldi, to touch his face. In the few moments before his hands reached his face I managed to make the shot. It was taken for his press office and has been published in several magazines.

Q | What do you do to stand out from other photographers, to make your work special?

A | The world is full of photographers, from professionals to amateurs, and many are very good. I tell myself, "this world doesn't need another photographer, so work hard if you want to do it." I love to see other photographers' work and I don't think I stand out any more or less than anyone else. I do my best to keep my style personal but also in line with contemporary imagery. Sometimes I try something new and post it on the internet to see what kind of feedback it attracts.

Q | Please tell us what you think about digital cameras and equipment.

A | I love it, although I still think that film has a better rendering and that the mood of some black-and-white film is something we will miss in the future. But I also feel that technology is making our life easier and is giving us new opportunities. I'm also sure that quality will increase with time. For students, digital cameras are great news as it means they can shoot as much as they want without having to worry about the cost of film, development, and printing.

Q | What do you think about image manipulation?

A | I believe it is an opportunity to make better images. Today, software is just part of the kit, like lenses, film or memory cards – although you can, of course, choose not to use it. Retouching is something that was already happening in the darkroom and today's technology simply makes it faster and more accessible. However, I think that retouching can often make an image worse, although this is a problem of taste rather than a technical issue. I also believe that some photos should not be retouched at all, such as reportage and documentary footage. You may work the contrast or remove some dust from the sensor but you shouldn't alter reality.

Q | Please tell us about an accessory that you find absolutely essential.

A | I would say my block notes, I would die without them! I always have so many notes to write down and so many notes from previous sessions to look up. For a more technical accessory, I would say that a small diffuser is a real necessity.

images **in depth**

fashion portrait | mixed message

Q | I like the ambiguity of this shot – the girlish pose in one half of the body and the grown-up pose in the other.

A | This image was shot for a Chinese fashion magazine. I was trying to achieve some sort of dynamism out of a static, sitting position. This photograph uses very simple lighting: only one big softbox on the top and a gold reflector on the left of the model. The model is Chiara Ceci and the styling and make-up are by Domenico Sanna.

I use several techniques when I convert images from colour to black and white. I'm very instinctive in that I don't follow a single method

light and dark | facial expression

Q | **This feels quite dark and sad but there is also humour just below the surface.**

A | We were shooting a beauty commercial and all the pictures were so clean and perfect. I wanted more of an atmosphere for this shot so I asked the make-up artist, Maurizio Menga, to apply the make-up so it looked dirty. I asked the model and actress, Elena Cucci, to play with her body and expression, and we worked for 30 minutes.

revealing character | close crop

Q | **You have cropped in fiercely here but the man's face is warm and sparkling with good humour. Do you only crop in camera?**

A | Yes, this image was cropped in camera and I rarely re-crop my images. I used a 100mm macro lens to show the detail of the man's face. The photo was shot in the street in natural light without any panel or softbox, and the model is someone I met on my way back to my studio one day. I asked him if I could take a portrait, then we had a coffee together. I love eye contact in my photos.

dancer | authentic pose

Q | It is easy to think that a subject as wonderful and handsome as this is easy to photograph, but the pose is very delicately judged and the lighting is gorgeous.

A | I was working with Konrad, a model and dancer, for an article for a Spansh magazine. The pictures were in colour and the mood was very different from this photo. At the end of the shoot I sensed he was tired and I wanted to capture this in a black-and-white portrait. I asked him for one very last photo and used a single light just 45 degrees to his left. I aimed the camera at him for several seconds before shooting, waiting for him to lose the artificial pose and look at me more naturally.

vintage chic | natural lighting

Q | You've achieved a wonderful combination of retro and modern chic here. Tell us about the shot.

A | I spotted Nandin, a Mongolian model, during a dinner and I asked her to model for me for a Russian magazine. It was shot in the ambient light of a cloudy day, which I always really like, and we went to several markets to find the vintage clothes and accessories. This image was desaturated and then I worked on the levels and curves to achieve the contrast I liked.

perfect model | image manipulation

Q | Is it always easy to produce a beautiful portrait if you have such a beautiful model?

A | I took this shot in a pause during a fashion shoot. The model, Angel Turner, was relaxing near a window and I asked her to look at the camera. As the image was shot in very soft natural light, the digital manipulation was quite strong, with high contrast and added red and yellow.

Assignment: **capturing character**

If there is any genre of photography in which the photographer plays the subservient role in a partnership, it is in portraiture. Your role is to be as self-effacing as possible in order to allow the personality of your subject to come through. At the same time, of course, you must exercise all your skill in camera technique, lighting, and the handling of relationships to convey the sense of the person through your photograph: they depend on you to interpret them to the viewer sympathetically and with understanding.

ISO 200 Focal length 60mm 1/60 sec at f/3.3

the**brief**

Arrange a portrait session with an acquaintance – someone you know, but not a good friend or member of your family. This is more difficult than working with someone you are close to, but not as tricky as working with a complete stranger. Use any means at your disposal – available light, flash, props, surroundings – to obtain a portrait that conveys the subject's character.

Points to remember
- use a medium or long telephoto for full-face shots
- to show some more of the subject's setting, use a standard or medium wide-angle lens
- for a portrait of the sitter surrounded by their environment, shoot with an ultra-wide-angle lens
- use a reflector to help control any deep shadows
- avoid photographing while the subject is speaking as this causes blur

ISO 400 Focal length 28mm 1/125 sec at f/2.8

must-see **masters**

Julia Margaret Cameron (1815–1879)
The greatest amateur photographer in history, and active for only 14 years, Cameron produced some of the most memorable and insightful masterpieces in all portraiture with a dedication that left many professionals far behind.

Wolfgang Tillmans (1968–)
Leading the generation of photographers reacting against the studied formalism of portraiture for a more intimate, confessional style of artless casualness

influenced by the studied informality of Nobuyoshi Araki, Tillmans represents the high-art end of the vernacular portraiture that's often seen on photo-sharing websites.

Arnold Newman (1918–2006)
Newman was the all-time master of the environmental portrait, his meticulously researched and executed images combining insight with sophisticated lighting. He defined high editorial portraiture and was widely influential.

ISO 400 Focal length 28mm 1/60 sec at f/3.3

ISO 200 Focal length 60mm 1/60 sec at f/3.3

ISO 200 Focal length 60mm 1/125 sec at f/2.8

ISO 200 Focal length 60mm 1/60 sec at f/3.2

ISO 200 Focal length 24mm 1/125 sec at f/2.8

ISO 200 Focal length 60mm 1/30 sec at f/3.2

ISO 200 Focal length 17mm 1/125 sec at f/5.6

1 2 3
4 5 6
7 8 9

light**box**

top**tips**

1 **full face** | medium telephoto
A good place to start is with a full-face shot using a medium telephoto lens. Your subject should be relaxed and not necessarily looking at the camera. Ask him or her to look around slowly.

2 **details** | interpretation
Turning your attention away from the face from time to time helps a portrait sitter to relax. Details can be telling, and add intimacy and atmosphere to a set of portraits.

3 **relaxation** | strategies
If the sitter is nervous, it helps to have someone else engage them in conversation, at least to begin with. However, too much talking can mean that the mouth becomes blurred, which is not desirable.

4 **5** **hands** | animation
Hands can be as expressive as the face. If your subject is relaxed and animated, you can bring a natural feel to the portrait by making hands the main focus of the image.

6 **formal compositions** | planning
It takes a good deal of practice to make formal compositions work properly. The best approach is to plan out the composition in detail before the sitter takes up his or her place.

7 **8** **monochrome** | advantages
Black and white is a natural medium for portraiture, since it eliminates potential distractions while losing nothing of what matters – the delineation of the sitter's gestures and face.

9 **environment** | and situation
An environmental portrait, taken with a wide-angle lens to show where or how the person lives or works, is invaluable for completing the story.

▶ see **results**

Imperia, Italy
David Rossi

"The university building where I study was a perfect background for a fellow student whose look was great for my post-processing technique."

▲ Canon EOS 400D ISO 200 Focal length 22mm 1/80 sec at f/4.5

the**critique**

It was once a sign of high social standing to have a portrait made, and even grander to be able to leave prints of your visage to remind people of what you looked like. Now, there are hundreds of millions of portraits on the social networking web-sites of the world, but there are few that capture personality in the singular image. In part this reflects the complexity of the modern personality, but it may also reflect the fact that we don't spend enough time on the portrait. When you work on portraits take your time and make sure you maintain eye contact as much as possible.

Imperia, Italy
David's striking portrait works at several levels. The most immediate is the strong contrasts of colour which, he explains, is the result of post-processing aimed at reproducing the colour palette and saturated quality of Fujichrome film. The relaxed, grungy informality of the pose is archly hip when combined with the over-sized shades, their metallic reflections juxtaposing bug-eye with gamin looks. The shadow details are also very nicely controlled – altogether a poised editorial portrait.

grandad's hat
Some portraits look posed when they were not, and some can look unposed when they were very carefully arranged. In this shot, the first impression is that it was posed but, in fact, perhaps the moment was not quite timed correctly: the smile was perhaps caught on its way down. But it doesn't make it any less genuinely warm.

portrait with ivy
With a face and hair that was less characterful, this portrait may have come across as being poorly composed, but the eccentricity of balance seems to be appropriate to the character portrayed. Normally, bleached-out skin tones would not be attractive, but here it seems to fit with the person.

grandad's hat
Thom Small

"His trademark hat was on a hatstand near the front door and he put it on to show off for the camera as he waved me goodbye."

▲ Nikon D50 Focal length 20mm f/2.0

portrait with ivy
Florence Fairweather

▲ Casio EX-Z700 Canon Focal length 10.7mm f/3.6

"My friend is quite photogenic anyway, but the ivy was well lit at the time and seemed to be a good background."

tutorial 15 documentary photography

In its heyday, documentary photography was structured on the basis of outsiders – often humane and sensitive, but outsiders nonetheless – looking in. We are now entering an exciting era in which documentary work is increasingly being carried out by people examining their own lives and cultures. The democratization of photography allows more of us to participate than ever before.

fact file

For many, the natural medium of documentary photography is black and white – certainly, the tradition grew from monochrome. But others feel that colour gives the truest record, one that does not allow the loss of colour to gloss over unpleasant facts, such as the appearance of blood. With digital photography, you now have a choice and can leave it to later to decide. Futhermore, the way you convert to monochrome and how you emphasize one colour over another can be safely left to the post-processing stage.

freedom of choice

The documentary genre offers unlimited opportunities to the photographer, since truly any subject can be explored. It can be as prosaic as household chores, as emotional as a domestic drama, or as monumental as the impact of climate change on maritime societies. Any subject can be rendered interesting provided you can deliver insightful, involving images.

traditions | and ethics

With the modern acceptance of any kind of pictorial approach, the limits to producing striking documentary work lie only with the photographer. Substantial bodies of work have featured topics ranging from household disorder to pet owners, members of gun clubs, and lifeboat volunteers. At the same time, the documentary tradition developed in LIFE and Picture Post, and surviving in magazines such as GEO, Stern, and National Geographic, is as strong as ever, inspiring new generations

> 𝄶𝄶 Viewers must be able to trust that what you show is what truly occurred 𝄷𝄷

emerging from countries that lack strong photographic traditions. There is still plenty of room for innovative, passionate documentary work, and any style appropriate to the subject can be effective. However, there is a common thread running through all documentary work that must never be broken: the photographer's allegiance to the truth. Viewers must be able to trust that what you show is what truly occurred, and is also what would have happened had you not been there to record it. This requires that you strive to ensure that you do not influence the situation in any way.

storytelling | filling in the details

With certain subjects, veracity alone may be enough to ensure that the story deserves an audience. This occurs when the story is so compelling that we want to learn as much about it as we possibly can – such as the main players, the circumstances, and the details. Many documentary photographers will tell you that subjects choose them, not the other way round: a subject may simply grab your attention, crying out to be photographed and recorded.

Once you've found your subject, your next step is to fully research it and, where necessary, consult specialist academics and experts working in the field. When you are shooting, keep in mind the story you want to tell. You need pictures that set the scene, introduce the major players, and show how they live, taking shots in progression. Cover the wider view as well as close-ups of telling details. Aim for some pictures that bring close-up and distant details together in a dynamic composition: these often make effective opening images.

URBAN VIEWS

PORTRAITS

CANDIDS

LEISURE

BUILT ENVIRONMENT

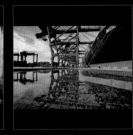
INDUSTRY

STREET

POSED GROUPS

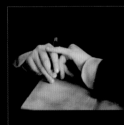
CLOSE-UP

variations on life

Urban views and the built environment **1, 5** offer rich material for documentary work, as does industry **6**. Portraits from different distances and levels of involvement **2, 8, 9** offer the chance to enter imaginatively the lives of other people. People alone **3**, at leisure **4**, or in the street **7** are easiest to document when in public spaces and travelling.

lightbox

local story

This image could simply be recording the pretty spray of sparks. It could be a day in the life of a worker, which could be part of a documentary of the loss of jobs in an area whose industrial past is now all but over.

altaf qadri

Nationality Indian
Main working location Kashmir

Born in Srinagar, Kashmir, Altaf studied science at Kashmir University and began his working life as a computer engineer. However, when a friend presented him with a camera he soon realized that it gave him the ability to document the events in the region. It was not long before Altaf gained his first freelance assignment and, in 2001, he became a staff photographer on a local newspaper. In 2003, he joined the European Pressphoto Agency, for which he provides extensive coverage of the conflict in Kashmir. His stories and photographs have been published globally, and his many honours include the Outstanding Awards in Spot News and General News at the 2nd China International Press Photo Contest (CHIPP) 2006, the National Geographic Society's All Roads Photography Program Award 2007, the Award of Excellence at the Pictures of the Year International (POYi) 2011, and first prize in the People in the News category at World Press Photo 2011.

see more of Altaf's work at:
www.altafqadri.com

in conversation

Q | **Altaf, what made you decide to specialize in documentary photography?**

A | I grew up amid mass uprisings against Indian rule and witnessed many important events. As a teenager, I was fascinated by the access journalists and photojournalists could get at times of war. Forces would commit atrocities on civilians but they rarely harassed or ill-treated journalists. So I thought being a photojournalist would save me from these things. I later strongly felt that my pictures would make people aware of the situation in Kashmir.

Q | **What aspect of photography do you find the most challenging?**

A | During natural or man-made disasters, it is extremely difficult to cope with the situation and produce your best work at the same time. There have been many cases of post-traumatic stress disorder among photojournalists covering wars, conflicts, and natural disasters. For example, Kevin Carter's photograph of an emaciated child with a vulture lurking nearby won him the Pulitzer Prize, and ignited efforts to send aid to famine-stricken Sudan. However, Carter was haunted by his own image and committed suicide just months after winning the accolade.

Q | **Please tell us about your camera gear and any essential accessories.**

A | I'm now working a lot with Canon digital EOS models, mostly a 5D with a 24–70mm lens. I also use a 16–35mm wide-angle zoom and a 70–200mm zoom. I use a film camera for some assignments. I always like to work with available light so I seldom use flash. My torch, Swiss Army knife, mobile charger, and compass are all "must-haves". A portable prayer mat, scull cap, head scarf, and the Qur'an are always with me so I can practise my religion as much as I can.

Q | **The 24–70mm is an intimidating lens, but perhaps the people in this photograph had more serious worries on their minds?**

A | In this shot, survivors of an earthquake in 2005 in Kashmir jostle as an aid organization distributes bread in Kamal Kot, Uri, some 125km (77 miles) north of Srinagar. I was lying on the roof of a truck that had arrived with supplies. People were more concerned about the food than my camera, so in this particular situation the intrusiveness of the lens made no difference.

Q | **Are you always ready to photograph?**

A | Cameras are a huge part of my life. Wherever I go I carry at least one camera because, in a conflict zone, you never know what is going to happen next. I feel insecure without a camera. If I'm not carrying my cameras I suddenly realize that an important body part is missing. I love them. I think, however, that excessive use of digital cameras can have an adverse affect on the quality of photography. People shoot so much that they think out of 500 frames they'll be able to get a couple of successful shots. This can ruin your ability to see and shoot good pictures.

Q | **What is your opinion of image manipulation?**

A | Technology, if it's used within certain limits, is bliss, but we should never cross these boundaries. I think that image manipulation is a big problem in photojournalism. Ethics plays a vital role here. A photojournalist must know to what degree he can manipulate or improve his image. For example, there is nothing wrong with darkroom techniques being used on the computer. RAW pictures obtained directly from the camera can be very flat so we sometimes adjust the tone, colour, and saturation. Anything more is manipulation and one should never add or remove information in the frame.

Q | **What do you hope to achieve with your photography?**

A | My main aim as a photojournalist is always to highlight human issues – no matter where they are. Nothing makes me happier than when I see that one of my photographs has helped someone. Recently, while covering a fierce gun battle between Indian soldiers and Kashmiri separatists in North Kashmir, a mortar shell landed in the compound and started a fire. From a distance we, a group of photojournalists, saw an old woman crying for help. We rushed over to her house and started dousing the fire with water. We succeeded in stopping it from reaching her house. When we began to leave, she hugged us with all of her sincerity. I felt so good – it satisfied me in a way that no picture ever has. I thank God for giving me a chance to serve humanity.

images **in depth**

policeman | eye contact

Q | **Please tell us about the circumstances here, and your approach to the situation.**

A | I made this an hour after a grenade attack, when the traffic had resumed. A policeman was told to move the car. The bullet and splinter marks on the windscreen were directly in front of the driver and I was sure he would look at me. I just waited for the right moment and quickly took two shots.

earthquake survivors | Kashmir

Q | **This needs a caption to convey the facts, doesn't it?**

A | We need captions because sometimes what a picture depicts is different from the facts – captions become a part of the picture. While walking past the tents, I heard a group of kids playing. I didn't want to intrude on their privacy so I shot with a 70–200mm lens, but they saw me and just carried on playing.

Kashmiri women | waiting

Q | **What is your policy on candid photography – do you feel it is disrespectful to make pictures without the subjects being aware?**

A | I like candid photography but I keep it strictly limited. I will never take a picture of someone if I think, if they see it published, they will be embarrased with themselves. For these types of shots, I usually take my time and talk to the people first. When I see that they are comfortable with me, I start shooting. I always make sure that my subject is well aware of my presence.

Sadly, some media organizations
sometimes manipulate images to suit their
stories, which I am totally against

Independence day | Srinagar

Q | Is it a relief to record a scene like this? The lighting, moment, and composition are lovely – what's the story behind this shot?

A | It wasn't a lovely scene at all. Soldiers were supposed to give bunches of balloons to the kids, but they never handed them over. The soldiers released the balloons only when the media was around – just to show that independence day is celebrated in Srinagar.

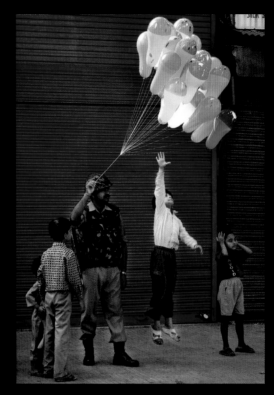

arms search | Srinagar

Q | This looks like a light-hearted moment?

A | Soldiers were searching a house for arms. While I was waiting to enter the house, I saw that a kid would peek out of his window every five minutes and pull funny faces. I caught the scene without letting the kid or soldier know.

Assignment: **a day in the life**

Photography entered a golden era when the combination of fast films and highly portable equipment enabled photographers to record life as it happened, without any need to slow it down for the camera. At the same time, the skills required to deliver a narrative through a carefully crafted series of still images were widely taught by example, disseminated in mass-circulation magazines by masters such as Bill Brandt, Eugene Smith, and Bert Hardy.

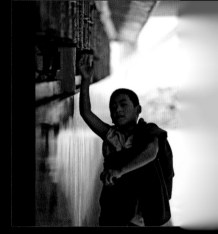

ISO 200 Focal length 200mm 1/4000 sec at

the**brief**

Record a day in the life of your subject, who may be a shopkeeper, farmer, office-worker, student – whatever takes your interest. Try to encapsulate a telling characteristic of their life in just one shot, which could be witty, observational, personal, close up or a long view. Don't set up shots; instead, try to observe and catch the moment naturally. Your aim is to convey a sense of an aspect of the subject's life.

Points to remember
- draw on all your knowledge of your subject to anticipate action
- be unobtrusive in your style of photography, working discreetly and quietly
- turn your flash off to prevent it firing in low light, and set relatively high sensitivities to catch action
- use a wide-angle fixed focal lens with a large aperture to enable you to get in close and capture wider views when you're working in available light

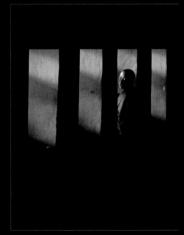

ISO 800 Focal length 300mm 1/85 sec at f/5

ISO 200 Focal length 70mm 1/60 sec at f/2.8

ISO 800 Focal length 35mm 1/160 sec at f/6.3

ISO 800 Focal length 105mm 1/200 sec at f/6.3

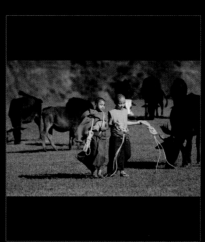

ISO 100 Focal length 285mm 1/320 sec at f/5.6

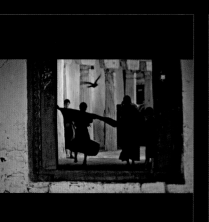

ISO 400 Focal length 365mm 1/100 sec at f/5.6

ISO 100 Focal length 24mm 1/85 sec at f/4.5

① ② ③
④ ⑤ ⑥
⑦ ⑧ ⑨

light**box**

top**tips**

① timing | inside knowledge
Use your knowledge of your subject's habitual movements so that you need only prepare the exposure settings, framing, and focus, and wait for your subject to walk into your shot.

② human nature | shared habits
Documentary photographs strike a chord with the viewer because of the recognition of a shared humanity. These boys, wrestling when they should be learning, could be found in almost any society.

③ details | close up
A key skill is to get closer and then closer still. Here we see the verses the acolytes have to learn by rote almost as a point-of-view shot. This type of image calls for a good relationship with the subject too.

④ ⑤ context | paired pictures
Long hours when nothing much is happening may be part of the subject's life but can be illustrated only indirectly. Here the images of the distracted student and sleepy student provide context for each other.

⑥ a day in the life | all aspects
For a well-rounded and balanced story, you need to cover all aspects of the day – not just the obvious aspects of work or study but also times of relaxation and the dynamics of relationships.

⑦ ⑧ narrative | contrasts
Some images work best in the narrative sequence as contrasts: for example, in 7 we see the acolyte looking, perhaps longingly, out of a high window. In 8 he flies out of a classroom at last, free as a bird.

⑨ opportunities | unexpected extras
Unexpected opportunities may also be part of the day: here a festival meal is being prepared, the colour and light a bonus for the story.

sports centre

Erling Steen

"The attitude of the kids, and the fighters across the hallway, suddenly caught my eye, the kind of thing you see without knowing exactly what you see!"

▲ Nikon D70s Focal length 70mm f/4.5

the**critique**

A day in the life of anyone is hard to capture adequately in a single image, but the selection of pictures here manage to capture significant moments in very different lives. In doing so, they bring us into a voyeuristic relationship with the scene: it's the case that the more special or emotionally charged the moment, the greater the feeling that we, as viewers, are uninvited observers. The power of the image to draw viewers into the lives of others calls for a corresponding responsibility from the photographer that the photography preserves the dignity of those depicted.

sports centre

Erling was photographing a children's Christmas competition in a sports centre in Copenhagen when the situation caught his eye. He says "As the kids moved constantly I had to be very fast and shoot with arbitrary settings of the camera. This is the first of a number of shots, but I knew immediately that it was the only one with potential. The big question was whether the camera would catch the fighters across the hallway behind the glass." The composition brilliantly captures a feeling about growing up that cannot be expressed in words.

Varanasi, India

This image is nicely framed, and the child half-hidden behind the glass can suggest a number of different readings. As a result, it's a useful editorial image for a documentary series.

oupa en ouma

When Lizelle walked in on the scene she immediately and stealthily retraced her steps to fetch her camera. She says "the biggest challenge... was to sneak into the room so that they would not hear me. They did, but only after the shutter was released." Anyone can see the shot is perfection itself in its composition and sense of ease.

Varanasi, India
Napoji

▲ Nikon D200 ISO 360 Focal length 70mm f/4.5

"I saw the woman first, then the child, but thought that the child would not come out; but with a little work he is clear."

oupa en ouma
Lizelle Lotter

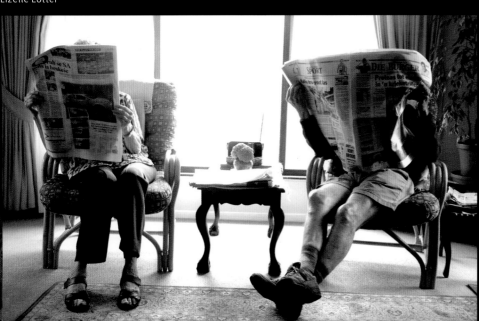

▲ Canon 350D ISO 100 Focal length 70mm 1/250 sec at f/5.6

"This moment was just one of those that asked to be photographed. I was visiting my grandparents ("ouma" and "oupa" in Afrikaans)."

Landscape and nature photography

The most joyful and celebratory of photographic genres is widely dismissed by critics as merely a collection of pretty pictures, incapable of comment and therefore devoid of significance. However, the subject remains one of the most popular and personally rewarding for many photographers. The key to distinguishing oneself is singularity of vision.

fact file

When photography was in its infancy, photographers yearned to capture the natural world in full colour. By the time we had colour, they had learned that black-and-white photography was not a constraint on capturing the essence of nature or landscapes – to the contrary, for some it was the best way. In fact, black-and-white can be tinted, and colours can be both weak and strong – there is a wide palette to work with.

individual **vision**

Given the aesthetic nature of the subject, you might feel you could simply let it speak for itself – but, while such an approach may have been valid early in photography's history, with the trillion images that are now produced yearly, you have to work harder than that. In addition to a strong personal vision, which comes from emotional links to the subject, the more photographic skill you can exploit, the greater the visual impact.

visual response | insight and creativity
The genre is sufficiently rich and varied to absorb many approaches, from the literal to the symbolic and from the formal to the pictorial. Consequently, landscape and nature photography is stylistically always in open season; there is no formula or canonical form that has to be adhered to.

> 66 With the trillion images that are now produced yearly – you have to work harder 99

Your task is to develop a visual response to the subject that is both personal and deeply felt, while at the same time offering revelations and insights to your viewers. There is nothing intrinsically wrong with a picture of a glorious landscape or beautiful plant whose ambition goes no further than to depict the subject – that is the language of the typical picture postcard, which is a faithful record leaving nothing to the imagination and itself devoid of creativity. However, the image can be so much more. Waiting for the right light, for example, brings out the form of hills and valleys and allows colours to emerge; careful use of limited depth of field and framing brings out the syncopated accents in the structure of a plant.

experimenting | and learning

It takes a lot of hard looking to upgrade your landscape and nature photography, but your digital camera is the greatest aid you could wish for. The aim is to learn about your own responses to what you see, and being able to record many variants of a subject is a great help. Try different exposures, depths of field, and points of focus; experiment with composition and work with deliberately soft-focused images. Try out ideas enthusiastically and extensively. That, after all, is how the masters of the past honed their craft, but without the benefit of instant results.

You may find that extremely shallow depth of field works for you, or that you prefer to work in black and white. You may concentrate on single blossoms against a plain background, or wider views that pull in the context as well. You may work with abstract shapes or try to show every last detail of a topography. In the process of learning, work in RAW to give yourself the most flexibility. Don't delete any shots, for you never know what you may discover later.

WIDE-ANGLE CLOSE-UP

NORMAL VIEW

BLACK-AND-WHITE

GRAPHIC

ULTRA WIDE-ANGLE

GARDENS

ABSTRACT NATURE

GRAND LANDSCAPES

DOCUMENTARY

nature's wonder

You can indulge yourself with nature's beauties, and the result is always rewarding. Try working close-up with a wide-angle **lightbox** lens **1**, **3** or a normal view **2**. Work with graphic shapes **4** or abstract tones **7**. Explore gardens **5**, **6** using different zoom settings. Or work with larger landscapes in monumental style **8** or in harder-edged documentary style **9**.

caterpillar views

If you wanted to see the world from the point of view of a caterpillar, it would be natural to place the camera in the insect's position. By experimenting in this way, you can open up an unexpectedly rich world of intimate views of a garden.

tamao funahashi

Nationality Japanese
Main working location Japan

Born in Tokyo, Tamao lives and works in Aomori city. A graduate from Musashino Art University, Tokyo, she studied visual communication design, for which photography was a required subject. She fell in love with photography but, after graduation, she worked in museums and newspaper companies for 10 years, during which time she took no photographs. In 2005, she went up to the mountains to ski with friends and used a cheap disposal camera to take pictures of frozen trees. The images came out well so she signed up with Flickr in order to share them with her friends, which rekindled her interest in photography. Her images have been used on CD covers and in books, and she has exhibited at the Camera Biyori Gallery and Monkey Gallery in Tokyo.

see more of Tamao's work at:
www.flickr.com/photos/tamjpn

in conversation

Q | **Tamao, you photograph a wide range of subjects but seem to have a strong feeling for nature and landscapes.**
A | I think one of the wonderful things about photography is the way it can document a person's perspective on a place or idea. For me, photography is the way I record the places I've visited or the special moments in my life. It's the best way to express my creativity and to communicate with other people. Photography is like writing a journal with light. I see my photos as living fragments of time, captured on their way to the past – if they weren't captured, they would never be seen again. As I live in Aomori, which is blessed with beautiful scenery, I've spent a lot of time photographing nature. It is one of my favourite subjects.

Q | **What aspect of your work do you think others find most enjoyable?**
A | It seems that people particularly enjoy the colours in my pictures, the framing and crop, and the point of view. They also like the way I focus on the joy and beauty in small, unusual things, and how I make the inert come alive.

Q | **Is that what makes you stand out from other photographers, what makes your work special?**
A | Sometimes I feel that photography might be more of an art of selection than creation. In the half second or so before I press the shutter button, I ask myself if I'm happy with the framing, the lighting, the colours, and the background: do I really like this image? I only press the shutter button when I can say "yes" to all my questions; it's done almost reflexively. I always try to be true to my feelings and emotions with my images. I never follow someone else's work because it's too easy to lose yourself in their vision. I have to be true to my own direction – it's such a solitary process, isn't it?

Q | **Tell us about this lovely image.**
A | You might not believe it, but this is a test shot that was taken with a macro lens for my Sony DSC-R1. I was so happy to get a good result in my first session; I was like a child with a new toy! On the day I captured this shot, I took many pictures with different settings to see what I could and couldn't do with the lens. This picture is a very standard close-up shot of a flower under natural light at ISO 160 and f/4.8. Since it was a windy day I kept my exposure very brief, which meant I had to adjust the brightness with Photoshop.

Q | **What is your opinion of the value of formally studying photography?**

A | I had a great time on my photography course, where I could truly think about many things – not only photography-related subjects. I improved on my own skills, and the background knowledge I gained still helps me to understand my photography and store new information. I think the main thing to remember is that it's what you learn that's important, not not where you learn it.

Q | **Please tell us about the cameras and lenses that you use the most.**

A | I mainly use the Sony Cybershot R1 and conversion lenses and filters. It is not a pro-grade camera, but most high-end dSLRs and equipment are too heavy and bulky for me to carry. I love cameras as both toys and working tools. The only thing I hate about them is that new products make current ones obsolete every few weeks.

Q | **Please tell us about your workflow and methods.**

A | I shoot in both JPEG and RAW, depending on the situation and assignment. I adjust contrast, brightness, colours, hue, and saturation only if I really need to. I don't manipulate anything if the original shot is as good as it can be, and I always try to get the original shot as close to perfection as I can.

Q | **What is the aim of your photography?**

A | If I can recreate the image that I saw in my mind's eye, then I've achieved what I set out to do. Artistically, I'd like to show people that there is always much more to see out there than you might think at first glance.

Q | **What is your dream assignment and why?**

A | My dream assignment? Hmm ... it's not exactly a "dream" but I would like to be of help to others who are interested in photography someday.

Q | **What do you think are the major challenges facing the emerging photographer today?**

A | It's good to keep up to date with what's hot in photography right now, but try not to overdo it if you think it's not your style.

images **in depth**

blue leaf | veins and water droplets

Q | **Please tell us about this deceptively simple picture. How did you come across this image?**

A | This is a "macro in the micro" image to me. Just as we have the "ocean" in our bodies, so we can say the same thing about leaves: "look, there are trees in them!" I found this leaf on the ground in a park and, as usual, I didn't touch anything; the water droplets looked gorgeous and perfect as they were and were too fragile to move. The natural lighting was beautiful as well so it was a lucky shot – although it took me a little while to think about the framing.

cherry blossoms | reflections

Q | **This is definitely my personal favourite. I love the combination of disorientation yet calm.**

A | This was taken in Hirosaki Park, which is famous for its cherry-blossom festival held at the end of April. The cherry trees line the moat by the castle, which I think is the best spot to shoot the blossoms. Millions of tourists and photographers visit this place during the festival so it's a challenge to keep people out of the frame.

❝ Sakura reflecting on the water and cherry petals covering the water-filled moat are my favourite subjects in the spring. Every time I visit the park I find something new that catches my eyes ❞

rice fields | bird on a wire

Q | **I think this picture comes alive because of the bird – almost too small to be significant yet, once you see it, it defines the space.**

A | The rice fields used to be one of the most boring scenes to me but, when I discovered them as a subject, I found something quite pleasing about them. I'm so happy you noticed the crow on the wire. One small thing can dramatically change an entire image, both in a good way and a bad way, which is why you should look at the whole scene with your eyes and not just with your camera.

trees in snow | Hakkoda, Japan

Q | **Did you move around to find the best balance between the main tree and the others, or was it a quick shot?**

A | It was hard to keep people out of the frame here, especially as I couldn't stand around outside for hours waiting for the best timing as it was −15°C! I have to admit that something about the framing bothered me. I tried different trimmings but decided to keep them as they were. I did, however, crop out skiers from below the main tree.

cherry blossoms | reflected

Q | **Is this close to what you saw, or is it perhaps what you wanted to see?**

A | I used a polarizing filter to maximize the blue and remove some reflection from the water's surface, which improved the colour of the water. It was taken in the morning and I like the original, but I wanted to turn it into a bewitching evening image. I adjusted the colours and contrast to exactly match the view and the colours of the sakura, or cherry blossoms, in Hirosaki.

body of crow | in petals

Q | **People will be intrigued by this shot – what were you aiming for?**

A | It is symbolic and metaphorical, or perhaps even psychological. At first glance it may look quite cryptic but you soon realize what it is – a dead crow covered by fallen cherry petals. Then you start to really see the image. People react to it in different ways, perhaps finding it sad, or peaceful, or cinematic. I think this is because there are so many contradictory elements held in balance.

Assignment: **spirit of place**

As one of the most inspiring sights in the world, the Taj Mahal is that rare subject that looks wonderful in any light, from the hardest to the mistiest. From this arises the essence of the tremendous challenge it sets the photographer: to depict the spirit of a place in a single image. Of course, most of us don't have access to such a legendary site, but somewhere not far from you there will be a well-known beauty spot, whether man-made or natural, that many photographers have tried to sum up in a single great shot.

ISO 100 Focal length 24mm 1/250 sec at f/8.0

the**brief**

Visit a beauty spot and imagine you have been commissioned by the local tourist authority or a travel magazine to create a definitive image of the subject – one that could be used on a website showing local attractions or in a brochure designed to tempt visitors to the area.

Points to remember
- use the full range of focal lengths to gain plenty of variation in perspective and distance
- photograph the subject at different times of day to record how the light affects the scene
- if you are visiting a site that is privately owned, obtain a photography permit in advance
- if the subject of the image is a well-known landscape it should be clearly recognizable, with no need for a caption to explain it

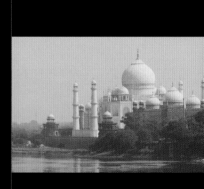

ISO 100 Focal length 280mm 1/640 sec at f/6.3

must-see **masters**

Albert Renger-Patzsch (1897–1966)
An exponent of the "new objectivity" movement, Renger-Patzsch created precisely observed topographies that aimed at documentary realism yet still captured the strongest sense of place.

Raghubir Singh (1902–1984)
Regarded as one of the great colourists of photography, Singh extracted order and elegance from chaos. His tour of India shot in and around a car is an inspiring, masterful work.

Steve McCurry (1950–)
McCurry works extensively in monsoon lands, his coverage of the Indian sub-continent providing context for its inhabitants and showing that there is little spirit to a place without its people.

Gustave le Gray (1820–1884)
Le Gray's original ambition to be a painter can be seen in his photographs, which were not only carefully composed and exposed but printed with tonalities of outstanding finesse.

ISO 100 Focal length 148mm 1/320 sec at f/4.0

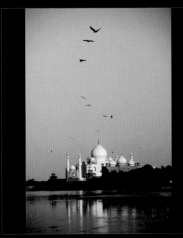

ISO 100 Focal length 130mm 1/250 sec at f/4.0

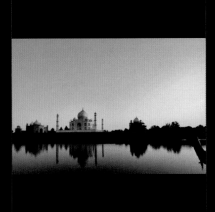

ISO 200 Focal length 12mm 1/100 sec at f/8.0

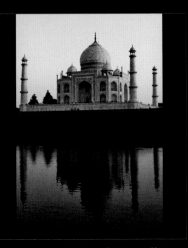

ISO 200 Focal length 24mm 1/200 sec at f/7.1

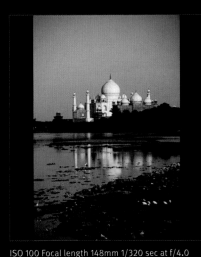

ISO 100 Focal length 148mm 1/320 sec at f/4.0

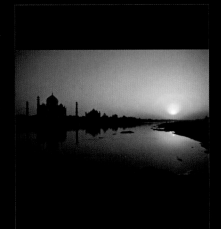

ISO 100 Focal length 18mm 1/80 sec at f/8.0

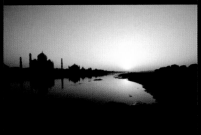

ISO 100 Focal length 12mm 1/25 sec at f/16.0

① ② ③
④ ⑤ ⑥
⑦ ⑧ ⑨

light**box**

top**tips**

① lenses | wide view
A super wide-angle view takes in all the surroundings but the main subject may be too distant and small in scale. While there is nothing wrong with having a large foreground, it does need to contain elements of interest.

② timing | waiting for the moment
It pays to be patient and wait to see what might come into view. With the buzzards riding the thermals, it was only a matter of time before they formed an interesting pattern.

③ animation | foreground interest
Look for ways to add a little animation to otherwise tranquil views. Here, the shot was framed to include the head of a passing camel.

④ dull light | postproduction
Even if the lighting looks hopelessly dull – as on this foggy morning – make the best photograph you can: the result often exceeds expectation, especially as you can help the image along with a little adjustment of contrast and colour.

⑤ ⑥ composition | reflections
Reflections always help to emphasize the space that a subject occupies by repeating the main outlines and doubling its volume.

⑦ viewpoint | indirect view
Reflections can be used to imply the subject rather than depict it directly, but the result may not be easy to decipher and the viewer's attention may be diverted to less attractive features of the subject.

⑧ ⑨ low sun | reflections
When the sun is very low on the horizon it's safe to include it in the shot. Here, the clear sky and stillness meant that the reflections could be worked with, and made a virtue of the empty space.

▶ see **results**

rocky beach

Paul Self

"I wanted to give the sense of struggling on the rugged rocks, which I remember from family holidays. I made the colour balance very warm to symbolize time past – and to show that the picture is as much a memory as a record."

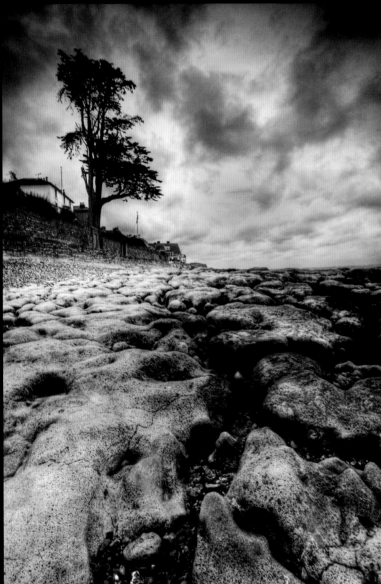

▲ Canon 5D ISO 50 Focal length 17mm 1/4 sec at f/14

thecritique

You know that your mastery of photography is growing when your images transcend verbal descriptions. This is clearest with landscapes and places: every language in the world has an extensive vocabulary for describing the land, but an image that successfully captures the spirit of a place works without words, like a guide who simply points to the scene and invites you to look and be amazed. The images shown here work wordlessly to describe the atmosphere of each location.

rocky beach

Paul has used an extra-low viewpoint and wide-angle view to emphasize the rugged rocks, causing the houses and looming sky to seem very distant. The diverging lines of force in the ground mirrored in the clouds create the sense of sweeping winds. The main image, with its warm (perhaps slightly over-warm) colour balance, brings the viewer into the picture more effectively than the alternatives.

tranquil lake

Sara came across her lake on a heavily clouded day, but instead of being put off by the low contrast, she made full use of the liquid quality of the light. While the alternative shots emphasize the beautiful cyan colours of the sky and water, the main image works best at smaller sizes as the foreground helps to impart a sense of scale.

woodland ruin

Sergei first visited this romantic ruin on a bright, sunny day, but found that the contrast between direct sun and deep shadow was very difficult to handle. He returned on an overcast day, when the soft colours of the woodland could be recorded and expressed to good effect. All three images are strong compositions, but the main image scores over the others by Sergei's effective use of a normal perspective to capture the scene.

tranquil lake
Sara Beckett

"At first I thought the day was a wash-out, but the light on the lake was so soft, it gave a genuine sense of the watery landscape."

▲ Fuji Finepix A510 ISO 100 Focal length 6.4mm 1/80 sec at f/8.5

woodland ruin
Sergei Andreev

"The first time I saw this little ruin it was bathed in sunshine. I returned on a rainy day and found really rich colours."

▲ Nikon D40 ISO 100 Focal length 28mm 1/60 sec at f/8.0

tutorial 17 **sports photography**

Sports is a relatively young speciality in photography, since it was well out of the reach of even the professionals for nearly a century after the invention of photography. The combined challenge of capturing high-speed movement from a distance was overcome only with miniature high-speed films allied with fast optics – and these did not make an appearance until the 1950s.

fact file

Sporting events are public occasions, so you can photograph athletes freely and reproduce their likeness without the need for model releases. This is one of the last arenas remaining in which you can snap the stars without being hindered by limitations on what you can or can't photograph. Nonetheless it is good practice to ensure that images of anyone are used only for editorial purposes, and not in advertising or product promotion.

beauty and **power**

Early sports photography concentrated on the muscular bodies and physical beauty of athletes in the static, studio environment. However, with the arrival of 400 ISO films such as Kodak Tri-X in 1954, and 135mm f/2.8 lenses, sports became fair game for any photographer. Shots followed of sportsmen and women in epic trials, pain, and jubilation, in the field rather than in the studio.

turning professional | the expert eye

One of the great attractions of turning your photographic hobby into a way of making a living is that you can indulge your own interests, whatever they may be. Car lovers may photograph rallies and races, while football lovers can think of nothing better than to be paid to sit near the goal-mouth for hours on end on a cold winter's day, watching a big match.

> 66 Sheer physical stamina is required when waiting for hours for the perfect shot 99

More than in any other speciality, photographers in the sports genre have experienced what they are now capturing in images. Not only do they bring their own passion for a sport into their photography, they have expert knowledge too. They understand how to read the situation on a pitch or the subtleties of a player's body language in order to be ready for what will happen next. They also contribute another important element to their photography: the sheer physical stamina that is required to, for example, sit in the sun for a day watching a cricket match without dozing and missing a shot, or to get into the best position for skiing slaloms and wait for hours in freezing conditions.

long lenses | new technology

The insuperable problem for all sports photographers is the impossibility of being physically close to the action. The first 200mm lens put into production, an f/4.5 from Zeiss, was introduced in 1933, while the first high-performance long lens was the Zeiss 180mm f/2.8, of 1936. We had to wait for computerized designs and rare glass formulations before very long lenses were of acceptable quality. The first of the new-generation telephotos was the Canon 300mm f/5.6L-F, of 1969. Since then, sports photographers have benefited from lenses that combine superlative image quality with long reach and very large maximum apertures. These range from the 200mm f/1.8, which is perfect for indoor athletics, to the 600mm f/4, ideal for photographing from the edge of, say, a baseball park. The cost of lenses such as the versatile 300mm f/2.8 has dropped over the years. In addition, the use of dSLRs with sensors smaller than 35mm format is an advantage for sports photographers, since the crop produces the effect of greater focal length.

CLOSE-UP DETAIL

MOTION BLUR

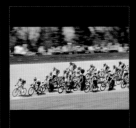
GENERAL VIEWS

BACKGROUND SCENES

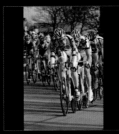
IN THE ACTION

PREPARATION

CROPPED ACTION

FULL-FRAME ACTION

TIGHT FRAMING

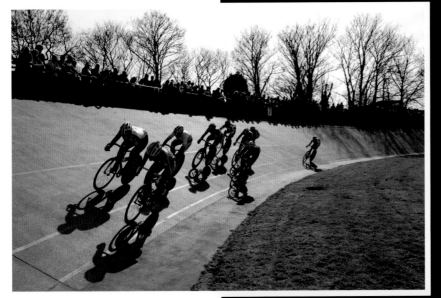

lightbox

variety of views
To photograph a sport successfully, you need to know what, how, and when to photograph. From the gear **1** and background scenes **6** and **4**, to general views of events **3**, as well as shots giving a sense of the sport using motion blur **2**, or telephoto compression **5**, all require specialist knowledge of the subject. And it helps to know who the major players are, to ensure that you feature them **7–9**.

action-oriented

Sports can be rewarding for the non-expert too, as the patterns, movement, and colours are so photogenic. If you lack specialist equipment or access, look for positions that face the action: movement towards you is more engaging than movement away, and it's easier to capture head-on motion than movement crossing your view.

duane hart

Nationality New Zealander
Main working location Australia

Duane was born and raised in the small town of Hawera on the west coast of New Zealand. After leaving school at the age of 15, he served an apprenticeship as an engineering draughtsman and also took up athletics, spending 10 years training and racing in his home country and a further two in the UK. Duane's interest in photography began when he was a teenager, using a secondhand camera to take shots of his friends competing in athletics. Within a couple of years, his skill had brought him cover shots for national magazines and he was able to buy his first long lens. Arriving in Australia in 1991, he succeeded in getting more and more shots published and, in 1993, he took the leap into full-time photography. He now covers sporting action from junior events to the Olympic Games.

see more of Duane's work at:
www.duanehart.net

in conversation

Q Duane, it's clear from your photos that you love your work. What do you find most challenging about it?

A Covering sports is always a challenge as you never know what's going to happen. Being familiar with a sport is very important. A good example of this is with my photo of Mike Powell's world record long jump at the World Championships in Tokyo in 1991. I had watched many of the athletes in training during the preceeding two years and knew how their seasons were progressing. I watched Mike Powell leap a huge jump during his warm-up and decided to climb in with the spectators and shoot a sequence side on. I was the only photographer up there with a long lens and shot two frames between the arms of celebrating fans. This is one of the images that really got me started professionally.

Q What do you think is the value of the formal study of photography?

A Sports photography is different to other forms of photography as the photographers themselves often have a sporting background. It is best to specialize in a particular sport from the start. You don't need the most expensive camera or lens — what you need depends on your chosen sport. I'm amazed by photographers who rely on auto. We use manual settings for all our work and none of our photographers have a light meter. There isn't time to take a reading when shooting action, and after a while you can tell exactly what adjustments to make.

Q Please tell us about your cameras and lenses.

A My main Camera is the Canon 1D Mk III with the Canon 1D Mk II body as backup. The Canon 200mm f/1.8 is my favourite lens — especially in low light — and it's also nice for the occasional portrait. I use the Canon 400mm f/2.8 for most cricket and football events. The Canon 17–35mm f/2.8 is handy for wide angles and I use it with my underwater housing as well as my soccer in-goal remote housings.

Q How did you obtain this cracking shot?

A It was taken in the pouring rain at the New South Wales Touch Championships in 2005 in Port Macquarie. I used the 400mm f/2.8 lens on a Canon 1D. There was a pool of water on the try line on the corner of the field and I waited there for about 40 minutes. I knew that if anyone actually scored at that spot on the corner it would make a nice photo.

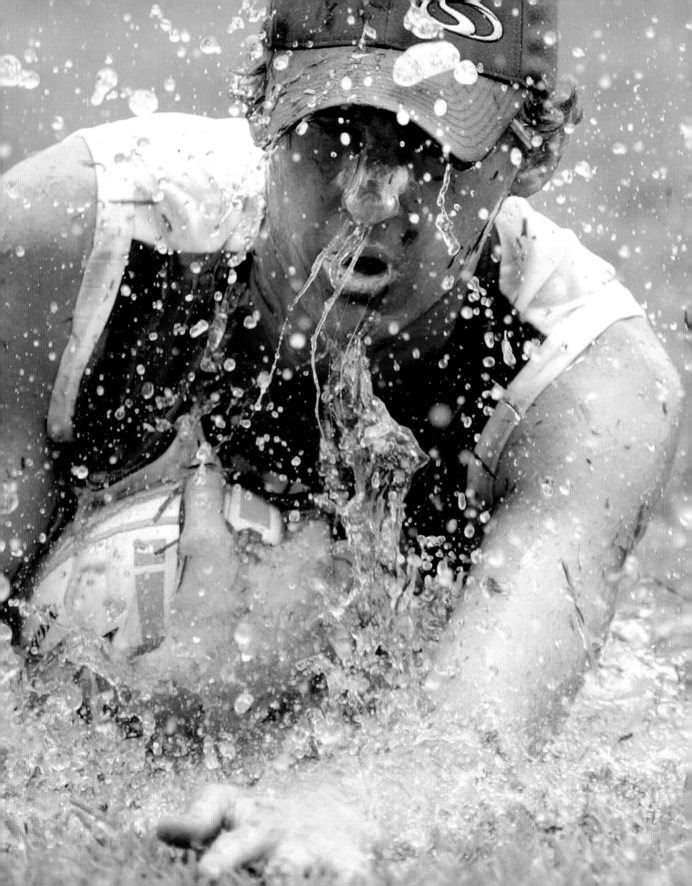

Q What do you do to stand out from other photographers, to make your work special?

A In the last few years I've tried a new approach. If I'm at a job where I'm required to take standard action shots, I'll try to set aside 30 minutes either before or after the event for experimenting and doing my own thing. Sometimes I might sit in one spot waiting for a shadow, or go tight for an emotion or jubilation shot. I still like to go for the one magic shot by finding a good background and trying to pre-empt what may happen in one particular spot.

Q What do you find to be the most enjoyable part of your work?

A I really enjoy working with junior sports. The pictures you get at junior events can be just as emotional and action-packed as some Olympic finals. I also donate a large percentage of my profits to certain sports and event organizers who have been loyal to us over the years. It's very fulfilling to see the money going towards a developing athlete or sport.

Q What do you think about today's camera gear?

A In the last few years it has caught up with the slide film. The new Canon 1D Mk III is amazing in low light, with no grain at ISO 3200. It's only when we scan some old negatives that we realize just how much grain we had. I still like Velvia slide film but haven't used my film body for five years. I think of my 200mm f/1.8 as my third child. It's done three Olympics with me, I've slept with it in youth hostels (for security reasons!), and cuddled it in the snow in Gothenburg when I arrived too late to find any accommodation and had to sleep out. It has been my favourite lens for ten years now.

Q Please tell us about your workflow and methods.

A It's always JPEG. Last week our photographers shot 50,000 images in a week at two events. Having to store, edit, and upload this many images to the internet in a single week means we have to use JPEGs.

Q What would be a dream assignment?

A I'm living my dream every time I get the chance to cover the Olympics Games. The action and emotion just doesn't get any better.

images **in depth**

Venus Williams | signing autographs

Q I love this shot for its oblique take on a sport. I guess it's an example of a picture where you need to be very familiar with factors such as the event schedule and the layout of the grounds. What's the story behind this image?

A It was taken with my Canon film body on 100 ASA Sensia slide film with manual focus in the late 1990s. Williams was signing autographs and I squatted down low in the exit tunnel to get the fans in the frame. My 17–35mm lens was right in on 17mm to get slight distortion on the fans and to crop two security guards who were standing out of the frame behind her.

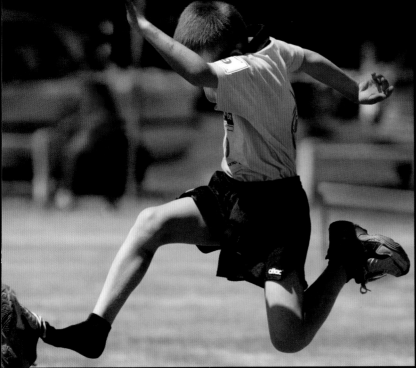

young athlete | losing a shoe

Q | This shot is not only hilarious – a rare thing in photography – but we really feel for the kid. It is also beautifully timed. Please tell us about it.

A | I was covering a Little Athletics event in 2002 with my Canon D30 and my favourite hand-held 200mm f/1.8 lens. This was one of 2,500 photos I took that the day. I did notice his shoe was flapping around but I didn't see it fly off. As I couldn't see his face I was about to delete it, but I noticed the shoe coming off just before I hit the delete button. A shoe company saw it and ran it in a campaign along the lines of: "Come into our stores and get your shoes fitted properly."

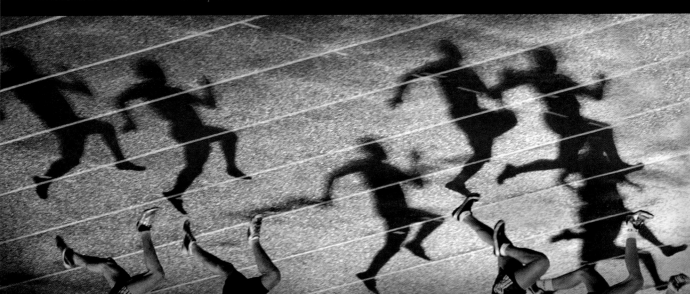

runners | shadows on the track

Q | Why did you decide to present this image upside down?

A | I was photographing the finish of the 2005 Queensland Secondary Schools 100m finals. I was up in the grandstand for a side-on shot and it was raining. I noticed the shadows being made by the lights and I thought it would look better inverted, with the athletes cropped and in mono.

❝ I always aim for quality not quantity. With the new cameras, it's too easy to machine-gun an event ❞

airborne athlete | long jump

Q | **This image is fabulous for its sense of athleticism – and the lighting is to die for! Tell us about the skill of releasing the shutter just before the peak of action: how do you do it?**

A | I was actually filming another event in the infield when I noticed that the light was coming across well. I saw that the athlete was leaping out of the pit after his jump so I waited until his next jump. I knew I only had one chance as the shade was about to cover the pit but I managed to get this shot, which is full frame with no cropping. I used a Canon 1D MkII with 400mm f/2.8 lens at 2.8 1/1000 at ISO 100. As for my shutter reaction time, I was tested in 1990 and had the fastest hand-eye reaction ever recorded. As I've been doing this for 15 years now, it's probably even improved some!

rugby tackle | fight for the ball

Q | **Again, here you manage to make us laugh and wince at the same time.**

A | I was in Papua New Guinea for the Rugby League Grand Final in 2005 in Port Moresby. These guys were the toughest and most physical of any athletes I've ever seen – they played with broken collar bones, snapped fingers, and wore no padding. There was even an old shipping container on the sideline, which is where the players hide and lock themselves in if the crowd invades the pitch.

Assignment: **essence of sport**

One of the most photogenic of all photographic subjects, sports of all kinds usually combine colour, lots of action, athletic bodies, and high emotion. What's more, you can get just as much from photographing a local or amateur event as from a world championship. Modern cameras, some with very long focal length settings, make it relatively easy to capture close-up views of action even from the spectator stands – but if you can get right inside the action it is much more fun and the pictures can be even better.

ISO 200 Focal length 18mm 1/120 sec at f/11

the**brief**

Photograph a sport that you know or love in order to communicate what it is about it that engages you. Is it the thrill of the speed, the delicacy of balance needed, the feel of water or air on the skin, or the camaraderie? It might be an extreme close-up that gets the feeling across or a general view.

Points to remember
- use shutter priority auto-exposure set to the shortest exposure times to capture rapid action that is passing across your field of vision
- set higher than normal sensitivity settings to allow for short exposure times
- use longer shutter times to create blurred motion shots
- take wide-angle views from close to the action if you can get near enough
- try flash synchronized with daylight to capture a combination of freeze-action with motion blur

ISO 100 Focal length 300mm 1/250 sec at f/3.5

must-see **masters**

Eamonn McCabe (1948–)
An outstanding photographer of sports who elevated newspaper sports photography into powerful depictions of the emotion of physical exertion, McCabe is also an accomplished and fastidious portraitist.

Leni Reifenstahl (1902–2003)

1936 Olympics in Berlin is a benchmark of cinematography that has widely influenced photography with its use of extreme close-up, tracking moves, and exaggerated camera angles.

Balazs Gardi (1975–)
The prize-winning images of the World Gymnastics 2002 by this Hungarian

ISO 200 Focal length 80mm 1/250 sec at f/7.6

ISO 200 Focal length 300mm 1/250 sec at f/3.2

ISO 200 Focal length 200mm 1/250 sec at f/6.7

ISO 160 Focal length 300mm 1/200 sec at f/4

ISO 160 Focal length 300mm 1/125 sec at f/4.0

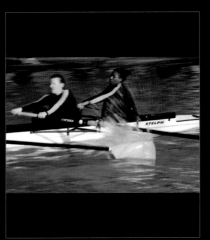

ISO 100 Focal length 200mm 1/60 sec at f/8

① ② ③
④ ⑤ ⑥
⑦ ⑧ ⑨

light**box**

top**tips**

① **overviews** | set the scene
Views taken far from the action set the scene but are not involving. To ensure your image is arresting you need a feature such as lovely lighting and good colours, as here, or a very strong composition.

② **timing** | advance knowledge
Careful timing can help you to make the most of positions you are unavoidably confined to. Knowledge of the sport helps too: these boats are ranged together like this only at the start of the race.

③ **background** | preparation
Remember that a great deal of activity happens before the actual event, from getting dressed to preparing kit and, here, placing the boat into the water: every step of the way presents opportunities for you.

④ **spectators** | another angle
Sports would be less appealing without spectators: they are part of the story, and every sport attracts a different type of spectator. They are worth a separate project in their own right.

⑤ **⑥** **atmosphere** | and emotion
Much of sports photography does not have to be clever in terms of use of light or compositional technique. Often you simply need to capture the expressions of effort, exhilaration, or despair.

⑦ **⑧** **abstract** | or literal
Some sports are so well known that you can create more interesting shots by revealing something of their character indirectly rather than showing the action literally. Repeating patterns always work well.

⑨ **using blur** | expressing motion
Motion blur is an effective and simple way to convey movement. For greater visibility try placing movement against a dark background, such as the water spray against dark clothes in this shot.

▶ **see results**

the illumination was very good for great photos, then I started to search for different angles."

are amenable to a variety of approaches, you don't have to compete at the same level as the professionals. The selection of images here show that insightful and delightful images can be obtained from the spectator position, without the need for super telephoto lenses. However, one of the problems of being among other spectators is the other spectators themselves. It's best if you can be higher than everyone else: remember that at peak moments they are likely to jump out of their seats and wave their arms.

bowling alley

Using great imagination and skill, Paulo has made the most of his modest technical means to produce several colourful and inviting shots – the kind that make you want to be there yourself to photograph. However, the images are rather static, so Paulo could transform them with a little movement such as the blur of a ball whizzing down the alley.

rugby game

David explains "Taking pictures of a fast-moving sport such as rugby in low-light conditions is tough; you can't use shutter speeds that are fast enough to capture movement without blur, pictures are grainy as you have to use high ISO ratings, and a wide open aperture loses depth of field and contrast tends to be poor." In obvious response, David chose a static phase of play, but brilliantly captures the steam rising from the players, caught in the floodlight.

baseball player

Jeffrey tells us "I took this shot of a baseball player in the Bronx, New York City. He was playing in the outfield and the late-afternoon sun was perfect." The off-centre, empty composition neatly expresses the condition of the outfielder.

▲ Casio EX-Z75, ISO 200, Focal length 6.3mm, f/3.1

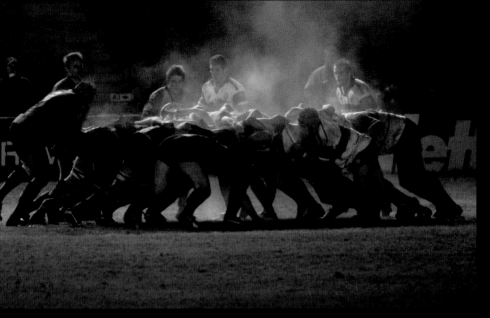

▲ Canon EOS 10D ISO 3200 Focal length 300mm 1/180 sec at f/5.6

"I attempted to photograph a phase of play that was static, but could still engender the feeling of contact and confrontation that rugby can produce."

baseball player
Jeffrey Shay

"The only issue I encountered when shooting this photo was the need to frame the shot over the other spectators' heads."

▲ Canon Powershot G7 ISO 100 Focal length 44.4mm 1/320 sec at f/4.8

architectural photography

There's a big difference between architectural photography and photographing buildings; it has nothing to do with technique or quality but everything to do with approach. While the architectural photographer's first responsibility is to the building – as with portrait photography, the character has to be faithfully and flatteringly caught – there's still a great deal of room for creativity.

fact file

One of the most basic and central requirements in architectural photography is for vertical lines to be truly vertical, and parallel lines to appear parallel. However, this is also a basic weakness of cameras with rigidly mounted lenses. Image manipulation software is effective at distorting a building that appears to be leaning backwards with converging parallels, to appear as if it is not distorted. Although altering the image does not correct perspective itself, the result is usually preferable to allowing the parallels to converge.

fidelity to spirit

Compared to the unpredictabilities of wildlife or sports photography, and the need to quickly establish a personal rapport with the subject in portraiture, buildings may seem to be the safest and easiest of subjects for a photographer. However, the demand for high-quality images and corrected perspective presents different challenges.

equipment | camera movements

Among all photographic genres, architectural photography has one of the highest requirements for sheer technical quality. Images are often made to be viewed very large, to show off the work of both architect and construction team. Images of structures may be used to make measurements using photogrammetry, which minutely measures details on the image in order to calculate the actual dimensions.

> Architectural photographers frame with great care and usually avoid using extreme wide-angle views

The preferred type of camera for architecture is one with camera movements – where the lens and film can be either shifted or tilted from side to side or up and down. The shift movements dictate which part of the image is seen by film or sensor, while the tilt or rotating movements change the shape of the captured image.

Architectural photographers routinely use the very best lenses. All are fixed focal length, with maximum apertures that are designed to give an image that is even from centre to corner, and with no light fall-off, so the whole image is evenly illuminated and, above all, distortion-free.

mindset | free

Freedom from distortion is an essential component of the rigorous quality required in architectural photography. Minimally, this means that straight lines in the building must be displayed as straight in the image. For example, an office block photographed on a compact camera with zoom lens will show bowed or sunken sides that would horrify the architect or construction engineer.

But there is room for less conservative approaches; a response to the experience and enjoyment of the space is equally valid. Seek out the play of light on form and texture; explore the flow of people through connecting spaces; work with pure colours to celebrate the modern.

Not all buildings are elegant edifices or design masterpieces, so your images can explore the dark side of architecture too: the abandoned hospital, the anomic spaces of office corridors, the shadowlands of suburbia at night-time. Indeed, the more precisely you frame the less-than-beautiful, the greater the visual irony. Become proficient in the formality of architectural photography and you will be equipped for all other styles.

EXTERIOR VIEWS HOTEL INTERIORS DOMESTIC INTERIORS

BUILDING SITES CONTEXT LIGHT/SHADOW

INTERIOR DETAIL GRAND VIEWS WIDE-ANGLE VIEWS

viewing versatility

1 2 3
4 5 6
7 8 9

light**box**

Exterior views **1** are always in constant demand, as are flattering interior views **2** and **3**. Large building sites **4** can offer a deep well of continuing work. Large, finished projects **5, 6** offer opportunities for impressive photography. Interior details **7** provide potential for attractive abstract images. Exploit the impressive lines **8, 9** of contemporary architecture.

magnificence contextualized

Modern architecture, such as the Ciudad des Arts y Science in Valencia, Spain, lends itself to magnificent views in any light but is even more impressive if you pick the moment light, sky, and position combine to create a fine composition.

iñigo bujedo
aguirre

Nationality Spanish
Main working location Spain

Born in Bilbao, Iñigo graduated in Social Sciences and Journalism at the University of the Basque Country before working as a photojournalist for several years. In 1995, he moved to London and obtained an MA in Photography at Goldsmiths College, where he subsequently lectured for several years. Iñigo has been working for architectural firms and designers whilst also contributing to several magazines, newspapers and publishing companies. His clients include Icon magazine, Wallpaper*, Quaderns, RIBA Journal, Building, and Laurence King Publishing. Since 2003, he has been based in Barcelona, Spain, with his work also taking him to Portugal, Latin America, and the UK. His urban landscapes were selected by Professor Richard Burdett, Centennial Professor of Architecture and Urbanism at the London School of Economics, to be exhibited at the 10th Venice Architecture Biennale.

see more of Iñigo's work at:
www.inigobujedo.com

in conversation

Q | **Iñigo, please tell us how you started in photography.**
A | I have been taking pictures since I was 15. When I was 19 and already studying journalism, I visited an exhibition in my hometown that was organized by a local photography school. I enrolled at the school and learned the rudiments of photography, and spent two years gaining a valuable visual education. My first job was as a staff photographer at a local newspaper in Murcia, southern Spain. The job was a daily challenge as I had to learn photography as I went along and deliver decent material daily. Every day was a deadline.

Q | **So what turned you towards architecture?**
A | I was assisting a friend who had a large-format camera – a Sinar. I liked the idea of working with large-format cameras and, by then, was already passionate about the work of Richard Avedon and August Sander. While I was studying photography at Goldsmiths College in London, I took the large-format camera, together with the super-wide Hasselblad, and began to explore architectural subject matter. But architectural photography is not the only area I work in. I also work on long-term documentary projects.

Q | **What aspects of photography do you find the most challenging?**
A | Keeping up with new technologies is always a huge challenge but, for me, the most important and challenging aspect of photography is to be satisfied with my own work. This means developing and constructing a personal visual universe: a style that people will recognize as my own.

Q | **Please tell us about the cameras and lenses that you use for your architectural work.**
A | For large format, I use the Linhof Technikardan 5x4in camera with 75mm, 90mm, 180mm, and 300mm lenses – all by Schneider. For the Technikardan, I use multi-format film holders from 6x12cm to 6x7cm. I also use a Hasselblad with 50mm, 80mm and 100mm lenses. For scanning, I have an Imacon Flextight and an Epson 4990 scanner.

Q | **This shot, for example, would not be easy to make on a small-format camera, would it?**
A | The perfect canvas for large-scale buildings is 5x4in. The challenge here was to interpret the light, and achieve detail in the glass and the world reflected in the building's skin.

Q | **Most architectural photographers haven't taken up digital techniques, have they?**

A | I am reluctant to give up my large-format camera for architectural work. Perspective correction is something that can be done in Photoshop, but this takes away the magic of composing on a 5x4in ground-glass screen. The level of investment required for a medium-format back is very high indeed. Besides, it would require the use of a laptop to shoot properly, and the whole kit becomes heavy and fragile and not suitable for taking on location.

Q | **So you shoot on film, scan, and then...?**

A | I produce high-resolution TIFF files from a very high-end scanner. Next, I work on them to clean them of dust and scratches, and to make the necessary adjustments in order to have the right tones and colours. I do this mainly by using Curves and Levels. I always work on a calibrated screen and with the correct profile for printing my work. Working in front of the computer is increasingly taking up my time, although I would much rather be on location. But I do enjoy seeing all the images on screen, as well as the possibilities it offers when editing or laying out my own book mock-ups.

Q | **What would be your dream assignment and why?**

A | To have a year to document a city – from its architecture to its urban and social fabric, combining large-format views and urban landscapes, to on-the-ground portraits and images of everyday people and situations. Also, to be able to work together with an art director and publisher who would assist me with the editing and final artworking. It is a dream project because I would have the opportunity to explore all the areas I am interested in and compile them into a book, which I think is probably the best way to see a body of work.

Q | **What do you think are the major challenges facing the emerging and up-and-coming photographer today?**

A | Nowadays, everyone thinks they are a photographer; that's the main problem. Everybody takes pictures, which is counter-productive to our profession because it has dramatically devalued it. Many people think that taking a picture is just about pressing a shutter, but there's so much more to it than that. I agree with André Kertesz, who said that in order to be a good artist you need to be a good technician.

images **in depth**

railway station | at dusk

Q | Could you tell us about the process of framing, choosing, and exposing this photograph?

A | Although it looks like a simple shot, I think it has a lovely quality. It was taken at dusk when the light disappears before you realize it, so composing the image, light reading, and shooting was done in a very short time. I think that light is well represented, and I like the diversity in tonalities. The image was carefully composed to play along the different lines.

swimming pool | reflected light

Q | **This looks like it could have been technically a very hard shot to take.**

A | Yes, this was very difficult technically as you have colours that reflect an awful lot of light. The light reading was a nightmare, with the white being particularly misleading as it reflects direct sunlight, and the ceiling appears blue from the reflected water of the pool.

66 Photography is about thinking, looking, seeing, interpreting, and narrating 99

empty office | wavy wall

Q | **How hard did you work for this shot? Did you have to clean the carpet or wait for a balance with daylight?**

A | It was a completely empty office building: a good opportunity to enjoy a large space without any furniture. However, the shot would only work by giving prominence to the glass wall to make the most of its wavy shape. The carpets had to be cleaned and some objects removed first, but the biggest challenge was to get the right light reading. I think I made about five different measurements.

escalator | multiple light sources

Q **This is a rich shot – vernacular yet very stylish.**

A I took this image at the beginning of my career as an architectural photographer without much knowledge of how to resolve the problem of different light sources, but I saw the potential for a beautiful image. I printed it as my card, which I sent out to dozens of art directors. One of them saw it and was persuaded to commission me.

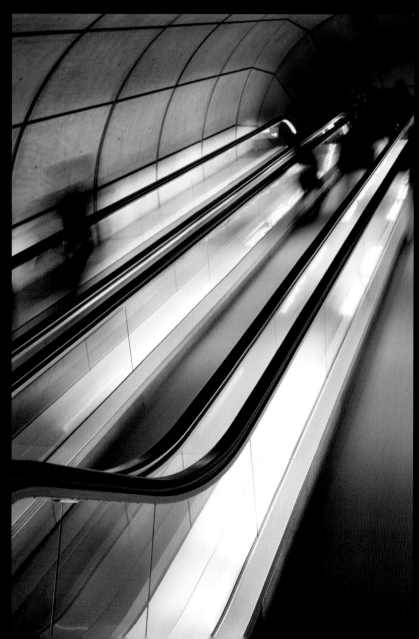

Bilbao airport | reflected surfaces

Q | The floor looks like water and there doesn't appear to be anyone around. How did you set up this shot and what were you aiming for?

A | This is the check-in area of the new airport at Bilbao, which was designed by the architect Santiago Calatrava. The airport was not yet in operation when I made this photograph, although the building works were completed. It was shot for a feature I was doing for a building magazine in London. The building is based on the idea of a dove and it was built using large, organic, bird-like symmetric shapes. I only managed

to have part of the lighting turned on as most of it was still being installed. However, I thought of doing a very saturated, very expressive image by waiting until dusk so that the window would show the blue sky on the inside. By setting the camera about one-and-a-half stops below on the inside compared to the outside, I hoped to best show the interior with its dramatic structure. I used Fujifilm Velvia 50 for the job because I could not find the usual Provia 100 that I normally shoot with. However, the result was great for shadow detail and colour saturation.

Assignment: **exploring light**

When you're photographing buildings you need to balance a sympathetic understanding of them with your photographic ambitions. You may like a particular angle, but if it's not in tune with the subject and the intentions of the architecture, the picture may be more of a subjective response than a portrait of a building. In approaching any building, your greatest ally is the light: by the way it falls on the shapes, textures, and spaces, light's interplay with the subject reveals the architect's intentions.

Focal length 20.7mm 1/1000 sec at f/4

the**brief**

Visit an outstanding building or construction – perhaps an old monument, a new landmark, or simply a building that you think is beautiful – and photograph it with the aim of capturing its relationship with light. Try to discover the architect's intentions or signature style, and explore how the building creates a spatial experience that is unique to it.

Points to remember
- use the full range of viewpoints and perspectives
- set your zoom at around the middle of its focal length range to minimize distortion of the building's lines
- walk all round the building first without making any photographs, concentrating on learning about it
- try to visit the building at different times of the day to witness the way the light and shadow changes

ISO 160 Focal length 82mm 1/60 sec at f/8

must-see masters

Roloff Beny (1924–1984)
One of Canada's most celebrated photographers, Beny's feeling for the monumental in architectural ruins and for the genius loci was unmatched.

Berenice Abbott (1898–1991)
Abbot defined the look of New York through her images and is perhaps equally important for her championship of Eugene Atget, whose studies of Parisian buildings make him arguably the father of architectural photography.

Bernd (1931–2007) & Hilla Becher (1934–)
The Bechers' record of industrial architecture, made over 40 years, stands as one of the greatest achievements of photographic documentation, bridging conceptual art and formalist objectivity.

Robert Polidori (1951–)
Polidori is one of the leaders in the photography of decaying interiors, abandoned spaces, and buildings that have fallen on hard times.

ISO 160 Focal length 18mm 1/60 sec at f/8

ISO 160 Focal length 62mm 1/60 sec at f/8.5

ISO 160 Focal length 29mm 1/30 sec at f/22

ISO 160 Focal length 18mm 1/60 sec at f/7

ISO 160 Focal length 18mm 1/60 sec at f/6.3

ISO 160 Focal length 22mm 1/60 sec at f/8

ISO 160 Focal length 80mm 1/60 sec at f/11

[1] [2] [3]
[4] [5] [6]
[7] [8] [9]

light**box**

top**tips**

[1] contextual | different styles
You can show buildings together with others to place your main subject in a context: differences of lighting help define contrasts of scale or of architectural style. A distant view enables extensive depth of field.

[2] people | and scale
Not only does the presence of people give scale to a space, what they are doing helps to define its nature – whether it acts as a corridor for transit or is an area designed for relaxation and rest.

[3] wide angle | extreme views
Photographers may like extreme wide-angle views, but architects seldom do. However, a few daring angles with highlight/shadow contrasts help to enliven the record.

[4] near | and far
Ambiguities can unsettle the composition and provoke interesting responses. What, for example, is the relationship of the white building to the main subject?

[5] [6] wide angle | viewpoints
Wide-angle views with the camera held level give properly vertical lines but often too much foreground, as in 5. In 6, a different viewpoint fills the foreground with the compositionally active shadows and railings.

[7] [8] abstraction | and scale
Modern architecture invites the abstract photograph. While the result can be striking, as in 7, the sense of scale is missing. The next shot attains a good balance between abstraction and a rudimentary sense of scale.

[9] shadows | and forms
Many buildings use reflections to borrow from their surroundings. With concrete, we have to look harder for reflections and work with any available shadows to bring out the forms.

▶ see **results**

Sagrada Familia
Lee Oyama

"The low sunlight that is particular to winter was slanting through the intricate stonework, creating the play of shadows and shapes."

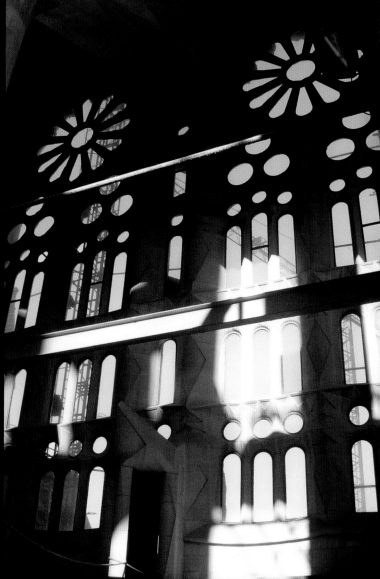

▲ Sony Cybershot ISO 100 Focal length 8mm f/5.6

the**critique**

Architecture is a popular subject for photography, so you need some strategies if you are to distinguish yourself from other photographers – particularly when the building is well-known. A finely tuned awareness of light is invaluable so that you learn when and where to position yourself to catch the sun making the most of the building's features. Attention to detail and an aversion to converging parallels are also great advantages as they ensure that the building is shown as its architect would wish to see it – which is the sternest test.

Sagrada Familia

Lee's image of the Sagrada Familia in Barcelona, Spain, is by far the most successful at meeting the brief to explore the relationship between light and a building. In doing so, it demonstrates what a winning combination marvellous light with a beautiful building can be. The exposure has been nicely judged to hold colour in the sky without burning out the sunlit areas, yet offers detail in the shadows. Some may find the rope in the lower left-hand corner a distraction, while others may consider it gives scale to the overall composition.

Milan, Italy

Although Barbara did not work on a bright day, her use of light is entirely appropriate to the subject and her approach to it. She was concentrating on the Lego-like blocks of colour and their geometries and has deliberately denied the viewer any sense of scale. With its strong diagonals, the image works better than her more symmetrical compositions.

Potsdamer Platz, Berlin

Ramon's image gives a good sense of the relationship between the buildings, but is clearly crying out for better light. A blue sky would help, as would some sunlight to improve contrast. Alternatively, he could have concentrated more on the abstract symmetries.

Milan, Italy
Barbara McKay

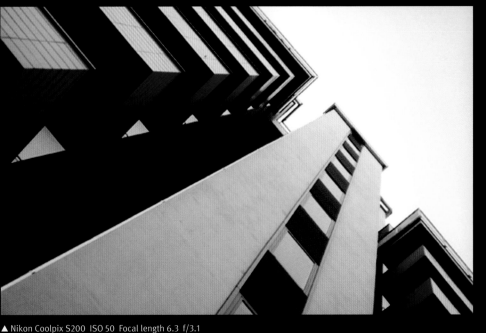

▲ Nikon Coolpix S200 ISO 50 Focal length 6.3 f/3.1

"I like the shape of this building and the geometry that could be seen ... I saw lines and angles more than balconies or walls."

Potsdamer Platz, Berlin
Ramon Rico

"What drew me to this structure was its height and its apparent weightlessness against the white sky, forming a delicate pattern of lines."

▲ Sony Cybershot ISO 400 Focal length 8mm f/5.6

tutorial 19 | wildlife photography

Thanks to the work of pioneers such as Eric Hosking, wildlife photographers could produce spectacular results even without modern technology; they just had to work harder to get close to the animals. Now, super-telephoto lenses of unsurpassable quality enable you to bridge the large "radius of fear" of many animals without any danger to them or yourself in the process.

fact file

The longer the lens, the greater your reach, but the less mobile you become. Carrying a 600mm f/4 lens any distance is not a task for the faint-hearted, and you need to account for the heavy tripod and heavy-duty tripod head that is needed. Also, setting up such a large lens for action can take quite a few seconds. Zoom lenses provide good performance and lower weight. Using a dSLR camera with APS-size sensor improves a lens' apparent reach by multiplying the effective focal length.

gaining access

The radius of fear of an animal is the distance within which it will allow you to approach before taking flight. For some, such as the desert donkey, it could be several kilometres. For others, such as many species of monkey, the radius of fear is smaller than yours. Much of the art of wildlife photography is to bring the viewer well within the animal's personal space.

long lenses | converter optics

In the 21st century, wildlife photography has been overshadowed by a sense of urgency caused by the threat to all wildlife from habitat erosion, global warming, and other pressures caused by humans. The achievements of this modern phase of wildlife photography rests in large part on the super-telephoto lens wielded by photographers expert in animal behaviour and dedicated to obtaining photographs without harming their subjects or their environment.

> Long lenses enable you to bridge the large radius of fear of many animals without any danger

The use of optics ranging from the 300mm f/2.8 – which is regarded as "normal" for wildlife – to the "medium long" 500mm f/4 and even 800mm lenses has made it much easier to obtain stunning wildlife images. Basic lenses can be extended by using converter optics, with a small loss in quality – so a superb 300mm f/2.8 lens can be turned into a good 600mm f/5.6 lens, or an excellent 500mm f/4 becomes an acceptable-to-good 1000mm f/8 optic.

The quality of modern wildlife images is a result of these lenses enjoying a level of aberration correction once thought impossible, with the growing use of image stabilization also an important factor. While long lenses are still very costly, they are no longer exclusive to wealthy professionals.

There is, however, a great deal of wildlife within reach of modestly priced macro lenses – those with medium to long focal lengths between 100mm and 200mm are ideal. Here, use small apertures and light the subject with one or preferably two flash units, or work only in bright sunlight.

accessories | tripods

The most basic accessory for wildlife photography is a high-quality tripod and tripod head. Together these can cost as much as a mid-range camera, but you will need a tripod that's able to withstand mud, salt water, and freezing or sweltering temperatures. If you use super-telephoto long lenses, your tripod must also be capable of supporting their considerable weight.

CRANES IN FARMLAND

CRANES IN THE SKY

BIRD IN RESERVE

LION IN ZOO

RED PANDA IN ZOO

DRAGONFLY IN PARK

TAKIN IN CAPTIVITY

GECKO IN DESERT

LION IN CAPTIVITY

1 2 3
4 5 6
7 8 9

light**box**

bridging distance
Aim for the type of image that is within the range of your equipment and your ability to reach the natural environment. For instance, birds can be photographed en masse **1**, **2**. Birds and mammals as individuals are easier to photograph in a zoo than in the wild **3–5**, but often the background reveals the confined space. In a reserve **7** backgrounds can be more realistic. With very small animals **6**, **8** a long focal length macro lens is best.

preserve of reserves
One of the best ways to experience wildlife is to visit animal reserves. Here, you can be sure to see animals, without having to trek and track for weeks. You may also be able to get very close to them, as with this Red Colobus monkey in Zanzibar.

marion hogl

Nationality German
Main working location Germany

Entirely self-taught, Marion's interest in photography started when she was a child, as her father was a very passionate photographer. She was given her first camera at the age of nine and has been photographing ever since. She acquired her first SLR when she attended college in Munich, where she studied Communication Sciences. Subsequently working as an advertising copywriter, she continued to pursue photography as a passionate hobby. She became a professional photographer only by accident: an advertising client saw her shots and wanted to use them for a brochure. As well as specializing in nature photography, Marion also takes photographs of people, receives advertising commissions, and teaches at a local photography school.

see more of Marion's work at:
www.painted-with-light.de

in **conversation**

Q | Marion, you live in a large city but specialize in nature photography. Why is this?

A | I was brought up in a rural area so wild animals and nature were always a part of my life.

Q | But what is it that draws you to this kind of photography and this kind of work?

A | It never ceases to amaze me how light can completely change a scene within minutes – like a spell being cast. That is what I try to capture with my camera. I find the minutes just before and after dawn especially fascinating, when the light envelopes the landscape. It comes first in tender pinks and blues, and then in flaming reds and oranges. It's when life begins to stir in Earth's diurnal creatures. With lots of patience and stamina, you can achieve that special shot that tells of wildness, an untamed spirit, or a caring mother.

Q | Is that what you find challenging – the need for patience and stamina?

A | What is really challenging is the fact that we have no control over nature. You can't say: "I will take shots of a wild leopard eating an antelope in the glowing evening light today". But if that happens, it's absolutely thrilling!

Q | Please tell us about the cameras and lenses you use.

A | I changed to digital four years ago and have never looked back. I love the possibilities that digital offers. I can take a shot at ISO 50 then, five seconds later, I can shoot at an ISO of 800. I use a Canon 1D Mark II and III, Canon 20D, Canon EF 100–400mm L IS, Canon EF 500mm f/4.0 L IS, Canon EF 100mm f/2.8 Macro USM, Canon EF 17–40mm f/4L USM, Canon Extender EF 1.4xII, and a Canon Extender EF 2xII. Cameras are only tools but with my latest cameras – the Canon 1D Mark II and Mark III – I simply fell in love!

Q | Please tell us about this shot.

A | I had heard there were burrowing owls at a local golf course. When I arrived, I was told to go to hole 7, where I saw this amazing little creature. They are tiny but so proud, with no fear of humans at all. In fact, I was startled when a golf ball nearly hit me, but the bird stayed cool! The little bird let me spend a long time with him and I witnessed some wonderful moments. It was taken with the Canon 100–400mm lens on a Canon 10D, handheld at 1/400sec, f/8, ISO 100.

Q | **What about image manipulation – do you feel it helps or obstructs your work?**
A | It depends. With nature photography I believe we should not manipulate or alter images, although I think that colour and contrast correction are fine. Even the use of a gradient filter simulation is OK.

Q | **If you don't do much manipulation, what is your workflow?**
A | I always shoot in RAW, which I find guarantees the best results, especially in difficult lighting situations. Apart from the basic corrections (such as cropping, colour and contrast correction, and removal of dust spots) I do no other manipulation unless it's needed for a special purpose. I do everything myself and I love my digital "darkroom". After four years of digital shooting I have learned a lot.

Q | **What do you hope to achieve with your photography?**
A | I always try to enjoy my work, see and capture exceptional scenes, and create something unique.

Q | **What is your dream assignment and why?**
A | To do a reportage about the burrowing owls of Florida. They are the most amazing and beautiful creatures I have encountered so far. The bird has adapted to human living conditions, and can live in peaceful co-existence with people on golf courses, gardens, and airfields.

Q | **What do you do to stand out from other photographers, to make your work special?**
A | I try not only to document but also to show things that the human eye can't usually see. For example, by using a slow shutter speed or finding an unusual shooting angle.

Q | **What do you think are the major challenges facing the emerging and up-and-coming photographer today?**
A | It is very hard to do something special today. Almost everyone is able to travel to remote locations and, with modern digital cameras, everybody can take decent pictures. So you have to do something very unique to be recognized and successful. I think an artistic approach becomes more and more important.

images **in depth**

lions | evening light
Q | **This is the kind of picture everyone adores and hopes to be able to get!**
A | The shot was taken in the Okavango Delta in Botswana, Africa. We were on an evening drive, and the light had a beautiful golden glow, when we came across a male lion with several females. It was amazing to see these powerful animals acting so tenderly. The shot was taken handheld with Canon EF 100–400mm L IS at 400mm on a Canon 10D, 1/500 sec, f/5.6, ISO 400.

waterfrog | early morning

Q | **Tell us about this – it's not as easy as it looks, is it?**

A | If you move and approach very slowly, the frogs will stay where they are and let you get close to them. I wanted to show the amazing beauty of the frog's eye so I lay down on the ground to get the low shooting angle I needed. I was steady enough to hold the slow shutter speed without using a tripod.

dragonfly | just after sunrise

Q | **Please tell us about this photograph.**

A | Just after sunrise, insects are quite immobile while they let the morning dew dry from their wings. This meant I had enough time to compose the shot and focus on the eye. I always try to find a nice clean background and blur it nicely.

> " I will never remove distractions in the picture but, out in the field, I might remove a little twig or some grass that is in the way "

Siberian tiger | in captivity

Q | I think this is a beautiful shot, with a powerful equilibrium to the pose.

A | This is a captive Siberian Tiger in a local zoo with large enclosures. I go there quite often and know the habits of the tiger well. He was standing right at the edge of a shady spot in the snow so the background was almost black, which made the colours of the fur stand out. The sun only lit part of the body and added nice catchlights to the eyes – almost a perfect studio setting! It was handheld with Canon 100–400mm at 400mm on a Canon 10D, 1/800 sec, f/5.6, ISO 400.

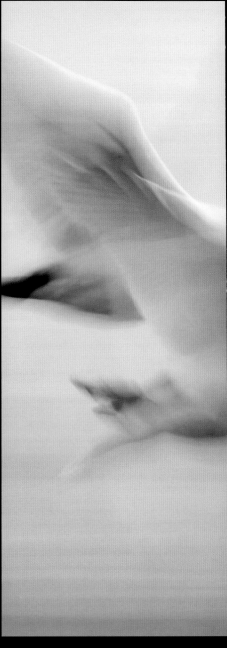

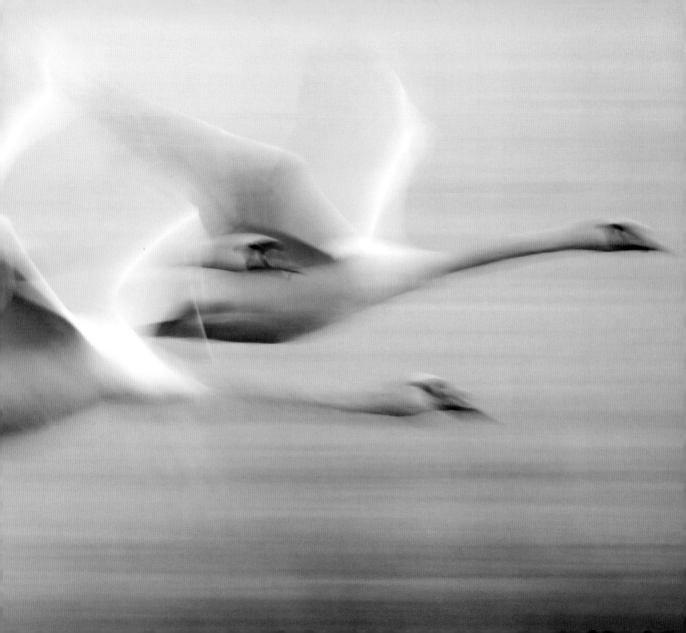

Assignment: **inspiring vision**

The invention of super telephoto and motor-driven cameras coincided with an explosive growth in world travel. As a result, wildlife photography progressed extremely rapidly: where once we were content with any sharp, magnified image of wildlife, we now expect beautiful compositions, exquisite light, and interesting animal behaviour. As our awareness of the natural world grew with our exposure to wildlife photography, so we became increasingly aware of the perilous state of animal populations and the threats to their survival.

ISO 400 Focal length 300mm 1/250 sec at f/5.6

the**brief**

Photograph wildlife with the aim of inspiring others to share your love of living creatures in the wild. Use every trick in the book to provide an insight into behaviour and to create the most stunning image you can: amazing lighting, dynamic colours, and careful framing. Wildlife can be found in a nearby zoo or animal park – you don't have to go on safari.

Points to remember

- compose with the animal in its habitat – they may complement each other or highlight contrasts
- if you are not familiar with the environment or the animals, ask local experts for advice on where to go and when to wait
- respect the animals: waiting patiently for the shot is your main priority
- if you can get close enough, try showing just one part of the animal – you don't have to show its whole body

ISO 400 Focal length 400mm 1/60 sec at f/4

must-see **masters**

ISO 800 Focal length 275mm 1/250 sec at f/9

ISO 200 Focal length 300mm 1/250 sec at f/4

ISO 100 Focal length 300mm 1/250 sec at f/8

ISO 100 Focal length 300mm 1/250 sec at f/4

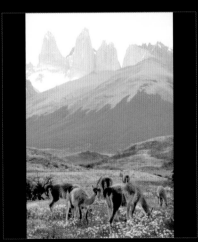

① ② ③
④ ⑤ ⑥
⑦ ⑧ ⑨

light**box**

top**tips**

① **vigilance** | and quick reactions
Wildlife photography may take you to far-flung places, such as the open seas to watch whales, but keep a constant watch as you will get little warning, and no second chances, when the perfect moment arises.

② **③** **eye** | to eye
Use the longest focal length setting for captive animals: this blurs out any intervening wires, brings you to a dramatically magnified view of the animals, and also conveniently cuts out the zoo surroundings.

④ **⑤** **reflect** | on symmetry
Reflections usually work best where they join in an unbroken line with the animal. Try to work on windless days and aim to capture the reflections before ripples ruffle the surface of the water.

⑥ **domestic** | parallels
Don't feel you have to show wild animals engaged in dramatic behaviour. It can be just as revealing to show animals at rest, perhaps looking for all the world like a domestic pet taking it easy in your garden.

⑦ **automatic** | photography
If you know the habits of an animal, it's inexpensive to set up equipment that will capture the image automatically: arrange an infra-red light and sensor that activates the shutter when the light beam is interrupted.

⑧ **motion** | blur
Panning – swinging the camera to follow movement during exposure – is very effective. Exposure times don't need to be long: 1/30 sec–1/15sec is a good starting point, or shorter for speedier animals.

⑨ **content** | and habitat
Over-concentration on the animal as hero can blind you to the habitat or environment: start with a wide view showing the animals in context before getting closer.

Ververt monkey
Chris Hopkins

"The pose in the best of the series embodies such thought and concern as the adult monkey watches its young playing nearby."

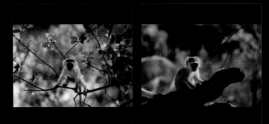

the**critique**

It's interesting that the majority of the wildlife images submitted were portraits of animals, some representing very close encounters indeed. Photography has enabled millions to look into the eyes of wild animals and start to feel some kinship, wonder, and respect. That is a tremendous achievement for what amounts to a bundle of glass and electronics. This selection shows that even very modest equipment can produce excellent wildlife images: the essential elements are being ready and having a love and interest in the animal world.

Vervet monkey

Chris explains "Vervet monkeys are fabulous to watch and photograph because of their mischievous nature and strong visage. Their grey fur also plays to the camera well, especially when set off against a soft green background." Chris concentrated on an individual that was relatively still and was rewarded with a gentle portrait with perfectly placed catchlights in the eyes. The soft background blur makes this already sharp image look even sharper: a lovely picture that invites you to get to know the animal better.

red toad

David says that he tried various framings and close-ups but decided that the wider view "showing the toad floating in the weed, gave context and a better overall image": the result is an engaging portrait, but perhaps a more central position for the frog would help to direct more attention to him.

wild seal

Thorsteinn explains that it was late in the day so the light was poor. But the important thing is that he captured the image anyway: a little post-processing to improve contrast gives a pleasingly warm glow to the lighting.

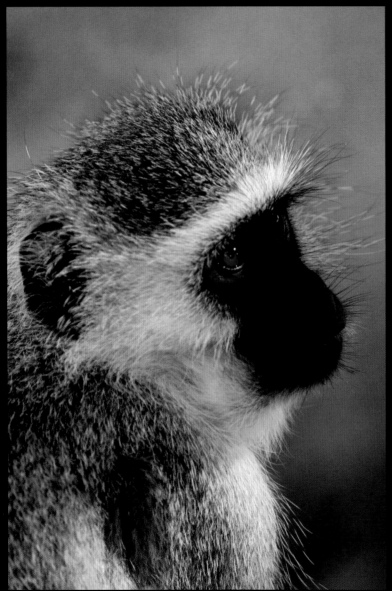

▲ Canon EOS 5D ISO 400 Focal length 400mm 1/100 sec at f/5.6

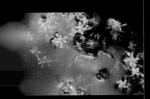

"I spotted this toad taking a well-earned rest from mating. We made eye contact and I thought I detected a smile. So I grabbed my camera."

▲ Canon EOS 20D ISO 100 Focal length 70mm 1/50 sec at f/5.6

wild seal

Thorsteinn Egilson

"The seal had climbed up onto the ice in the marina and stayed there for a day. Next day he was gone."

fine art photography

Until recently, the term "art photography" was largely regarded as an oxymoron. Today, while there is a great deal of photography that isn't art, much of modern art is photography. It embraces a range of practices and tastes, from rough shots on mobile phones to finely crafted platinum palladium prints, and from digital composites to stage-set portraits; all forms are accepted.

fact file

Some photographers disdain art photography for its lack of quality. But not all art photography is produced by cameras with cheap lenses or by mobile phone cameras. Some art photographers make the largest, highest-quality images using large-format cameras and by scanning their films at the highest resolution. Digital technology has enabled much larger prints to be made than ever before, and artists have been amongst the leaders in exploiting ultra-large prints.

vision over record

If there's one single feature that distinguishes art photography from other genres, it's the precedence of vision over record. Photographers have to work harder than other artists to express their own personal vision as they have first to overcome the inherently industrial nature of photography. Art photography maps its practitioners' struggles against their chosen medium.

theory | and practice

Photographic practice may be viewed as stretching across a spectrum that runs from the perfectly objective at one end to the perfectly subjective at the other. Scientific or surveillance images are at the former end of the spectrum, while art photography driven by personal vision is very subjective, if not perfectly so.

Another type of spectrum may stretch from one end with the photographer as neutral observer – as idealized by documentary photojournalism – in which the unvarnished truth is accepted, and image cropping is forbidden. At the other

> ❝ Anything goes, so long as a solid conceptual framework is created and articulated ❞

extreme, the photographer may choose to construct every element of the image, building the background, selecting and posing the model, and manipulating the light: this is the omnipotent photographer, in control of everything within the frame.

Some photographers are keenly aware of yet another spectrum. In this, the camera may be seen as a tool at the service of the subject, its sole purpose being to present the subject in the most pleasing way. At the other end are those who regard cameras as a tool entirely at the service of the photographer alone.

concepts | and images

The notion of a spectrum of types of practice gives us a way to locate the genre of art photography. It is at the far end from objective photography, close to the image that is wholly constructed, and it is entirely comfortable with the camera being wielded for the photographer's personal needs.

In short, art photography can be defined as that in which the practice has thrown off all rules. However, the genre has created its own institutions which impose their own rules – and these allow it to embrace certain other types of work, such as documentary.

Art photography expects its practitioners to be able to articulate the ideas driving the work, and it expects to see a coherent corpus of images. Above all, it expects to be evaluated within its own framework: it will deny that an image is poor from the standpoint of composition if composition is not within its terms of reference. In short, anything goes, so long as a solid conceptual framework is created and articulated.

RAINDROPS ON GLASS

BUILDING ABSTRACTS

LIGHT COMPOSITION

URBAN BLUR

LIGHT PLAY

PORTRAIT

MONO LANDSCAPE

COMPOSITE

PHOTOJOURNALISM

art images

(1) (2) (3)
(4) (5) (6)
(7) (8) (9)

light**box**

What is art photography is up to the photographer to define, display, and defend. From blurry colours 1, 4 to pin-sharp abstracts 2 or landscapes 7, any approach can be accepted and defended. You work with play of light 3, 5 in the abstract or on the portrait 6. For some, photojournalism 9 is an art but all are agreed composites 8 are clearly fine art.

inverted plume

The muddy waters of a small stream in an estuary are transformed with basic inversion of colours and tone into an abstract that is suggestive of landforms or satellite pictures. Its allusions and elusiveness suit it to the art market.

emily allchurch

Nationality British
Main working location UK

Constantly painting, drawing, and working in collage from a very young age, Emily always knew she wanted to be an artist. Trained in sculpture at the Kent Institute of Art & Design in 1996, she graduated from the Royal College of Art in 1999. Within a short period of time, her large-scale, back-lit transparencies – which draw closely on art history to make recreations of old master paintings set in a contemporary idiom – have won her a firm international reputation. There are public collections of her work in Monaco, Italy, Canada, and England.

see more of Emily's work at:
www.emilyallchurch.com

in **conversation**

Q | Emily, how did you start in photography and what led you to your style of work?

A | London had a huge impact on me when I moved there and I felt compelled to make work about the built environment and our experience of it. I found photography to be the most direct art form through which to communicate my ideas. The first real picture I ever printed was an 8ft x 7ft (2.4m x 2.1m) photo of my hand with memory maps traced onto it. I worked to a plan, scaling the negative up in sections and then piecing the parts together to create a giant free-standing jigsaw. I have always liked to bring many different parts together in a single piece.

Q | What aspect of photography do you find the most challenging?

A | I haven't had a very technical approach to my photography until now, tending to shoot still objects in flat daylight. I simply need to get the building or object in the frame and in focus, and then extract the part I require and paste it into the main composition. Judging a situation, waiting for the right moment, and positioning yourself correctly can be challenging, but I have learned through experience and can correct most things in Photoshop.

Q | How do you approach your assignments?

A | Generally I work to my own brief, but I do enjoy taking part in a commissioned project. Before I start, I always make sure I can meet the expectations of the client without compromising my own practice. Once I'm confident about this, I embrace the challenge, which always exposes you to new ways of working and thinking. A good example of this was when I took part in the BBC4 series A Digital Picture of Britain. The challenge was to work with a digital camera for the first time, and it made me see the advantages of working digitally for my processes. I would have made the switch eventually, but this prompted the change immediately.

Q | This image looks very complicated.

A | This is Urban Chiaroscuro 4 (after Piranesi) from a series of interpretations of Giovanni Piranesi's Carceri d'Invenzione (Imaginary Prisons) from around 1745–1761. It's a complex labyrinth constructed from images of Rome and it took a month to make, both to photograph for it and to piece it together using Adobe Photoshop.

Q | **Please tell us about the photographers who have inspired you.**

A | I admire Jeff Wall's work very much – the subject matter, scale, and presentation as back-lit transparencies. Other people I admire include Hiroshi Sugimoto (particularly his Theaters), Gregory Crewdson, Elisa Sighicelli, and Sophy Rickett. All of these photographers use light with intensity to make the mundane extraordinary.

Q | **What is your opinion of image manipulation and image effects?**

A | I have no problem with image manipulation when it's clear that that is the intention of the work and there is a good reason for using it. For instance, my work is obviously manipulated, which is the point of it – to create a fabricated space that otherwise couldn't exist. Image manipulation has enabled many masterpieces in photography, film, and advertising in recent years. It also allows an almost perfect image to be corrected. I'm not keen on many of the filters and special effects, though. They can be fun and they have their place, but they shouldn't be taken too seriously.

Q | **Do you regard yourself as an expert in image manipulation?**

A | Like most people, I actually use a very small percentage of Photoshop but, with what I do use, I would say I'm pretty skilled. I am also able to draw on my ability with colour, light, and shade to compose my pieces. It took many years to find my own way of working and it's so satisfying to combine all my skills and interests through this technique. I so enjoy constructing my work on the computer and, after four to six weeks of working on one image, it's always hard to leave it and start a new piece.

Q | **How do you develop your work – and what informs it?**

A | I tend to create a series of works. Completing one is a long process that can take up to a year. During this time, I visit exhibitions, read around, and gradually build up an idea of how to take the work forward. I am always trying to challenge myself to find new ways of developing my visual language. It's not always possible at the time to understand why you feel compelled to make a body of work – you have to trust your instincts and take a leap of faith. However, in hindsight, the links between your life and your work become very clear.

images **in depth**

ideal city | (after della Francesca) 2006

Q | **This is so sumptuous and elegant. What was the source of your inspiration?**

A | The original is a model for the perfect urban design that has inspired architects and city planners ever since. I knew I would be able to create this model for the 21st century from real architecture found in both the poorer and more affluent suburbs of the city: the left side comprises photographs from west London and the right side from the east.

❝ I incorporate signs and objects... to build a narrative and humanize the scene, from the message 'don't even think of parking here' to the patriotic flags ❞

Tower of London | (after Bruegel)

Q | **I enjoy its tragi-comic look.**

A | This homage to Bruegel's Tower of Babel (1563) has to be the most complicated image I've ever created, taking three months to complete and using 500 photographs of London. I took over 1,000 shots to get everything I needed. I then created an archive on my Mac for different parts, such as buildings from above and below, distant water, building works, and so on. Piecing it together was a complicated process and, by the end, I had merged over 1,500 layers! The references to different religions and the peace flag at the top demonstrate London's ability to unite against adversity, particularly in light of the 2005 terrorist attacks, which occurred while I was making this work.

riverside | (after Whistler) 2005

Q | **Now, this looks deceptively simple.**

A | This piece was made for the BBC4 series A Digital Picture of Britain, in 2005. The aim of the series was to challenge professional photographers to capture the British landscape using digital cameras for the first time. I was given a Sony Ericsson mobile phone camera and chose to recreate Whistler's Nocturne in Blue and Silver – Cremorne Lights (1872), as I thought it would be interesting to update Whistler's abstract brush strokes with the digital pixellation from a low-grade camera. In fact, I was amazed at the image quality the mobile phone camera gave me and the digital process lent itself perfectly to my way of working. I went to the same location as the original painting and took photographs from Battersea Bridge. I then recreated the scene as it is today using Whistler's original as my template. Building up the subtle shift of colour and tone in the water was as close to water-colour painting as you get working on a computer.

urban chiaroscuro 1 | London (after Piranesi)

Q | You start off quite dark here, but can't help being optimistic, can you?

A | I compress a journey around London into a single scene. The colour palette is derived from the yellow of east London brick and the weak sunlight cast across architectural structures. The work offers a visual meditation on contemporary urban existence, and specifically a suggestion of the claustrophobic climate of fear and the prevalence of the technology of surveillance. At the same time, the sunlit spiralling staircase in the distance provides a note of optimism with its possibility of choice and escape.

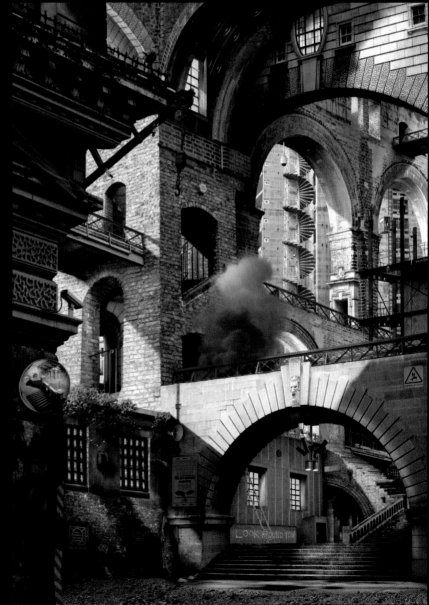

Assignment: **creative expression**

A digital camera can be like a voluble speaker: it can deliver pictures with such facility that at first you don't realise there is not much meaning in your image, and very little depth. The temptation to fire off shot after shot in search of what you want to show is a very strong one, and is the reason why more than a trillion images are taken by digital camera users every year. But if you seek artistic satisfaction, you will find that the clearer your vision before you click the shutter, the stronger and more meaningful your images will become.

ISO 100 Focal length 50mm 1/160 sec at f/4.5

the**brief**

Using your skill and imagination, and exercising your freedom to work with any kind of subject or approach, with or without manipulation, produce images that are expressive and subjective, rather than objective and representational. Imagine that your photographs may be used for a magazine, poster, or a greetings card.

Points to remember
- art imagery accepts a very wide range of technical quality: what matters is that the quality is appropriate to the message or intention
- other forms of art such as movies, music, and fine art can be very inspiring and can suggest ideas and themes for your photography
- make use of the qualities and characteristics of your equipment; accept any distortion in the lens or strange colours rather than fighting them
- work at a theme rigorously – your images will improve steadily

ISO 200 Focal length 12mm 1/250 sec at f/13

must-see **masters**

Sylvia Plachy (1943–)
One of the more sensitive and visually rich explorations of cultural and individual identity, Plachy's work swings from the documentary to the artfully nostalgic, but is always interesting. It is work in which the effect of the whole is deeper than the sum of its parts.

Man Ray (1890–1976)
The photographer most closely associated with Modernist art movements such as Dada and

Surrealism, Man Ray's work spans an astonishing range of visual styles. His work is distinguished by a tireless exploration of the possibilities of the photographic medium.

Joel-Peter Witkin (1939–)
Constructing elaborate tableaux featuring death, disease, the disfigured, and the marginalized, Witkin's work is quintessentially transgressive and challenging, both visually and viscerally, and should not be ignored.

ISO 100 Focal length 40mm 1/400 sec at f/10

ISO 800 Focal length 70mm 1/12 sec at f/18

ISO 125 Focal length 59mm 1/160 sec at f/4.5

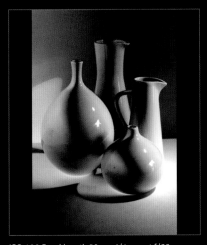

ISO 400 Focal length 50mm 1/4 sec at f/22

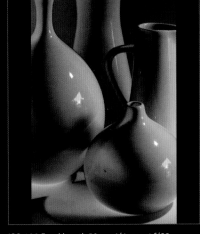

ISO 400 Focal length 50mm 1/4 sec at f/22

ISO 100 Focal length 50mm 1/200 sec at f/5.6

ISO 400 Focal length 52mm 1/160 sec at f/3.2

1 2 3
4 5 6
7 8 9
light**box**

top**tips**

1 **manipulated** | surface
You can choose to apply image manipulation effects quite obviously, as here, or you can work with more subtlety: some of the best photographic art combines elements of both of these approaches.

2 **visual** | puzzles
The technique used in this image is the same as that used in image 1, but because of the nature of the original, the result is more of a visual puzzle. The viewer needs to do more work to interpret the image.

3 **light** | effects
Modern cameras can now fit into tight corners for views that were once impossible to capture because cameras were too large. Our view of the world is educated by the camera, and that, in itself, is a contribution to art.

4 **transforming** | space
Art can concern itself with the meaning of representation or misrepresentation. Here, strange colours are imparted to the sky and to the massive structure which is also seen from an unusual angle.

5 **6** **simplicity** | stillness
A favourite subject for art photography is still life, because it is easily accessible to photographer and viewer, yet it can also be interpreted in many different ways.

7 **observing** | detail
Photography is an unabashed plagiarist, and a favourite art to borrow from is sculpture. Try using other artforms to inspire your art photography, such as fashion, machinery, architecture, and interior design.

8 **9** **accidental** | art
Framing paint and cracks on a wall turns an accidental composition into an artwork: keep the camera square to the wall and try different framings.

▶ see **results**

Cagliari, Italy
Sandro e Patrizia

"The only problem with taking this photo was trying to avoid getting any of the numerous people who were there at the event in it!"

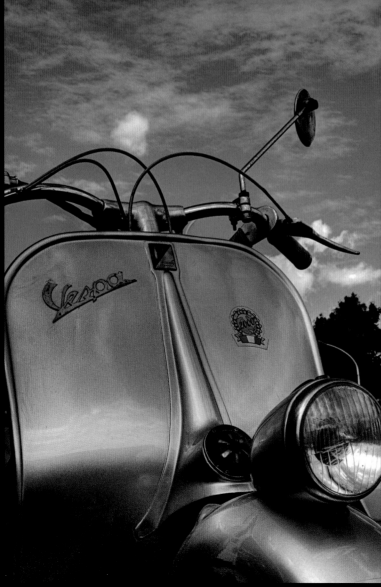

▲ Canon EOS 350D ISO 400 Focal length 31mm 1/400 sec at f/16.0

the**critique**

Although being creative and expressing yourself is widely encouraged and a popular way to enjoy photography, it seems that many are diffident about presenting their artistic efforts. In fact, the showing of your personal work is a central part of the creative art: in exposing your ideas and expressions to the cold light of impersonal inspection, your work – and your own attitude to it – gains strength. It's the only way. This is not even simply about making your work visible, it is to say that diffidence actually inhibits creativity. Show your art!

Cagliari, Italy
A photograph of a work of art may itself be a work of art, and for some classic bikes and cars are works of art. When Sandro and Patrizia made this photograph at a fair for vintage vehicles their preoccupation was avoiding the crowds. But the viewpoint has succeeded in turning the mundane into the monumental, if only on a small scale. That transformation elevates this simple shot into a celebration – but equally valid is the view that it's only a snapshot.

Barcelona
Monika's enthusiasm for the visual language of Gaudi has clearly inspired her approach to her photography. This appears to be less about imitating Gaudi's visual language but being led by his freshness of vision. In this image, shot through a distorting glass, a little boost of colour and contrast would be beneficial.

glowing flower
Some may see little point in photographing flowers but the reward rests not just in personal satisfaction but the desire to share the glad feelings evoked by nature. Robert inverted the tones to make the image more abstract – a set of large prints would look marvellous.

Barcelona
Monika Madej

"I'm fascinated by Gaudi's work and when I had a chance to visit Barcelona I couldn't stop taking pictures."

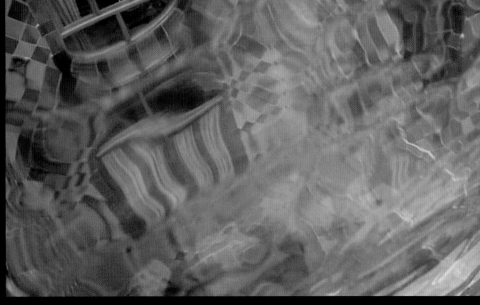

▲ Fujifilm FinePix S602 ISO 200 Focal length 7.8mm 1/180 sec at f/3.2

glowing flower
Robert Eaves

"I find flowers really compelling, beautiful, and fascinating; I could photograph them and work on their images endlessly."

▲ Pentax K110D ISO 200 Focal length 55mm f/8.0

system set-up

As a keen photographer you will, at first, be only too glad to produce images that please you and impress others. Before long, the boundless potential of digital photography will encourage you to shoot more and more. You will seek consistency in the quality of your output, and then you'll start to worry about the security of your images. It is time to set up your system and manage your image workflow.

colour spaces

The Working Colour Space is the one in which you carry all your digital image work: viewing, manipulating, and preparing for output or slide-show. Use a large Working Colour Space if you are preparing for high-quality print, use a smaller one for web use. The Output Colour Space defines the colours that are reproduced by your desktop or out-source printer. If you're using a single desktop printer, different papers and inks call for different output profiles. Use the output profile to soft-proof or check colours before you commit to print.

setting up

Keep in mind that once you've captured your image, and even after you've manipulated it on the computer, the work has only just begun. There are three main strands to workflow – managing the way you handle images – digital photo management, archiving, and output. But central to all these processes, and to image manipulation itself, is colour management.

controlling | colour

Modern systems of reproducing colour – from image capture through to printing images – are extremely well controlled. This means that the majority of problems with colour reproduction can be pre-empted simply by correctly setting up your system.

Your main monitor – that used for viewing images – should be calibrated and profiled. Modern calibrators are not expensive, and count among the most important accessories you should purchase if you're serious about your photography.

Ensure, in support of the calibration, that you make the correct colour settings in your software – from that used to import images, to your image manipulation application, to the printer drivers. If you do this, images from any source that you view on your monitor will colour-match from image import to final output.

software | workflow

While there is no question that calibrating your monitor is essential to a colour-managed workflow, you have a choice regarding how to manage the flow of images from camera to final output, via image processing. One option is to work on image files directly, wherever they happen to be located: this is the browser-based method. It is the most straightforward to understand but involves using two separate software applications: one to locate your files, and another to process them. For example, use an image browser such as Camera Bits Photo Mechanic or Adobe Bridge to locate

files, then process them using GIMP (GNU Image Manipulation Program) or Adobe Photoshop. You may use the operating system to manage files but that's not to be recommended as it's slow, inflexible, and unable to handle metadata.

Alternatively, work with proxy or stand-in files via a library or catalogue of images. Library-based systems call for images to be imported or accessioned into the library first before you can work on them. This may seem cumbersome, but it provides an integrated solution because a single application (such as Adobe Photoshop Lightroom, Apple Aperture, or Capture One Pro) can import images, add metadata, and process both RAW and JPEG files. They work by saving instructions that determine the size and appearance of the processed image – so-called "parametric processing".

heavyweight | solutions

While your collection of images is small, the browser-based method is workable and the least expensive route. You use the computer's operating system to locate files and open them in free software such as GIMP. But as your collection of images grows, you'll need ways of looking for images that don't involve trawling through one folder after another. It also means you are no longer stuck with one way to organize images.

Suppose, for example, that you organize your files by date and that each year you holiday in Tuscany. If you wanted to look at all your Tuscan shots at once, you'd have to open the Tuscany folder for each year. Using library-based software, you can locate all the Tuscany shots made over many years in a single mouse-click. And once you've located your image, you can work immediately to enhance it, add metadata, and prepare it for output, all without having to open another piece of software.

Library-based software work by creating small versions of your images, which are much faster to deliver up than full-size ones. And because they're stored separately, in a very efficient database, they can be readily found. The disadvantage comes with very large collections: the library becomes extremely big and can be tricky to handle.

profile connection space
The diagram demonstrates how colour characteristics of different devices can be translated to each other, using colour profiles and a common colour space.

Working colour space is your starting point. The RGB colour space is widely used and gives acceptable results. Adobe RGB (1998) gives better results for professional use.

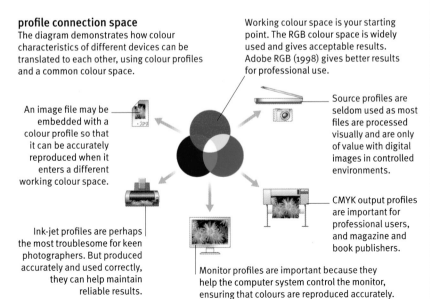

An image file may be embedded with a colour profile so that it can be accurately reproduced when it enters a different working colour space.

Source profiles are seldom used as most files are processed visually and are only of value with digital images in controlled environments.

Ink-jet profiles are perhaps the most troublesome for keen photographers. But produced accurately and used correctly, they can help maintain reliable results.

CMYK output profiles are important for professional users, and magazine and book publishers.

Monitor profiles are important because they help the computer system control the monitor, ensuring that colours are reproduced accurately.

colour reproduction set-up
This flow diagram summarizes the set-up needed to ensure accurate and reliable colour reproduction.

- set camera's colour space
- set software working colour space
- calibrate and profile monitor
- maintain monitor calibration
- soft-proof images
- embed appropriate profiles with output

import and metadata

It's a sobering thought that the images in your camera are completely worthless until they reach a computer. Only then can they be properly viewed, prepared for use, then safely stored away. They also need a vital component added: searchable data.

importing | images

It is useful to compare the process of importing images to accessioning books into a library: both items need to go through certain formalities. Simply copying them into the computer is rather like dumping a load of new books onto the first available shelf: if you don't know what the books are about, and whether they're in the correct place, they're not as useful as they would be if properly catalogued.

When you import images, a software application administers the images' progress into the computer. It will create suitable folders, add information to the images, and rename files if you wish. Import software may also make copies of the images onto connected hard-disks simultaneous to their storage on the computer itself.

In contrast, when you copy files – that is, when you select and drag them from the camera or memory card into a folder on the computer, you first have to create a suitable folder; then the duplicate files are simply stored in your computer. Generally, it is best to import images using the software which came with your camera, or to use specialist software such as Apple iPhoto, Adobe Photoshop Lightroom, ACDSee, or Camera Bits Photo Mechanic.

making | the connection

You can connect your camera wirelessly with a computer or tablet if your camera is equipped with Wi-Fi (either built-in or through accessories). If you're working close to the storage device, images can be sent to the device as you shoot, rather than having to wait to download them all at once. Wi-Fi streaming is best when recording relatively small files, but it is a liberating experience to have the transfer done automatically. Naturally, the images are also stored on the camera's memory card.

Compared to the slickness of Wi-Fi, having your camera connected through cables seems almost quaint, but it is the best way to handle large files and large numbers of images. Make use of high-quality card readers and high-quality cables: this is not the place to compromise on quality.

As the original files remain on the memory card until you erase them or format the card, they are effectively backed up as soon as you transfer them to your computer or tablet. It is wise not to erase memory cards until you have confirmed you have at least two copies of each image on your system (see also pp. 346–47).

what | is metadata?

Your image is your primary data, so information about your image is the secondary or metadata. There are broadly three classes of metadata. The first type is attached to the image data at the time it is created in the camera: called EXIF (EXchangeable Image File Format), it was originally attached only to JPEG files, but was later added

to TIFF and RAW. It summarizes the camera settings used when the picture was taken. All the data recorded is amazingly useful, especially as a tool for analysing your own photography. Information such as aperture, exposure time, and ISO rating are recorded, as well as the capture date and time, and data useful for printing out.

The IPTC (International Press Telecommunications Council) data is added to the image during or after import. Technically, the data can be embedded into a wide range of image formats using the XMP (Extensible Metadata Platform) specification. Under this scheme, you can add numerous types of information to the image – anything from copyright details and your contact number, to preferred cropping dimensions and global positioning coordinates.

For the majority of photographers, however, the most important element is the ability to add searchable words or tags to your image. The more completely you describe your image using keywords relating to the subject, concept illustrated, and even the dominant colour, the easier it will be to find that image again via a simple keyword search. It is the revenge of text on image: the sheer volume of pictures can be brought to order only through submission to the power of words.

managing | image files

While each person will have preferred ways of working, there are well-known pitfalls for those who do not work in an organized way. The most common mistake is to think that you capture so few images that it's not worth troubling to organize your photos.

Make extensive use of folders to store related images: keep those from the same event or location together. Likewise, keep image folders together, perhaps under a big umbrella folder called "Pictures". For example, the hierarchy could start with Pictures, then sub-folders by year (2013, 2012, etc.), followed by events ("Hannah's birthday") or places you've visited, and individual projects. This organization may be reflected in the structure of your library in library-based software, but thanks to all that metadata you will have added, it will be easy to search across folder boundaries (see also p. 343).

You may wish to rename your images on import, so that the camera's alphanumeric code is turned into an immediately recognizable name with serial number: this is another reason for importing files rather than simply copying them. For example, instead of a cryptic "_DSC1234.JPG", you include the name of the location, changing it to "AbuDhabi_1234.JPG". If you add dates, use the eight-figure number in the order year–month–day, such as 20140410, as these will then be sorted in the correct order.

rescuing | images

Modern digital cameras are reliable to incredible levels, with a failure of only one in every few hundred thousand images. In fact the largest cause of lost images is human error, such as erasing images from a memory card before importing it, or over-hasty deletion (hint: never, ever delete images while out on location). Even then, it may be possible to rescue the erased images. Rescue utilities such as SanDisk RescuePRO, Prosoft Klix, and Lexar Image Rescue are inexpensive and work well, if slowly, at reconstructing lost files. The key to successful rescue is to stop immediately as soon as you notice a problem or realise you have made a mistake. And never format a memory card until you are absolutely confident you have its contents safe on hard-disk.

import workflow
Efficient import of images calls for some work even before images are captured. In fact, the more preparation that's done, the more efficient the workflow will be.

set up metadata templates

enter specific data before import

import images

check metadata integrity

back up images

import to management software – if required

locate image by searching metadata

handling and archiving

The price for the flexibility and manoeuvrability of digital files is their extreme fragility: it takes very little for a digital image to be destroyed. Entire systems have been developed to safeguard image integrity.

archiving | images

The modern amateur photographer produces thousands of images each year, while professional photographers now seldom complete a day's work with fewer than two thousand images. The sheer numbers of images made and the fragility of the digital image give rise to the core operational issue in archiving: access versus permanence.

It will come as no surprise that the methods of storing images that give the speediest, most convenient access are those that are most prone to catastrophic and total failure. Storing your images on hard-disk drives is relatively inexpensive and the most accessible method by a long way: you can keep 2TB (terabytes) or more of images on each drive, and you can access any of them within seconds.

As we all know, however, disk drives will sooner or later fail. This will entail the loss of every last bit of data stored on them. There are techniques for recovering data, but these require very time-consuming, highly expert work, and are therefore costly – it is a last-resort solution.

archival | solutions

One approach to unreliable hard-disk drives is to accept that while one may fail, two are unlikely to fail at the same time. We therefore run three or more drives at once, set up so that all the information is mirrored across every drive. In other words, the data is stored redundantly, giving the arrangement the name "redundant array of independent drives", or RAID. If one or more drives fail, the others will be unaffected (in theory), and the failed drive can be replaced. It is a solution that is essential in proportion to the importance that image files are safe: certainly professional photographers should regard it as their standard solution.

For the fastest access to data, use the latest connectors, such as USB 3.0, eSATA, or Thunderbolt. Also consider using solid-state drives (SSD), which are extremely responsive in use and refreshingly silent in operation.

Other storage methods, such as Blu-ray or DVD, offer more stability and long-term reliability, but accessing them is long-winded because each disc stores only a relatively few images compared to a hard-disk drive. Read-out speeds also compare poorly with hard-disk or solid-state drives.

off-site | safety

Whatever solution you choose, it is an elementary precaution to keep the archive copy in premises far from the originals. For example, store originals in the studio, but the archive copies at home. You may come across the advice to store precious discs in a fire safe, that is, one that resists fire. Unfortunately, in all but the costliest fire safes, in the event of fire the inside of the safe becomes an oven: the contents

may not burn, but polycarbonates, resins, and coatings of the type used on DVDs and hard-disks will certainly melt or lose their magnetism, and therefore all the data will disappear.

safety | in clouds

Another off-site solution is to store images on remote servers. This is growing in popularity as server technology continues to drop in price. You download your images as you create them to your designated portion of a "farm" of hard-disk servers. Some companies operate redundancies not only at the one farm, but also scatter them to different regions or countries: geographical redundancy helps ensure a natural disaster affecting one server does not destroy all the data.

The most popular architecture for off-site storage is "cloud storage". Essentially, you have an allocation – some services are free – that you fill as you wish. This allocation is spread out over a number of different physical servers around the world. Software interfaces from corporations such as Apple, Microsoft, and Adobe make it easy to synchronize the contents of a folder with the copy of the folder in the cloud.

remote | selling

Some services take the notion of remote server storage a step further: the concept is that while the images are available, they should be put to work and offered for sale. These services provide software which enable you to construct a personalized web presence from which you can sell your images. The service takes care of the e-commerce programming needed; you have only to supply the images and market your photos.

These remote picture server services are a viable alternative to running your own website and, of course, also double as secure places to store your best images. Compare photo sale sites such as PhotoShelter and ClusterShot, or microstock companies such as Fotolia and iStockphoto, to learn which one offers the services that best suit your requirements and budget.

photo-sharing | sites

A variant of off-site storage is the photo-sharing site. This solution is suitable for those satisfied with using smaller image sizes, and is considerably less costly than professional remote picture server sites. It must be, for tens of millions of people make extensive use of these sites to show off their pictures, and many photographers use these sites to promote their portfolio and parade photographic accomplishments to potential commercial clients. The standards of photography and types of material vary considerably, but the advantage is that you can put any images you like on the site (provided, of course, that they do not offend, and are not illegal or unlawful in any way).

Photographs on these sites serve a wide range of functions, from sharing interesting shots to using images as a currency for social exchange and group bonding. The numbers of images which can be viewed on photo-sharing and photo-storing sites are hard to contemplate, but, at the time of writing, just four of the main sites – Flickr, Yahoo! photos, Photobucket, and Webshots – contain tens of billions of images. No accurate estimate can be made as the amount rises at the rate of several millions of images every day.

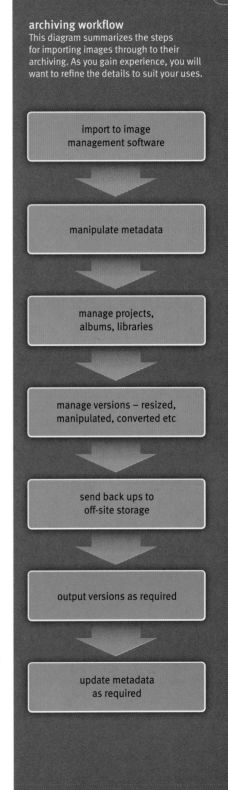

archiving workflow
This diagram summarizes the steps for importing images through to their archiving. As you gain experience, you will want to refine the details to suit your uses.

import to image
management software

↓

manipulate metadata

↓

manage projects,
albums, libraries

↓

manage versions – resized,
manipulated, converted etc

↓

send back ups to
off-site storage

↓

output versions as required

↓

update metadata
as required

gamut colours
These images simulate the bright appearance of an image on screen (top) with saturated colours, and how it may appear once printed (above). There is superior differentiation of bright colours on output, but appearance overall is dulled.

image output

To the great disappointment of the photographic industry, the explosion in making photographs has not resulted in a corresponding increase in the numbers of prints being made. Far from it; photographers print fewer images than ever.

output | directions

It's obvious that since images can be viewed easily on screen, the incentive to make a print on paper is reduced. In fact, in the early days of digital photography, there was a high demand for prints because access to monitors to view images was limited.

Unfortunately, the industry was not ready for the enormous technical difficulties that this involved: colour management was poorly understood, and equipment was unable to maintain colour reproduction from print to print. Disaffection with digital printing grew at the same time as computers entered more and more homes. Photographers and the public became accustomed to viewing images on screen, so much so that even the poor quality of a mobile phone display is now acceptable. The end result is that photographers print out a miniscule proportion of the images they have on file.

This is such a pity, because a fine print of a lovely photograph is a product of great beauty; one of the pinnacles of technology-enabled culture. What's more, despite the relatively small numbers of photographers printing out their photos, enough are doing so to encourage a burgeoning industry of printing papers: there are probably as many different types of paper, surfaces, and weights (thicknesses) as there were at the height of dark-room based photography. You can print on papers with hard metallic gloss through semi-gloss or eggshell finishes to hand-made watercolour paper textures. Paper tints range from the most brilliant whites to subtle creams and magnolias.

preparing | for print

If you have any experience with making prints you know that you cannot prepare carefully enough. Inks and papers are costly, and so is the time it takes for a printer to churn out best-quality prints. The flow-chart opposite summarizes the main steps.

The crucial element is a critical evaluation of the soft-proof – the preview on your monitor of your image as should appear when printed. In Edit › Color Settings (which may be in the Preferences panel of your image manipulation software) set your output profile to match the paper and ink-set that you intend to use: profiles may be provided by your paper or printer manufacturer or you can send off sample prints for custom profiles to be created. You can also create your own profile using a flat-bed scanner or a colour measuring device and suitable software.

With the output profile set, when you preview your image using View › Proof Colors, the image on-screen will instantly look more dull than before. This leads to a crucial element of making prints that is often lightly skipped over: the need to control expectations. The image as usually seen on screen is almost always more brilliant, brighter, and snappier than any printed image can be.

files | fit for function

If you are sending files to a laboratory, website administrator or publisher, you are now expected to send files fit for purpose or function. In addition to the specifics regarding the content, the specifications for your files should be suitable for the job. The aim is to eliminate the need to resupply the file.

This means that the image is printable or viewable at 100 per cent: the output size of the image should be exactly the required size – no more, and certainly no less. Printing at other than 100 per cent is not a serious problem, but it places an unnecessary burden on the processes and may not provide the best image quality.

Related to this, file sizes should be no larger than needed – usually output resolution should be 1.3X to, at most, 2X the line (or equivalent) screen frequency: in most cases, the standard of 300 dpi for desktop or mass-production print is over-generous: a resolution of 225 dpi is sufficient for the majority of purposes.

Image files should also be in their most basic form: flattened to the background, that is, with no layers (remember that a single layer still needs flattening into a background) which also means no masks or selections nor paths, or spot-colours (separate colour layer) unless specifically required.

Files must be in an acceptable format: in practice this means using either TIFF for 4-colour reproduction – whether for inkjet or mass-printing – or JPEG for web-based work. TIFF files must be 24-bit colour. Special image modes such as Indexed Color or Duotone should be turned into RGB files. For web use, files should be JPEG or GIF with a level of compression appropriate to the intended use.

Concerning colour, your files should have their working colour space profile embedded. This is very important for colour accuracy because inconsistencies between the colour space that your laboratory or client expects and the profile you provide can lead to very poor colour reproduction.

Everyone will thank you for naming files in a helpful manner: if there are formalities related to the pictures, such as job or order code number, you will make yourself popular with the technicians if you place the relevant code into the name of all the image files, together with sequential number or a brief descriptive title, for example DD270_cat_portrait_093.JPG.

Finally, ensure that you use only "system-legal" letters and numbers in the name and that the punctuation follows your computer's rules. For example, symbols such as forward slash, brackets, per cent, and star, as well as multiple spaces in a name can make the file unreadable by the computer.

RGB | or CMYK

One common debate is whether files should be supplied as RGB or as CMYK. For the majority of photographers, who print to their own desktop printer, the answer is always to print with RGB files, unless the instruction manual instructs otherwise. Using RGB allows you to work with the largest colour gamut, which would be constricted by converting to CMYK. Besides, many modern desktop printers print to a larger colour gamut than that enclosed by CMYK profiles.

However, if you supply to a publishing house or laboratory, they may ask you for CMYK files. If so, ensure that you are supplied with the correct output profile to make the conversion from RGB to CMYK. This also doubles as your soft-proofing profile.

printing images
The flow of work starts with checking the image, then optimizing the file before output, and repeating the whole workflow to refine the results if necessary.

- soft-proof and check profile
- optimize size and resolution, save as
- flatten image, remove masks, paths etc
- set up printer controls and clean if necessary
- match paper to profile and soft-proof
- print using correct side of paper
- evaluate print under standard lighting conditions

24-bit Measure of the size or resolution of data that a computer program or component works with.

6500 White balance setting that corresponds to normal daylight. It appears warm compared to 9300.

9300 White balance setting that is close to bright daylight. It is used mainly for visual displays.

additive colour Combining or blending two or more coloured lights in order to simulate or give the sensation of another colour.

additive primaries The additive primary colours are red, green, and blue. When all three are added together white light is produced.

AE Abbreviation for Automatic Exposure.

AF Abbreviation for Auto-Focus.

ambient light The available light that is not under the control of the photographer.

analogue A non-digital effect, representation, or record that varies in strength.

anti-aliasing A method of smoothing the diagonal lines in a digital image to avoid a "staircase" effect caused by the edges of individual pixels.

aperture The lens setting that controls the amount of light entering the lens of the camera.

aperture priority An automatic exposure mode that varies the shutter time as required.

APS (Advanced Photo System) An obsolete film format. Also refers to sensors of around 24mm x 16mm in size.

artefact Any information on a digital image that is unwanted.

background The bottom layer of a digital image; the base.

backlighting Lighting the subject from behind with the light source facing the camera.

back-up Copy of a digital file that is kept in case of damage to, or loss of, the original.

bicubic interpolation A type of interpolation in which the value of a new pixel is calculated from the values of the eight pixels that are adjacent to it.

bilinear interpolation A type of interpolation in which the value of a new pixel is calculated from the values of the four adjacent pixels on the left, right, top, and bottom.

bleed (1) A photograph or graphic object that extends off the page when printed. (2) The spread of ink into fibres of the paper, which causes dot gain – dots print larger than intended.

Bluetooth A standard for high-speed wireless radio connections between electronic devices, such as mobile phones, keyboards, and laptop computers.

bracketing Taking a range of shots and deliberately under- and over-exposing in order to find the best exposure.

brightness (1) A quality of visual perception that varies with the amount or intensity of light. (2) The brilliance of a colour related to hue or colour saturation.

browse To look through a collection of digital material, such as images or web pages.

brush An image-editing tool used to apply effects such as colour, blurring, burn, dodge, and so on.

burning-in A digital image-manipulation technique that mimics the darkroom technique of the same name. This method gives a selected part of the image extra exposure, making it appear darker.

byte A unit of digital information that is the standard unit for measuring the memory capacity of a digital storage device.

calibrate Setting up a monitor or other device to conform to industry or manufacturer's standards.

camera exposure The quantity of light reaching the light-sensitive film or light sensor in a camera. It can be varied by adjusting the aperture of the lens and the duration of the exposure.

CCD (Charge-Coupled Device) A type of imaging sensor found in digital cameras.

CD-R (Compact Disc-Recordable) A type of CD suitable for storing data such as images.

CD-ROM (Compact Disc-Read Only Memory) A type of CD used to supply software or collections of images.

CD-RW (Compact Disc-ReWritable) A type of CD that can be used more than once by erasing contents prior to re-recording.

centre-weighted metering A type of metering that gives more importance to the central areas of an image.

channel A set of data used by image manipulation software to define colour or mask.

close-up lens An attachment lens used to enable normal lenses to work close up.

clone To copy part of an image and paste it elsewhere on the same image or onto another image.

CMYK (Cyan, Magenta, Yellow, Key black) The primary inks used in desktop and commercial printing that are used to simulate a range of colours.

ColorSync A proprietary colour-management software system that ensures the colours seen on the screen match those to be reproduced.

colour balance The relative strengths of colours in an image.

colourize To add colour to a greyscale image without changing the original lightness values.

colour cast A tint of colour that covers an image evenly.

colour gamut The range of colours that can be produced by a device or reproduction system.

colour management A system of controlling the colour output of all devices in a production chain.

colour temperature The measurement of the colour of light.

compositing A picture processing technique that combines one or more images with a basic image.

compression The process of reducing the size of a digital file by changing the way the data is coded.

contrast A measure of the difference between the lightest and darkest parts of an image.

crop (1) To remove part of an image in order to improve composition, fit the image in the available format, or square up the image to the correct horizon. (2) To restrict a scan to the required part of an image.

definition Subjective assessment of the clarity and the quality of detail visible in an image.

delete To remove an item from an image or an electronic file from the current directory.

depth of field The measurement of how much of an image is acceptably sharp, from the nearest point to the camera which is acceptably sharp to the furthermost point which is acceptably sharp.

diaphragm The apparatus in the lens that forms the aperture.

differential focusing Focusing on a subject and rendering some parts sharp, and other parts unsharp.

diffuser An accessory that softens light or the image.

digital manipulation The process of changing the characteristics of a digital image using a computer and software.

direct vision finder Type of viewfinder in which the subject is observed directly, for example, through a hole or optical device.

display A device such as a monitor screen, LCD projector, or LCD panel on a camera that provides a temporary visual representation of data.

dodging Technique for controlling local contrast during printing by reducing selectively the amount of light reaching parts of the image that would otherwise print too dark, and its digital equivalent.

dpi (dots per inch) The number of dots

that can be addressed or printed by an output device; indicative of how much detail (or resolution) the device gives.

driver Software used by a computer to control or drive a peripheral device such as a scanner, printer, or removable media drive.

drop shadow Graphic effect in which an object appears to float above a surface, leaving an off-set fuzzy shadow below it.

dSLR Abbreviation for digital Single Lens Reflex.

duotone (1) Photo-mechanical printing process using two inks to increase tonal range. (2) Mode of working in image-manipulation software that simulates the printing of an image with two inks.

DVD (Digital Versatile Disc) An electronic storage medium, of which there are many variants.

electronic viewfinder An LCD screen, viewed under an eyepiece, showing the view through the camera lens.

enhancement A change made to one or more qualities of an image, for example, increasing the colour saturation or sharpness.

EPS (Encapsulated PostScript) A file format used for graphics.

evaluative metering A type of metering system which divides a scene into a number of sections and measures the brightness in each in order to determine the final exposure.

EVF (Electronic ViewFinder) Small, enclosed display panel viewed under viewfinder optics.

f/number Setting of lens diaphragm that determines amount of light transmitted by lens.

f-stop (f/number) The f/number or aperture setting.

file format Method or structure of computer data.

fill in (1) To illuminate shadows cast by the main light by using another light-source or reflector to bounce light from main source

into shadows. (2) In image manipulation, to cover an area with colour using the bucket tool.

filter Software that is used to convert one file format to another or to apply effects to the image.

FireWire Proprietary name for IEEE 1394, the standard for high-speed cable connection between devices.

flare A non-image forming light caused by internal reflections within the lens.

flash (1) To illuminate with a very brief burst of light. (2) Equipment used to provide a brief burst of light. (3) Type of electronic memory used in, for example, digital cameras.

flatten To combine multiple layers and other elements together into a single background layer.

focal length The distance from the centre of a lens to its point of focus on the film or digital sensor, when the lens is set to infinity. Usually measured in millimetres.

focus To bring an image into focus by adjusting the distance setting of the lens.

gamma In monitors, a measure of the correction to the colour signal prior to its projection on screen. A high gamma gives a darker overall screen image.

GIF (Graphic Interchange Format) A highly compressed file format designed for use over the Internet.

graduated filter A type of filter that varies in strength from one side to the other.

grain Small particles of silver or colour that make up an image.

greyscale A measure of the number of distinct steps between black and white in an image.

highlights The brightest or lightest parts of an image.

hot-pluggable Connector or interface, such as USB and FireWire, that can be disconnected or connected while computer and machine are switched on.

hue Name for the visual perception of colour.

IEEE 1394 See FireWire.

i.Link Proprietary name for IEEE 1394, the standard for high-speed cable connection between devices.

infinity Lens focus setting at which, for all practical purposes, the light rays enter the lens parallel to each other.

interpolation Method of inserting pixels into an existing digital image using existing data.

iris The hole created by the lens diaphragm to admit light into the camera.

IS (Image Stabilization) Lens A lens with integral sensors to correct camera shake and so give better sharpness without using a tripod.

ISO (International Organization for Standardization) Body that sets standards for measures such as sensor sensitivity and output.

JPEG (Joint Photographic Expert Group) A lossy data compression technique that reduces file sizes.

K (1) A binary thousand, sometimes used to denote 1024 bytes. (2) Key ink in the CMYK process. (3) Degrees Kelvin, which measure colour temperature.

key tone The principal or most important tone in an image, usually the mid-tone between white and black.

layer A part of a digital image that lies over another part of the image.

layer mode Picture-processing or image-manipulation technique that determines the way that a layer in a multi-layer image combines or interacts with the layer below.

LCD (Liquid Crystal Display) A display using materials that can block light.

lens hood An accessory for the lens that shades it from light and protects it from rain.

light meter A device used to calculate camera settings in response to light.

lossless compression A computing routine, such as LZW, that reduces the size of a digital file without reducing the information.

lossy compression A computing routine, such as JPEG, that reduces the size of a digital file but also loses some information or data in the process.

lpi (lines per inch) A measure of resolution used in photo-mechanical reproduction.

macro Focusing in the close-up range but with the subject not magnified.

manual exposure Setting the camera exposure by hand.

marquee Selection tool used in image manipulation and graphics software.

mask Selecting parts of an image to restrict the area that digital manipulation will affect.

megabyte One million bytes of information.

megapixel One million pixels. Used to describe a class of digital camera in terms of sensor resolutions.

Memory Stick Widely available USB-compatible portable storage drive.

metadata Textual information used to supplement or add extra information to image data.

moiré A pattern of alternating light and dark bands or colours caused by interference between two or more superimposed arrays or patterns, which differ in phase, orientation, or frequency.

monochrome Photograph or image made up of black, white, and greys. May or may not be tinted.

motordrive An accessory or camera feature that winds on automatically after every exposure.

ND (Neutral-Density) filter A filter used to reduce the amount of light entering the lens.

nearest neighbour A type of interpolation in which a new pixel's value is copied from the pixel nearest to it.

noise Irregularities in an image that reduce information content.

opacity A measure of how much of an image can be "seen" through a layer or layers.

open flash A flash exposure technique in which the shutter is set to open before the flash is fired.

operating system The software program that coordinates the computer.

optical viewfinder A type of viewfinder that shows the subject through an optical system, rather than via a monitor screen.

out-of-gamut Colours from one colour system that cannot be seen or reproduced in another.

output Hard-copy print-out of a digital file.

paint To apply a colour, texture, or effect with a digital "brush".

palette (1) A set of tools, colours, or shapes. (2) A range or selection of colours in an image.

panning Moving the camera horizontally to follow the action.

partial metering Metering that measures from a part of the image, usually in the centre.

passive autofocus A type of autofocus in which the image is analyzed for sharpness.

peripheral A device such as a printer, monitor, scanner, or modem that is connected to a computer.

photomechanical halftoning A technique that is used to represent continuous-tone originals, such as photographs, as a grid of dots of ink that vary in size.

photomontage A composite photographic image made from the combination of several other images.

pixelated The appearance of a digital image whose individual pixels are clearly discernible.

plug-in Application software that works in conjunction with a host program into which it is "plugged" so that it operates as if part of the program itself.

polarizer A type of filter that polarizes the light passing through it. Mainly used to darken sky or remove reflections from water.

posterization Representation of an image that results in a banded appearance and flat areas of colour.

ppi (points per inch) The number of points seen or resolved by a scanning device per linear inch.

predictive autofocus A type of autofocus that calculates the speed of a moving subject in order to set the correct focus point for the moment of exposure.

prefocusing A technique of setting focus first before re-composing a photograph to take the shot.

program exposure A type of autoexposure control in which the camera sets both shutter time and aperture.

Pull processing The process of giving extra exposure to film followed by reduced development to compensate and obtain lower-contrast negatives than normal.

RAM (Random Access Memory) A computer component in which information can be stored or rapidly accessed.

rangefinder A focusing system that places two images of the same scene, viewed from slightly different viewpoints, into the viewfinder. The focusing ring on the lens is turned to move the two images together. When the images overlap the scene is in focus.

RAW Image data delivered by sensor with minimal processing and maximum information.

reflected light reading The most common type of light reading, which measures the light reflected from the subject.

re-sizing Changing the resolution or file size of an image.

resolution A measure of how much detail an optical system can see.

retouching Changing an image using bleach, dyes, or pigments.

RGB (Red, Green, Blue) The colour model that defines colours in terms of relative amounts of red, green, and blue components.

sabattier effect A darkroom effect in which tones are partially reversed.

scanning Process of turning an original into a digital facsimile, creating a digital file of specified size.

sensitivity Measure of how much an instrument – such as a sensor – outputs in response to a given input – such as light.

shutter priority A type of auto-exposure in which the user sets the shutter while the camera sets the aperture automatically.

SLR (Single Lens Reflex) A type of camera where the photographer looks through the viewfinder to see exactly the same image that will be exposed onto the film or sensor.

stair-stepping Jagged, rough, or step-like reproduction of a line or boundary, which was originally smooth.

standard lens A lens of focal length roughly equal to the diagonal of the picture format.

stop (1) A step in processing that halts development. (2) A unit of exposure equal to a doubling or halving of the amount of light.

subtractive primaries The three colours (Cyan, Magenta, Yellow) that are used to create all other colours in photographic printing.

telephoto lens A type of lens with a focal length that is longer than the physical length of the lens. It is used to make distant objects appear larger.

thumbnail A representation of an image as a small, low-resolution version.

TIFF A very widely used digital image format.

tint (1) Colour that can be reproduced with process colours; a process colour. (2) An overall, usually light, colouring that tends to affect areas with density but not clear areas.

TTL (Through The Lens) metering A metering system that reads through the taking lens.

upload Transfer of data between computers or from network to computer.

USB (Universal Serial Bus) The standard port design for connecting peripheral devices, such as a digital camera, printer, or telecommunications equipment to a computer.

USM (UnSharp Mask) An image-processing technique that improves the apparent sharpness of an image.

UV filter (Ultra-Violet filter) A type of lens filter that stops ultra-violet rays passing through.

vignetting The technique of darkening the corners of an image through the obstruction of light rays.

warm-up filter A type of lens filter used to increase the yellowness of an image.

white balance A shade of white (warm, cold, neutral) used as a standard white.

wide-angle converter A lens accessory that increases the angle of view of the lens to which it is attached.

zip A method of compressing files.

zoom lens A type of lens in which the focal length can be altered without changing focus.

index

index

index

acknowledgments

(Key: a-above; b-below/bottom; c-centre; f-far; l-left; m-middle; r-right; t-top) p2 © Tamao Funahashi (l), © Robert Eaves (cr); p10-11 (l-r) 3+9+10 © Andy Mitchell, 6+8 © Wendy Gray; p14 © Andy Mitchell; p15 © Tim Keweritsch (b); p16-17 Getty Images © Martin Ruegner; p27 © Gerard Brown except (bl) © Andy Mitchell; p28 © Adrienne Babin; p29 © Chris Hopkins (t), © Kathrin Long (b); p34-35 © Tim Keweritsch; p36 © Wendy Gray; p37 © Wendy Gray (t); p40-41 © Wendy Gray; p42 © Gerard Brown (t), © Andy Mitchell (c, b); p43 © Gerard Brown (tl, tr, cl), © Andy Mitchell (bl, br); p44 © Erling Steen; p45 © Tara McMullen (t), © Sandro e Patrizia (b); p54 Alamy © Michele Falzone (t), Alamy © Karsten Wrobel (c), Alamy © imagebroker (b); p55 Axiom Photographic Agency © Peter Rayner (c), Alamy © Andrew Wheeler (cr), Still Pictures © Gordon Wiltsie (bc); p56 © Florence Fairweather; p57 © Tim Keweritsch (b); p70-71 Alamy © Tim Gainey; p72 Getty Images © David Sacks (t), © Andy Mitchell (b); p73 Getty Images © Justin Pumfrey (tl), © Micheal Orton (tr), naturepl.com © Laurent Geslin (cr), Getty Images © Matt Carr (br); p74 © Nikolaus Christian Madzar; p75 © Milo Baumgartner (t), © Nicolas Bonnet (b); p77 © Tim Keweritsch (b); p79 © John Munro (tl, tr, al, ar); p84-85 Photolibrary © Vaughn Greg; p86 © Wendy Gray(t), © Gerard Brown (c, b); p87 © Gerard Brown except (br) © Wendy Gray; p90-91 (l-r) 1 PunchStock © Zen Shui, 8-10 © Andy Mitchell; p97 © Wendy Gray (tl, tr, cr) © Tim Keweritsch (m); p110-111 © Tim Keweritsch; p112-113 © Wendy Gray; p114 © Gaston Laurent; p115 © Amy Bell (t), © David Summers (b); p123 © Corbis (t); p126-127 © Andy Mitchell; p128 © Sandro e Patrizia; p129 © Dennis Low (t), © Victoria Fevre (b); p134 © Wendy Gray; p142 Axiom Photographic Agency © Chris Caldicott (c), © Andy Mitchell (b); p143 © Andy Mitchell except (tr) PunchStock © Zen Shui; p144 © Michael McCauslin; p145 © Nick Jones (t), © Bogdan Grosu (b); p147 © Wendy Gray (cl, cr, cr); p151 © Andy Mitchell (t); p154-155 © Gerard Brown; p156 © Annabel House; p157 © Tim Keweritsch (t), © Monika Madej (b); p158-159 (l-r) 2 © Andy Mitchell, 5 © Paul Self, 9 © Dan Powell; p163 © Andy Mitchell; p174-175 © Andy Mitchell; p179 Corbis © Cameron Davidson (cr, crb), Getty Images © The Image Bank / Bruno Morandi (tl, tr); p188 Corbis © Frank Krahmer (tr, cra, cr, crb, br); p189 Corbis © Frank Krahmer (tl, cla, cl, bl, tc, ca, c, bc); p190 © Max Ackermann; p191 © Janet Baker (t), © Annabel House (b); p195 © John Munro (b); p197 © Gerard Brown; p198-201 © Andy Mitchell; p203 © Andy Mitchell; p208-211 © Andy Mitchell; p214 © Erling Steen; p215 © Paul Self (t), © Dan Powell (b); p216 © Gerard Brown; p218 Corbis © Sidsel Clement / Cultura (ac, ctl, ctr, cbl, cbr, b), © Studio MPM (t, ctl); p221 © Wendy Gray; p222-223 © Tony Worobiec; p234-235 © Gerard Brown; p236-237 © Gerard Brown; p238-239 © Gerard Brown; p240-241 Corbis © Terry Eggers (1b, 2-9), © Nice One Productions (1t, 2-9); p242 © Harvey Roberts; p243 © Sandro e Patrizia (t), © Ayush Bhandari (b); p244-245 (l-r) 1+7+10 © Gerard Brown, 6 © David Summers, 8 © Vania Cunha; p248-253 © Clay Enos; p254 © Andy Mitchell (c), © Vania Cunha (b); p255 © Vania Cunha (tl) © Andy Mitchell (bl, br); p256 © Napoji; p257 © Rahul Kumar (t), © Dmitry Dudin(b); p258-263 © Eolo Perfido; p266-267 © Gerard Brown; p268 © David Rossi; p269 © Thom Small (t), © Florence Fairweather (b); p272-277 © Altaf Qadri; p280 © Erling Steen; p281 © Napoji (t), © Lizelle Lotter (b); p284-289 © Tamao Funahashi; p292 © Paul Self; p293 © Sara Beckett (t), © Sergei Andreev (b); p296-301 © Duane Hart; p302-303 © Gerard Brown; p304 © Paulo Perez; p305 © David Coldrey (t), © Jeffery Shay (b); p308-313 © Inigo Bujedo Aguirre; p314-315 © Andy Mitchell; p316 © Lee Oyama; p317 © Barbara McKay (t), © Ramon Rico (b); p320-325 © Marion Hogl; p326 Alamy © Steve Bloom Images (tr), Alamy © David Tipling (br); p327 stevebloom.com © Steve Bloom (tr), Corbis © Winfred Wisniewski – Frank Lane Picture Agency (bl), Alamy © imagebroker (br); p328 © Chris Hopkins; p329 © David Summers (t); © Thorsteinn Egilson (b); p332-337 © Emily Allchurch; p340 © Sandro e Patrizia; p341 © Monika Madej (t), © Robert Eaves (b).

All other images © Tom Ang
For further information, see:
www.dkimages.com

More than any other book I have worked on, this is the product of a high level of collaboration between many photographers. The result is a richness and variety of voice which no one photographer could match. To all the contributing photographers – both the enthusiasts who sent in their images and the professionals contributing their wonderful portfolios – go my warmest thanks.

To the team at Dorling Kindersley that pulled together a complicated project, I also give my very warmest compliments and thanks. Star and chief is project editor Nicky Munro who led the entire project, aided by designer Sarah-Anne Arnold, whose design set a stylish framework that enhances the photographs. I am also very grateful for the expert help with image manipulation from Adam Brackenbury, and to Andy Mitchell and Gerard Brown for filling holes in the photography.

Finally, as ever, and to as constant a companion and help-mate as anyone has been blessed with, I am glad and privileged to thank Wendy. Not only did she give me constant support and encouragement (and no, she does not also write my acknowledgments), she also contributed many fine images to the book.

Tom Ang
Auckland

Dorling Kindersley would like to thank Margaret McCormack for compiling the index.